TREKKING BEYOND

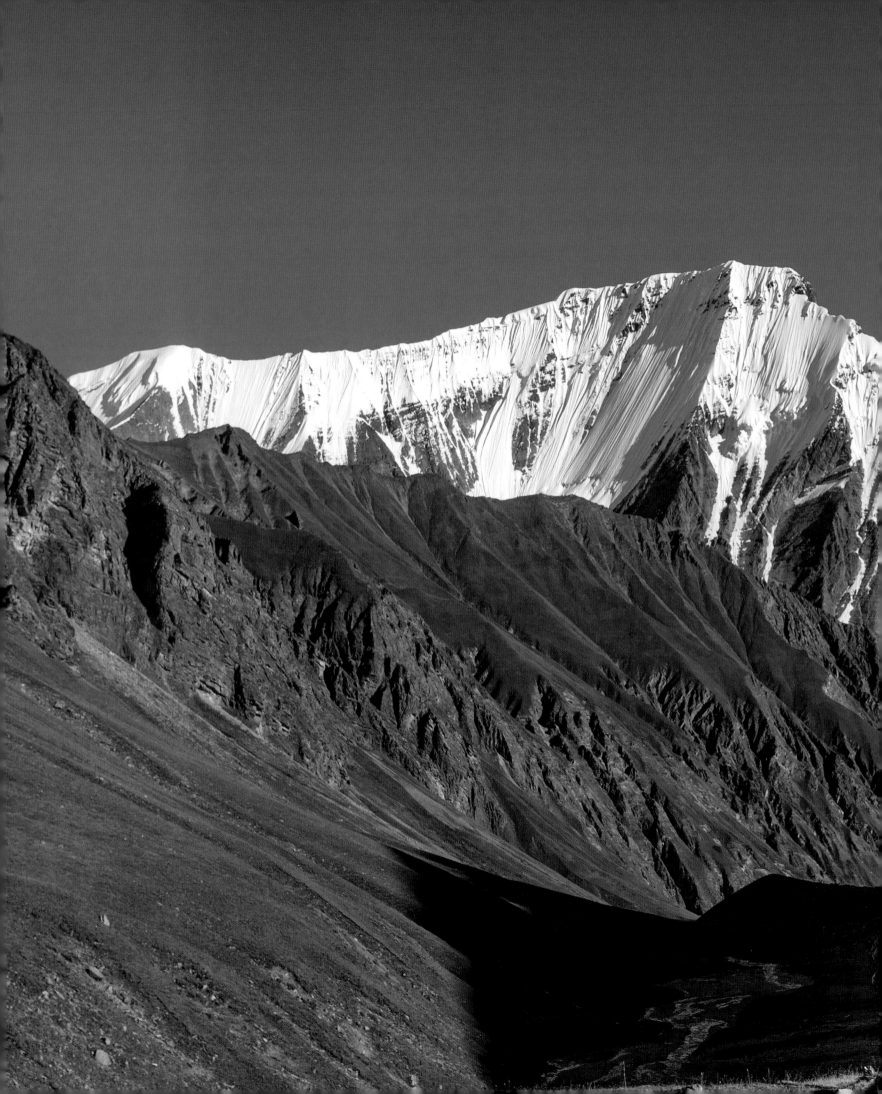

TREKKING BEYOND

Walk the world's epic trails

DAMIAN HALL, DAVE COSTELLO
AND BILLI BIERLING

WHITE LION
PUBLISHING

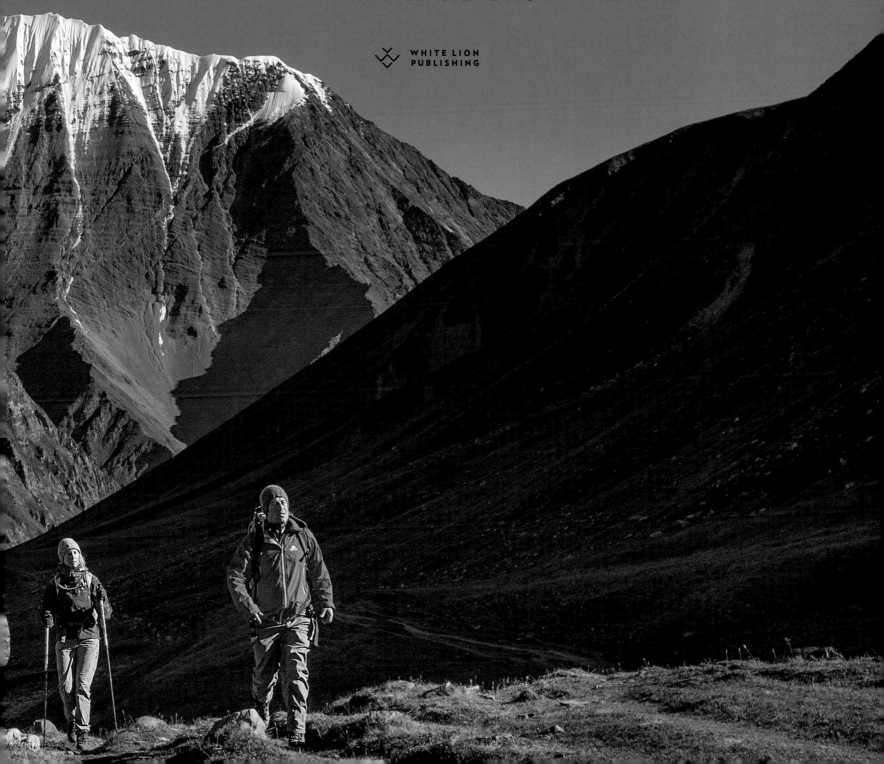

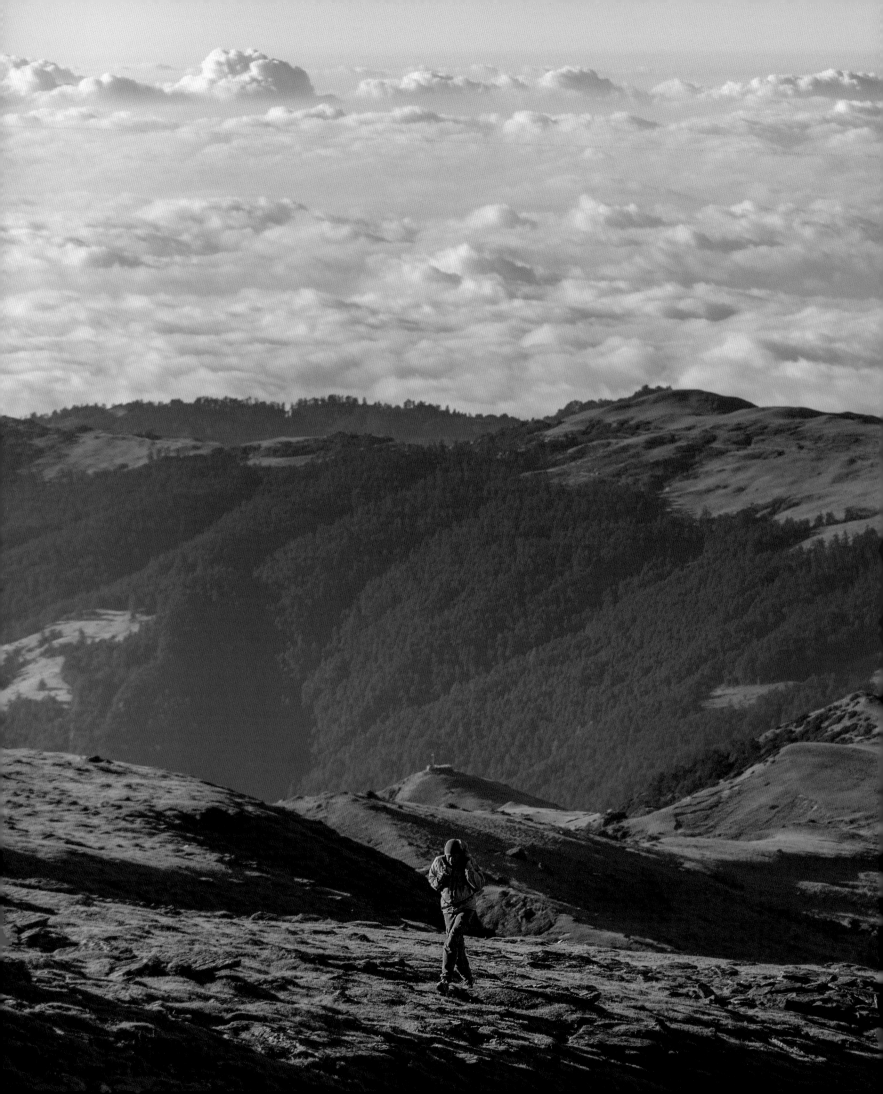

TREKKING BEYOND

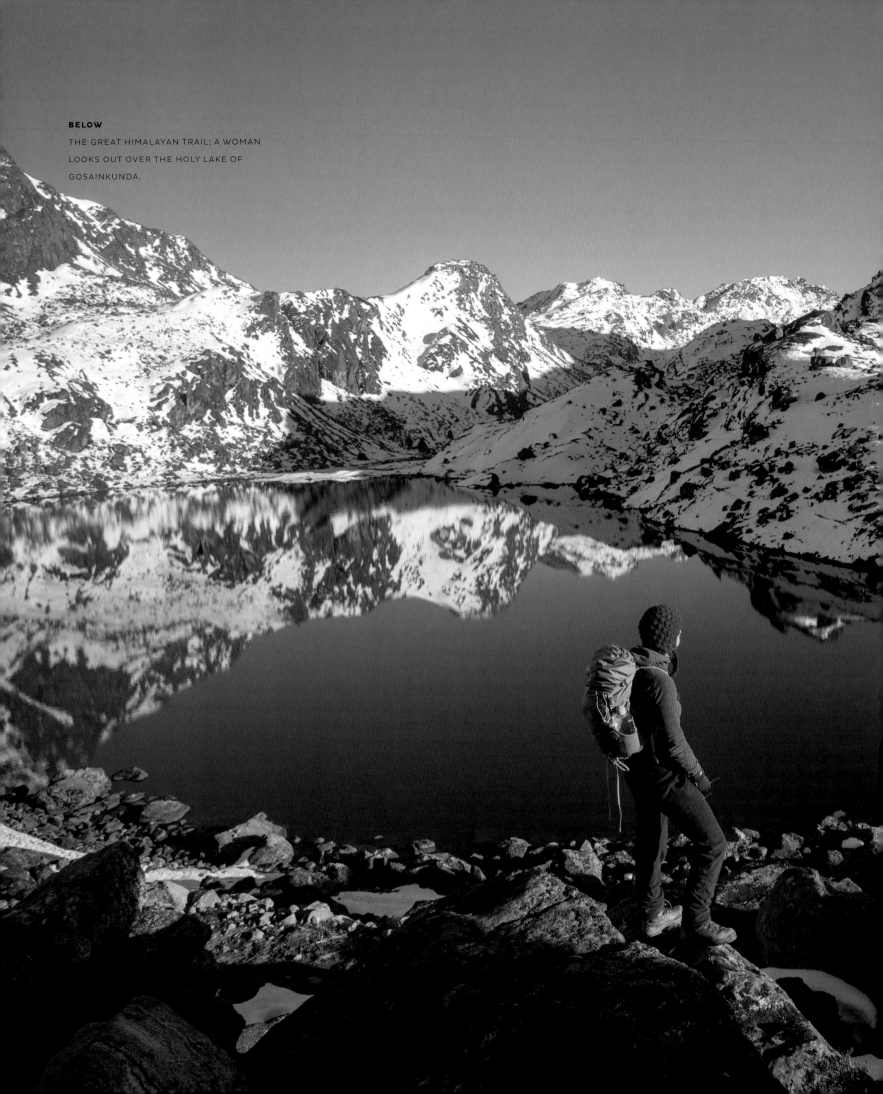

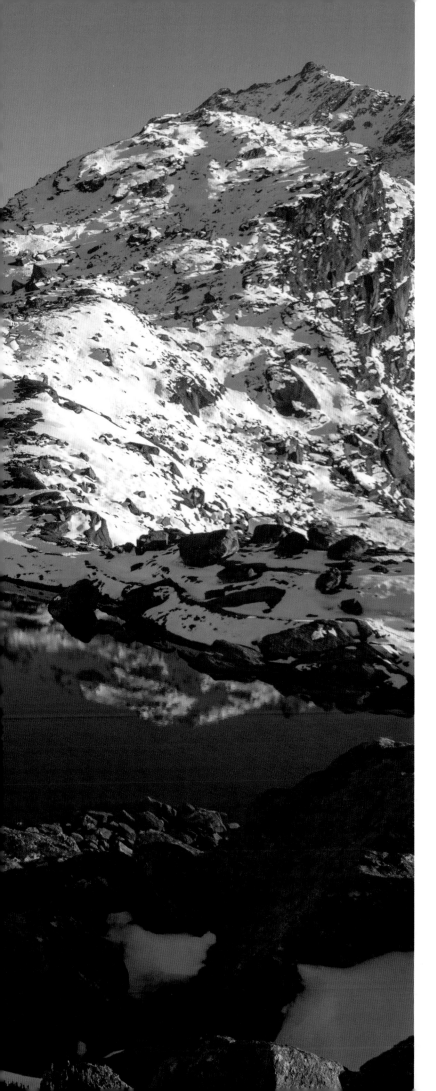

INTRODUCTION

Walking, hiking, backpacking, trekking, tramping, yomping – call it what you like: few things are more natural to us than putting one foot in front of the other. But why do we choose to hike in our leisure time, when ostensibly we don't need to? Usually a car, bus or plane can get us to the end point much faster, in greater comfort, with a radio to listen to. Maybe it's because – inherently, primally – we need to walk. It seems more than coincidental that whilst our lives are becoming increasingly immobile, thanks to advancements in technology and transportation, we are seeking out more simplistic and natural activities in our spare time.

The call of the wild and the enormous psychological benefits we get from spending time surrounded by nature – and the huge health rewards gained from exercising – are well documented. Where better to roam free than in the world's wild, remote and often mountainous places? A day's walk can be thoroughly satisfying, but the screens and information overload are still there when you get home. Far more exhilarating is to go on a multiday journey, a long-distance walk – a trek; truly immersing yourself in an experience that is a physical, emotional and geographical journey, self-powered and self-sufficient, through scenery that stirs the soul.

From the monstrous Himalayas and condor-circled ice kingdom of the Patagonian Andes to the wilds of the Scottish Highlands and the dusty Australian Outback; from the awesome Alps and Pyrenees to the ancient Dolomites; from Greece's surprising flora and fauna to India's remote Ladakh region; from the vastness of Tanzania and Namibia to South Africa's rugged Drakensberg; not to mention the vibrant trekking communities – with the landscapes to match – of the United States: this lovingly crafted book is a celebration of the best places in the world to take your journey.

In these hugely handsome regions, specific trails are discussed in detail and include America's legendary Appalachian and Pacific Crest trails, New Zealand's famous 'tramps', Lapland's Kungsleden and Peru's Inca Trail, as well as lesser-known hikes in India, Burma, Canada, Europe and Mexico.

Each region and trail is illustrated with exceptional photographs showcasing the compelling drama of the forests, mountains and glaciers of the world's best trekking regions. Immerse yourself in these incredible places, let your imagination take hold, start dreaming, and plan for new adventures in places to which only your feet can take you.

Happy trekking!
Damian Hall

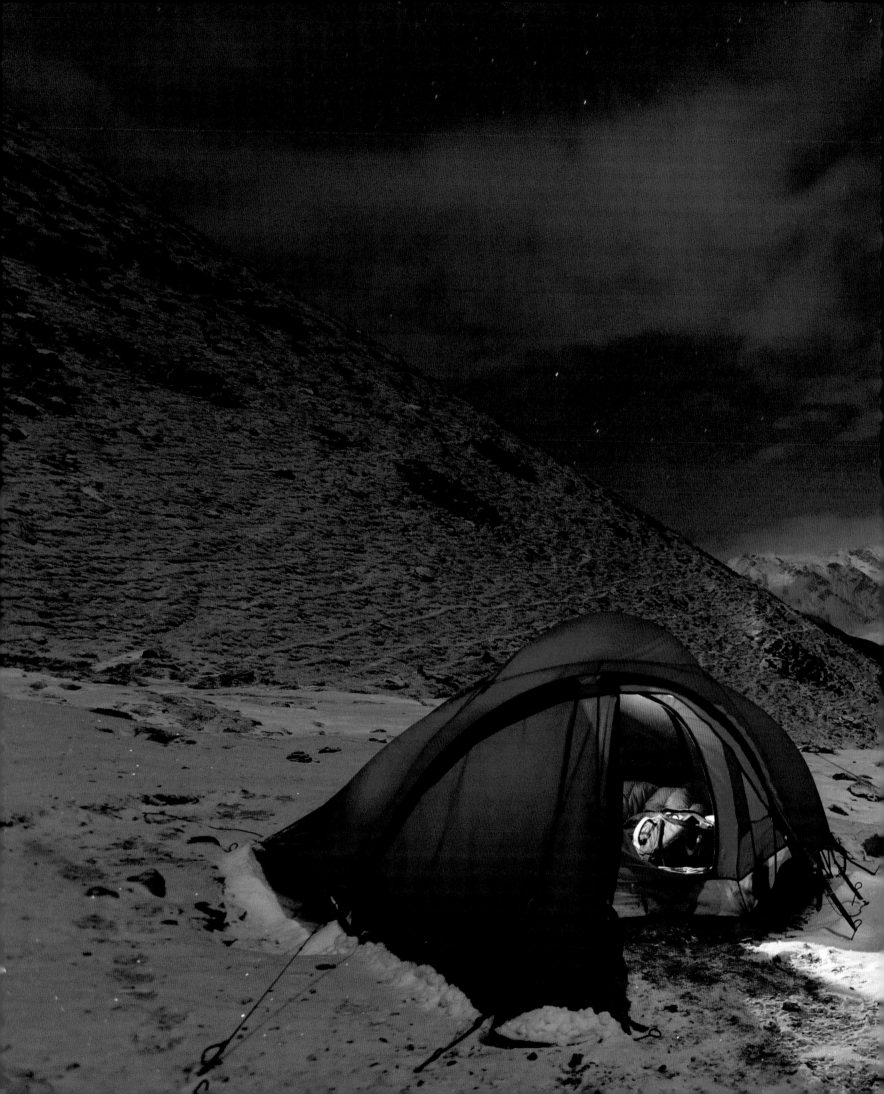

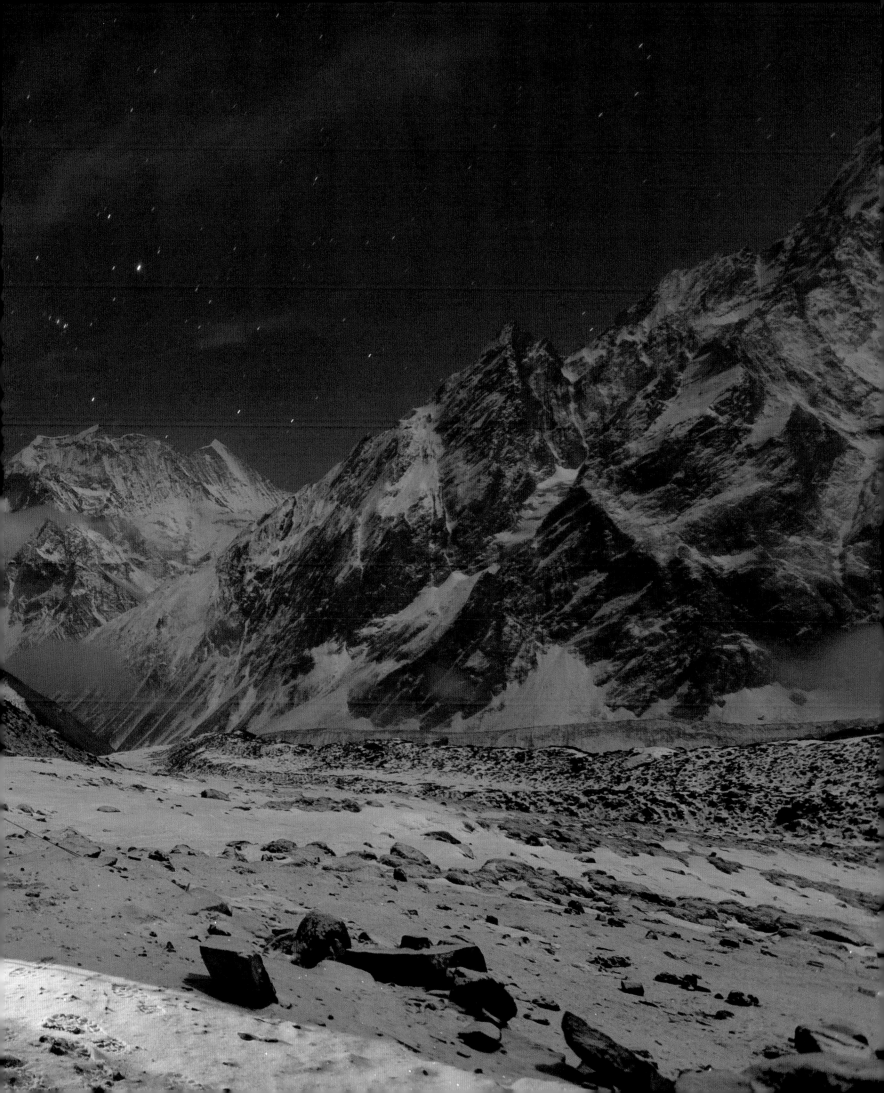

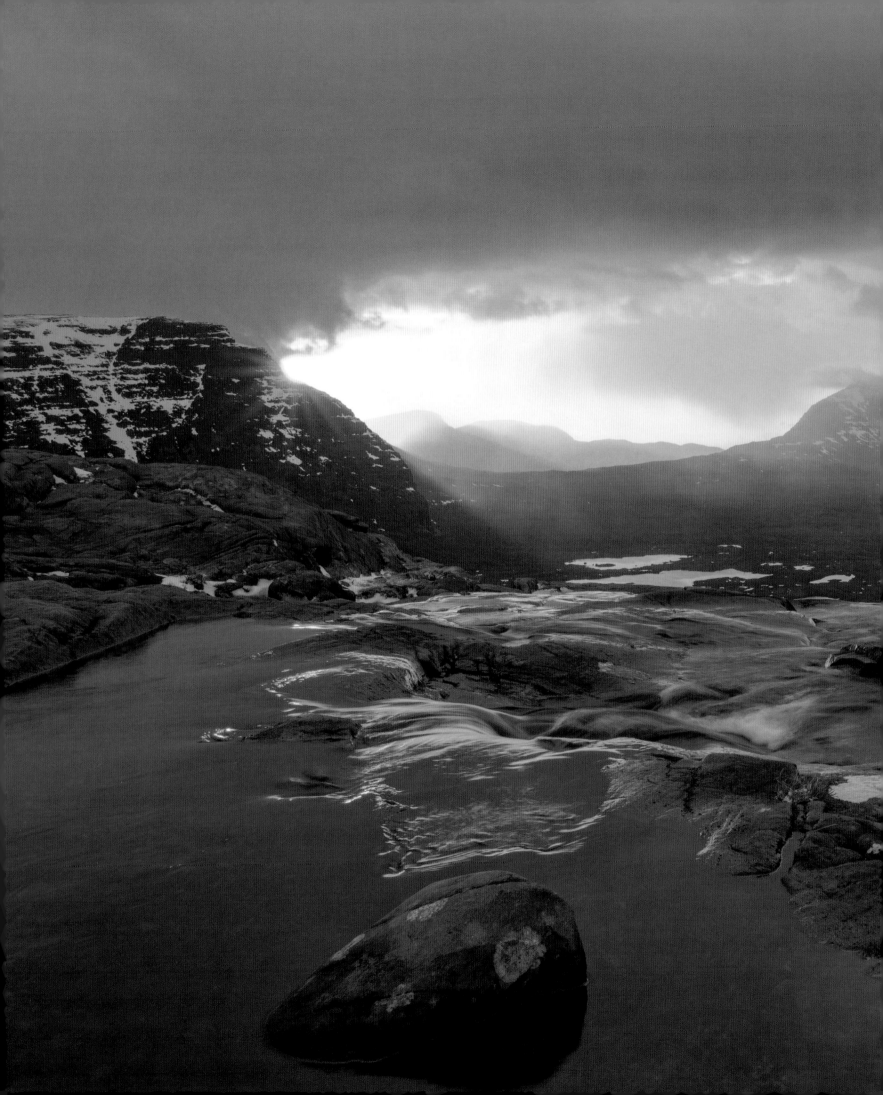

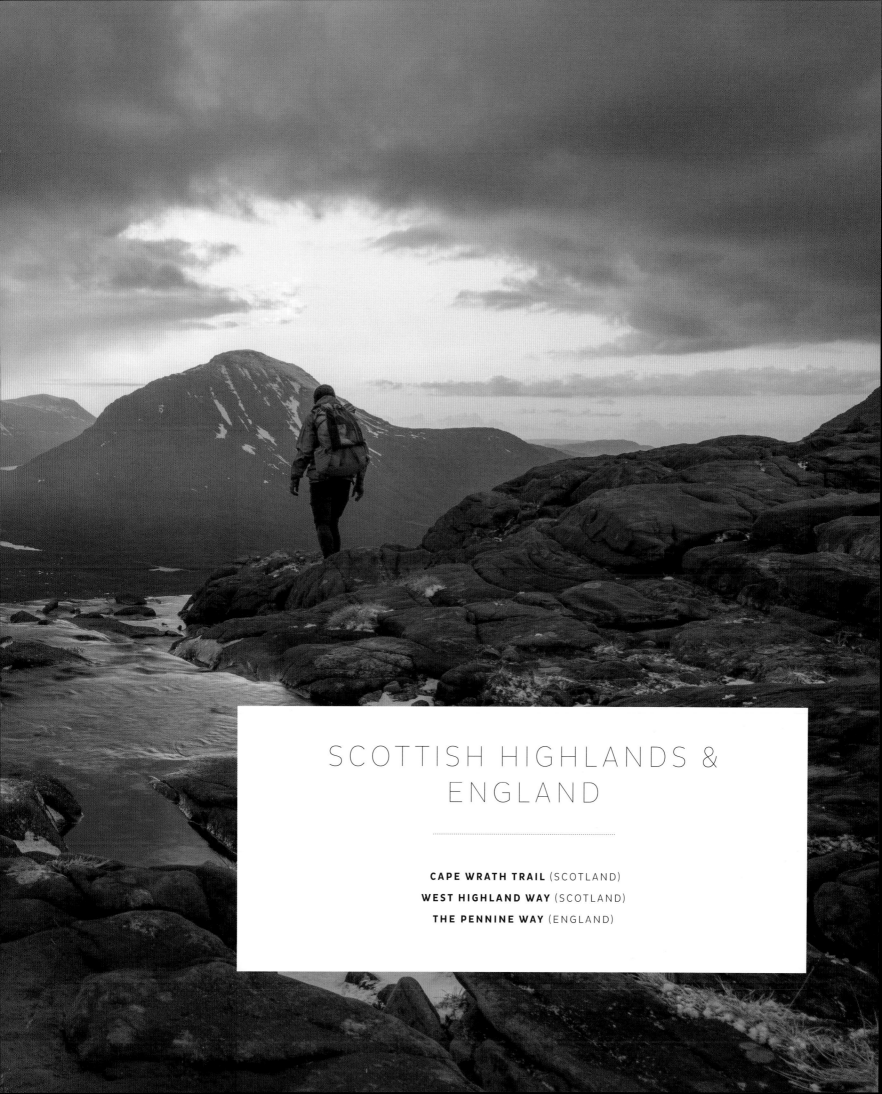

SCOTTISH HIGHLANDS & ENGLAND

..

CAPE WRATH TRAIL (SCOTLAND)
WEST HIGHLAND WAY (SCOTLAND)
THE PENNINE WAY (ENGLAND)

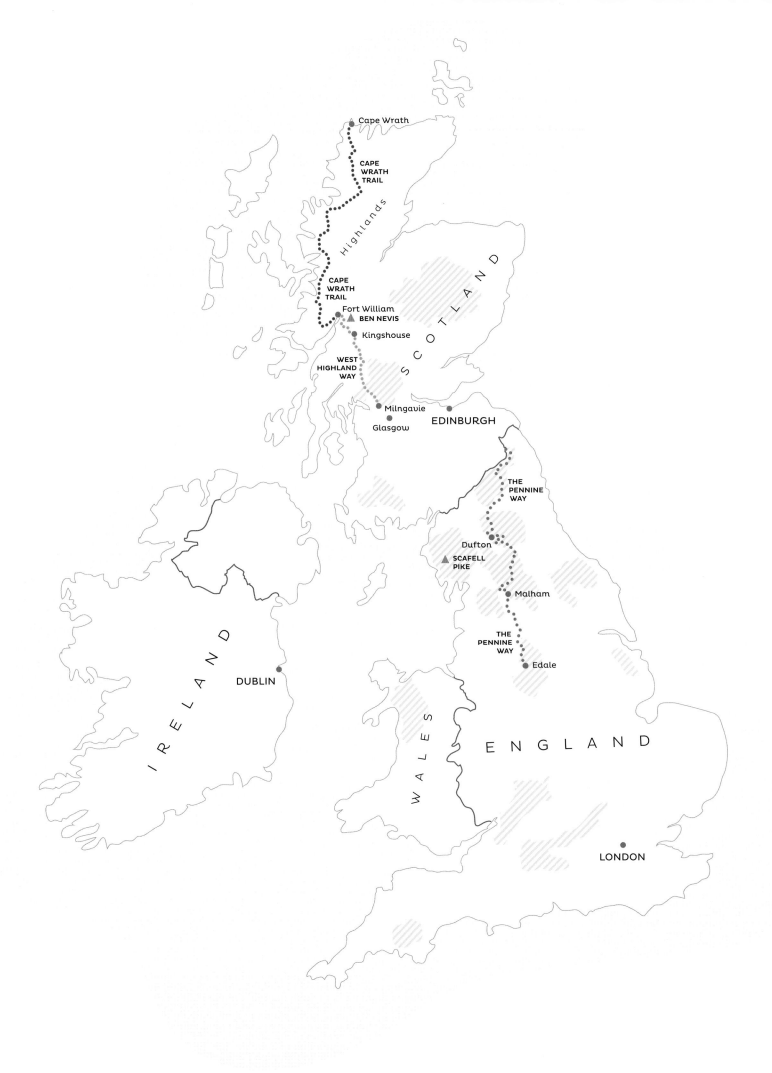

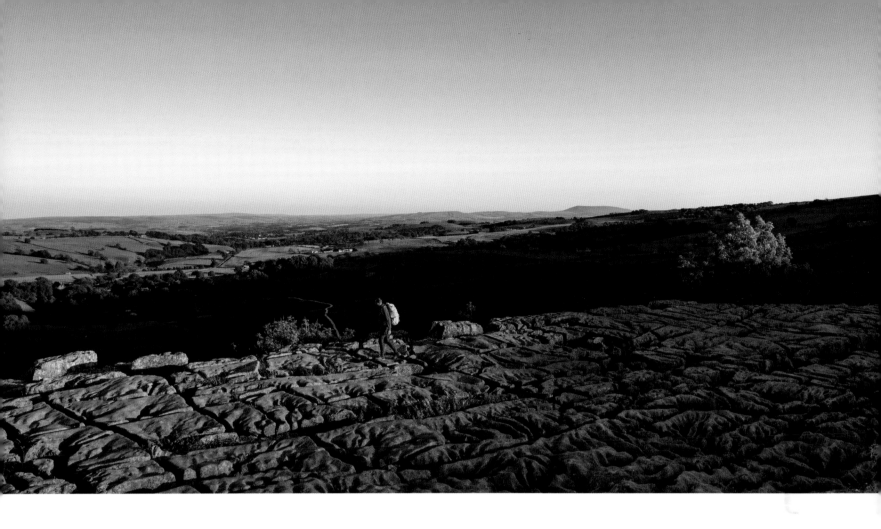

Scottish Highlands & England

Compared to other hiking hotspots, Britain doesn't offer big mountains, remote wilderness or comparatively exciting wildlife. And yet it is still undoubtedly one of the world's premier hiking destinations. Why? Because it offers something most other places can't: testing hills and impolite weather, at times; spectacular views and some compelling history; but all with most of the comforts of civilisation available, and very little risk of being bitten by something big and toothsome. It is a satisfying wildness experience, but with creature comforts. The best of both worlds.

Despite being a relatively highly populated island, hills and mountains, dales and fells (the last two words being local names for the aforementioned) abound. So, too, do welcoming villages and small towns. This combination means that you can spend the day getting your hat blown off up on the moors and dales, but call in to a café for a lunch or a cream tea, and later, fine dining with a glass of Merlot, followed by a night in a historical B&B ('bed and breakfast' accommodation).

And what of the landscapes? The island hasn't got deserts and volcanoes, but it has got: the melodramatic, purple-and-yellow-dotted moors of Yorkshire and Dartmoor (Britain has 75 per cent of the world's heather moorland); the chalky Downs (with their white horses and rude giants) in the south; endless views from the Cotswold Edge; the sheer green walls of the Brecon Beacons; incredible coastal scenery; craggy Snowdonia; the remote Cambrian Mountains; stone circles and hill forts; castles; history and mystery; clandestine valleys and ancient woodlands; long whistling rivers and crashing waterfalls; the peaty Peak District and – oh my – the Lake District; plus the tangible history of Hadrian's Wall. Then you cross

ABOVE

THE PENNINE WAY: LIMESTONE PAVEMENT ON TOP OF MALHAM COVE.

PREVIOUS PAGES

CAPE WRATH TRAIL: SUNSET AT LOCH COIRE MHIC FHEARCHAIR BELOW BEINN EIGHE IN TORRIDON.

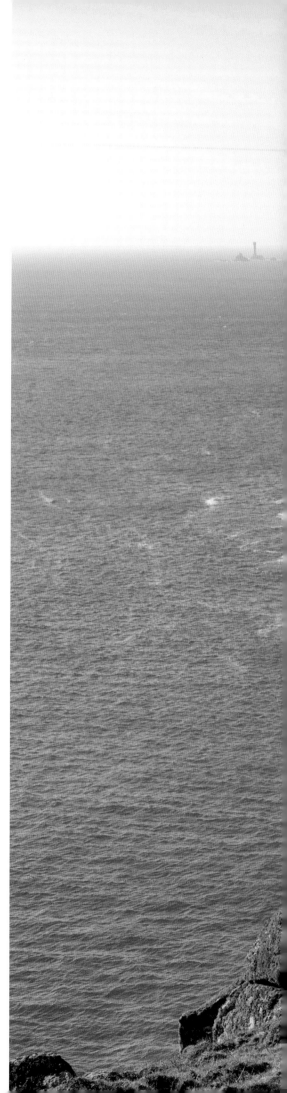

the border to the north and Scotland's Highlands. Up there, everything's bigger, wilder and more colourful – with decent mountains and a surprising sense of remoteness, too.

This is a land that loves walking. Charles Dickens, Bruce Chatwin, George Orwell, C.S. Lewis (who thought talking spoiled a walk), Thomas De Quincey, and many other legendary literary folk were serious yompers. Composing verse as he went, Romantic poet William Wordsworth is thought to have hiked approximately 300,000 kilometres (180,000 miles) in his lifetime (and not always while high on opium). It is said that his friend and fellow Romantic poet, Samuel Taylor Coleridge, once strode from Nether Stowey in the Quantocks to Lynton/Lynmouth and back again – some 145 kilometres (90 miles) – in just two days. Their unusual habit of night walking aroused government suspicion that they were French spies.

Britain has a long, healthier-than-ever tradition of hill walking and rambling. It was once a political struggle. In 1932, around 400 walkers scuffled with gamekeepers to mass trespass, a form of civil disobedience, on the summit of Kinder Scout in the Peak District, in protest against limited access to the countryside. 'Right to roam' legislation followed, opening up the countryside for us all to walk in, when previously much of it had been privately owned. The mass trespass also lead to the first modern long-distance path, the Pennine Way National Trail.

Many of the footpaths are ancient routes, historical trails that British ancestors took to travel to markets, places of work and worship. Footpaths used to be a transport network, and they are still cobwebbed across stout hills and wind-tickled dales, linking rustic villages and remote places of forgotten wilderness. People come from all over the world to walk this green and pleasant land.

It is difficult to find similar statistics for every country, but it is very likely Britain has either the most walking trails or is in the very top echelon of trail offerings. The Long Distance Walkers Association estimate the trails at over 1,400 (with the country's path network as a whole covering some 240,000 kilometres (150,000 miles). They are often well waymarked and reasonably well maintained – especially if they are designated National Trails – and maps are excellent. There are currently 16 National Trails in England and Wales, premier paths administered by government-funded Natural England, and 29 Great Trails in Scotland. There is a footpath along the entire glorious coast of Wales (the 1,400-kilometre/870-mile Wales Coast Path), and, in the near future, the England Coast Path will finally become a reality, the longest managed and waymarked coastal path in the world, covering an estimated 1,740 kilometres (2,800 miles).

RIGHT

CORNISH COAST: DRAMATIC CORNISH
COASTLINE NEAR LAND'S END AT THE
WESTERNMOST PART OF THE BRITISH ISLES.

14 SCOTTISH HIGHLANDS & ENGLAND

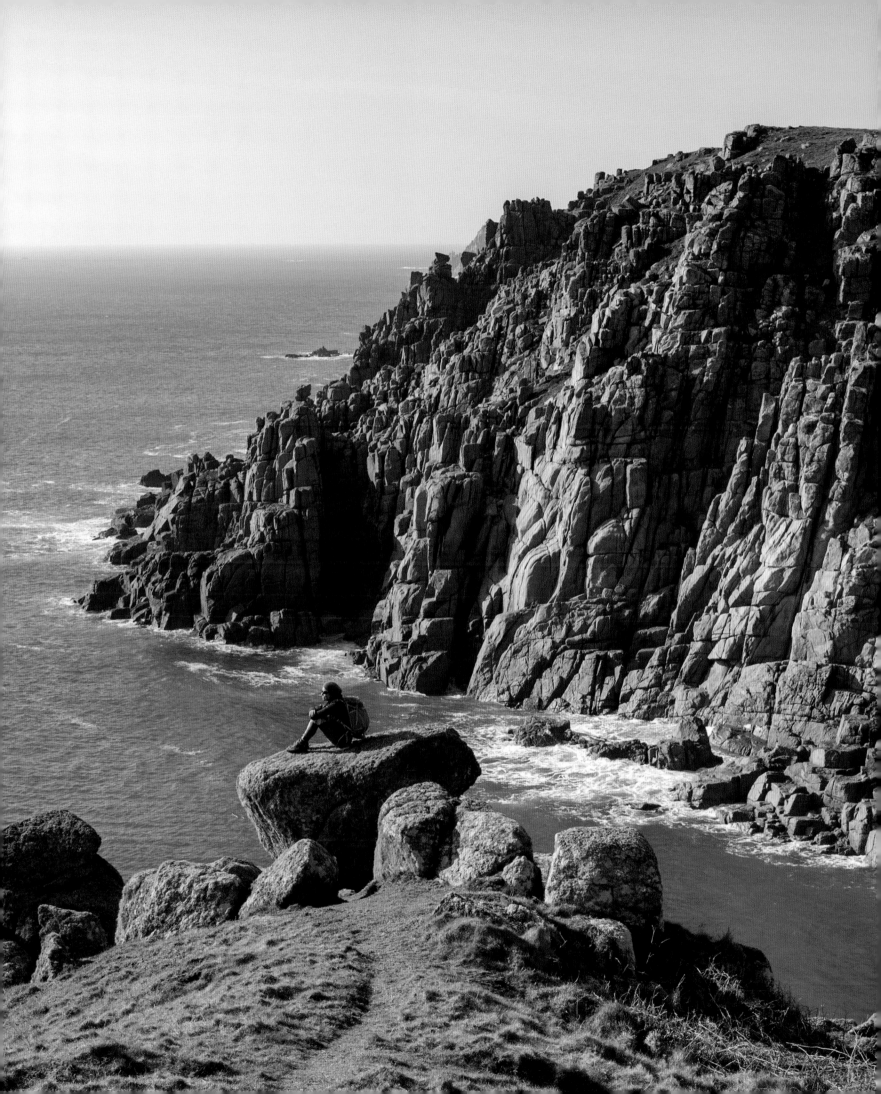

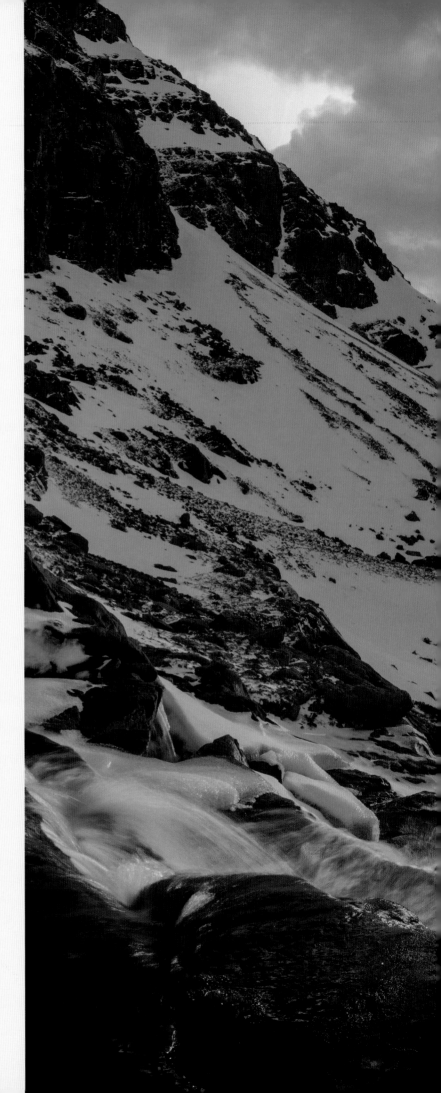

CAPE WRATH TRAIL
SCOTLAND

Though Britain doesn't have any vast Yukon-esque wilderness regions, where you can walk for weeks without sign of civilisation, the Cape Wrath Trail is as close as it comes. The 370-kilometre (230-mile) trail from Fort William, north to the tip of the country at Cape Wrath, covers some of the wildest mountain terrain Britain has to offer. It isn't waymarked and often there is not even a clear path; of course, this lack of formality and its tough reputation has only mushroomed its legendary status.

The route, which takes most people between 17 and 21 days, is not an official National Trail. In a way, it is not really a trail at all, more a jigsaw of routes between Fort William and Britain's most northwesterly point, to be assembled according to a trekker's preferences. Limited resupply points mean self-sufficiency for much of the journey and several days' supplies need to be carried on some stretches.

The idea arose when photographer David Paterson headed north with his camera and a bivvy bag, his 1996 book *The Cape Wrath Trail: A New 200-mile Walking Route Through the North-west Scottish Highlands* setting out a basic route template. Cameron McNeish, high-profile backpacker and writer, has further popularised it: 'It's the sort of long-distance route that most keen walkers dream of. A long tough trek through some of the most majestic, remote and stunningly beautiful landscape you could dare imagine. [It] could be described as the hardest long-distance backpacking route in the UK.'

From Fort William, trekkers traverse Ardgour and take in the gloriously remote Knoydart, before switching north to tick off Shiel Bridge, Kinlochewe and Inverlael. The approximate route goes inland to Oykel Bridge, before heading towards Glencoul via the majestic Ben More. Below the shadows of Arkle and Foinaven, the final leg passes Rhiconich and on to the west coast and over the windswept moors to Sandwood Bay and the Cape Wrath lighthouse, the journey's end.

There's no doubting Cape Wrath is a tough test, in remote country, on rugged terrain, likely to be accompanied by challenging weather. But those more testing moments will be quickly forgotten amidst a solitude and beauty rarely found in modern life. This is a trek for connoisseurs of wilder, more remote places.

RIGHT

SUNSET AT LOCH COIRE MHIC FHEARCHAIR
BELOW BEINN EIGHE IN TORRIDON.

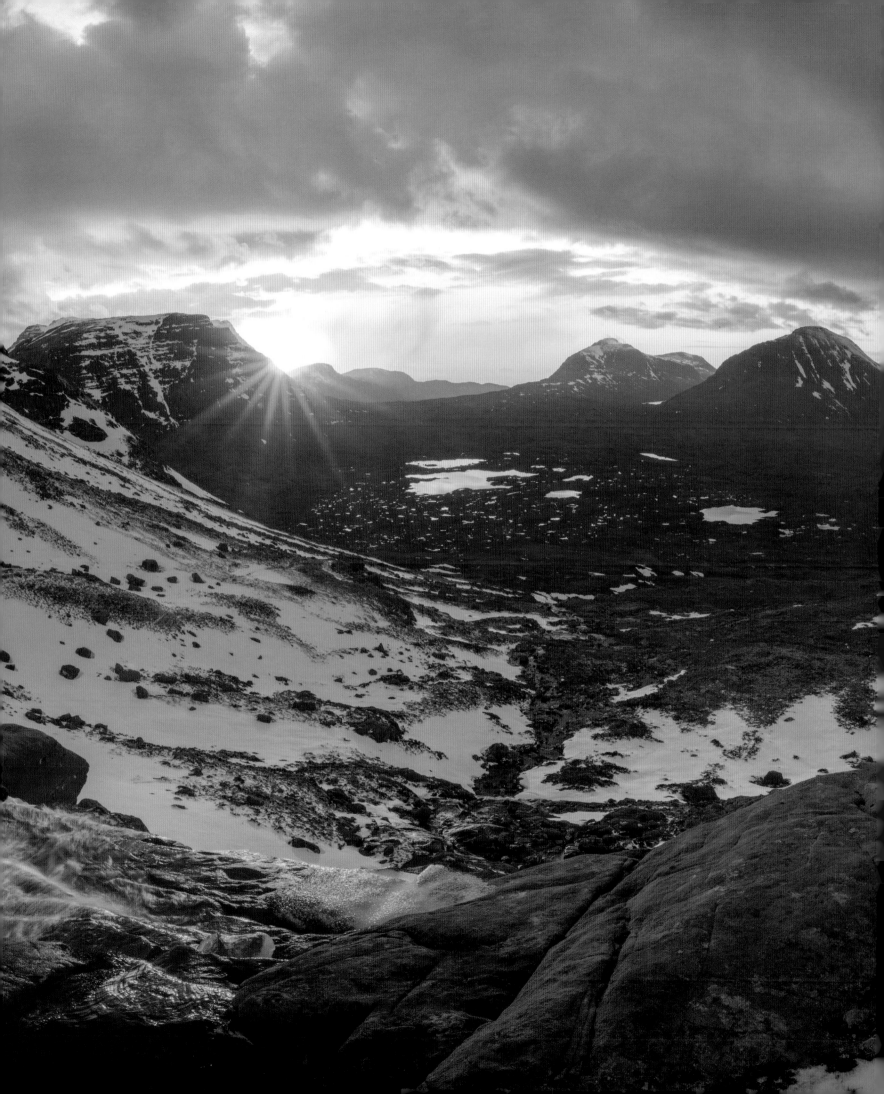

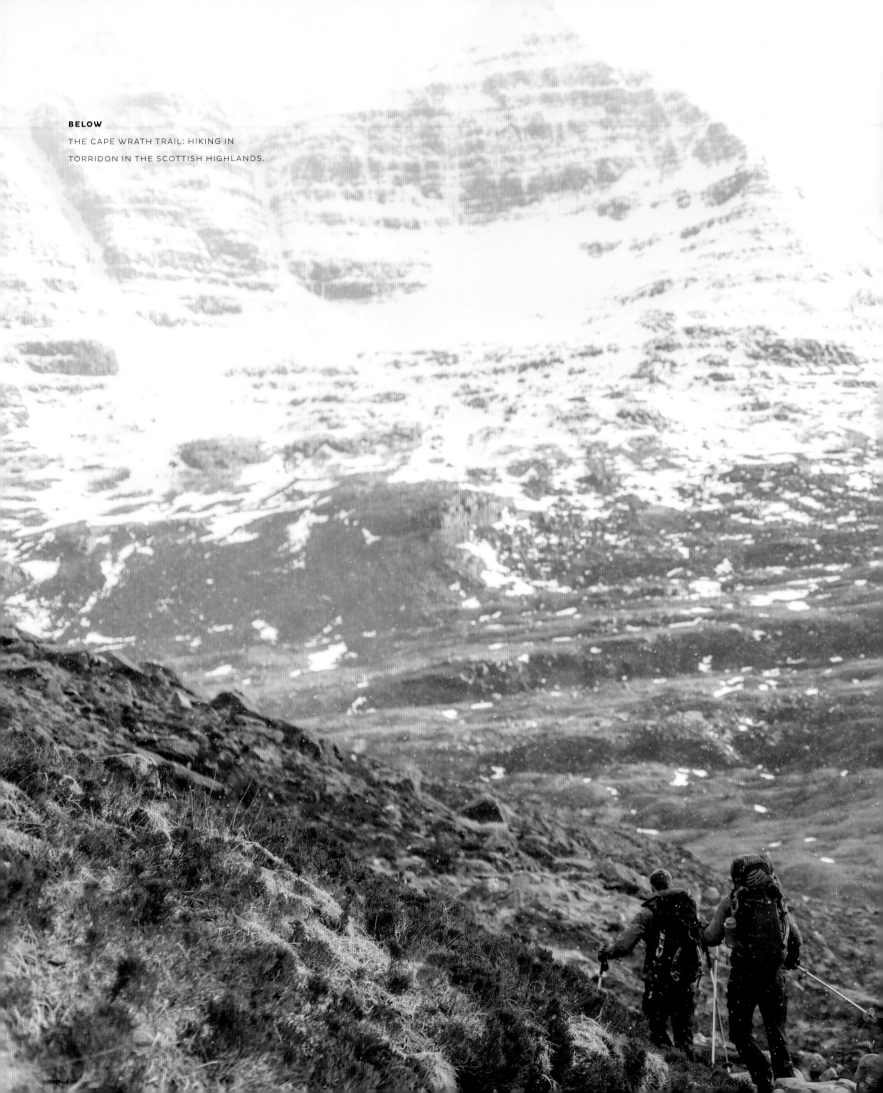

BELOW

THE CAPE WRATH TRAIL: HIKING IN
TORRIDON IN THE SCOTTISH HIGHLANDS.

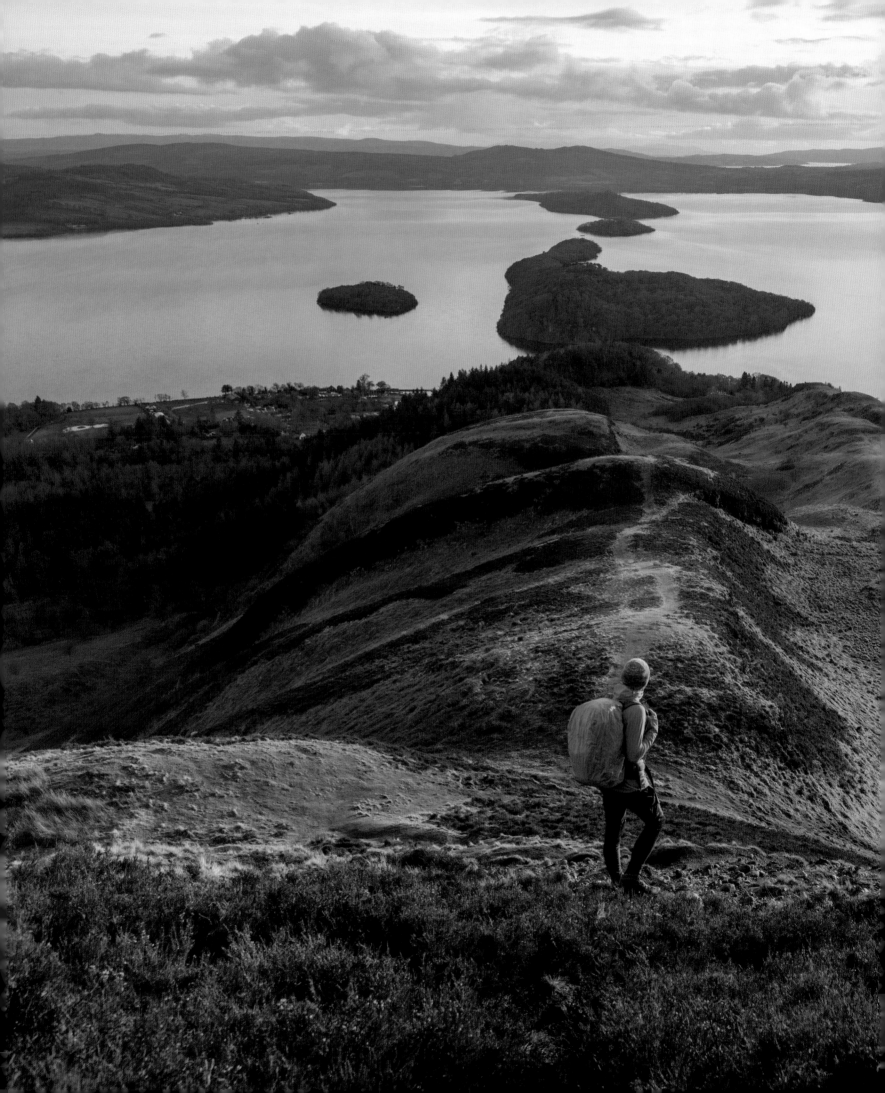

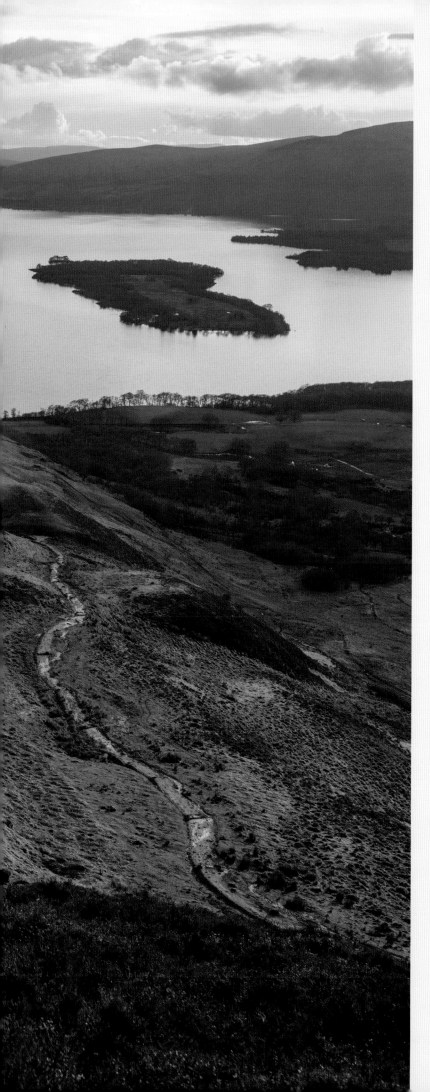

WEST HIGHLAND WAY
SCOTLAND

The West Highland Way is Scotland's – if not Britain's – most trekked trail. The reason for the 151-kilometre (94-mile) trail's popularity is simple: it takes in some of the most dramatic scenery of Scotland's Highlands, but on a well-maintained, easy-to-follow trail, mostly in farmland, lowland and gentle hills. The path never goes too high and only the most topographically challenged could get lost. The mountains are almost always there on the horizon, but the West Highland Way is a safe experience of Scotland's spectacular yellow peaks.

The trail begins in Milngavie comparatively gently, then goes over Conic Hill, a stout little climb that bequeaths huge views across the serene Loch Lomond, the largest inland stretch of water (by surface area) in Britain, with the pointy Highland mountains rearing behind. Mature woodland accompanies walkers on much of the trail here.

After following the eastern shore of the loch (lake), the trail heads up Glen Falloch ('glen' is the Scottish term for a valley, but they are usually long, U-shaped and carved out by a glacier in the last ice age) and over the fringes of Rannoch Moor, a beautifully barren expanse of brackish pools and grassy hummocks. Then it is on to the mountains surrounding Glencoe.

A first sighting of Buachaille Etive Mòr is quite some view, and is to the Highlands in symbolism what the Matterhorn is to the Alps. There are two spectacular climbs over mountain ridges and the first is next, up the excellently named, infamous Devil's Staircase. The perspiration spent here is well worth it for the huge wild views of rugged yellow mountains at the top and along the next section.

From Kinlochleven there is another tough (the two biggest climbs are nearly 609 metres/1,998 feet each) but hugely rewarding climb. Then it is down to Glen Nevis, the mighty Ben Nevis at 1,345 metres (4,413 feet) and the town of Fort William.

For those keen on history, the route follows the line of General Wade's military road (built in the 18th century as the British government tried to bring order after the Jacobite rebellion of 1715), and Glencoe is famous for the massacre of the MacDonalds clan by rival Scots.

Simply put, if you love to experience mountain scenery without feeling at risk, you are very likely to love this walk. The Way also better suits those who are happy to regularly see other hikers, less so those who want more of a remote experience. This is a beginner-friendly mountain trail. During the summer months – and often long before – accommodation on the route is usually sold out.

LEFT

HIKING DOWN FROM THE TOP OF CONIC
HILL TOWARDS LOCH LOMOND.

RIGHT

WEST HIGHLAND WAY: HIKING
ALONG BETWEEN BRIDGE OF
ORCHY AND INVERORAN IN THE
SCOTTISH HIGHLANDS.

THE PENNINE WAY
ENGLAND

When it comes to the UK's long-distance trails, the Pennine Way National Trail is the original, the roughest and the toughest of them all. It features 431 kilometres (268 miles) of footpath, mostly along the top of the Pennines, the backbone of England, as the hills are often called. It is without question some of the wildest, remotest and best upland walking in England.

The Pennine Way leads from Edale in Derbyshire's rugged Peak District – the world's second-most visited national park, incidentally – through the glorious Yorkshire Dales and along the stirring Hadrian's Wall to the underrated Cheviot Hills and Kirk Yetholm in Scotland. The route leads through landscapes that inspired great writers, such as the Brontës, William Wordsworth, Charles Dickens and Charles Kingsley. It is a history lesson on Northern England, including insights into the Bronze Age, the Romans, Vikings, Normans, industrialisation, mining, farming and more. It is a fascinating geological field trip, not least at Malham Cove and its remarkable limestone pavements. It is a tour of cosy pubs, welcoming cafés and numerous charming villages that you have probably never heard of and may never want to leave. But most of all, The National Trail is a walk through life-affirming natural beauty.

You will be tramping your muddy boots across the bleakly beautiful gritstone plateaus and melancholy moorlands, up and down secret dales, along rugged ridges with endless views and expansive skies, past limestone splendour sculptured by Norse gods, following singing rivers and past crashing waterfalls, through wild flower-strewn meadows, up stout mountains and many more lonely and dreamy wild places.

If you like ticking things off, the Pennine Way includes England's highest waterfall above ground (Hardraw Force), the highest pub (Tan Hill Inn), the coldest place (Cross Fell), the highest road (Great Dun Fell), and one of the famous Yorkshire Three Peaks (Pen-y-ghent). That's not forgetting totemic Kinder Scout (site of the mass trespass), the terrifying yet compelling chasm of High Cup and 13 kilometres (8 miles) along Hadrian's Wall.

Sixty-one per cent of the trail is in national parks (Northumberland, as well as the Peak and the Dales) and it strides through the North Pennines Area of Outstanding Natural Beauty, two large national nature reserves and 20 sites of special scientific interest. Fans of Harry Potter, Wallace & Gromit and *Robin Hood: Prince of Thieves* will find places of interest, too.

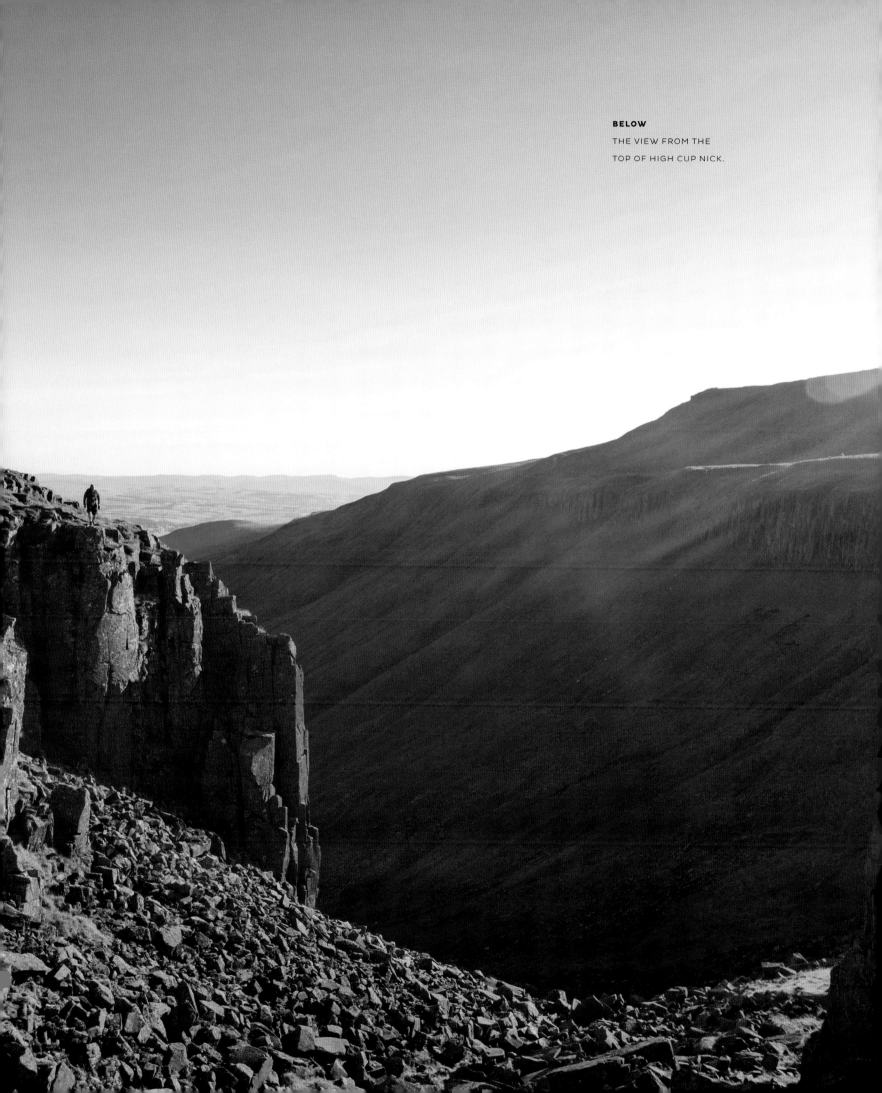

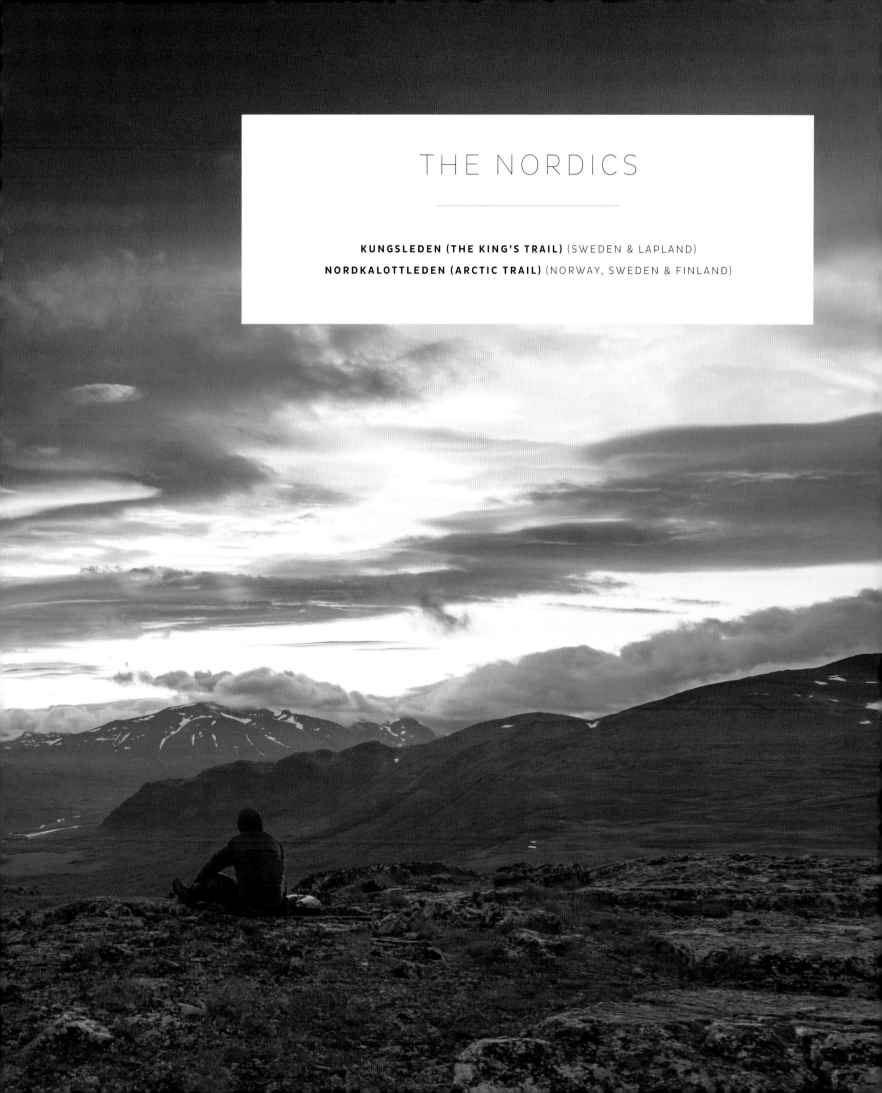

THE NORDICS

KUNGSLEDEN (THE KING'S TRAIL) (SWEDEN & LAPLAND)
NORDKALOTTLEDEN (ARCTIC TRAIL) (NORWAY, SWEDEN & FINLAND)

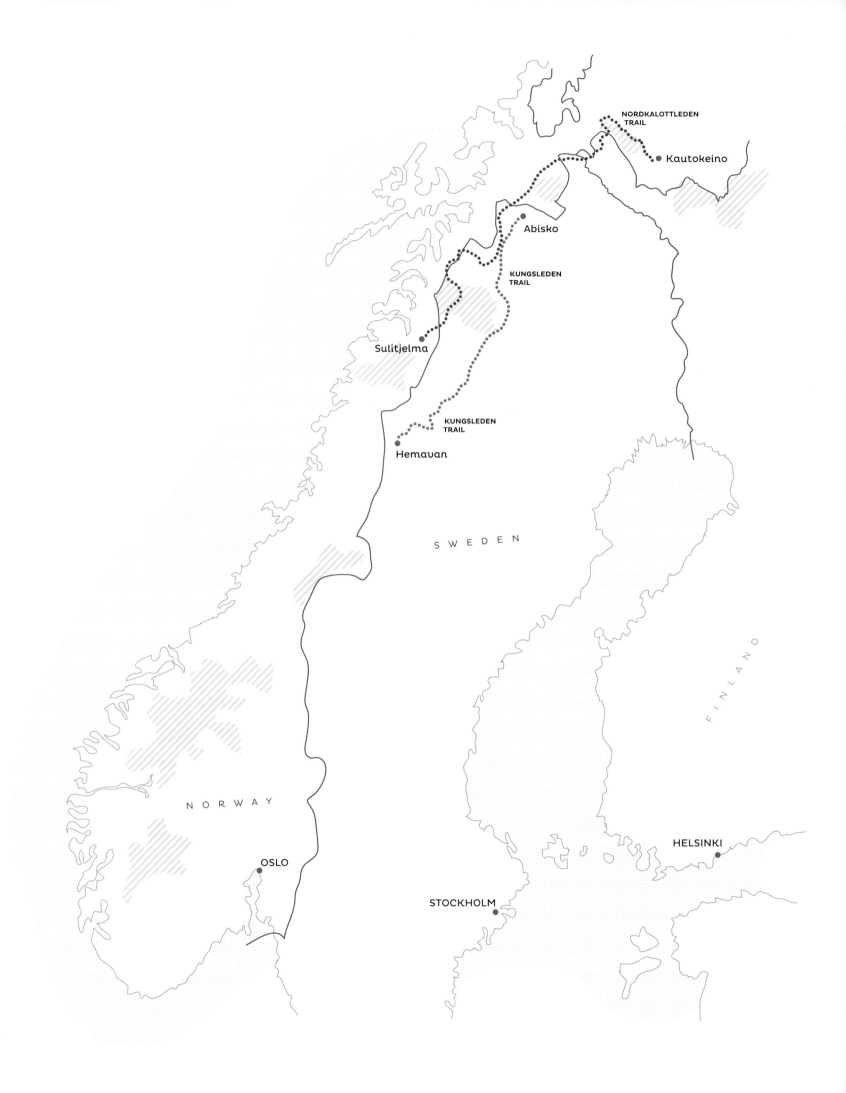

NORDKALOTTLEDEN
TRAIL

Kautokeino

Abisko

KUNGSLEDEN
TRAIL

Sulitjelma

KUNGSLEDEN
TRAIL

Hemavan

S W E D E N

N O R W A Y

F I N L A N D

OSLO

HELSINKI

STOCKHOLM

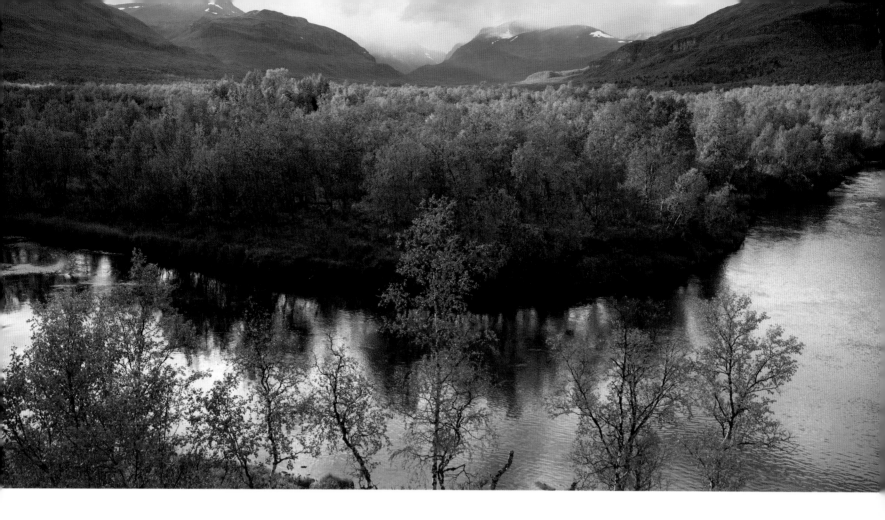

The Nordics

Between them, Sweden, Norway, Finland and Denmark have reams and reams of dreamy wilderness, stretching well north of the Arctic Circle, and boasting fairy-tale glaciers, epic fjords, mountains soaring over 2,500 metres (8,000 feet), lakes, forests, tundra, upland plateaux, plunging waterfalls, elk, reindeer and lemmings.

Norway is the wildest of the Nordic countries and is magnificently mountainous down its entire length. Sweden and Finland are significantly flatter, but well wooded and not short of lakes in the south, with stout mountains in the north and west. Lapland is the northern part of these three countries, straddling the Arctic Circle. It is a wondrous place with a real sense of remote and authentic wildness, and those world-famous, incredible, ethereal Northern Lights (aurora borealis).

Scandinavian mountains were once part of the same range as the Scottish Highlands, the great Caledonian mountain chain. They are renowned for their striking wildflowers, boasting over 250 species – best seen in early summer, straight after the snow melts. Except for the most popular areas at holiday times, these mountains are quiet and empty compared to British fells, the Alps or Pyrenees. You can walk for days without meeting anyone (especially if camping rather than using huts). Thankfully, plenty of land is protected in Scandinavia and national parks are numerous – a staggering 44 in Norway, 35 in Finland and 26 in Sweden.

A land of mountains (over 200 summits above 1,800 metres/5,900 feet) glaciers (over 100), cliffs and steep valleys, Swedish Lapland's Sarek National Park is one of the most magnificent wild areas anywhere in the world. Sarek has no huts or waymarks and few bridges, a place more suited to the more experienced outdoors person.

ABOVE

KUNGSLEDEN: ON THE TRAIL TOWARDS VISTAS CABINS.

PREVIOUS PAGES

NORDKALOTTLEDEN: SKIERFE VALLEY, SAREK.

Throughout Scandinavia, wildlife is thrillingly plentiful, with elk, beaver, brown bears, wolverine and the rarer lynx and wolves. Reindeer are semi-domesticated and owned by the Sami people of Lapland. Birdlife includes white-tailed eagles, falcons, long-tailed skua and snowy owls.

Although the wilderness is huge here, it is relatively accessible. Thousands of kilometres of trails are served by an excellent hut system, while wild camping is a legal right. The huts are run by national organisations (DNT in Norway, STF in Sweden, FPS in Finland) and range from basic shelters to large hotel-like lodges with restaurants and shops.

Snow doesn't melt until early June and starts to fall again in October, so the trekking season is short. March to early May is excellent for ski-touring, with lengthening hours of daylight and better weather. Summer weather can be mixed. But in the far north at midsummer there are 24 hours of daylight.

In Sweden, the High Coast Trail has walkers passing mythical forests, characterful mountains and big views of the Gulf of Bothnia. The Österlen Way, too, carries you along the coast of the Baltic Sea, visiting pretty fishing villages and white, sandy beaches.

As well as the epic Nordkalottleden, Norway has plenty of classic and challenging long-distance routes, namely Preikestolen, Trolltunga, Galdhøpiggen, Besseggen and Romsdalseggen. In Finland, there are extensive areas of forest and open fell, especially in Finnish Lapland, which are often state-owned, and though many of the southern forests are privately owned, laws of public access give everyone the right to roam the forests and countryside freely, no matter who owns it.

Despite the lack of high mountains, Denmark offers an inviting trekking experience nonetheless. The Camønoen is known as the country's friendliest hiking trail, stretching 175 kilometres (109 miles) around Møn, Nyord and Bogø. A highlight is Møns Klint, white limestone cliffs over 100-metres (325-feet) high, with a sheer drop down into the sea. The 220-kilometre (137-mile) Øhavsstien passes through a beautiful cultural landscape of poppy fields and country estates, always close to the sea. Bornholm is a coastal and historical path including cliffs, sandy beaches, little fishing villages and charming towns, where you can find both a room for the night and a good place to eat – the ideal trail for those wanting to experience a bit of Danish *hygge* (meaning contentment, or well-being).

Go to Scandinavia and walk for days, weeks or months in the mountains and wilds without having to call in to civilisation (as places with televisions tend to be called).

OVERLEAF

VIEW FROM NJULLA LOOKING TOWARDS THE 'LAPPORTEN' AND THE MOUNTAINS TJUONATJÅKKA AND NISSUNTJÅRRO. THE TRAIL FROM ABISKO IS IN THE BOTTOM OF THE VALLEY ALONGSIDE THE ABISKOJÅKKA RIVER, WITH THE 'EYE' LAKE NJAKAJAURE IN THE MIDDLE.

RIGHT

NORDKALOTTLEDEN: MAGICAL VALLEY NEXT TO MOUNT PÄLTSAN NEAR TRERIKSRÖSET.

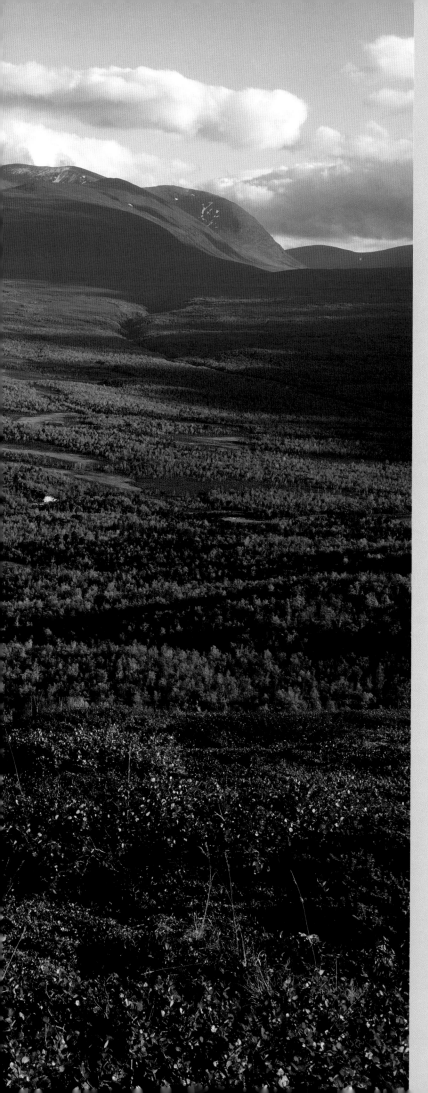

KUNGSLEDEN (THE KING'S TRAIL)
SWEDEN & LAPLAND

Kungsleden, or The King's Trail, is Scandinavia's most famous long-distance trail. Located in the Swedish Arctic, between Abisko in the north and Hemavan in the south, the 440-kilometre (270-mile) route bisects one of western Europe's largest remaining wilderness areas and the Vindelfjällen Nature Reserve, one of the largest protected areas in Europe. The trail passes through four national parks – Abisko, Stora Sjöfallet, Pieljekaise and Sarek, part of the Laponian region – where no roads, tracks or bridges mean it is terrain for more experienced hikers.

The trail dates back to 1885 and the formation of the Swedish Tourist Association (STA), a group wishing to open up access to the mountains for all. Over the decades it has been developed in stages, reaching its current form in 1975 and becoming one of the most famous in Europe. Used by hikers in the summer and cross-country skiers in the winter, Kungsleden is an Arctic dreamscape of gleaming glaciers, dashing peaks, poetic tundra scattered with tarns, raging rivers and milky waterfalls, and birch and dwarf forests. The trail has regular huts and occasional inviting villages. The indigenous Sami people still herd their reindeer here, and you're also likely to encounter elk, moose and lemmings.

Sweden's highest peak, 2,099-metre (6,886-foot) Mount Kebnekaise has a tempting lodge at its foot and is one of the trail highlights. As is the 330 square-kilometre (127 square-mile) Lake Torneträsk, ice-covered between December and June (as are all lakes here). The Tjäktja Pass at 1,150 metres (3,773 feet) is the trail's highest point, and suitably scenic. You will find intriguing villages, such as Hemavan, Tärnaby and Kvikkjokk, an old mountain farming village with an appealing hostel. Another Kungsleden characteristic is huge glaciated valleys, especially the epic Tjkjavagge, which bisects the highest mountains in Sweden.

Camping is permitted along the trail's entirety, while 21 basic huts offer amenities for sleeping and cooking (some even have small shops nearby), with occasional emergency huts offering rudimentary shelter.

The trail is well marked and most sections are well maintained (by the Countyboard of Norrbotten), with plank walkways covering swampy and rocky ground. Other sections are eroded and rocky, making for more of an adventure.

Kungsleden is nominally separated into four portions, each representing about one week of hiking, with the northern end deemed the most spectacular and, accordingly, the most popular. The weather can be unpredictable at all times. To avoid mosquitoes, August to mid September is best. Go in mid-summer to see the midnight sun.

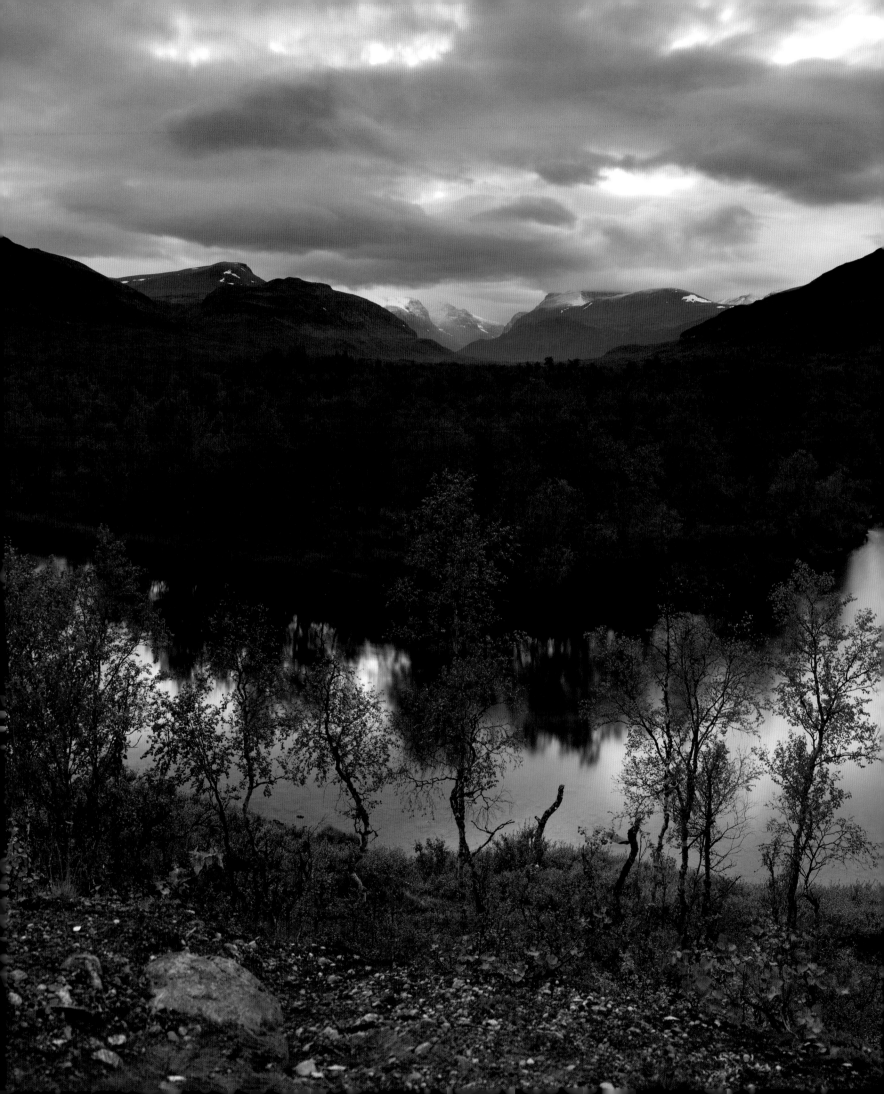

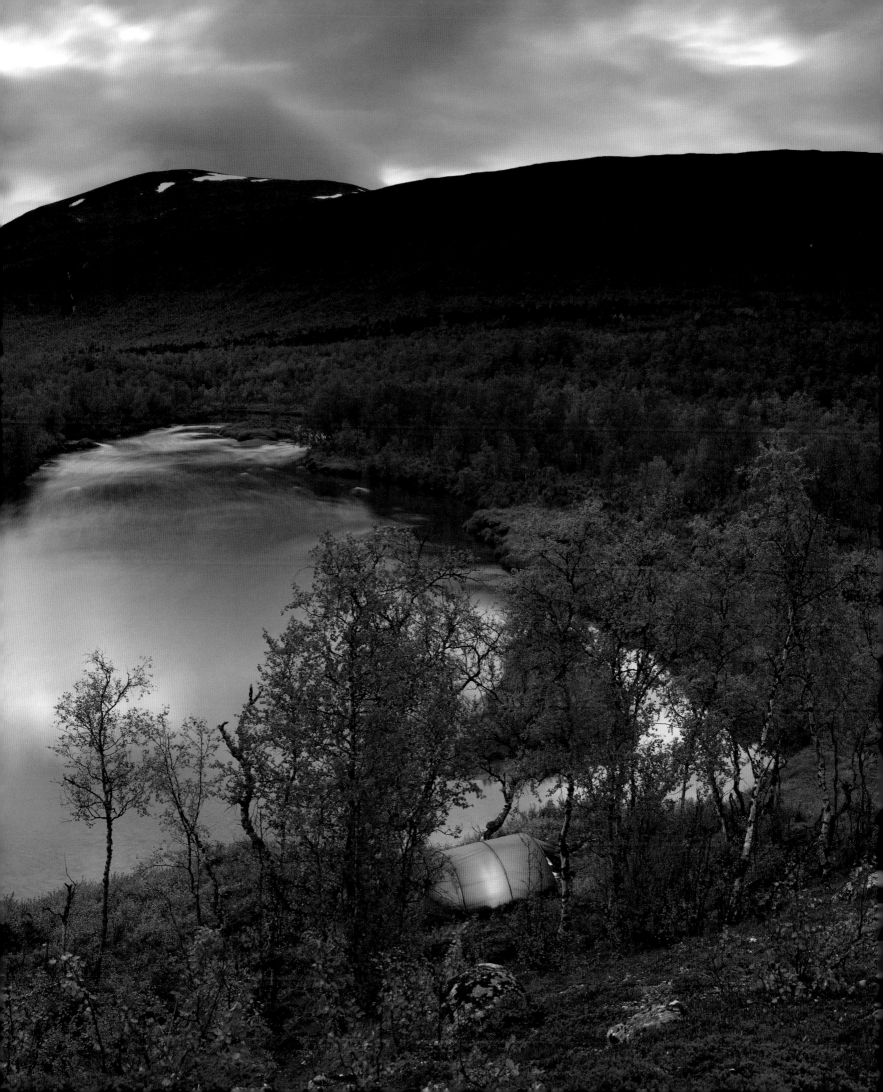

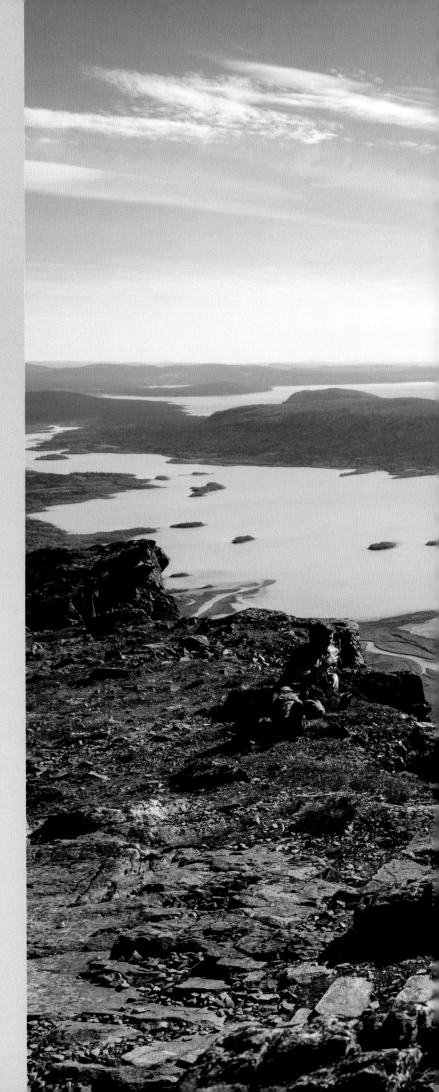

NORDKALOTTLEDEN (ARCTIC TRAIL)
NORWAY, SWEDEN & FINLAND

The epic Nordkalottleden, or Arctic Trail, is one for the more committed trekker, mostly because of its distance, but also the remoteness and, at times, challenging terrain. The landscape is reassuringly wild and gloriously desolate, peppered with mountains, big lakes, steep-sided gorges and spell-binding glaciers. Wide-open landscapes, such as those on the high plateaus contrast with more intimate, lush birch forests.

The 800-kilometre (500-mile) route weaves roughly along the borders of Norway, Sweden and Finland. With 380 kilometres (235 miles) in Norway, 350 kilometres (215 miles) in Sweden and 70 kilometres (45 miles) in Finland, the trail crosses international borders some 15 times. It is the most northerly long-distance hike in Europe, and all above the Arctic Circle.

The trail visits the Øvre Dividal, Reisa, Abisko and Padjelanta National Parks, as well as the Sulitjelma Fjellet Swedish mountain massif – much of which is covered by the huge Sulitjelma Glacier – and Norway's Narvikfjellet regions; whilst the Finnish section leads through Käsivarsi Wilderness Area – the country's most mountainous region – and the remote Malla Strict Nature Reserve, where you may see lemmings, rare birds and butterflies.

Nordkalottleden has two start (or end) points, Sulitjelma in Norway or Kvikkjokk in Sweden. On the Norwegian side, the Nordlandsruta crosses the arresting mountains and plateaus of Nord-Helgeland, Saltfjellet and Sulitjelma. On the Swedish side, the route follows the Padjelantaleden trail through Padjelanta National Park, then picks up Kungsleden (see page 33). From Abisko, the northern trailhead of Kungsleden, the Nordkalott trail continues for a long distance, through Troms and passing over Finland's highest peak, Halti, at 1,365 metres (4,478 feet), finishing in the Samen village of Kautokeino, Norway.

Some parts are well maintained, but as you would expect with a trail of this length and involving different countries, other parts are much more rugged, with challenging river crossings. The trail also visits Treriksröset (Three-Country Cairn), the only place where Norway, Sweden and Finland meet.

The entire route is marked and serviced by mountain huts, most of them unstaffed, so trekkers must carry their own sustenance (except along the Kungsleden and Padjelantaleden, where staffed huts take over and meals and provisions are available). Additional emergency shelters can also be found on the route. It is possible to camp anywhere along the trail.

Other Scandinavian novelties to be enjoyed include some waymarking idiosyncrasies. In the Finnish section, the trail is marked with white wooden poles with orange tops; in Norway, stones with paint signs; in Sweden, red crosses and signs with route symbols.

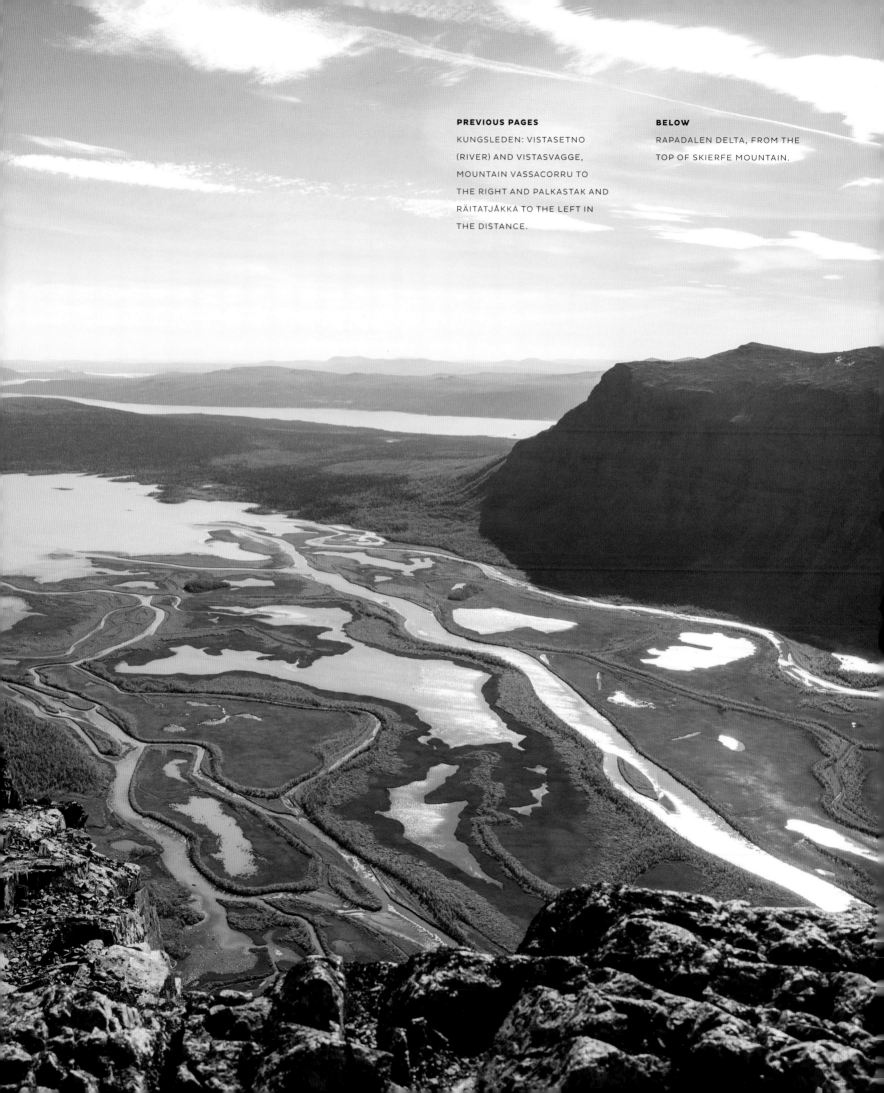

PREVIOUS PAGES

KUNGSLEDEN: VISTASETNO
(RIVER) AND VISTASVAGGE,
MOUNTAIN VASSACORRU TO
THE RIGHT AND PALKASTAK AND
RÄITATJÅKKA TO THE LEFT IN
THE DISTANCE.

BELOW

RAPADALEN DELTA, FROM THE
TOP OF SKIERFE MOUNTAIN.

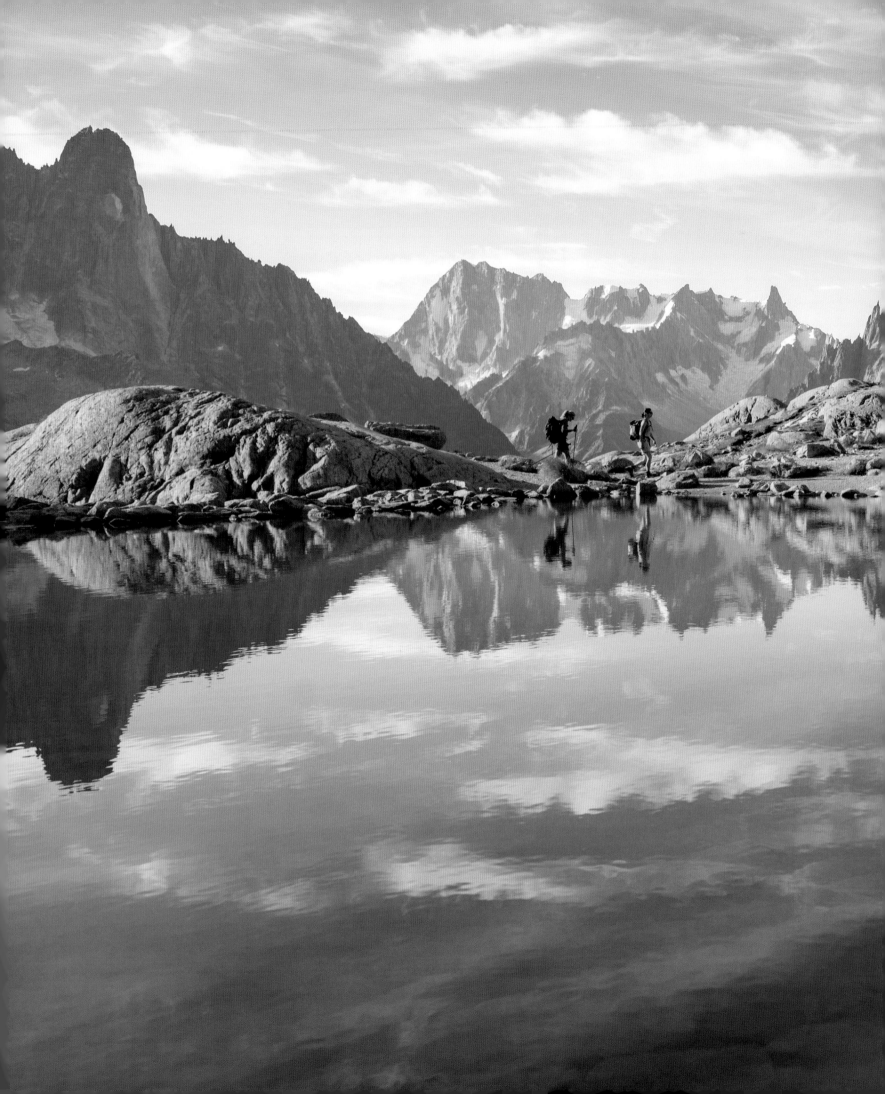

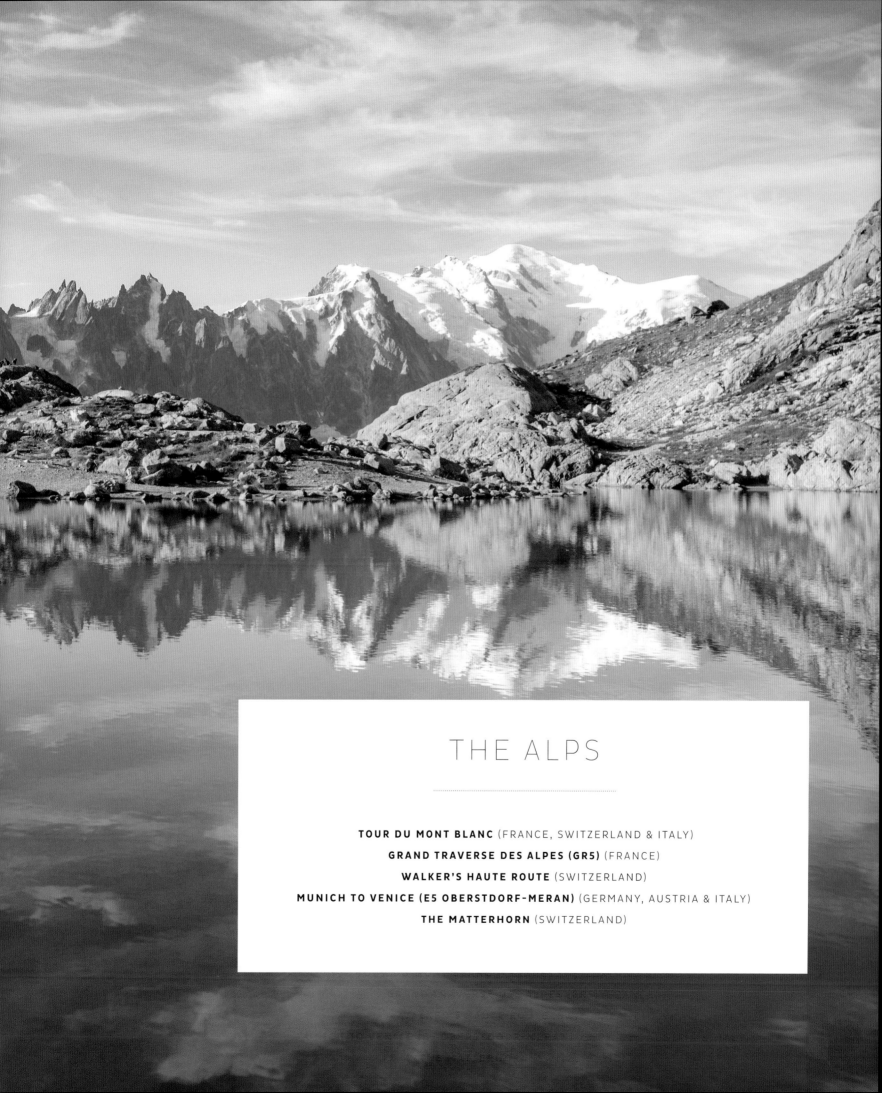

THE ALPS

TOUR DU MONT BLANC (FRANCE, SWITZERLAND & ITALY)
GRAND TRAVERSE DES ALPES (GR5) (FRANCE)
WALKER'S HAUTE ROUTE (SWITZERLAND)
MUNICH TO VENICE (E5 OBERSTDORF-MERAN) (GERMANY, AUSTRIA & ITALY)
THE MATTERHORN (SWITZERLAND)

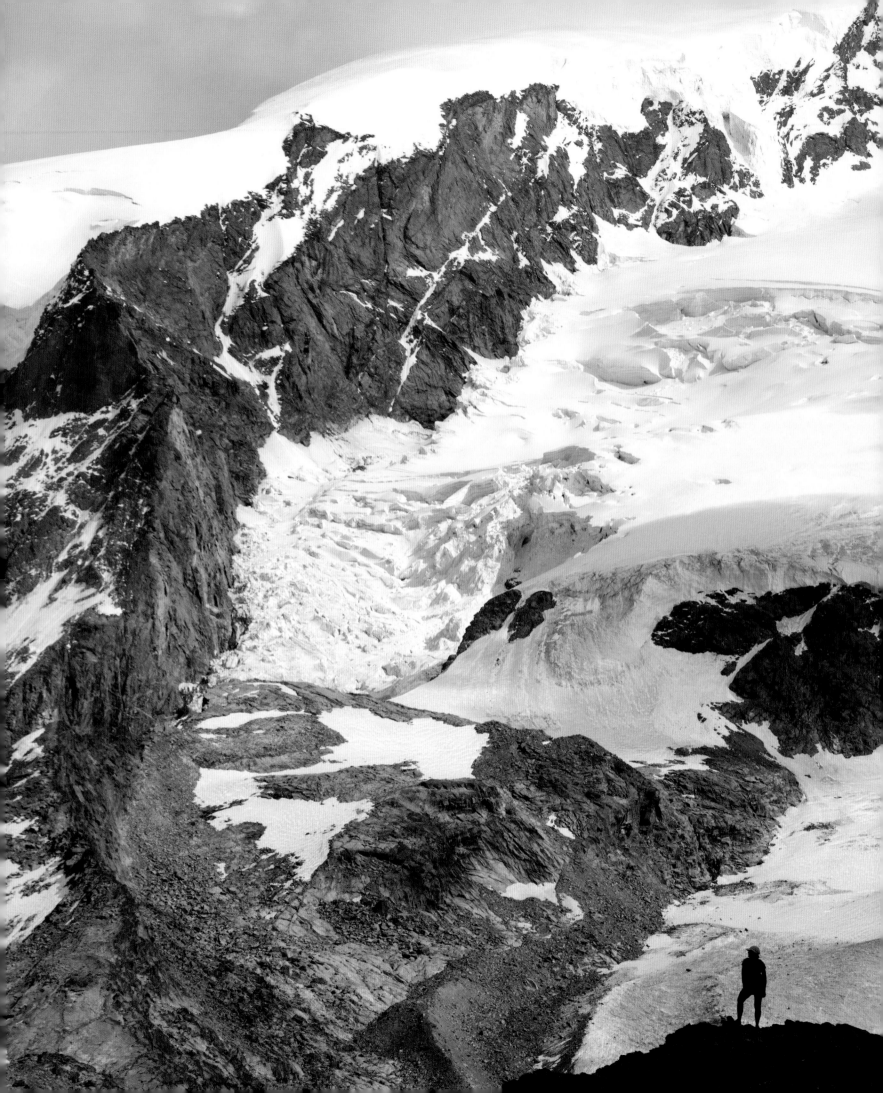

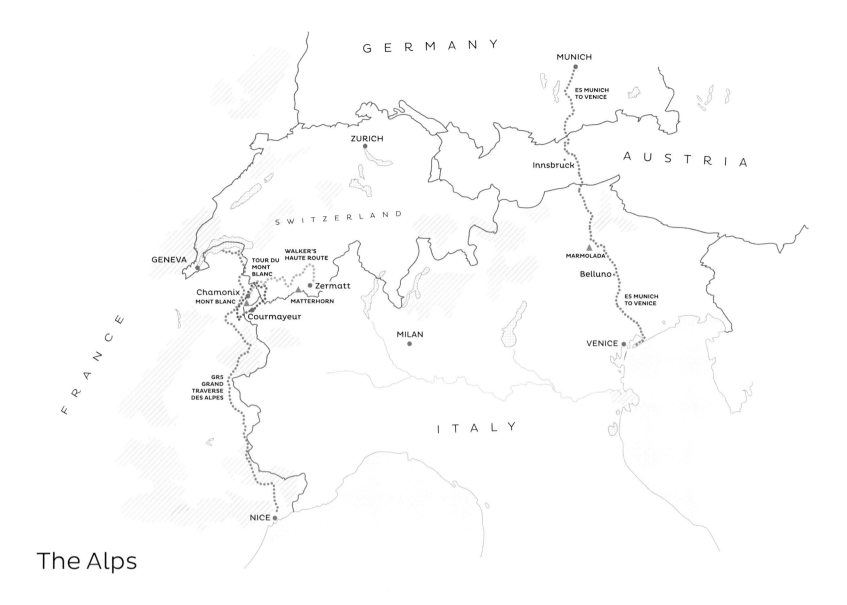

GERMANY

MUNICH

E5 MUNICH
TO VENICE

ZURICH

AUSTRIA

Innsbruck

SWITZERLAND

MARMOLADA

GENEVA

WALKER'S
HAUTE ROUTE

TOUR DU
MONT
BLANC

Belluno

E5 MUNICH
TO VENICE

Zermatt

Chamonix
MONT BLANC

MATTERHORN

Courmayeur

MILAN

VENICE

FRANCE

GR5
GRAND
TRAVERSE
DES ALPES

ITALY

NICE

The Alps

Having plonked themselves right in the middle of Europe tens of millions of years ago, the Alps have become an integral part of central Europe. For more than a century, hikers, climbers, researchers, paragliders, skiers, writers, photographers, armchair mountaineers and many others with a true love for nature have been attracted by the grandeur and majestic beauty of these mountains.

Stretching over a length of 1,200 kilometres (750 miles) and, in some places, a width of 200 kilometres (125 miles), the Alps were formed about 44 million years ago, when the African and Eurasian tectonic plates collided. Huge rock formations rose from the ground and spread across eight countries: Austria, France, Germany, Italy, Liechtenstein, Monaco, Slovenia and Switzerland. It is one of the most important and well-known mountain ranges in the world, counting 82 official peaks higher than 4,000 metres (13,120 feet), the tallest being Mont Blanc at 4,810 metres (15,780 feet), sitting gloriously on the French-Italian border. The Alps are home to 14 million people, 13,000 species of plants and 30,000 species of wildlife.

It goes without saying that the Alps have a very long history, and some of the first records are provided by Hannibal, who allegedly crossed them with a herd of elephants in 218 bc Later, Caesar and other Roman leaders fought their way through their steep and menacing cliffs, and even Napoleon led his army through the Alps on a mule in 1800.

During the 19th century, this significant mountain range became the playing ground for a number of pioneers trying to conquer its high and pointy peaks, many of which were deemed unclimbable. The Matterhorn, towering at 4,478 metres (14,690 feet) above Italy

and Switzerland, was a hard nut to crack until the Englishman Edward Whymper and his rope party of eight stood atop its prominent peak on 14 July 1865. The price they had to pay for this glory was high, as four of the climbers tumbled to their deaths on the descent. Plenty of heroic and tragic events have happened on their flanks since, and if the Alps could speak, a constant echo of incredible stories would be reverberating from their otherwise impenetrable rocks.

If you have ever stood on the bottom of one of the deep valleys, which look as if they were hollowed out of the surrounding rocky walls, or on a meadow covered in buttercups on the top of a hill with high snowy peaks all around, you will understand what the Alps are all about. Offering a plethora of walks, the Alps have something in stock for everyone. With the huge variety of people, cultures and languages, the trekker will find everything from long-upheld customs such as cheese-making, traditional music (maybe even some yodelling) or the traditional cattle descent to the more modernised lifestyle of the Alps, featuring luxury huts, viewing platforms at dizzying heights and adventure parks.

Alpine tourists can use the amenities of modern technology and hop on a cable car, train or ski lift to enjoy the fresh mountain air, without even having to break out in a sweat. But if you feel that a few hours or even a day is not long enough to absorb the breathtakingly beautiful panorama, you can embark on a multiday trek from the famous to the less travelled. Known as *doma*, *Hütten*, *refuges* or *rifugi*, depending on the country you are in, there is a huge swathe of huts that dot the routes (for the individual and large groups), allowing you to travel light – and far.

The more ambitious hikers are served by multiday treks such as the Tour de Monte Rosa, the Bernese Oberland Trail or the classic and ultimate Grand Traverse des Alpes, which covers the full length of the French Alps, from Geneva in Switzerland all the way to Nice in the South of France.

OPPOSITE

WALKER'S HAUTE ROUTE: RIGHT AT THE END OF THE ROUTE FROM CHAMONIX TO ZERMATT THE TRAIL LEADS DOWN INTO ZERMATT, WITH THE MATTERHORN AHEAD.

BELOW

THE GORNER GLACIER: CAMPED BESIDE THE GORNERGLETSCHER AT THE FOOT OF MONTE ROSA.

OVERLEAF

MONT BLANC'S SNOWY SUMMIT REFLECTED IN LAC BLANC.

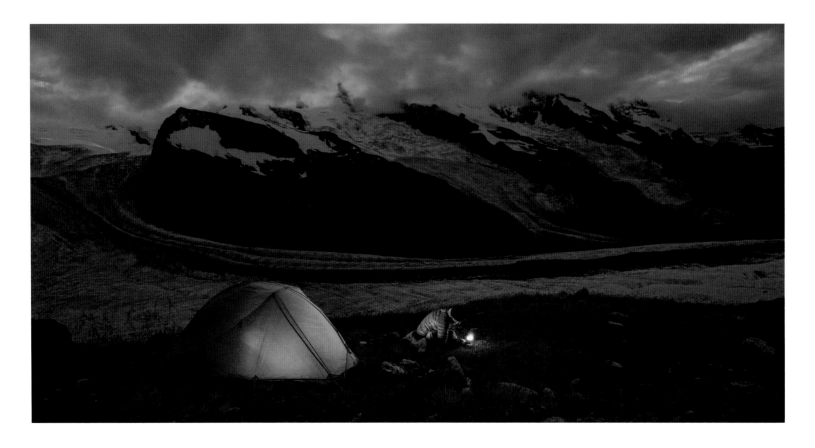

However, if walking 620 kilometres (385 miles) is too far, or you don't happen to have three weeks at your disposal, there are plenty of shorter long-distance hikes to do in the Alps, such as the Tour de Mont Blanc or the Walker's Haute Route. Following the footsteps of the first explorers, from Chamonix to Zermatt, the latter is a spectacular and demanding summer hike, which is much more than just getting from A to B in a rush: it is about appreciating the efforts and hurdles that the pioneers of the Alps had to endure during their first visits, when there were no trails or signs and mountain huts were still a thing of the future.

No matter which region or hike you choose, the Alps have something to offer everyone.

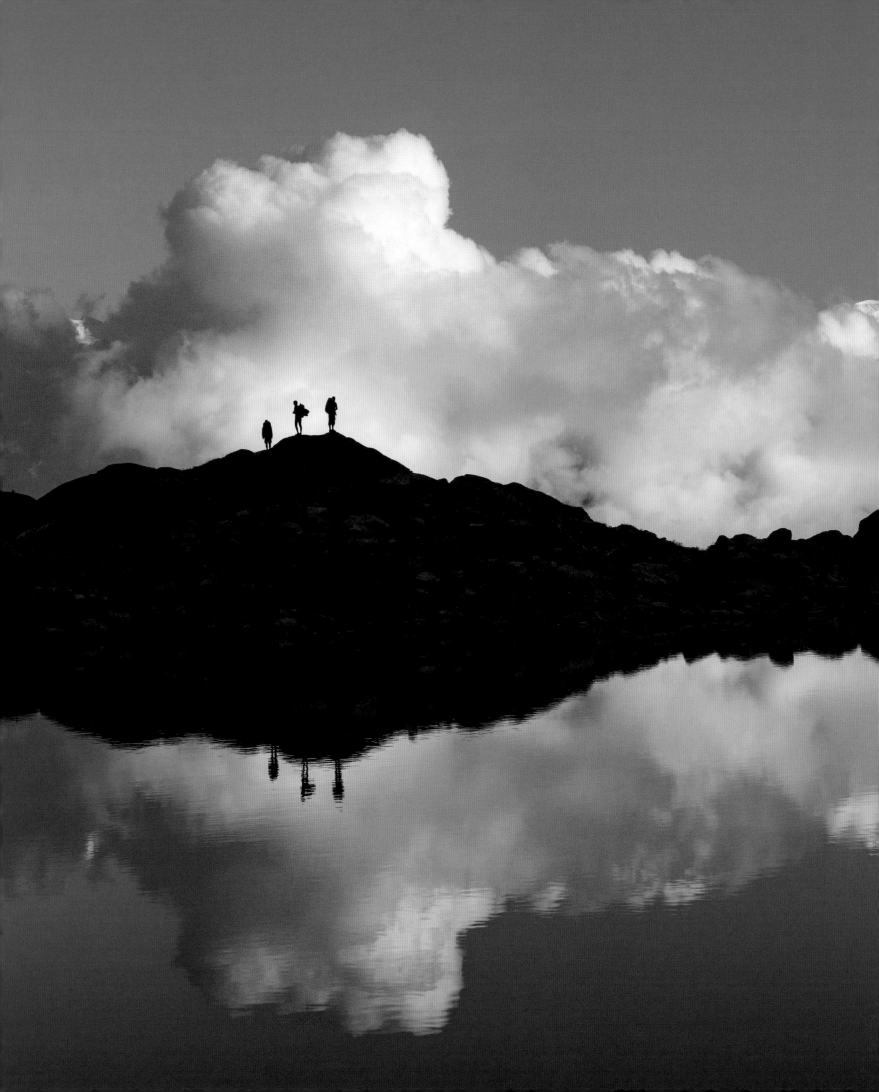

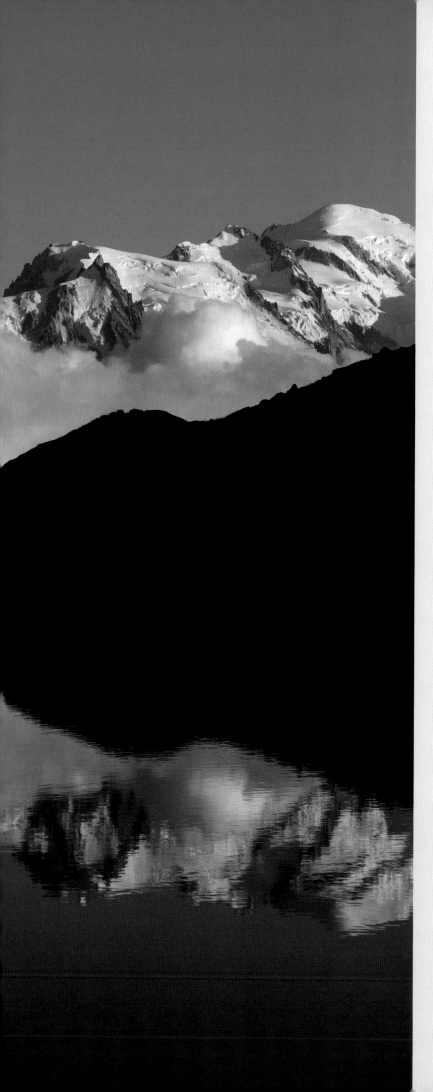

TOUR DU MONT BLANC
FRANCE, SWITZERLAND & ITALY

When it comes to hiking in Europe, the Tour du Mont Blanc (TMB) is probably the most iconic trail. Circumnavigating the mighty slopes of the highest mountain in the Alps, the Tour introduces the ambitious trekker to some of the most dramatic and versatile scenery in the world.

With its 170 kilometres (105 miles), the Tour du Mont Blanc certainly qualifies as a long-distance trek, but more impressive are the 10,000 metres (32,800 feet) of cumulative ascent and descent on this 11-day hike. Without requiring technical skills, crampons or a down-suit to fend off the biting cold, Mont Blanc trekkers cover more cumulative metres of altitude than Everest climbers. And all that in the comfort of excellent accommodation, delicious food and the reassuring proximity to civilisation, should you need support. Being extremely well marked and accessible, the TMB is a great first long-distance hike.

The walk naturally navigates you through three countries – each with a distinct feel, yet united by the great rocks that are the Alps. Just like the chamois, mountain hares, marmots and ibex residing on the flanks of the 'White Mountain', unaware which country they are in, you will have a similar experience when you hike up from the Col de la Forclaz to Tré-le-Champ – climbing up a hill in one country and coming down it in another. Fauna lovers also get their share of kicks, as a multitude of plants grow up to 2,500 metres (8,000 feet), an elevation that you will reach five times during this trek. Beyond that, the landscape becomes more barren, opening up the most spectacular panoramic views of the massif's glacier and Mont Blanc itself.

The best time to do this trek, which starts and ends in Les Houches near Chamonix, is between early July and mid-September, as this greatly reduces the risk of getting stuck in the snow at the higher elevations. The route takes you along some of the most picturesque Alpine lakes, and, despite its proximity to populated towns, the vastness and respite from city life is something you usually only read about in adventure novels. Walking into the village of Champex, for example, and setting your eyes on the shimmering green mountain lake makes you feel as if you have just entered paradise. Mountain huts offering comfortable accommodation appear every 10 kilometres (6 miles) or so, and if you don't want to carry your gear, it can be transported to your chalet each night, allowing you to take only a light day-pack for your hike.

Even though the TMB is more of a trek than an actual climb, each section of the trail comprises a big uphill slog followed by an equally steep descent. With the average daily walking time hovering between five and seven hours, it is certainly no walk in the park, but the rewards are well worth the effort.

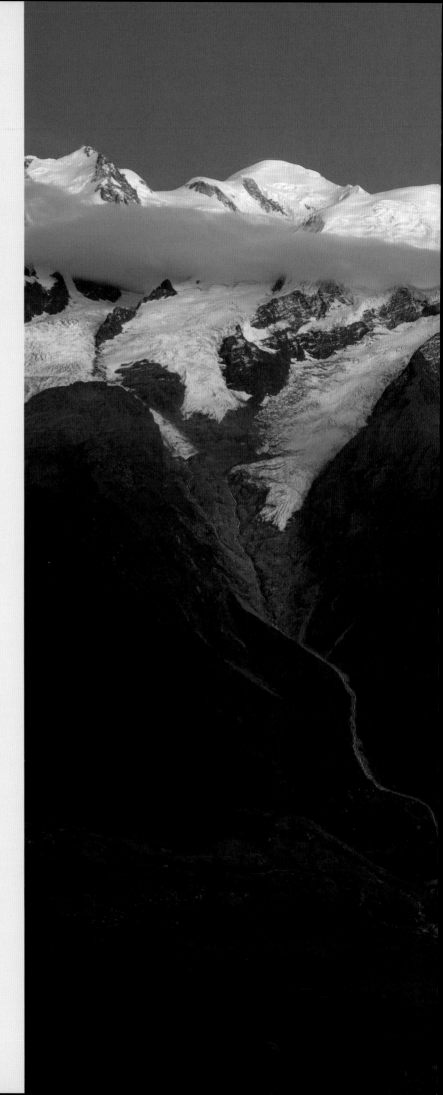

GRAND TRAVERSE DES ALPES (GR5) FRANCE

At a lengthy 620 kilometres (385 miles), taking around 20 to 30 days, the Grand Traverse Des Alpes is an ambitious route, demanding serious distance out of your boots and legs. Even though the emphasis is on mountains, this trek starts and ends near water – setting out from the shores of Lac Léman in Geneva to the Mediterranean Sea in Nice. It meanders through the Alps, following well-graded and well-marked paths, and can be trekked in one go, but if you want to prolong the enjoyment, the Grand Traverse des Alpes can be split over a series of trips.

The trek is filled with high mountain passes, revealing stunning views of Mont Blanc, enchanted limestone gorges, thundering waterfalls, lush Alpine meadows, clear mirror lakes, forest paths, historic villages and rustic refuges. There is also no shortage of comfortable hotels, local wines and sumptuous cheeses. With its old arch bridges, windmills and Alpine cheesemakers – who still use mules to carry their produce down to the valley – you are immersed into the history of the area. This route is off the beaten path, and promises an immensely rewarding journey that takes you through landmark locations such as Chamonix, St Etienne, St Martin Vesubie and, finally, Nice.

You may be surprised to discover just how wild Europe still is, in its remote parts. Despite some signs of habitation, the ruggedness of some of the places makes you believe that they are still untouched. It may even be the case that you don't see another human being for hours, giving you peace and quiet to observe the ibexes, chamois and marmots that can be found wandering at the higher elevations.

Accommodation along the route is plentiful, and varies between luxurious rooms with fluffy hot towels and en-suite bathrooms and rather basic options offering a mattress in old stables and communal showers.

Once you near the end of the trek, which covers a daily average of 1,200 metres (3,937 feet) of ascent and descent, and a distance of around 24 kilometres (15 miles), you will find that rolling hills slowly replace the rough scenery of the higher elevations. Significant also is the change of fragrance in the air: once the crispness of the Alps gradually turns into a more aromatic smell of lavender and rosemary, you know that your dip in the Mediterranean is imminent.

RIGHT

WILD CAMP NEAR REFUGE DE BELLACHAT.

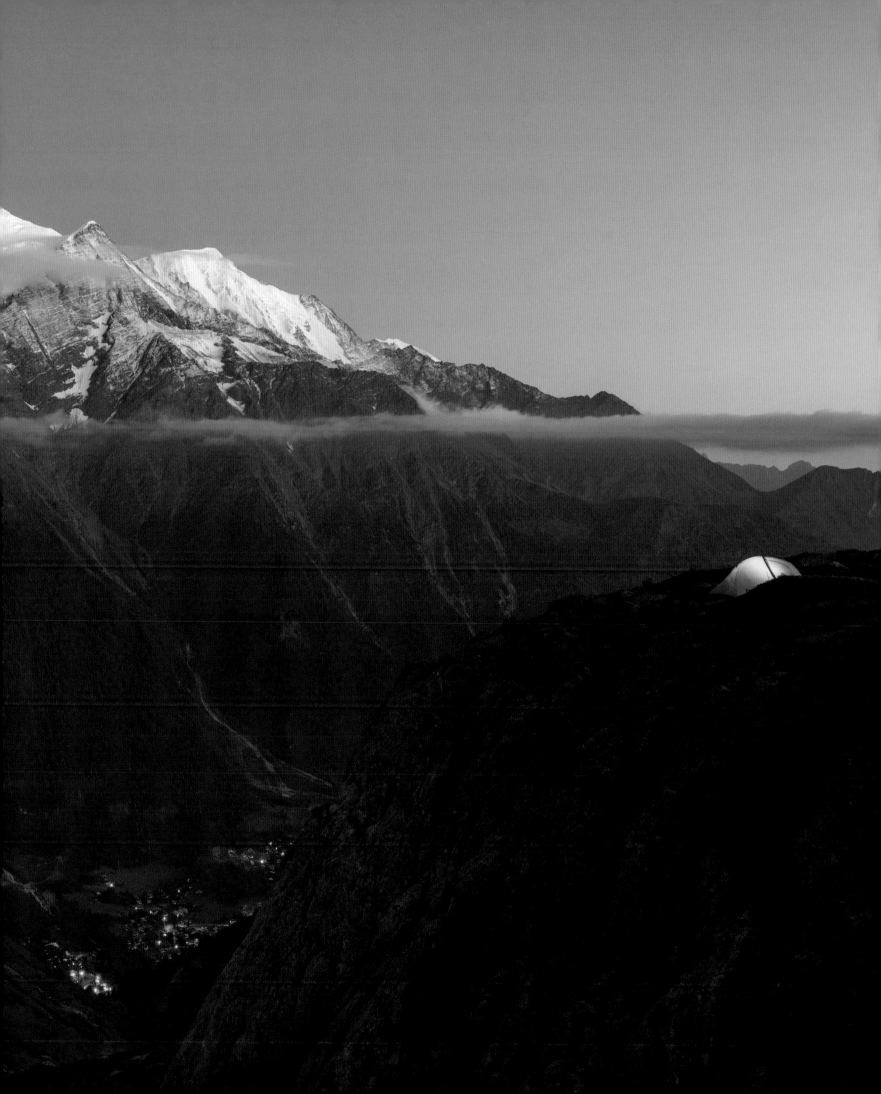

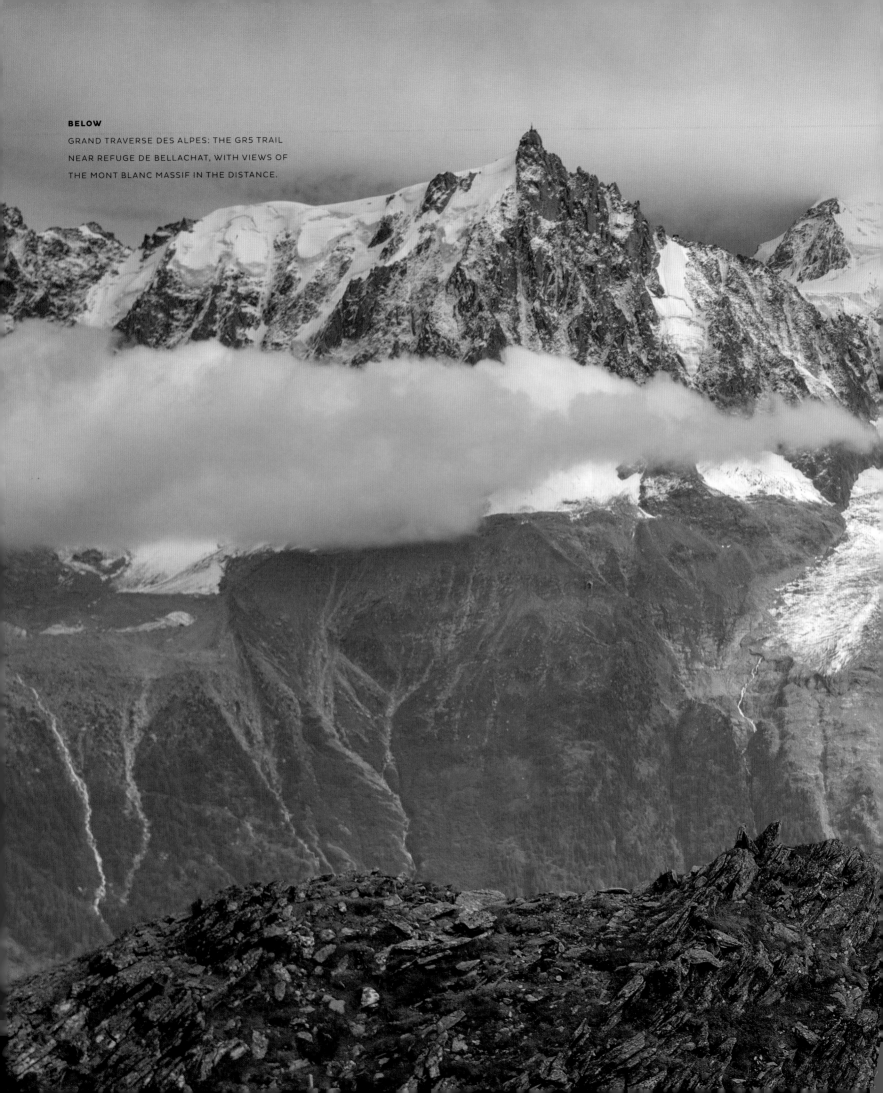

BELOW
GRAND TRAVERSE DES ALPES: THE GR5 TRAIL
NEAR REFUGE DE BELLACHAT, WITH VIEWS OF
THE MONT BLANC MASSIF IN THE DISTANCE.

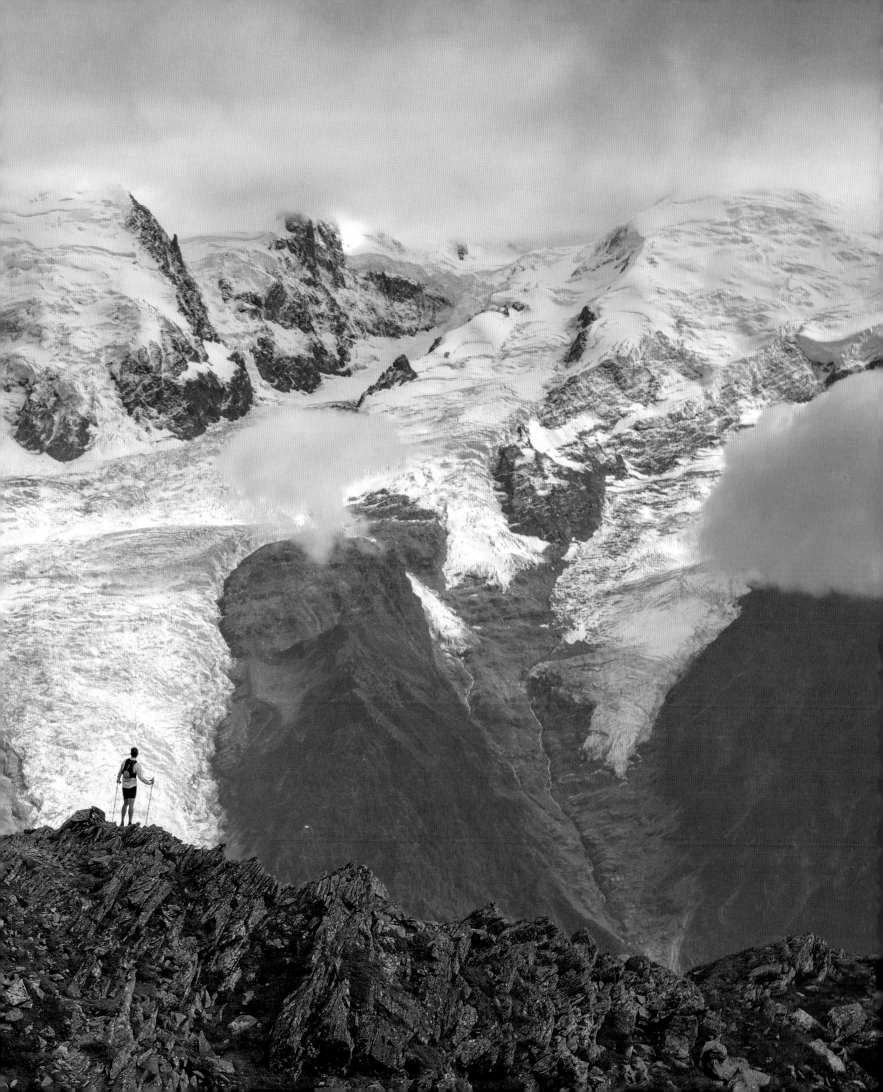

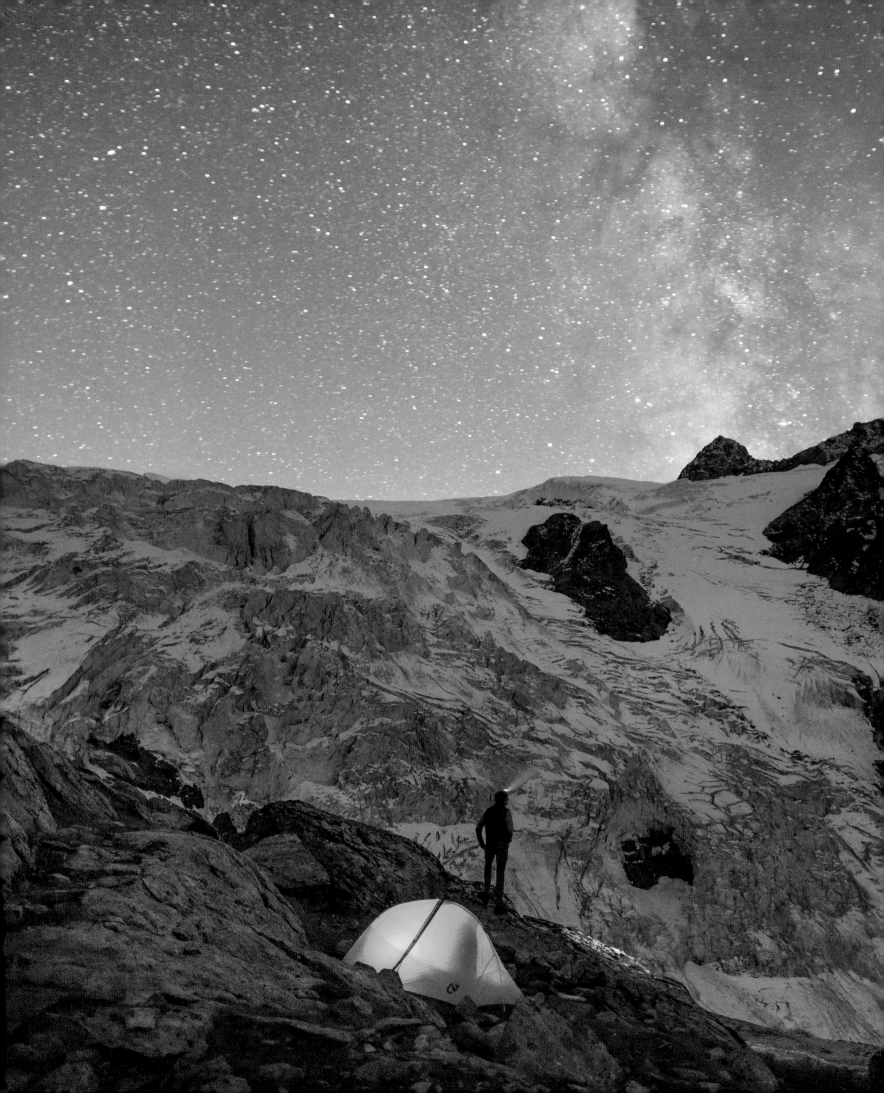

WALKER'S HAUTE ROUTE
SWITZERLAND

There are many hikes to explore in the Alps, but there is only one that connects the two greatest mountaineering centres in the world. The Walker's Haute Route starts at the foot of Mont Blanc, the highest massif in western Europe, and ends on the flanks of the most famous – if not the most elegant and instantly recognised of all mountains – the Matterhorn.

This 10- to 12-day hike was pioneered by members of the British Alpine Club in 1861, who wanted to create a high-level mountaineering route between the two significant mountains. They called it the 'high-level route', which was later translated into the more melodic French term, the Haute Route.

Even though it has made its name for being one of the best winter hikes on skis, the 200-kilometre (125-mile) summer version of this trek is certainly no less interesting or challenging. You will visit spectacular valleys, pass through delightful villages and remote Alpine hamlets, amble through flowery meadows and deep, fragrant forests, skirt exquisite lakes, cross cold streams and clamber beside huge glaciers hanging suspended from buttresses of rock. In all, 11 passes clock up more than 12,000 metres (40,000 feet) in ascent and pass under 10 of the 12 highest peaks in the Alps, including Dent Blanche, Zinalrothorn and Weisshorn. You will most likely be able to spot the ubiquitous marmots and ibex among the boulders at the higher elevations.

A well-marked and well-trodden trek, the Haute Route is suitable for regular hill walkers who are able to walk between six and eight hours per day. The conditions of the trail can be challenging at times. Mild scrambling is sometimes necessary and the gradient of the path can be extremely steep, but, unlike the winter Haute Route, the walker's version stays just below 3,000 metres (10,000 feet) at all times, and does not require any technical skills, ropes, crampons or other climbing gear. This trek makes it possible for the hiker to absorb the beauties of the mighty glaciers from afar, without getting too close to danger – huge crevasses, some as deep as 50 metres (165 feet), line several points of the route.

The Walker's Haute Route is certainly not for the faint-hearted, yet it gives hikers a chance to glimpse the world that so fascinates mountaineers. Most hikers choose to travel from Chamonix to Zermatt, for a dramatic finish at the base of the majestic Matterhorn, but you can go in either direction. Shorter options are plentiful, ranging from very accessible day hikes to multiday excursions.

LEFT

THE MOIRY GLACIER, WITH THE SÉRAC-STREWN
ICEFALL AT THE FOOT OF GRAND CORNIER, PIGNE
DE LA LÉ AND POINTES DE MOURTI.

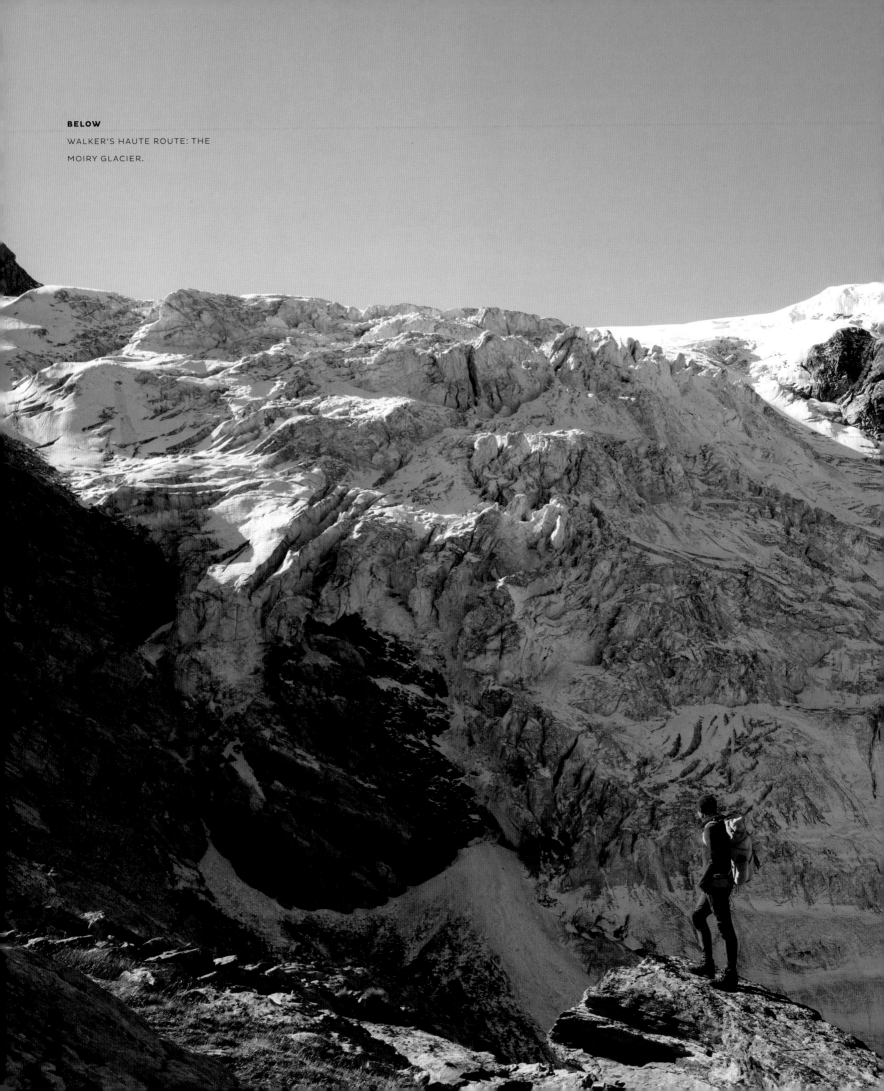

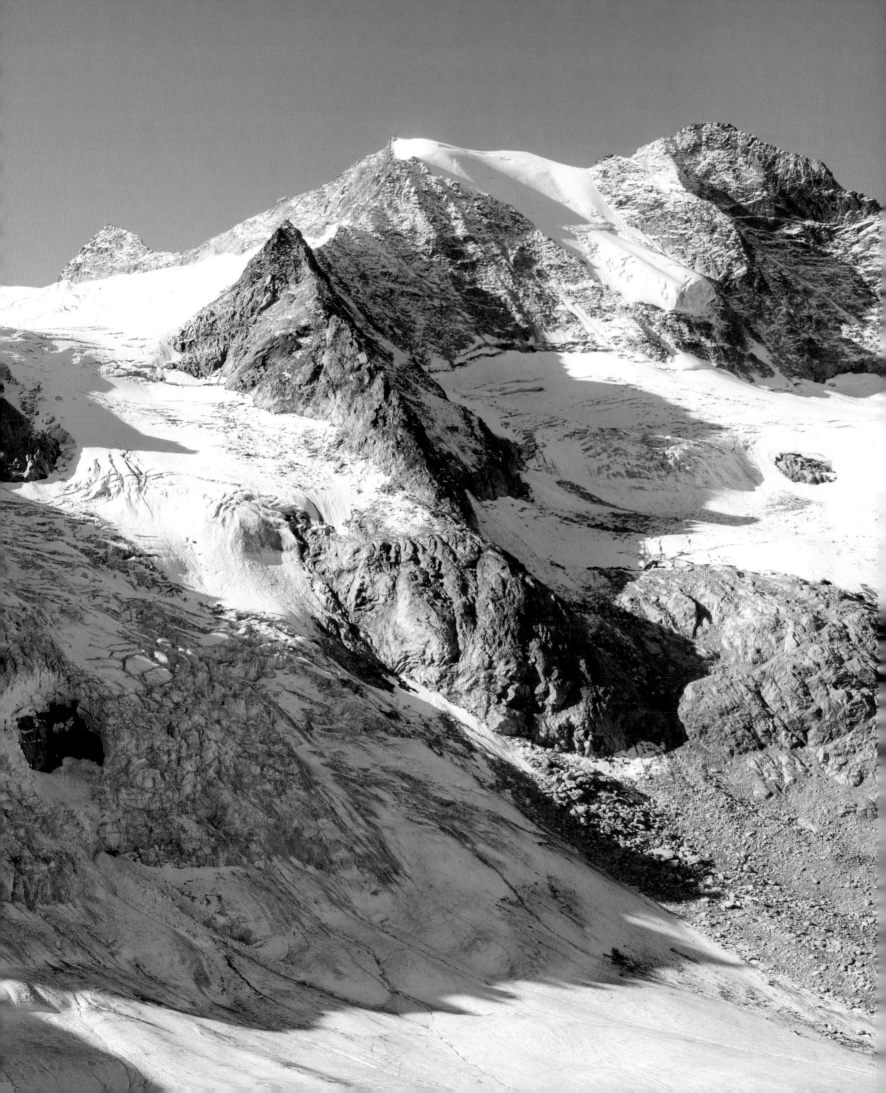

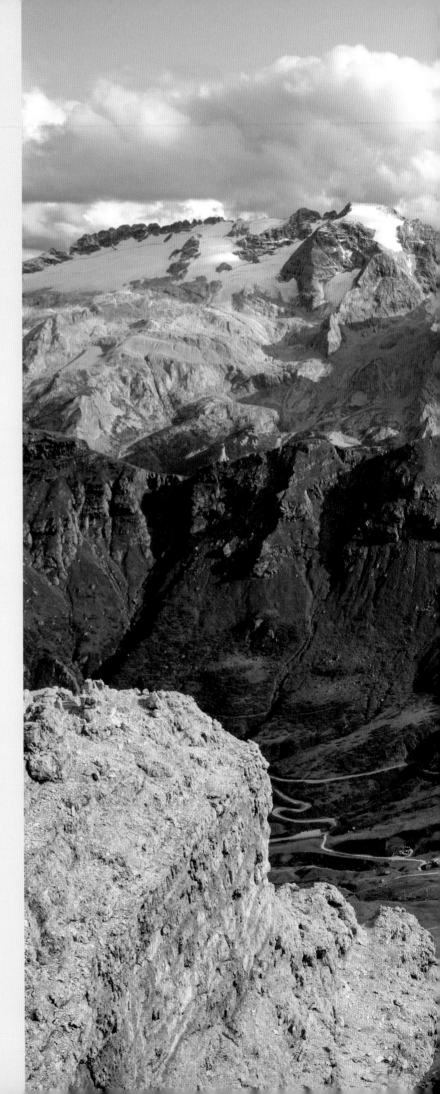

MUNICH TO VENICE
(E5 OBERSTDORF-MERAN)
GERMANY, AUSTRIA & ITALY

With its array of Roman-influenced buildings, this trek from Germany's 'Beer Capital' to the Italian water-city of Venice is an extraordinary architectural masterpiece in its own right. In addition to that, it covers 520 kilometres (323 miles) in distance and more than 20,000 metres (65,600 feet) in elevation. The route can be trekked in 30 stages, offers plentiful variations and is suitable for most walkers with a head for heights.

Little did German trekker Ludwig Gassler know, when, in 1977, he mapped and scribbled down his ideal route across the Alps through Germany, Austria and Italy, that this would become the Dream Trail. What is special about this trek is that it starts out and ends on the flat. The few hills thrown in along the way take you through the most spectacular mountain landscapes in Europe.

The classic starting point is Munich's Marienplatz, one of Europe's most beautiful squares and featuring the famous Glockenspiel. Can there be a better way to be sent off on such an adventure than to the tune of 43 bells from 32 life-sized mechanical figures?

If you find the first few days meandering across meadows, creeks and gentle hills too flat, you will be rewarded by the third day, which gets you onto proper Alpine terrain, from where you can absorb the stunning scenery down below.

Technically, this trail does not pose many difficulties, apart from maybe the Via Ferrata, or Ironway, above Belluno in northern Italy. However, this is not to underestimate the significant collective ascent and descent that you clock up if you take on the full trek. It accumulates to more than 20,000 metres (65,500 feet) and, covered in a single month, it requires mental and physical strength. You can reduce the trek's duration by skipping the flat bits at the beginning and the end, as well as by making use of chair lifts. Whichever option you choose, it won't lessen the achievement and the feeling of following in the footsteps of the ancient Romans.

RIGHT

THE VIEW ABOVE THE FALZAREGO PASS
NEAR REFUGIO LAGAZUOI.

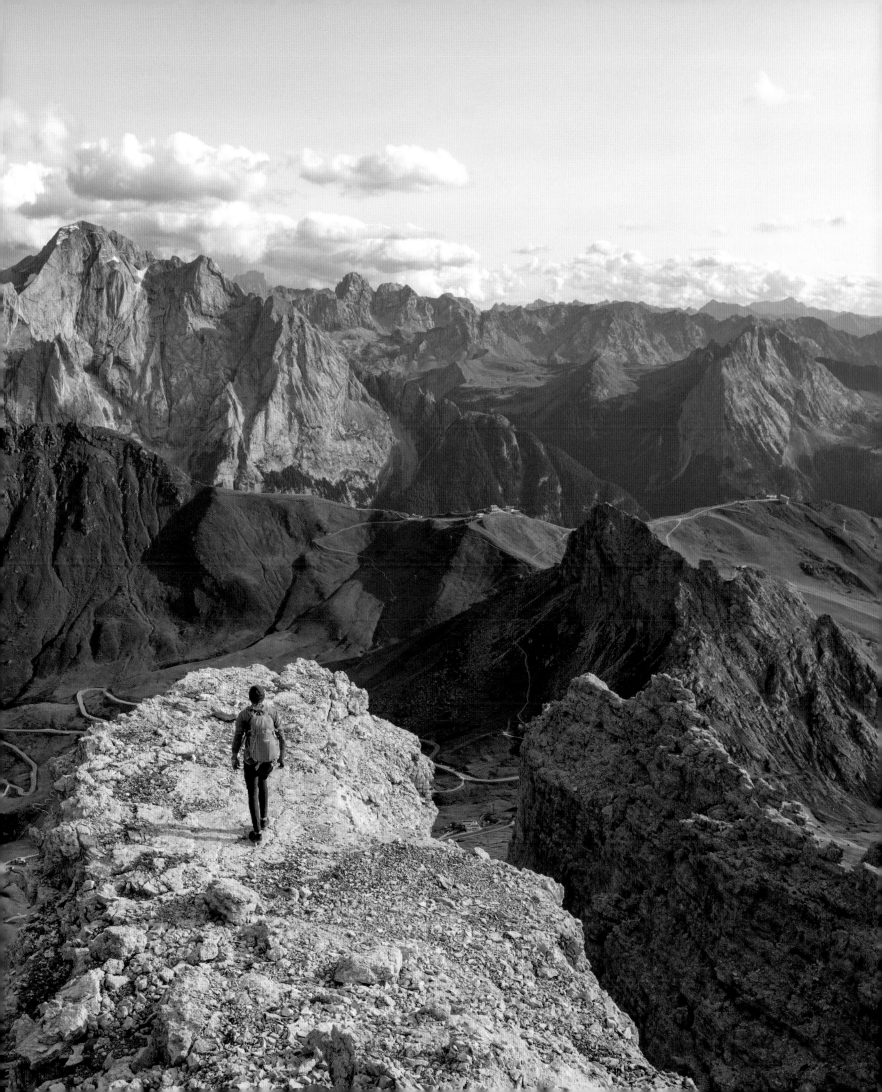

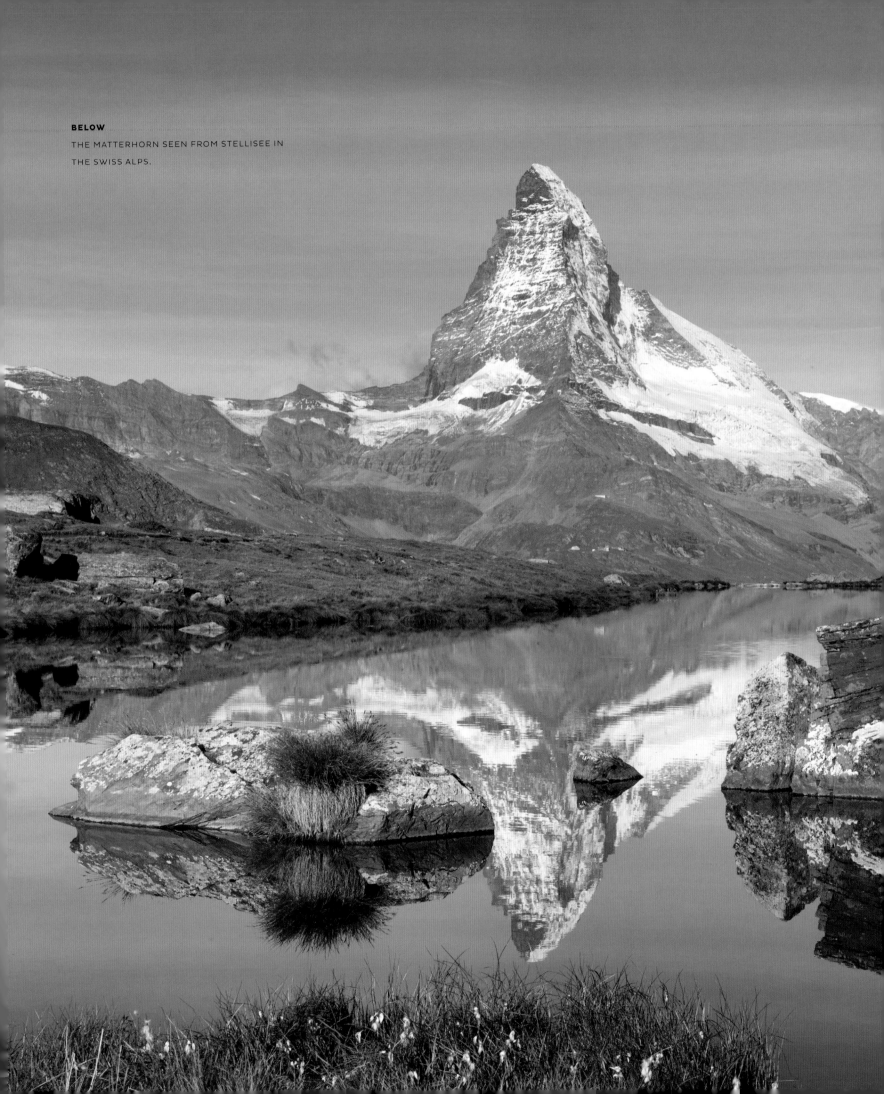

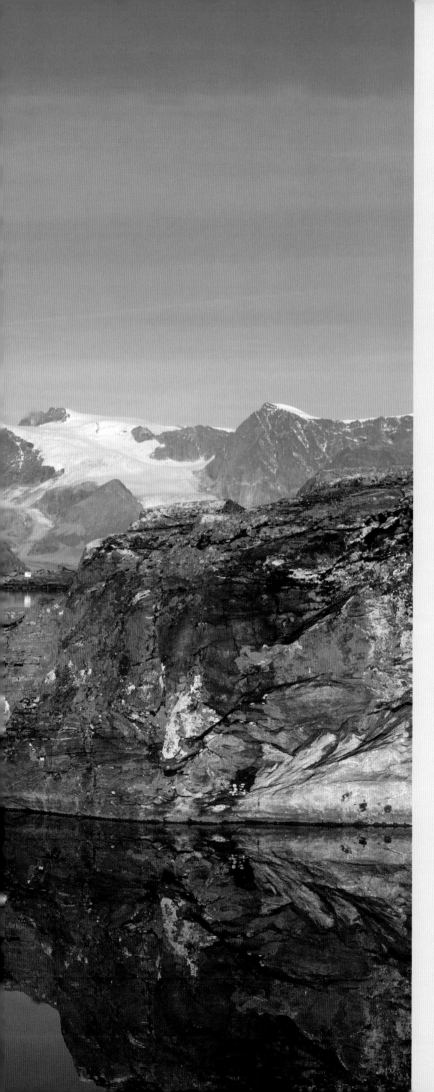

THE MATTERHORN
SWITZERLAND

Looking at the sheer north face of the Matterhorn, it is not surprising that this formidable mountain was deemed unclimbable for a long time – even though it is not the tallest peak in the Swiss Alps. Nowadays, the mountain pass is so popular that the Hörnli Hut on its ascent route needs to be booked many months in advance. So, instead of having your eyes glued to only one flank and the summit, circumvent this pyramid-shaped mountain and see all four distinctive faces from two countries.

Many explorers tried their luck on the formidable peak of the Matterhorn, and it wasn't until 1865 when the Englishman Edward Whymper and his rope party became the first men to set foot on the 4,478-metre (14,692-feet) high mountain. Since then the Matterhorn, or Monte Cervino, as the Italians call it, has been scaled thousands of times.

From the moment you step off the Swiss-red train in Zermatt and catch sight of the cobbled streets and horse carriages, you feel as if you have stepped back in time. There are no cars, the air is crisp and the majestic Matterhorn towers above this traditional village with its cosy cafés, shops with handmade gifts, and the Matterhorn museum displaying everything relating to the triumph and tragedy of its first ascent.

The Matterhorn Trek has been described as one of the most beautiful hikes in the world, taking in many ancient trails that have linked the Swiss and Italian valleys for centuries. The route covers a distance of 150 kilometres (93 miles) and offers a multicultural experience as it crosses from the pristine and rather conservative surroundings of Switzerland to the slightly more buoyant Italian towns, hence its nickname, the 'Spaghetti Tour'. This eight-day trek also crosses the Five Lakes Trail, which can be done in a single day, and leads you to Lake Stelli, probably the most-photographed lake in the area, given the pristine reflection of the Matterhorn on the lake's mirror-like surface.

This trek requires good stamina and fitness, as well as sure-footedness. The footpaths on this tour are well maintained and lead through meadows covered in Alpine flowers, spectacular glacial crossings and high passes offering the most rewarding views of the surrounding 4,000-metre (13,123-feet) peaks, such as the Dent Blanche and Zinalrothorn.

Hiking days are challenging, but the scenery is breathtaking, and at the end of the day a comfortable bed, hot shower, delicious meal, a glass of local wine and the company of other hikers awaits. Don't miss the chance to chat to the hut wardens, most of whom are mountains guides, as they often have exciting stories to tell.

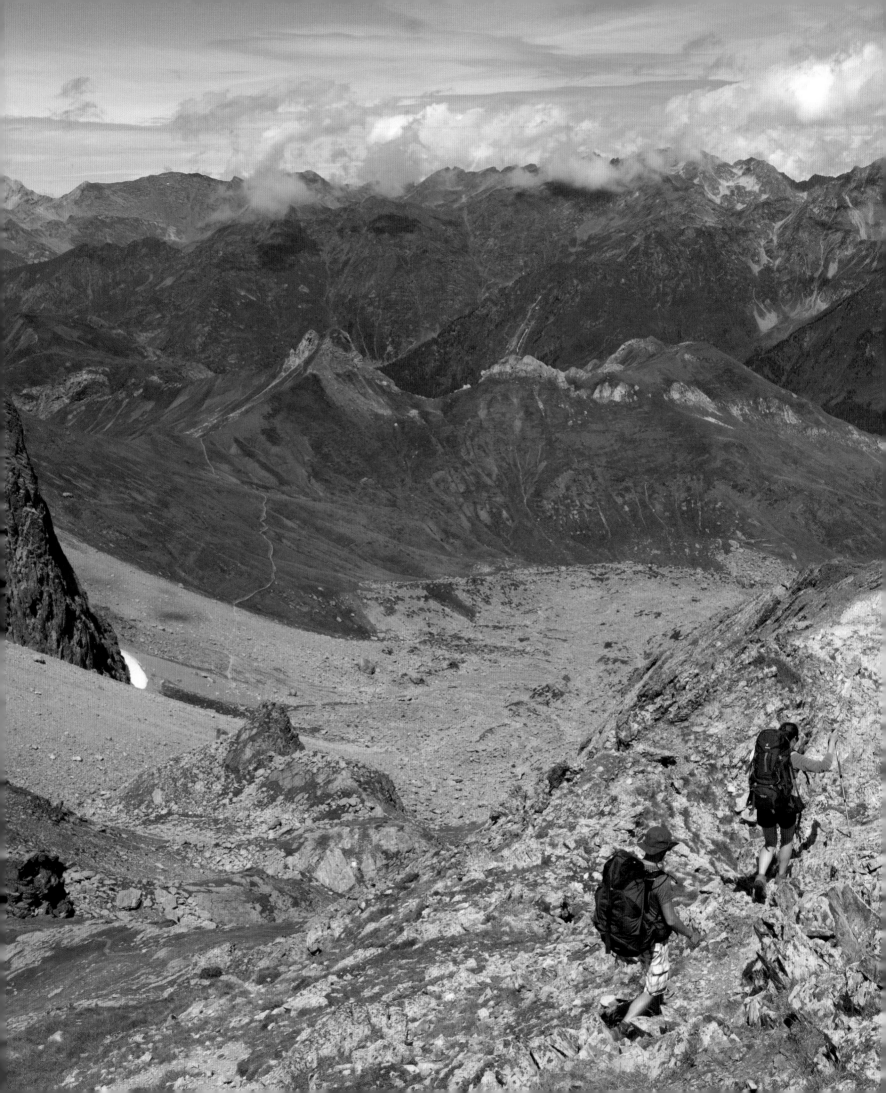

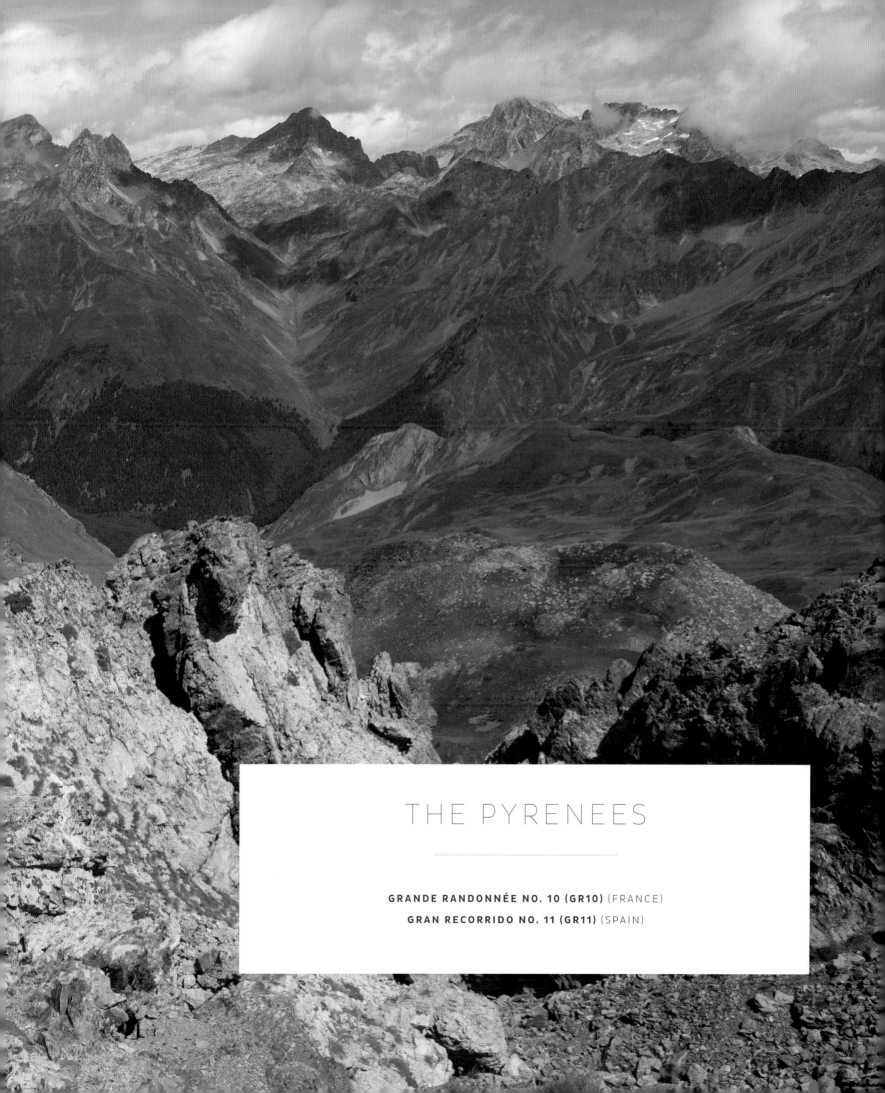

THE PYRENEES

GRANDE RANDONNÉE NO. 10 (GR10) (FRANCE)
GRAN RECORRIDO NO. 11 (GR11) (SPAIN)

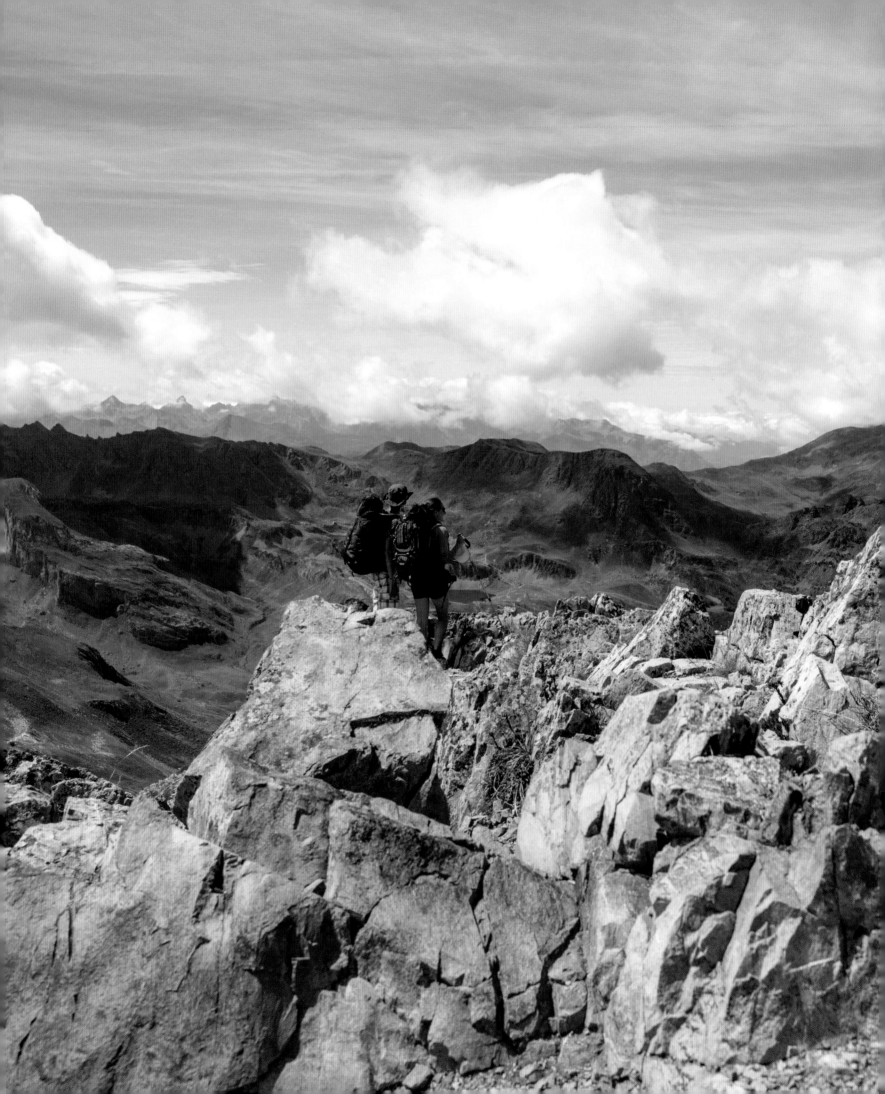

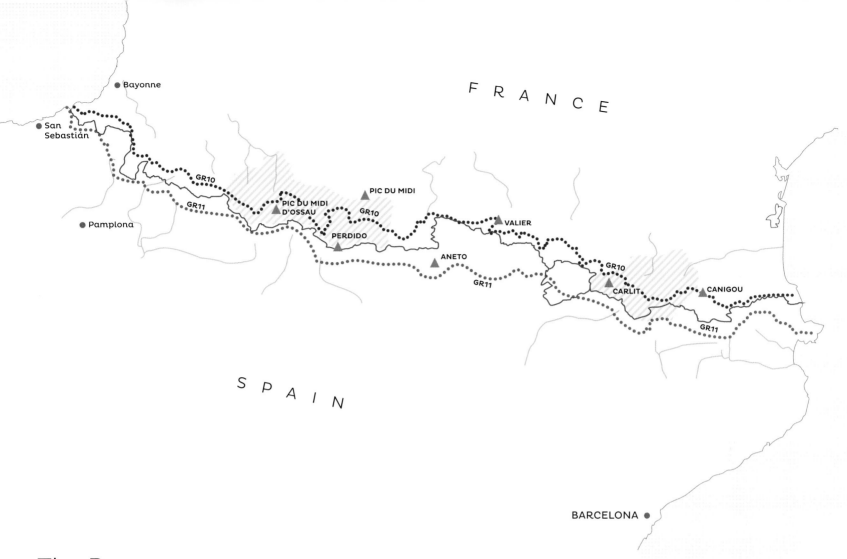

The Pyrenees

Rising along the border of France and Spain, the white-capped peaks of the Pyrenees massif stretch 435 kilometres (270 miles) from the Bay of Biscay in the Atlantic Ocean to the Mediterranean Sea. The entire region serves as a natural rock wall that is about 129 kilometres (80 miles) wide and, in some places, more than 3,000 metres (9,850 feet) tall; effectively separating the Iberian Peninsula and the countries of Portugal and Spain from the rest of mainland Europe.

The Pyrenees offer rugged, high-alpine country, and are home to some of the most unique people and cultures on the continent – not to mention three remarkable long-distance treks that each span the entire length of the range: the Grande Randonnée (or GR 10) in France, the Gran Recorrido (or GR 11) in Spain and the Haute Randonnée Pyrénéenne (HRP), which crosses the border between the two countries multiple times, and presents the highest route of the three great trails through the mountains.

The Pyrenees is one of few mountain ranges that have a tidy, kept footpath running through them in their entirety. The Appalachians, with their Appalachian Trail is another.

Considering that each of the GR trails has comfortable, picturesque, mountainside villages spaced a convenient day's walk apart along its entire length, it is no surprise that trekking the Pyrenees is on most mere-mortal adventurers' to-do lists– because it is actually quite doable, and notably enjoyable at that.

With an average elevation of about 1,067 metres (3,500 feet), the majority of the mountains here are shorter than their towering cousins in the Alps to the north – but are no less spectacular, and are far less crowded. They are harsher and more remote than the Alps,

too, despite their lower elevation, yet are filled with abundant wildlife, towering white-rimmed ridgelines, vibrant cultures and cascading waterfalls.

Cool wet air blowing across the Atlantic brings frequent precipitation to the western and central regions of the range, where most trekkers begin their journey east of the Mediterranean. This sometimes excessive moisture requires waterproof layers for trekkers, but also accounts for the western region's now world-famous emerald hills, its deep forests of conifer and beech, and crystalline white water streams; not to mention the central region's lofty alpine meadows, cloud-level lakes and perpetually snowy mountaintops. It also means that navigating the topography here requires sturdy calf muscles, as well as an affinity for getting a little dirty and wet.

Known as Euskal Herria, or in English, The Basque Country, the Western Pyrenees are home to a fiercely proud, independent and yet overtly welcoming people. Having carved their lives out of this rugged, lush landscape for centuries – herding sheep and tilling steep, stony fields – the Basques still speak their own unique language (that predates the Romance languages) and govern themselves by functioning as an autonomous community within Spain. Conversation with the locals tends to be the most time-consuming delay – and welcome diversion – of most treks through this region.

Like the mountains themselves here, The Basque Country is a remarkable world apart, filled with charming, culturally vibrant villages surrounded by a remote, rugged landscape and a seemingly impenetrable beauty.

Outside of the villages and mountainside towns, heading east, deep-green, broad-leafed trees give way to prickly, wind-stunted pines that gradually dissipate into permanent snowfields and sparsely covered pastures above 2,000 metres (6,500 feet). Numerous day treks dot the region, and scrambling the lesser peaks of the range is a popular pastime. As trekkers travel higher and further from the ocean, however, there's suddenly nothing but mountains, valleys and sky for more than 300 kilometres (185 miles), until the Pyrenees reach their end at the bright blue expanse of the Mediterranean Sea.

In the Eastern Pyrenees, the climate could hardly be more different, whilst still being impeccably amicable. The Mediterranean side of the mountain range, known locally as Cantalonia, receives an average of 300 days of sun each year, making it one of the sunniest places in Europe.

Like the villagers in The Basque Country to the west, on the Atlantic side of the Iberian Peninsula, many of the people in the Eastern Pyrenees still farm the rocky hills and shepherd flocks of sheep in the high tawny meadows – in the same way that their ancestors did for centuries. Descending from the treeline towards the sea, straggly cork oak forests give way to sprawling, sun-drenched vineyards that stretch out below dry, rocky crags and deep blue sky.

Rising between these two drastically different climates and cultures lie the Hautes (High) Pyrenees: the highest, most removed peaks of the entire range, in one of the last and largest untouched wilderness areas remaining in Europe, which includes France's 457-square kilometre (176-square mile) Parc National des Pyrénées and Spain's 156-square kilometre (60-square mile) Parque Nacional de Ordesa y Monte Perdido.

At 3,404 metres (11,168 feet), Spain's Pico Aneto on the Maladeta (or Accursed) Ridge is the loftiest of all the mountains amongst them, followed by 3,375-metre (11,073-feet) Pico Posets and France's 3,555-metre (11,663-feet) Monte Perdido. Known for their unusually high mountain passes and the raging torrents that flow down from their heights over some of the continent's tallest waterfalls, the High Pyrenees are not the easiest place to trek, but offer those who do venture into them an unparalleled opportunity to see wild Europe as it once was – stunning, yet often harsh.

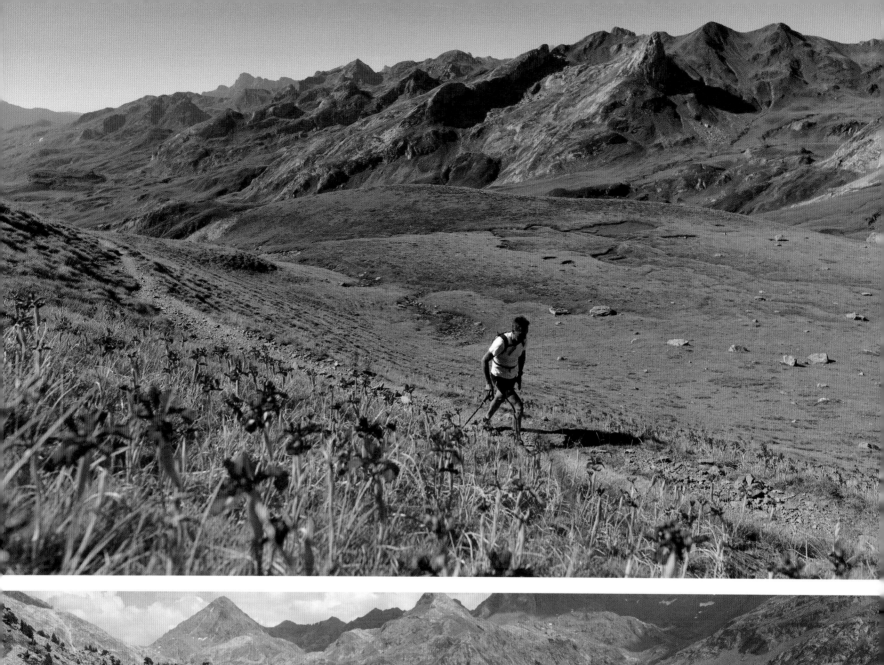
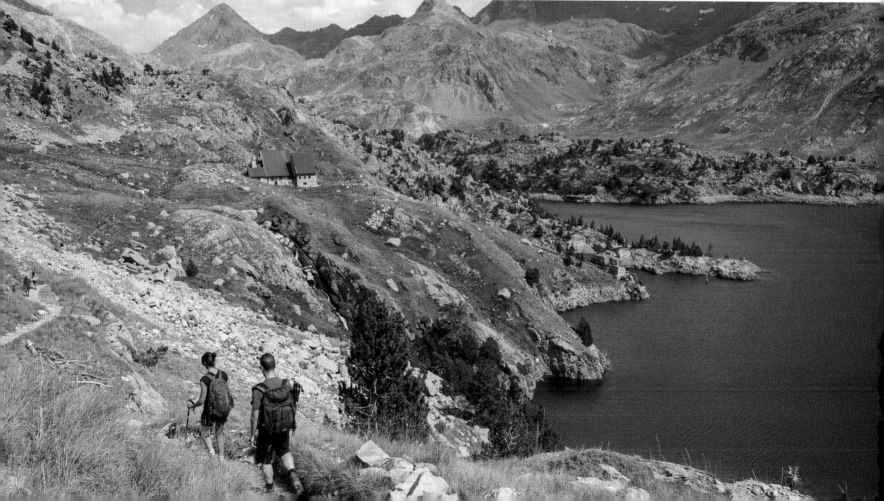

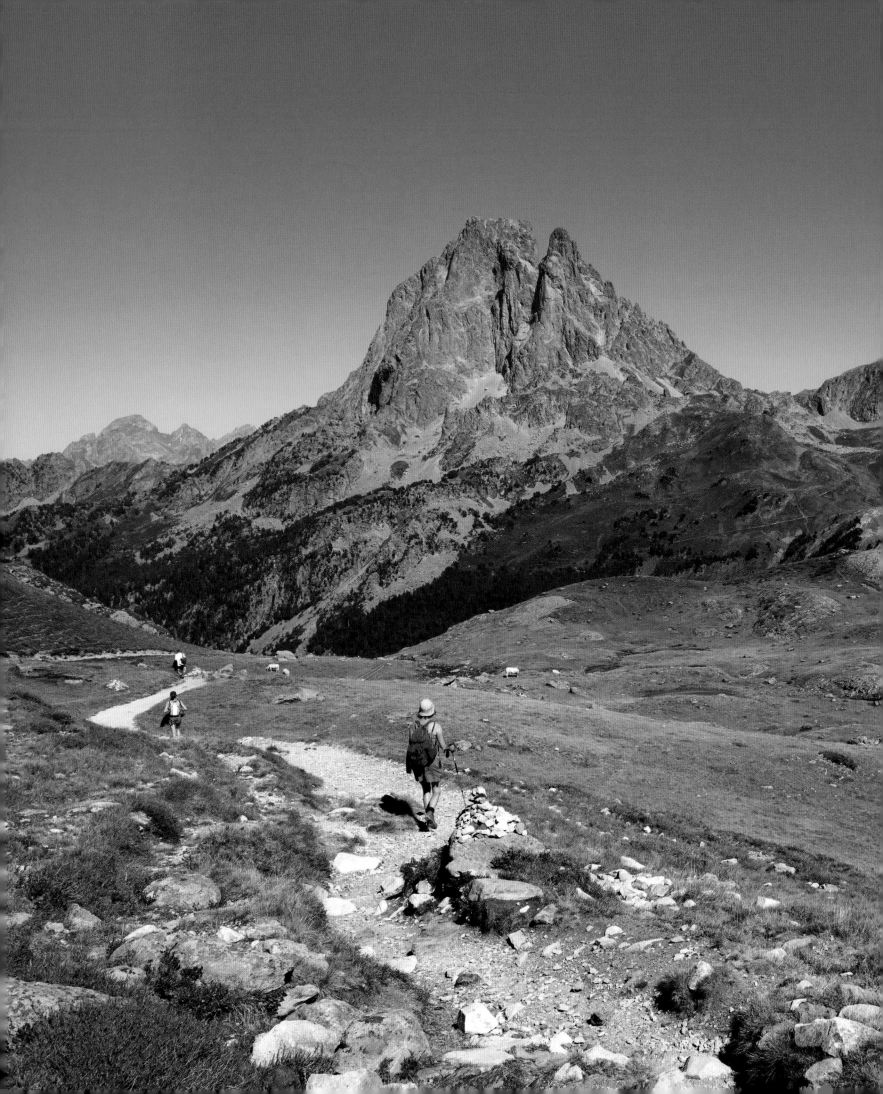

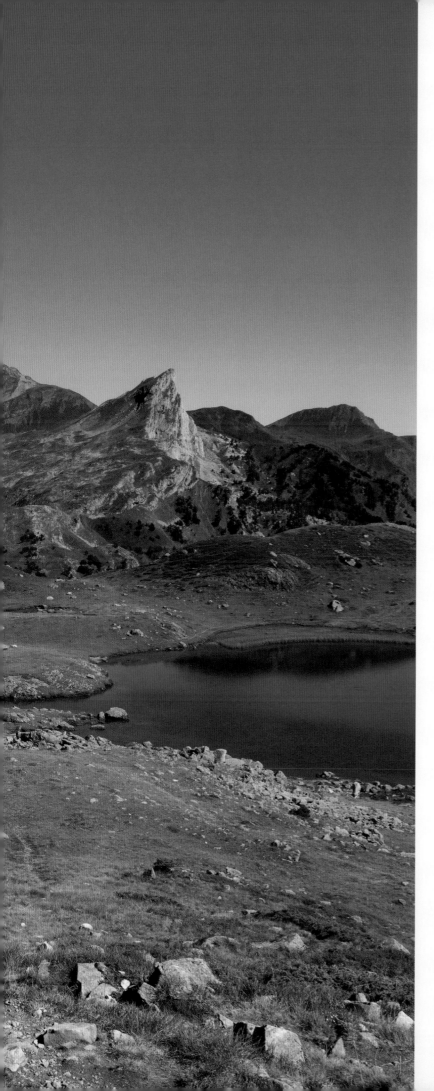

GRANDE RANDONNÉE NO. 10 (GR10) FRANCE

Crossing the whole of southern France, along the edge of the Pyrenees Mountains, the Grande Randonnée, or GR 10 – also known as The Pyrenean Way, is likely the second-most challenging long-distance trek in the world that doesn't require a tent; second only to its slightly more elevation-prone neighbour, the Gran Recorrido, or GR 11 (see page 69), across the border in Spain.

Whilst a crow could fly in a straight line from one end of the Pyrenees to the other and cover only about 435 kilometres (270 miles), the GR 10 winds its way up, down and around ridgelines, across valleys and over high mountain passes for nearly 900 kilometres (560 miles), along its path from the Atlantic Ocean to the Mediterranean Sea. Conveniently, there are huts, hostels or other forms of permanent shelter positioned a day's walk apart the entire way.

It is possible to traverse the GR 10 from east to west, but most travellers begin their long, 45- to 60-day journey in the Atlantic coastal town of Hendaye, France, in June, and eventually end it on the shores of the Mediterranean in Banyuls sometime in late August or September. This allows most of the snow to melt from the higher mountain passes and leaves enough time for even the slowest walkers to finish long before the cold and storms of autumn; it also keeps westerly driven wind and snow at hikers' backs.

In the western Pyrenees, the often rain-soaked trail begins by wandering through the rolling green hills of the Basque Country until reaching the high-altitude mountain village of Sainte-Engrâce. After venturing even deeper into the mountains, the trail enters the expansive wilds of Pyrenees National Park, which stretches more than 100 kilometres (60 miles) from the Aspe Valley to the Aure Valley, along the Spanish border. Here, the trail ventures through the austere and rocky Hautes Pyrenees, where it passes some of the most scenic and storied peaks in the entire range, including the 800-metre (2,600-foot) deep and 3,000-metre (10,000-foot) wide Cirque de Gavarnie.

Nearer the trail's end in the Eastern Pyrenees, after winding through the gorge of Carança and the natural reserve of Mantet and Py, the GR 10 descends from the high lakes and plains of the lower mountains to the Roman spa town of Arles-sur-Tech, through the last mountain foothills of the Massif des Albères, until it ends abruptly in Banyuls, at the bright blue expanse of the Mediterranean Sea.

LEFT

TREKKING BESIDE LAC DU MIEY.

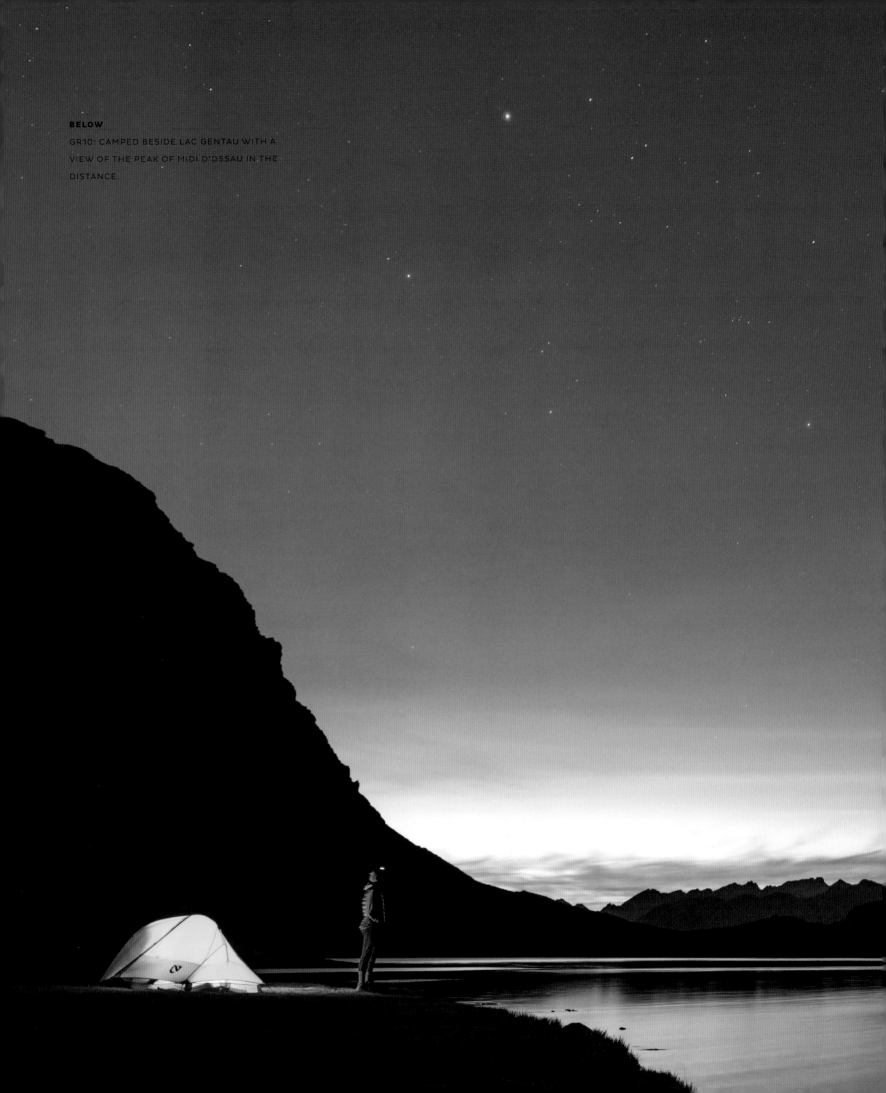

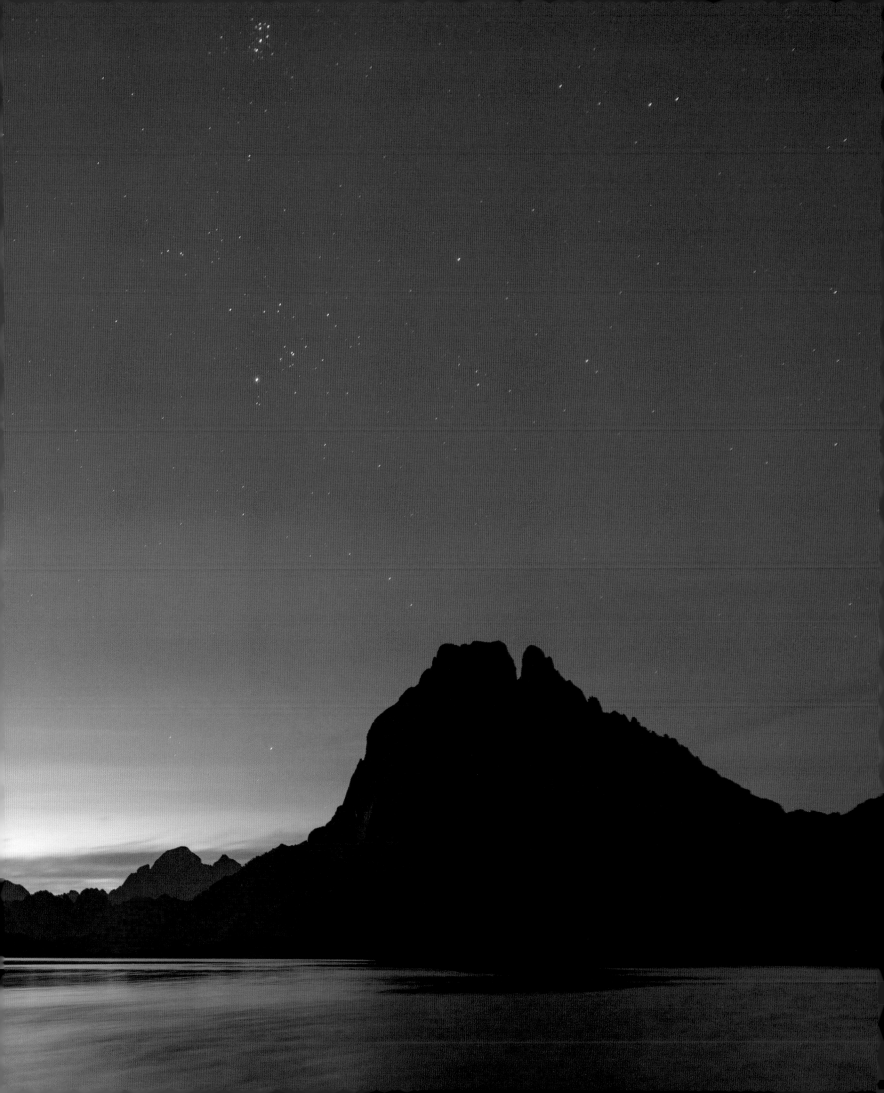

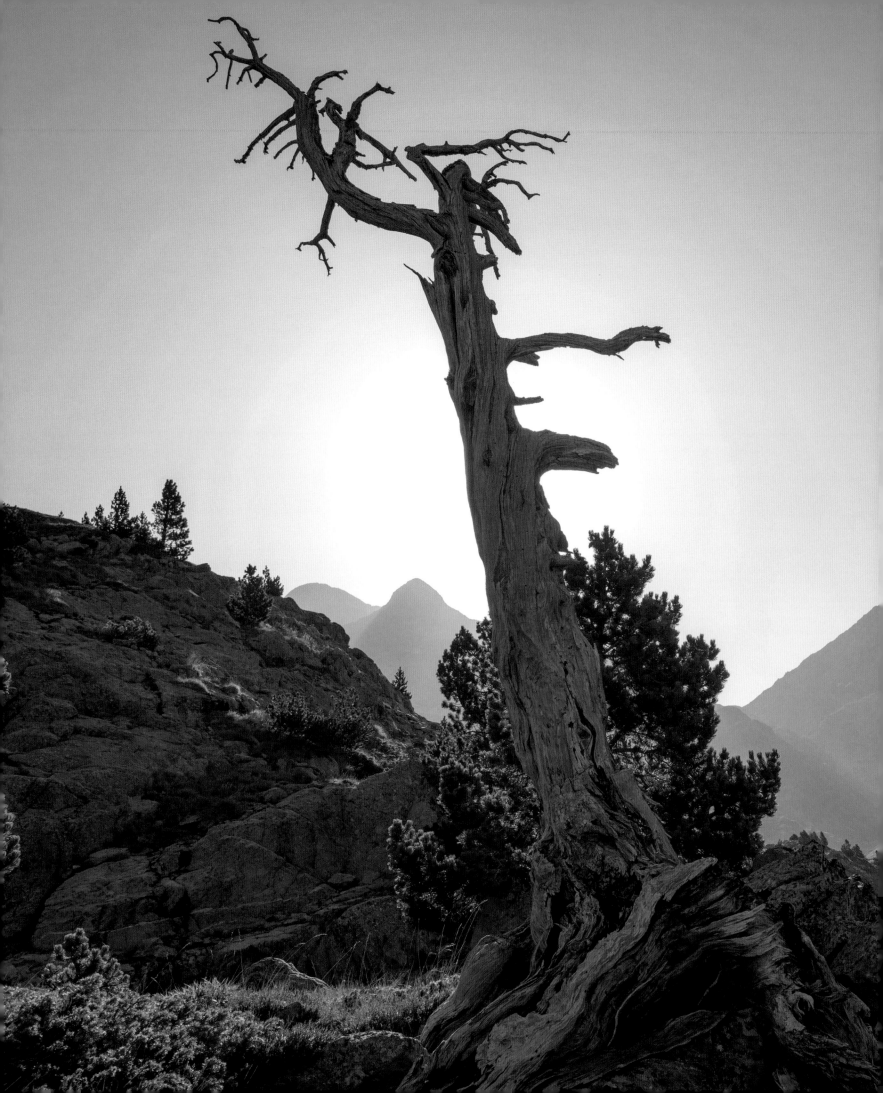

GRAN RECORRIDO NO. 11 (GR11) SPAIN

For trekkers looking for the wildest, remotest way to traverse the length of the Pyrenees without needing to load a pack with a heavy tent or cooking kit, Spain's GR 11 is simply unmatched.

Mirroring its older, more established French cousin, the GR 10, to the north, Spain's GR 11, or Ruta Transpirenaica, also traverses the Pyrenees from the Bay of Biscay to the Mediterranean. It offers a similar, other worldly, 'sans tent', trans-Pyrenees trekking experience, only with fewer people, higher elevations and, by at least some accounts, more sun.

Whilst the climate and cultural differences between the Western and Eastern Pyrenees are drastic – the damp, lush Basque Country to the west compared to the dry, sun-drenched Mediterranean Eastern Pyrenees – these differences are less noticeable north to south, across the French–Spanish border.

Where the GR 11 starts at Cape Higuer in the Basque Country, for example, it is just as wet and green and beautiful as it is in Hendaye, France, where the GR 10 begins its journey east only a few dozen kilometres away. In Cap de Creus, where the Spanish route finds its end at the Mediterranean, it is still just as sunny, dry and bright blue as it is north of the border in Banyuls, France, where the more popular northern route also reaches the sea.

And while the GR 11 often plays second fiddle to its more established sister trail to the north, the Ruta Transpirenaica is more than just the same path on the other side of the mountains – it is a completely different adventure, with its own unique set of challenges and once-in-a-lifetime rewards.

The main differences between these two great walks (aside from the local language) are elevation and population. Where the GR 10 crosses only one pass above 2,500 metres (8,200 feet), for example, the GR 11 crosses 10 such passes. And whilst tent-free accommodation is available along the entire length of the Spanish route, the lower-lying villages found along the French path are replaced on the GR 11 by more remote, lonely looking huts and isolated, helicopter-supplied mountaintop hostels.

On account of this added remoteness, many trekkers find that the GR 11 leaves less opportunity for conversing with fellow travellers – because there are fewer to be found – and more time to focus on the path ahead.

LEFT

VIEW OF THE PYRENEES FROM NEAR REFUGIO RESPOMUSO.

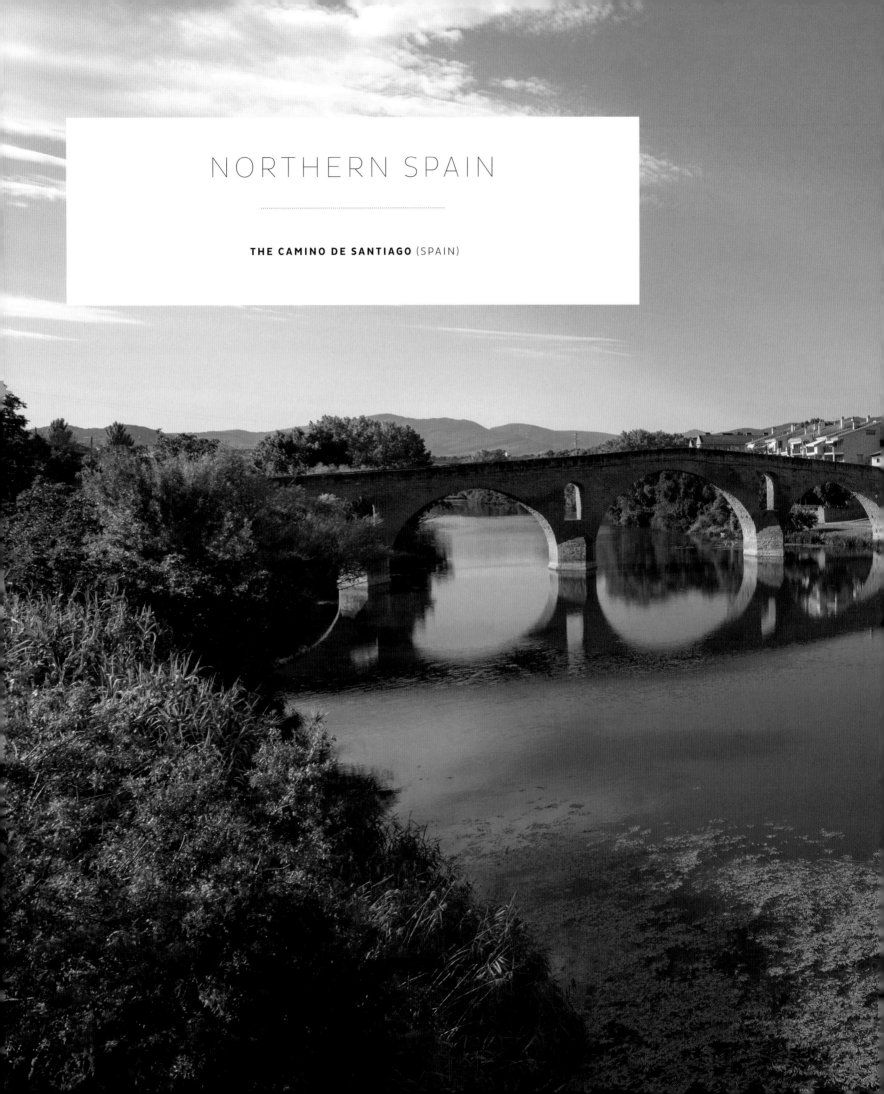

NORTHERN SPAIN

..

THE CAMINO DE SANTIAGO (SPAIN)

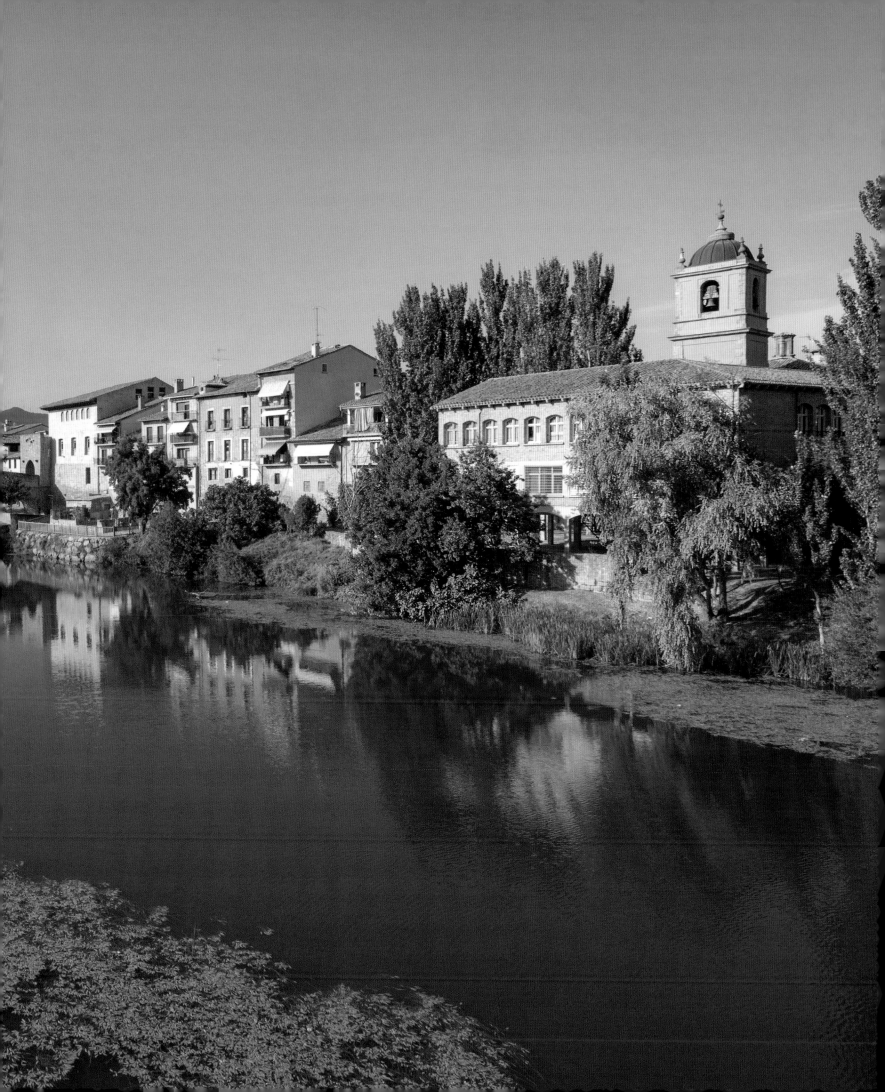

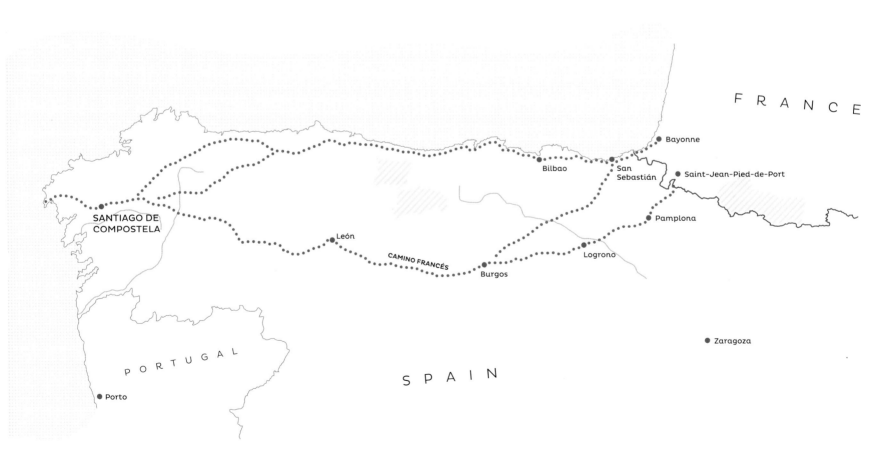

FRANCE

SPAIN

PORTUGAL

Porto

SANTIAGO DE
COMPOSTELA

León

CAMINO FRANCÉS

Burgos

Bilbao

San
Sebastián

Bayonne

Saint-Jean-Pied-de-Port

Pamplona

Logrono

Zaragoza

Northern Spain

Trekking in northern Spain is like walking into the past. From the pristine Palaeolithic cave art of Altamira and the miraculously still-standing eighth century stone Church of Santa María del Naranco in Oviedo, to the modern-day, autonomous Basque-speaking villages of the northeast, few places in this world have managed to retain such a vibrant and well-preserved history or culture across such a broad swath of land. Fewer still possess such a remarkable, mountainous backdrop. No other region can lay claim to having what is likely to have been humanity's first long-distance footpath, either: the Camino de Santiago, or The Way of St James.

Originally this existed as a large network of ancient Catholic pilgrim routes stretching across Europe that converge at the tomb of St James (Santiago) in the city of Santiago de Compostela in northwest Spain. The most popularly travelled modern-day variation of the route, the Camino Francés (the French Way) traverses approximately 750 kilometres (466 miles) across the four Spanish provinces of Euskal Herria (the Basque Country), Cantabria, Asturias and Galicia, before ending on the northern coast of the Iberian Peninsula.

Despite the increasing popularity of this ancient network of pilgrim paths over the past several decades, these northern, mountainous reaches of the Iberian Peninsula are comparatively untouched by the levels of tourism seen in central and southern Spain – where most foreigners fly in to the country and then disperse south towards the perpetual sunshine and warm, blue waters of the Mediterranean Sea. For the adventurous, historically minded trekker who's keen to go for a long walk, however, there's no better destination than the northern provinces of Spain and the countless mountain and coastal trails that run

ABOVE

THE CAMINO DE SANTIAGO: ON THE SUMMIT OF ALTO DE PERDON IS A FAMOUS SCULPTURE DEDICATED TO ALL THE PILGRIMS WHO WALK THE CAMINO DE SANTIAGO.

PREVIOUS PAGES

THE CAMINO DE SANTIAGO: THE BRIDGE AT PUENTE LA REINA.

through them. The region is worth exploring whether you're attempting to make it all the way to Santiago de Compostela or not.

Here, along the Costa Verde (Green Coast), the same cool, wet air that blows inland off the Bay of Biscay into the Western Pyrenees along the Spanish–French border, regularly drenches the entire northern side of the Cantabrian Mountains. Rising up from sea level only a few kilometres from the Atlantic Ocean, and running unbroken from the coastal edge of the Pyrenees in the east to the northwest tip of the country in Galicia, these mountains form a stark separation between the Costa Verde and the high, dry plateau, or *meseta*, of central Spain. The mountains also create an incredibly varied landscape for those traversing through them. The less than predictable weather helps keep all but the purposely driven and innately curious tourists at bay, but the persistent rains keep the countryside vibrant.

From Basque Country to Galicia, northern Spain offers a wide range of hikes besides the month-long Camino de Santiago trek. They include easy out-and-back day hikes that lead to awe-inspiring mountain vistas as well as a multitude of multiday treks that meander through remote, medieval villages and historic bull-fighting cities such as Pamplona. Along the coast, old and elegant seaside towns fringe deep-blue water that is warm enough to swim in, at least in the summer months. Inland, high above the treeline, dense coastal forests give way to sharp limestone peaks and deep, rocky gorges that form a lunar-like landscape.

Where the Cantabrian Mountains rise to their highest elevation, travellers venture through Peaks of Europe National Park, the second-largest national park in Spain. Also known as the Picos de Europa, or the Picos, for short, these abrupt peaks – whose jagged, lofty appearance, seems more typical of the Alps than the northern edge of Spain – cover portions of Cantabria, Asturias and northern Castilla y León, and pack several distinct climates and habitats into a relatively small geographic area. A trail in the Picos may start at the bottom of a lush valley, but will manage to travel through montane, subalpine and alpine zones in a matter of hours over the course of just a thousand or so metres of elevation change.

Originally named by Spanish conquistadors returning from the Americas, these mountains' would have been seafaring Spaniards' first sight of European landfall after their long journey home across the Atlantic. The highest peak among them, Torre Cerredo, at 2,648 metres (8,688 feet), rises up from near sea level, along with several other peaks over 2,600 metres (8,530 feet), creating an enormous mountain cathedral-of-sorts, visible from miles out at sea.

Whether walking from one *albergue* (hostel) to the next on one of the long-distance Camino de Santiago routes, or trekking through a deep, remote mountain gorge such as Cares Gorge, in the Picos, which is carved into the sides of cliff faces – there is no apparent end to the scenic or cultural variations to be explored in northern Spain.

No wonder people have been walking long distances here for centuries. It's almost impossible not to.

RIGHT

THE CAMINO DE SANTIAGO: PILGRIMS WALK THE TRAIL.

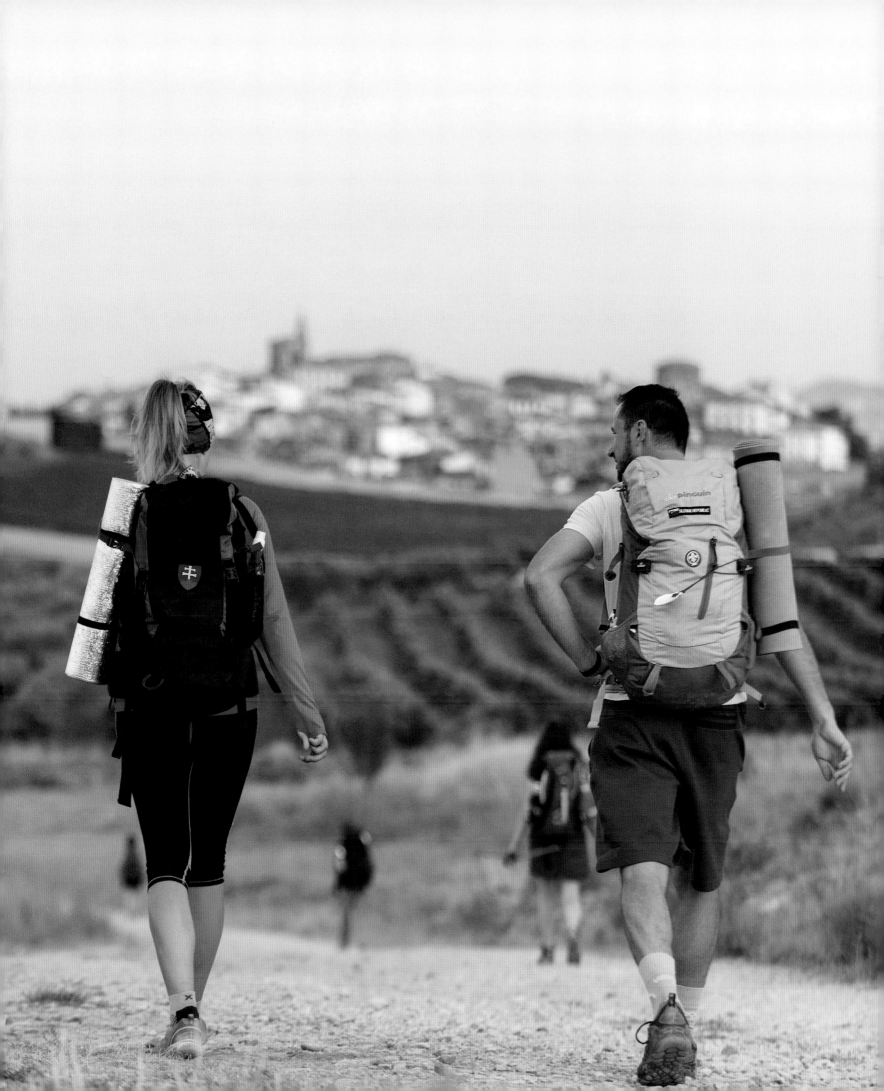

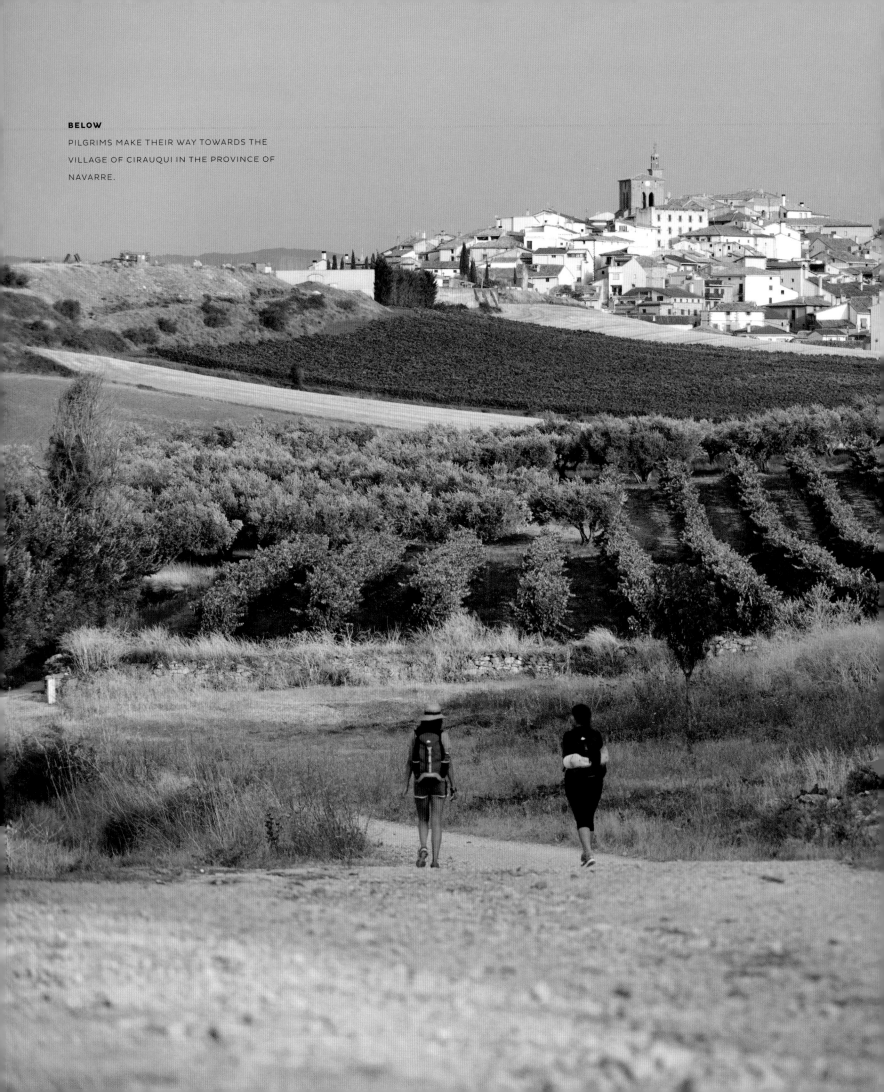

BELOW

PILGRIMS MAKE THEIR WAY TOWARDS THE
VILLAGE OF CIRAUQUI IN THE PROVINCE OF
NAVARRE.

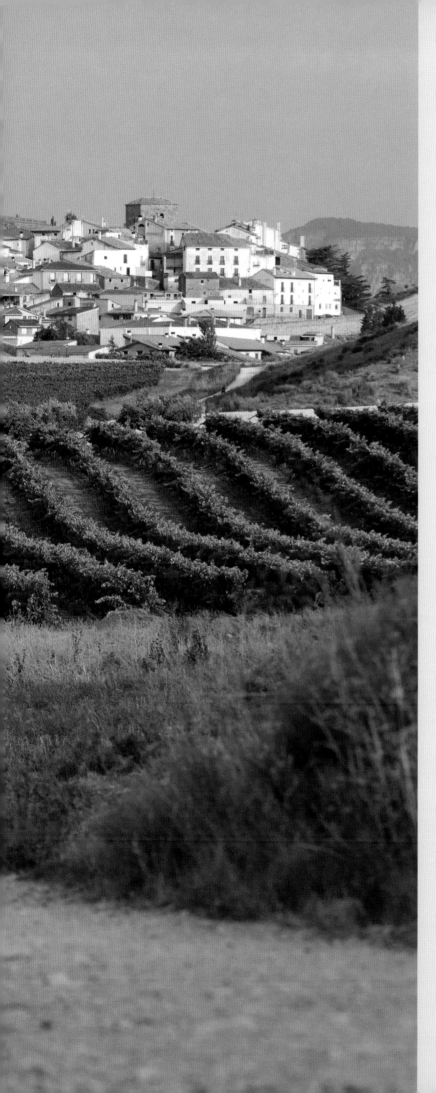

THE CAMINO DE SANTIAGO
SPAIN

One of the most ancient long-distance treks in the world, the traditionally Catholic pilgrimage known as the Camino de Santiago ends in its namesake city of Santiago de Compostela in Galicia, where the Christian martyr St James is buried. Where the route starts is a more complicated question to answer, or impeccably easy, depending on how you look at it. The Camino de Santiago, or The Way of St James, begins wherever someone starts it. If someone finds themselves walking to Santiago de Compostela to see the tomb, they are on the Camino de Santiago. It's as simple as that.

No matter where a pilgrim begins his or her journey – whether in France, southern Spain or Portugal – all paths inevitably lead through northern Spain and, eventually, the Spanish province of Galicia. This means that, over the years, a number of established and well-marked Camino de Santiago trails have been carved into the landscape – 12, to be exact – each complete with regularly and conveniently placed villages and *albergues*. Conveniently enough, this means that no matter where someone begins the Camino de Santiago, so long as they are in or relatively near Spain, they don't need a tent or cooking kit to complete the journey. It is just a matter of walking from one well-accommodated town to the next.

Since the ninth century, emperors such as Charlemagne, kings such as Alfonso II and popes such as Calixtus II, as well as knights, peasants and even beggars, have all walked from their front doors to Santiago de Compostela in order to attend a pilgrims' mass and receive a certificate that, according to Catholicism, ensures they spend less time in purgatory.

Nowadays, the majority of Camino de Santiago pilgrims travel along the 750-kilometre (466-mile) long Camino Francés (The French Way), which begins in Saint-Jean-Pied-du-Port in France, crosses the Pyrenees and continues west across northern Spain, eventually passing through the towns of Pamplona, Burgos and León, along with countless other small villages. As tourism and interest in the ancient pilgrimage routes grow, however, an increasing number of travellers are discovering the lesser-known routes too, such as the Camino del Norte (The North Way), which runs along the Atlantic Coast, and the Camino Portugués (The Portuguese Way), which travels up from the south along the Portuguese border.

To this day, the routes leading to Santiago de Compostela remain a melting pot of peoples and cultures, all travelling from around the world to find a sense of what first drew the pilgrims and, inevitably, others trying to do the same.

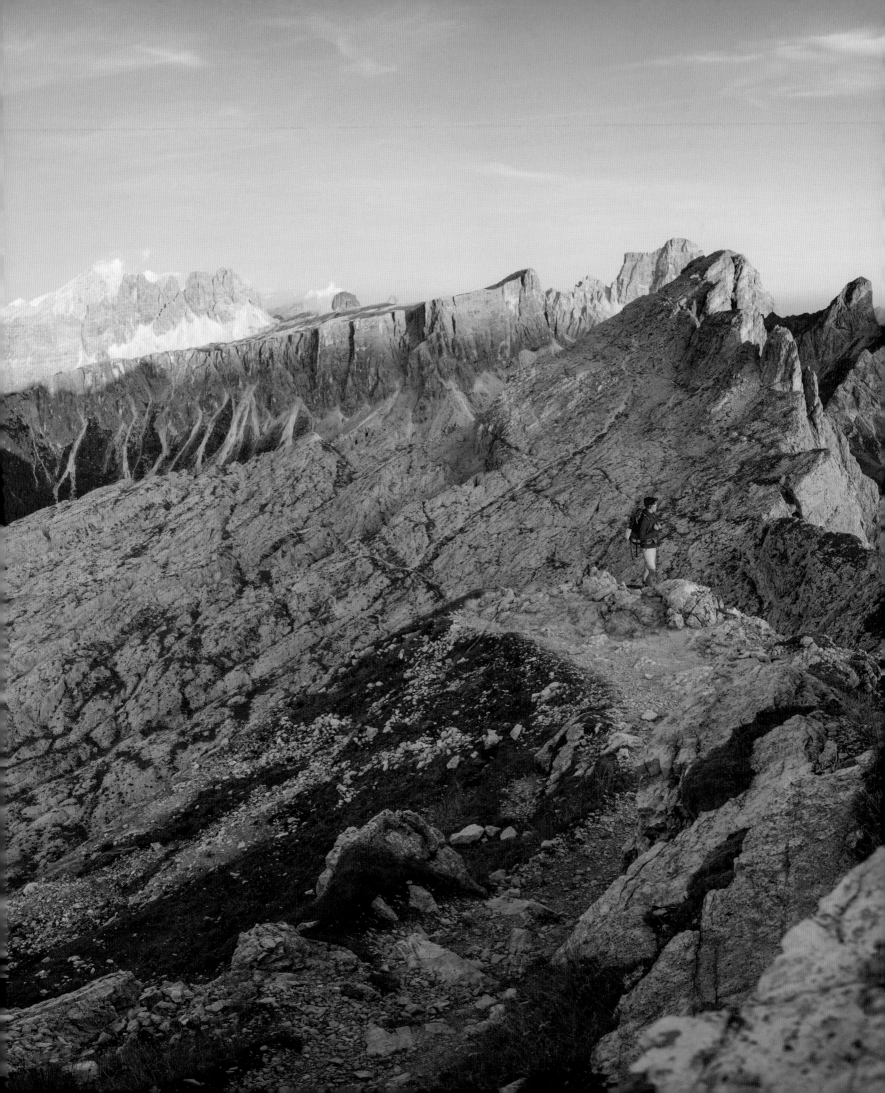

THE DOLOMITES

ALTA VIA 1 TREK (ITALY)

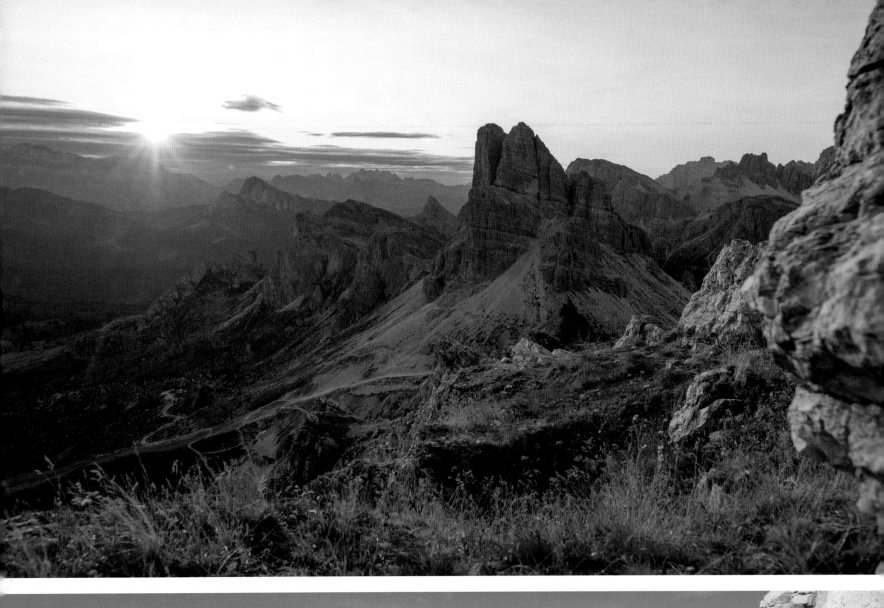

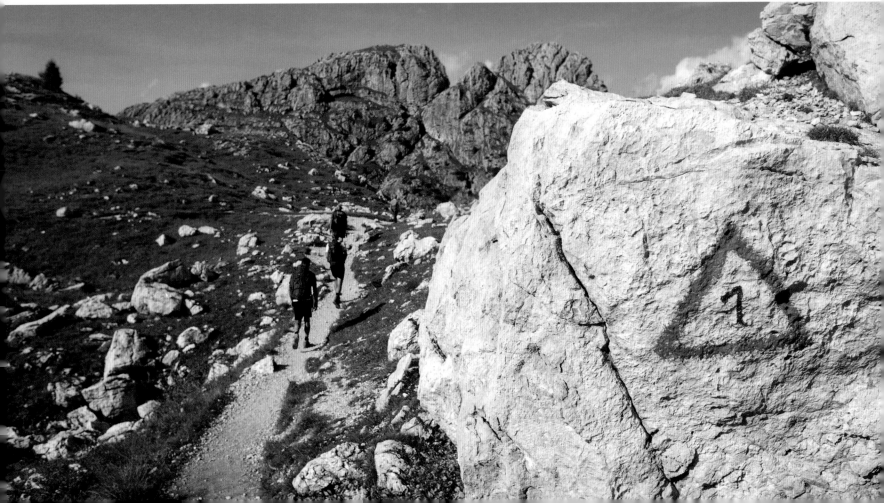

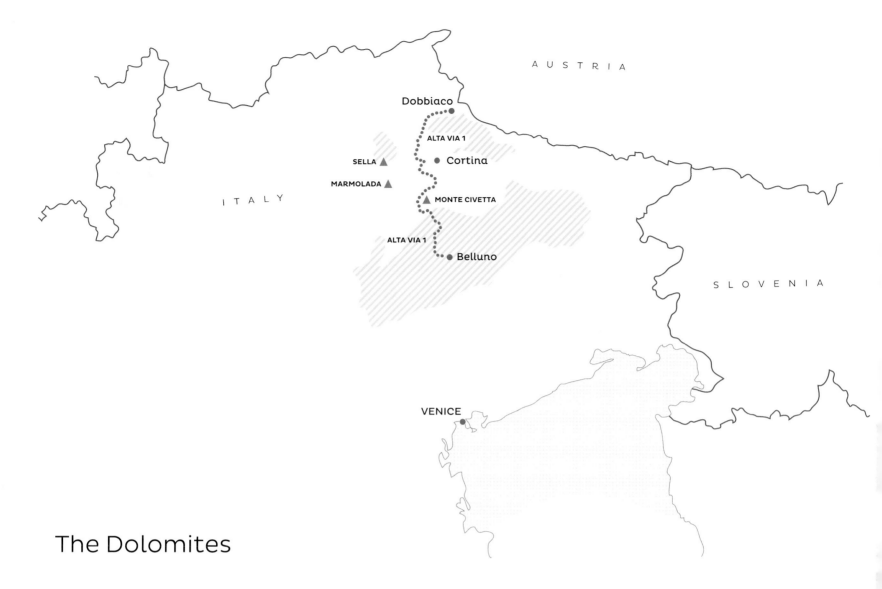

The following labels appear on the map:

AUSTRIA

Dobbiaco

ALTA VIA 1

SELLA ▲

Cortina

MARMOLADA ▲

MONTE CIVETTA ▲

ITALY

ALTA VIA 1

Belluno

SLOVENIA

VENICE

The Dolomites

'Each mountain in the Dolomites is like a piece of art.' This is how the revered South Tyrolean mountaineer Reinhold Messner describes the grandeur and beauty of the sheer rock formations scattered across his home turf. Rising high into the sky in northern Italy, the Dolomites have been the subject for many a painter, sketcher or photographer. Long, steep mountain valleys, dense forests, gushing rivers and emerald green lakes are spread across the landscape, which is surrounded by the pink-grey walls of the Dolomites.

Forming the south eastern part of the Alps, the Dolomites were created about 250 million years ago. Mainly composed of sedimentary rock and limestone, they are nearly equally shared between the provinces of Belluno, South Tyrol and Trentino. It is hard to imagine that these huge lumps of rock were once enormous coral reefs formed in a primordial ocean, the Tethys. This natural paradise used to be referred to as the Pale Mountains, for the white rocks glow with golden, pink and purple hues at dawn and dusk, a phenomenon referred to as 'alpenglow'.

Only in 1789 did they receive the name Dolomites, when French geologist Dèodat de Dolomieu discovered the dolomite brick, which later became the eponym for the entire mountain range. Covering a surface of more than 140,000 hectares (540 square miles), they host 18 peaks soaring above the imposing height of 3,000 metres (9,800 feet), with some of the sheer rock cliffs rising higher than 1,500 metres (4,920 feet) from their very bottoms. The peaks that stand out most are the Drei Zinnen (Three Pinnacles), which jut into the sky on a plinth of grey scree. With the highest peak being the Marmolada at 3,343 metres (10,968 feet), the Drei Zinnen are most prominent but by no means the tallest in the Dolomites.

OPPOSITE TOP

ALTA VIA 1: SUNSET FROM REFUGIO NUVOLAU.

OPPOSITE BOTTOM

DISTINCTIVE BLUE TRIANGLES MARK THE WAY ALONG THE ALTA VIA 1.

PREVIOUS PAGES

ALTA VIA 1: SUNSET ALONG THE AV1 NEAR CINQUE TORRI.

This magnificent mountain range used to belong to Austria, but became part of Italy after World War I, when the two countries fought a bleak and merciless battle across its terrain. To this day, the South Tyroleans and their share of the Dolomites do not feel as if they are a part of Italy, and even though reading a road sign bearing both Italian and German can be a lengthy business, 96 per cent of the population speaks German. Remarkably, it is also home to ancient Ladin, the third language of the province, spoken by 30,000 of the 510,000 South Tyroleans.

It is not surprising that this wild and jagged mountain range – with its spectacular pinnacles, spires and towers – became a UNESCO World Heritage Site in 2009. It was listed for 'the aesthetic value of its landscape and the scientific importance of its geology and geomorphology'. However, the Dolomites are not just about pretty trails, science and geology – there is much more to discover.

The best trekking season is between June and October, although that, of course, means it is the most popular and busiest time to wander around these sharp, rocky peaks. No matter how many other hikers you encounter on the trail, always remember to look up and beyond the crowds: it is hard not to be overwhelmed by the immensity of this grey, ice-capped rock – especially when thinking back to the soldiers of the World War II who hid and fought across these grand spikes of land.

The Dolomites have everything from short, flat hikes and challenging treks with significant elevation changes, to thrilling scrambles along Via Ferratas, which are omnipresent in the Dolomites. Literally translated, *ferratas* are 'iron ways', artificially equipped with steel cables, ladders or other anchors, enabling even the inexperienced hiker to brave an exposed route. No matter at which level you choose to explore this magnificent lunar landscape, colourful alpine meadows, lush forests, soaring peaks, dramatic walls and towering heights will be your companions, wherever you go.

Once you have decided on the level of your hike, you can opt between a day hike, a one-night stay in a *refugio*, or a proper multiday trek, staying in the many *refugios* that are considered some of the best in the Alps. The Alta Via treks, of which there are eight, range between a length of 6 to 13 days at different levels. Being extremely well developed, you can also facilitate one of the multiday hikes by doing a trip in one of the many cable cars. Many of the *refugios* are also accessible by gondola, which means you could always catch a ride to the top for an overnight stay and continue your hike from there.

OVERLEAF

TREKKING ACROSS THE ROCKY DOLOMITES.

RIGHT

ALTA VIA 1: TREKKERS NEGOTIATE THEIR
WAY ALONG A SECTION OF TRAIL NEAR
REFUGIO NUVOLAU.

82 THE DOLOMITES

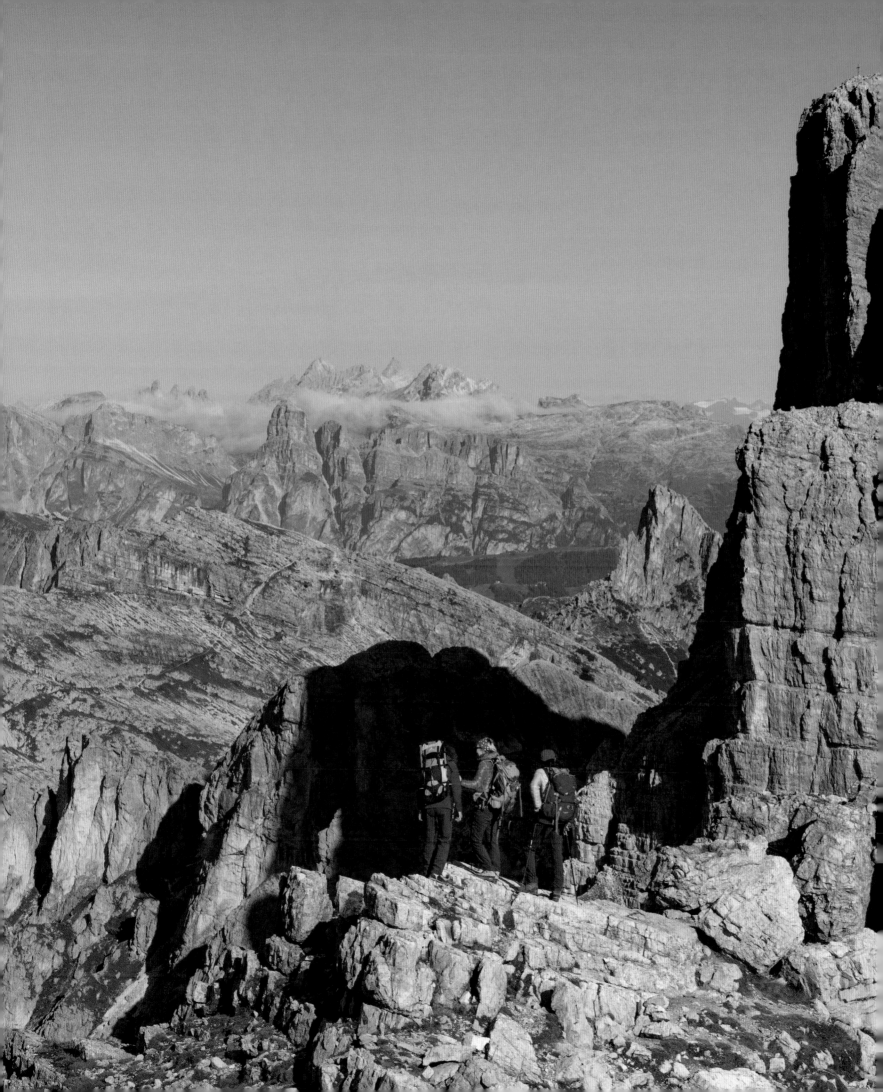

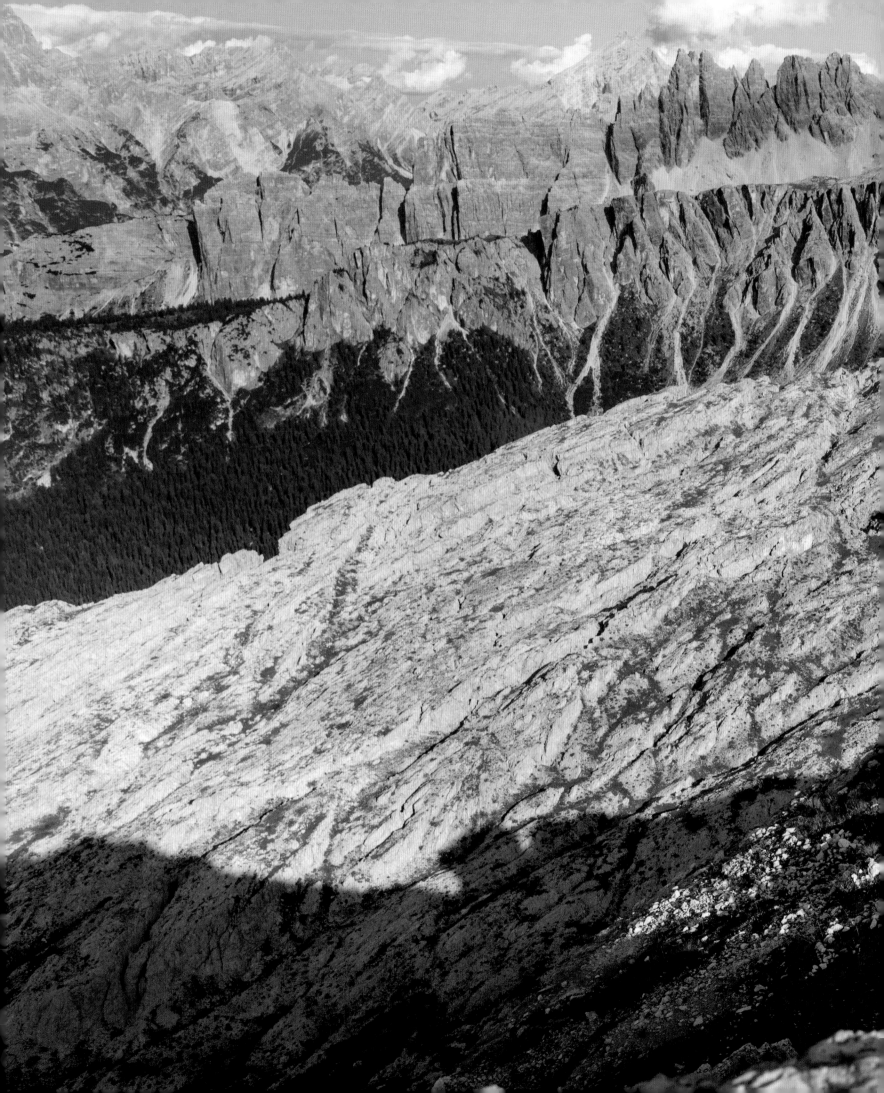

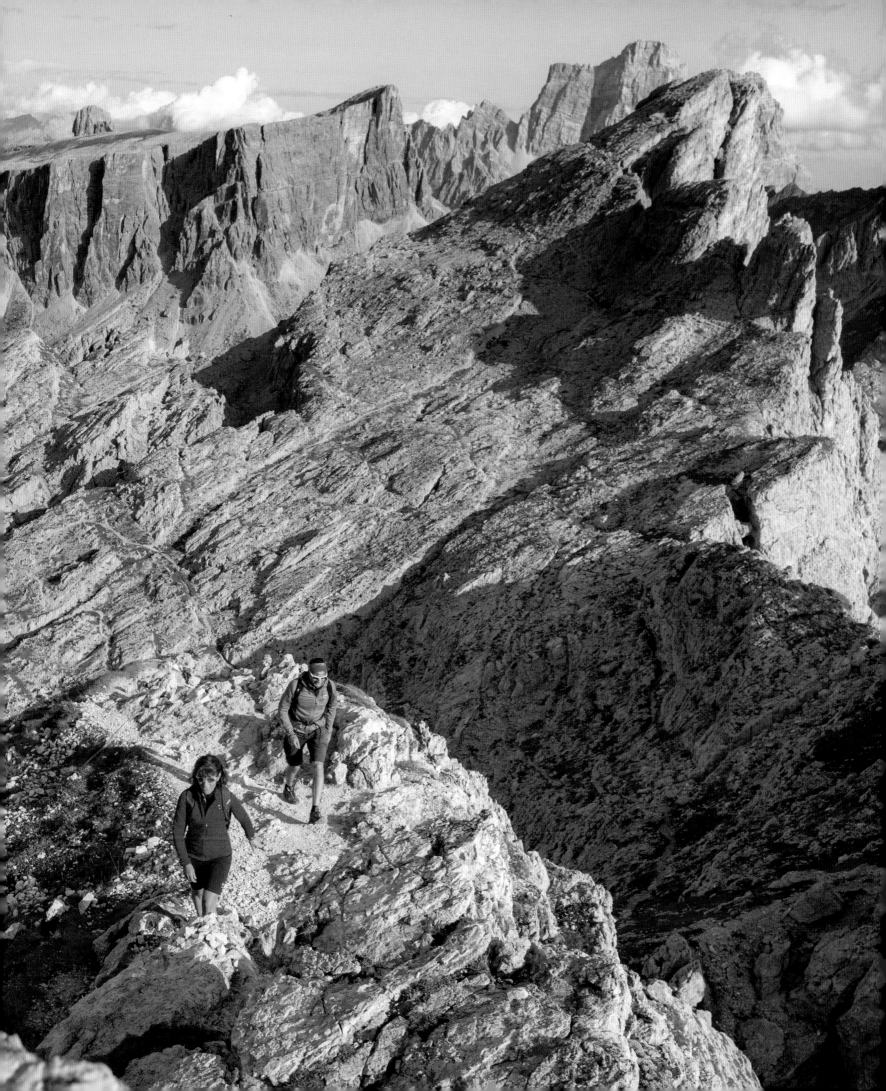

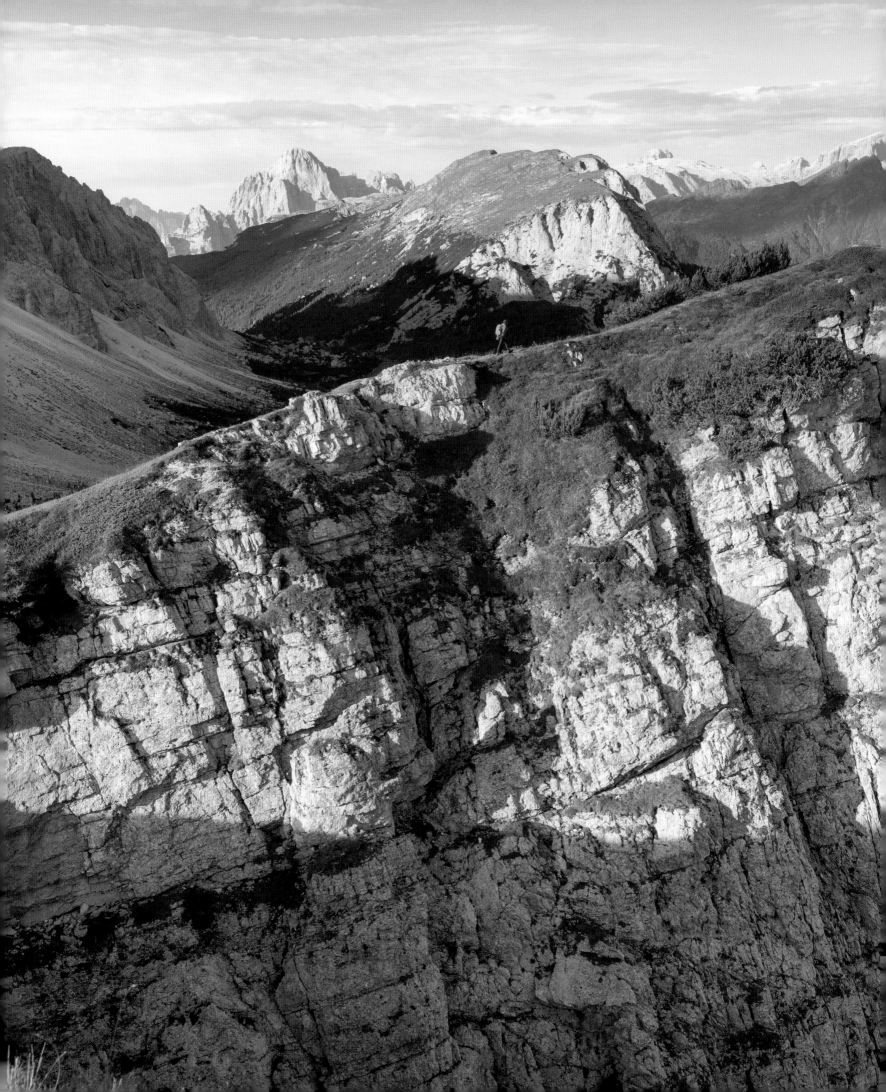

ALTA VIA 1 TREK
ITALY

With thousands of trails winding their way up high passes or jagged mountaintops, the Dolomites offer a multitude of hikes of varying scale and challenge. Some of the most popular hikes are the eight Alta Via Treks. These long-distance trails are perfect for multiday, hut-to-hut alpine tours, and they lead you through some of the most breathtaking and varied terrain in the world. At these great heights you can experience snow, sleet and biting cold, as well as piercingly bright light and searing heat. The traditional mountain huts offer a cosy atmosphere, allowing you to recover from exposure to the elements.

The Alta Via 1 Trek can be done in six, seven or ten days, depending on the stages you undertake, and covers a distance of between 70 and 150 kilometres (44 and 93 miles). The full route starts at Lake Braies in the north and ends in Belluno in the south. From here you can easily reach the Adriatic Sea, should you feel like squeezing your well-trained hiking body in between the sun-worshippers to go for a dip. However, a tanning session on the beach is no rival to this trek, which takes you through some of the most beautiful scenery in Italy, and makes you feel dwarfed by some of the Dolomite's most impressive and pointy peaks, such as the Lagazuoi, Tofane, Pelmo and, most famously, the Civetta. From the high point of 2,752 metres (9,029 feet) at Monte Lagazuoi, you can watch the sun set on the biggest rock faces of the Dolomites, with the impressive Cinque Torri, (meaning five towers) right in front of you.

The paths of this trek are laced with an air of remembrance: Their historic routes take you back in time as they lead through a number of tunnels (built as hideouts) and secret pathways used in World War I. The ruins of some of these most brutal of battlegrounds have become a distinct, sombre and integral part of these paths.

Some of the trek is equipped with cables, allowing even the relatively inexperienced hiker to explore the rocky hillsides and find out what it feels like to look down a sheer face from the safety of a steel rope. If you prefer pretty pastures over ragged rock, don't give up, as you can be back in the rolling green and gentle hills in no time. There is hardly another place in the world where green meadows, charming pastures, rough rocky faces and imposing peaks are as close together as in the Dolomites.

LEFT

ALTA VIA 1: DRAMATIC ROCK FORMATIONS ON TOP OF COL REAN NEAR REFUGIO ATTILO TISSI.

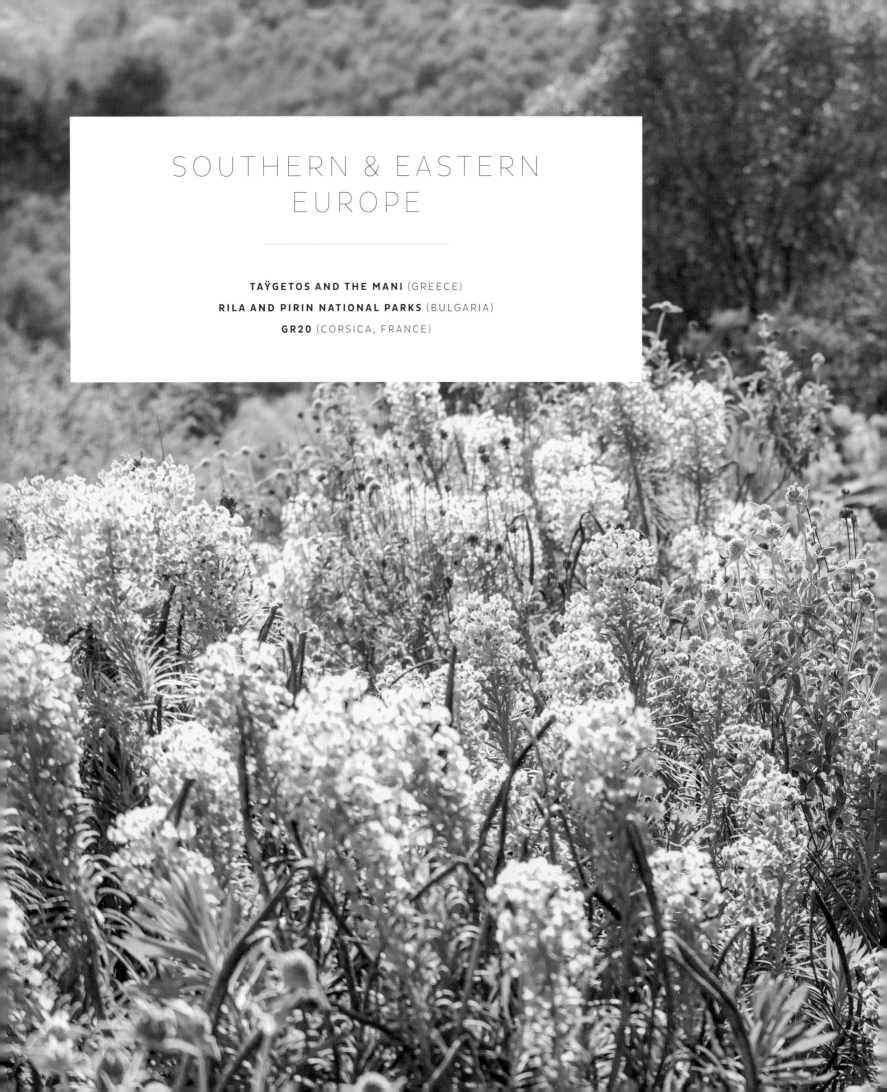

SOUTHERN & EASTERN EUROPE

TAŸGETOS AND THE MANI (GREECE)

RILA AND PIRIN NATIONAL PARKS (BULGARIA)

GR20 (CORSICA, FRANCE)

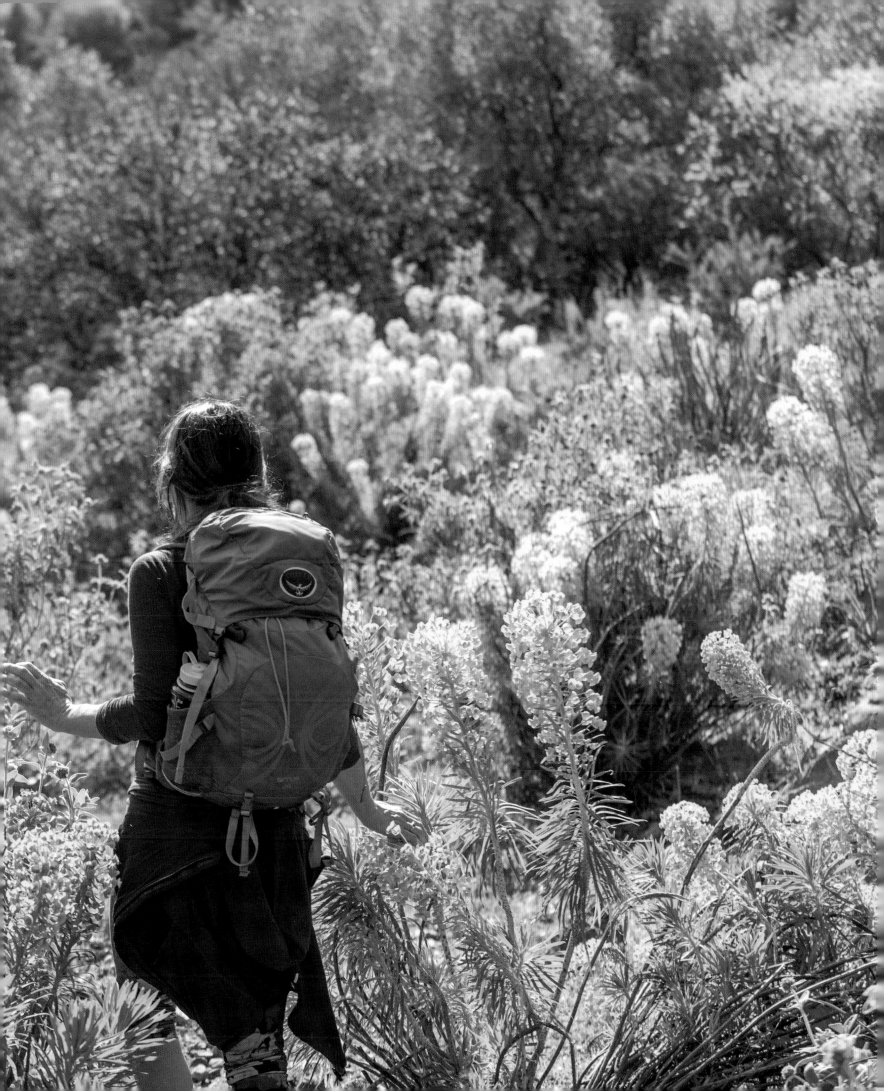

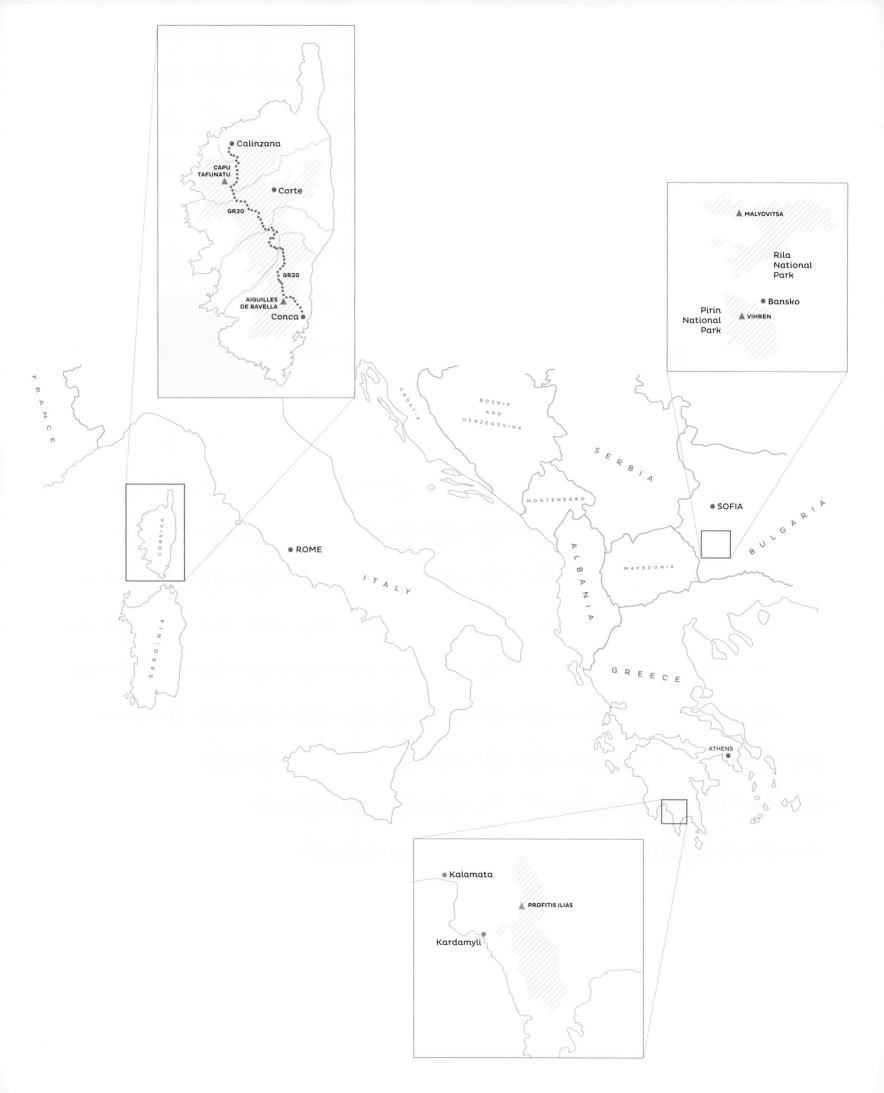

Calinzana

CAPU
TAFUNATU

Corte

GR20

GR20

AIGUILLES
DE BAVELLA

Conca

FRANCE

CROATIA

BOSNIA
AND
HERZEGOVINA

SERBIA

MONTENEGRO

ALBANIA

MACEDONIA

BULGARIA

SOFIA

MALYOVITSA

Rila
National
Park

Bansko

Pirin
National
Park

VIHREN

CORSICA

ROME

ITALY

SARDINIA

GREECE

ATHENS

Kalamata

PROFITIS ILIAS

Kardamyli

Southern & Eastern Europe

From the princely Balkan Mountains, where bears and wolves still roam, to the dry coasts of much mythologised Greece, this large and much underrated walking region of Europe offers delightfully varied and hugely attractive trekking. Loosely understood as the Balkans – Albania, Bosnia and Herzegovina, Bulgaria, Croatia, Kosovo, Macedonia, Montenegro, Romania, Serbia and Slovenia – plus Greece and Turkey, southern and eastern Europe may not have the Alps or Pyrenees; but they still have a whole load going for them, often without the crowds that flock to other hiking destinations.

Think jagged granite spires, sheep grazing in Alpine meadows, huge canyons and gorges, ancient forests, curvy coastlines and welcoming villages. The region is wonderfully remote, though tourist infrastructure is decent, with a surprising number of guiding companies.

The word 'Balkan' originates from Ottoman Turkish, meaning 'a chain of wooded mountains', and, wonderfully, most of the region is covered by peaks: the Balkan Mountains (from the Black Sea coast in Bulgaria to Serbia); the Rhodope Mountains (southern Bulgaria and northern Greece); the Dinaric Alps (Bosnia and Herzegovina, Croatia and Montenegro); the Šar massif (from Albania to Macedonia); the Pindus range (from southern Albania into central Greece); and the Albanian Alps. The highest point of the Balkans is Mount Musala at 2,925 metres (9,596 feet) in Bulgaria's Rila mountain range (see page 97).

The 192-kilometre (120-mile) Peaks of the Balkans circuit is one of several enticing options. The trail loops through the mountains of northern Albania, eastern Kosovo and southern Montenegro, and includes turquoise glaciers, huge lakes and the likelihood of staying with local families in villages along the way.

ABOVE

RILA AND PIRIN NATIONAL PARKS: LOOKING SOUTHWARDS FROM A HIGH POINT IN THE MALYOVITSA VALLEY IN THE RILA MOUNTAINS.

PREVIOUS PAGES

TAŸGETOS AND THE MANI: THE MANI PENINSULA LIES IN THE PELOPONNESE REGION OF GREECE.

The more ambitious trekker might consider the 1,930-kilometre (1,200-mile) Via Dinarica hiking trail, which traverses eight countries and the Dinaric Alps and Shar ranges, mostly via ancient trading and military routes. In 2017, National Geographic's *Traveller* magazine labelled the trail a 'Best of the World' destination, noting that you can 'sleep in remote mountain shelters along the Adriatic Sea, atop the region's highest peaks and above the continent's deepest gorge.'

The path is a cultural experience, too, where walkers can find themselves lost in old-world traditions uncovered after five decades of communism, during homestay layovers in nomadic shepherd settlements and isolated, but hospitable, villages.

On Turkey's famous 509-kilometre (316-mile) Lycian Way, the urge to jump into the Aegean Sea is huge. As the trail runs along the Teke Peninsula into the Mediterranean on Turkey's south coast, it regularly entwines with the sea via many a tempting cove or lagoon, while in between are dramatic limestone cliffs, pine forests and characterful villages.

The Lycian Way's popularity has inspired other, new, long-distance routes across the country. For many of these a lack of quality walking maps brings the excitement of discovery.

The Istiklal, or Independence Trail, follows an undulating and remote route used by liberating armies in Turkey's 1919 War of Independence, close to the Black Sea. The spectacular 500-kilometre (310-mile) St Paul Trail weaves through the high Taurus Mountains and connects Roman cities in south-central Turkey that were visited by St Paul. In northeast Turkey, the Kaçkar trails form a trail network through the mountains, some traversing the regal glaciated Kaçkar range, which reaches nearly 4,000 metres (13,200 feet).

Greece is a walker's daydream. Almost 80 per cent of it is covered with hills and mountains, plus reams of spectacular coastlines steeped in unrivalled ancient history and mythology. Some will enjoy climbing Greece's most famous and highest mountain, Mount Olympus at 2,917 metres (9,570 feet), mythical home of the Greek gods, on an 18-kilometre (11-mile) hike.

In Greece's northwest, the mysterious and appealing Zagorohoria region's 46 traditional stone-and-slate villages pepper the Pindos range, which also contains Greece's second-highest peak, Mount Smolikas, at 2,637 metres (8,652 feet). Hikers come here for the mountainous routes, as well as the dramatic Vikos Gorge – at 12 kilometres (7.5 miles) long and 900 metres (3,000 feet) deep, it bisects Zagorohoria.

Hiking on the islands can be particularly satisfying – Crete, Andros, Naxos, Tilos, Nisyros, Paxi and Ithaki all have reasons to visit. Other inviting trails include Meteora (zigzag through rocky monastery-topped spires, caves and obelisks) and the lushly forested Pelion Peninsula, with a centuries-old network that connects quaint mountain hamlets to seaside villages. Elsewhere, some routes are barely more than an overgrown sheep's path (a preferred style of trekking for some), but well-established companies offer guiding options. Spring (April to May) is the best time for hiking in Greece, when the landscape is green and fresh from winter rains, and carpeted in wildflowers.

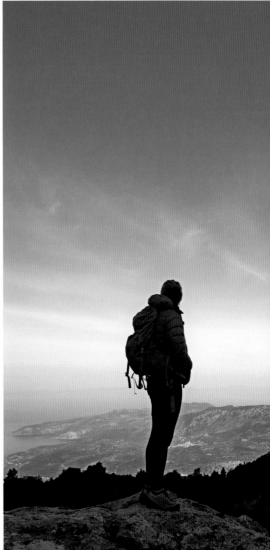

OVERLEAF

TAŸGETOS AND THE MANI: HIKING IN
THE TAŸGETOS MOUNTAINS ON THE
MANI PENINSULA IN THE PELOPONNESE
IN GREECE.

OPPOSITE

TAŸGETOS AND THE MANI.

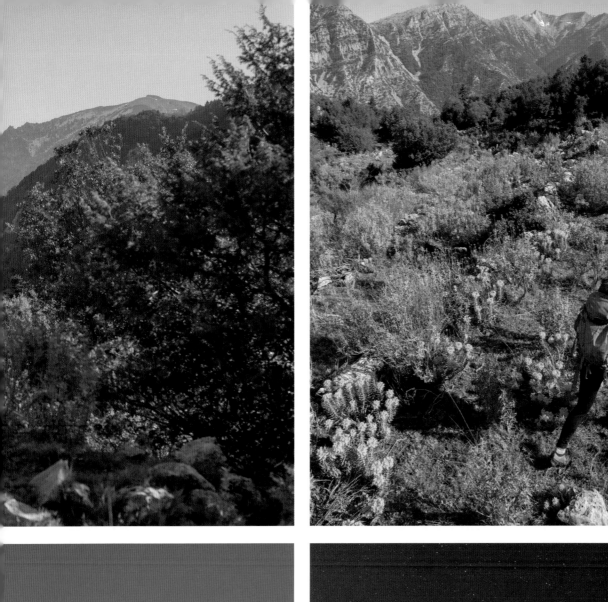
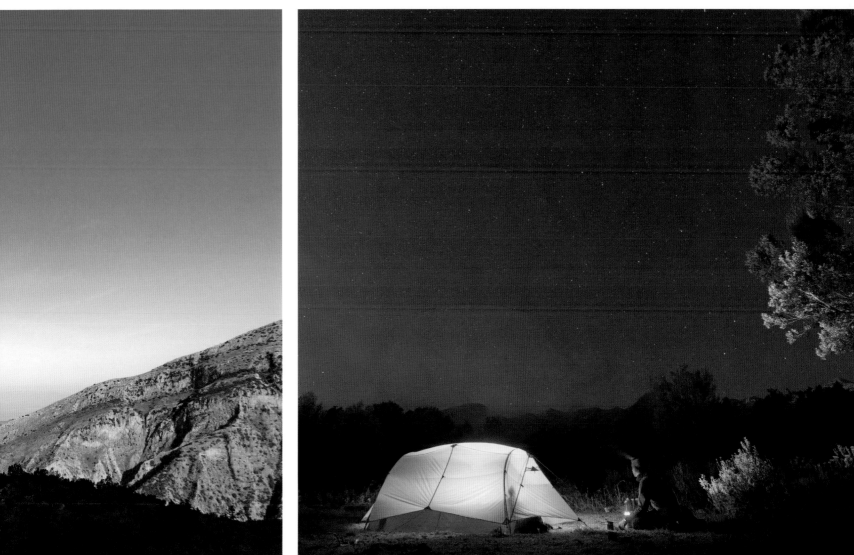

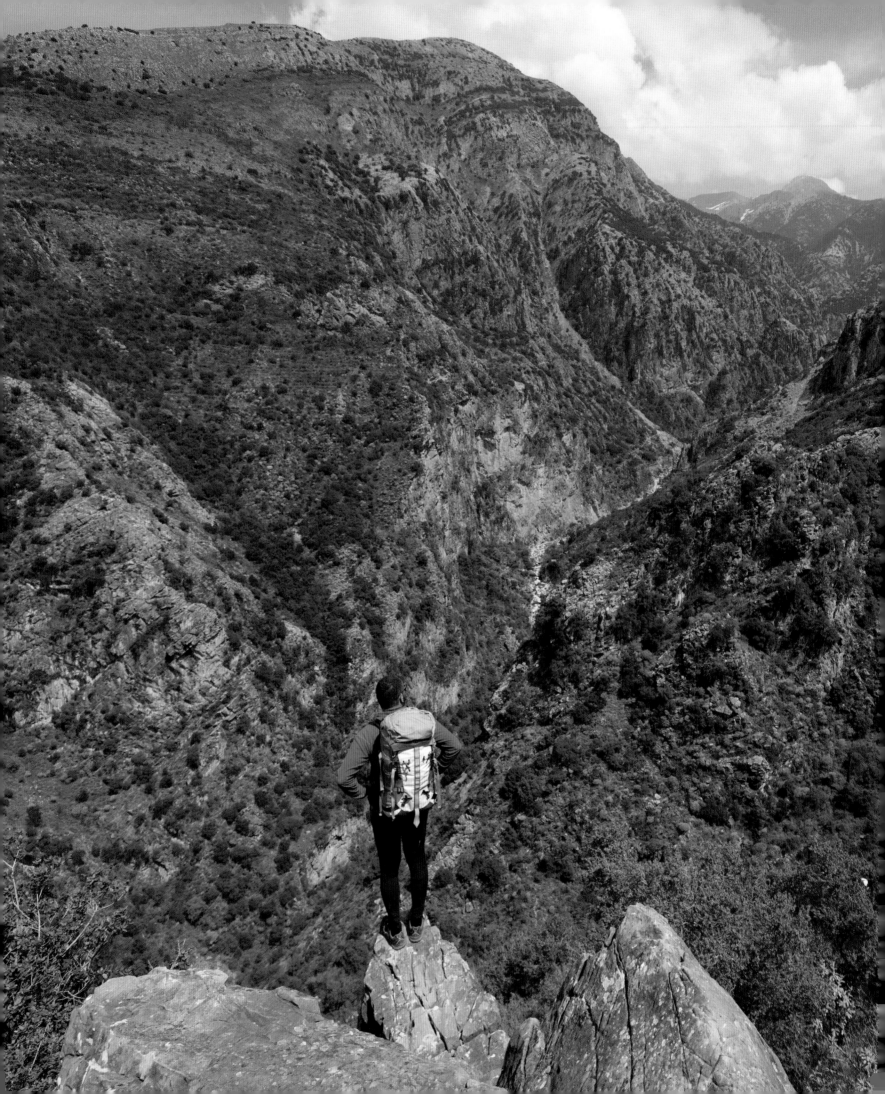

TAŸGETOS AND THE MANI
GREECE

The word 'Taÿgetos' (or 'Teÿgetus') is one of the oldest recorded in Homer's Europe, appearing in *Odyssey* and in classical mythology, where it is associated with the nymph Taygete. Nowadays, the name is shared by both the 100-kilometre (62-mile) range that forms the backbone of the Peloponnese's central-southern peninsula and the range's highest peak (also known as Prophet Elias/Profitis Ilias), at 2,404 metres (7,887 feet).

The snow-topped Taÿgetos mountains form a wonderfully wild and harsh, broken-limestone range, rising sharply from steep foothills peppered with gorges. The hub of Taÿgetos is the serrated Pendadhaktilo Ridge, which resembles five knuckles, with peaks over 2,000 metres (6,500 feet) including the totemic, often snow-topped pyramid of Mount Taÿgetos. The range gradually lowers as it approaches Cape Tainaron (Matapan), before finally sliding into the Aegean Sea. The slopes are covered in attractive scrub and forests, terracing and olive groves but, more famously, flamboyant spreads of wildflowers in spring.

The Taÿgetos range separates the northern, or outer, Mani from the inner Mani, and the challenging heights have historically helped keep the region relatively isolated. The area is a place of pristine coastal coves and villages snuggled in olive groves; while abandoned stone towers scatter the arid, delightfully unexplored scenery. The pleasing cacophony of birdsong is a regular soundtrack here as the area is on migratory routes. Wild boar are snuffling about, too.

Mani's inhabitants are fiercely independent. They did not convert to Christianity until the ninth century and remained effectively outside the control of the Ottoman empire. Their quiet villages are spread across the foothills and middle slopes, linked by a network of *kalderimi* (old, paved mule tracks). Nowadays, they make for glorious walking – the region is spiderwebbed by footpaths.

The E4 (European Long Distance Path) runs along the eastern slopes, from Mystras to Ghythio, on the middle-to-upper slopes for much of the time. It is both a top-notch multiday hike, or, if you prefer, a collection of excellent day hikes. The high ridge itself is only accessible from May to October (unless you are happy on snow). Be prepared for all weathers all year round.

The Pendadhaktilo Ridge is the centre of the range and presents a demanding hike. It can be done in two days (with transport to roadheads), but four are ideal, as it would be a shame to miss the picturesque walk in.

The 2,407-metre (7,897-foot) -high Mount Taÿgetos, or 'The imperious mountain of ancient Sparta', is a tough slog (some 900 metres/2,950 feet of climb) on rough terrain, but on a choice of several beautiful, well-signed hiking routes, via pretty mountain villages, streams and stone bridges.

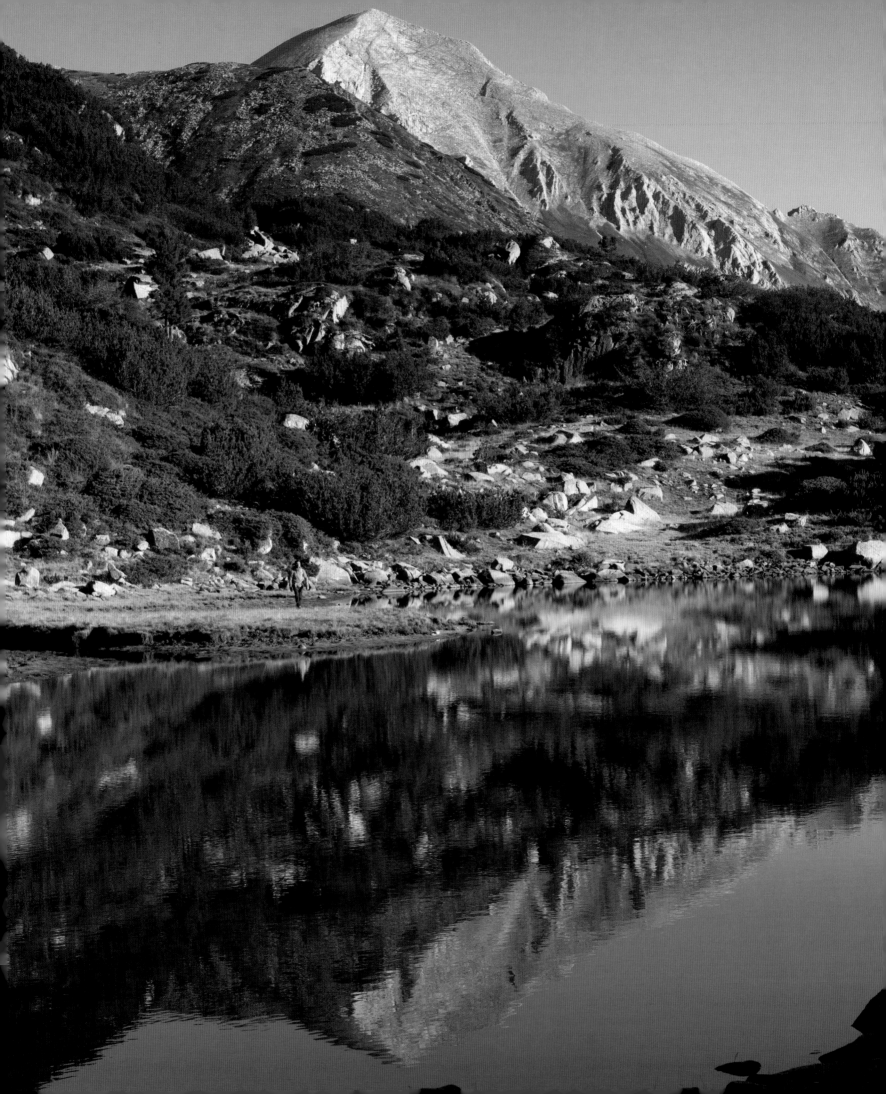

RILA AND PIRIN NATIONAL PARKS
BULGARIA

Few places in the world have as extensive a network of easily accessible trails in such a rugged alpine landscape, and with such a relatively small number of foreign visitors, as southwest Bulgaria. It's a veritable trekking wonderland. One of the most pristine and picturesque natural wild spaces left in Europe, the Rila and Pirin mountain ranges that dominate this region consist mainly of two massive national parks that go by the same names as the ranges they occupy.

The two parks of Rila and Pirin contain no permanent human settlements and are home to the highest peaks on the Balkan Peninsula, including 2,914-metre (9,560-foot) Mount Vihren in the Pirin Mountains and 2,925-metre (9,596-foot) Mount Musala in the Rila range.

Surrounding these two massive peaks is a nearly continuous 5,000-square kilometre (1,930-square mile) wilderness area that contains hundreds of gin-clear glacial lakes, mineral springs, thunderous waterfalls, snow-covered ridges and a seemingly endless expanse of dense, old-growth coniferous forests; all of which are largely connected by well-accommodated huts and a well-maintained road system. With an average elevation of just over 1,500 metres (4,920 feet), the mountains here aren't as tall as their more popular towering cousins to the north – the Caucasus, Alps and the Pyrenees; however, they're just as stunning, if not more so, and far less crowded.

The Seven Rila Lakes trek can be done in a matter of hours, and meanders along a series of ice-cold glacial lakes that are so far above the treeline, that it seems as if it should have taken days to get there. However, the nearest hotel is less than 5 kilometres (3 miles) away from the trailhead.

The Rila Mountain's Scary Lake – also known as the Amphitheatre of Thunder – sits serenely at 2,465 metres (8,087 feet) above sea level, but can be accessed in three hours from the nearby Malyovitsa Ski Centre. In the Pirin Mountains, the Koncheto Ridge is only 400 metres (437 yards) long, but is situated between the range's second- and third-highest peaks – Kutelo and Banski Suhodol – and is only a metre wide in places, offering adventurous day-hikers a chance to experience real and consequential high-altitude exposure, just from wandering a few hours away from the nearest carpark.

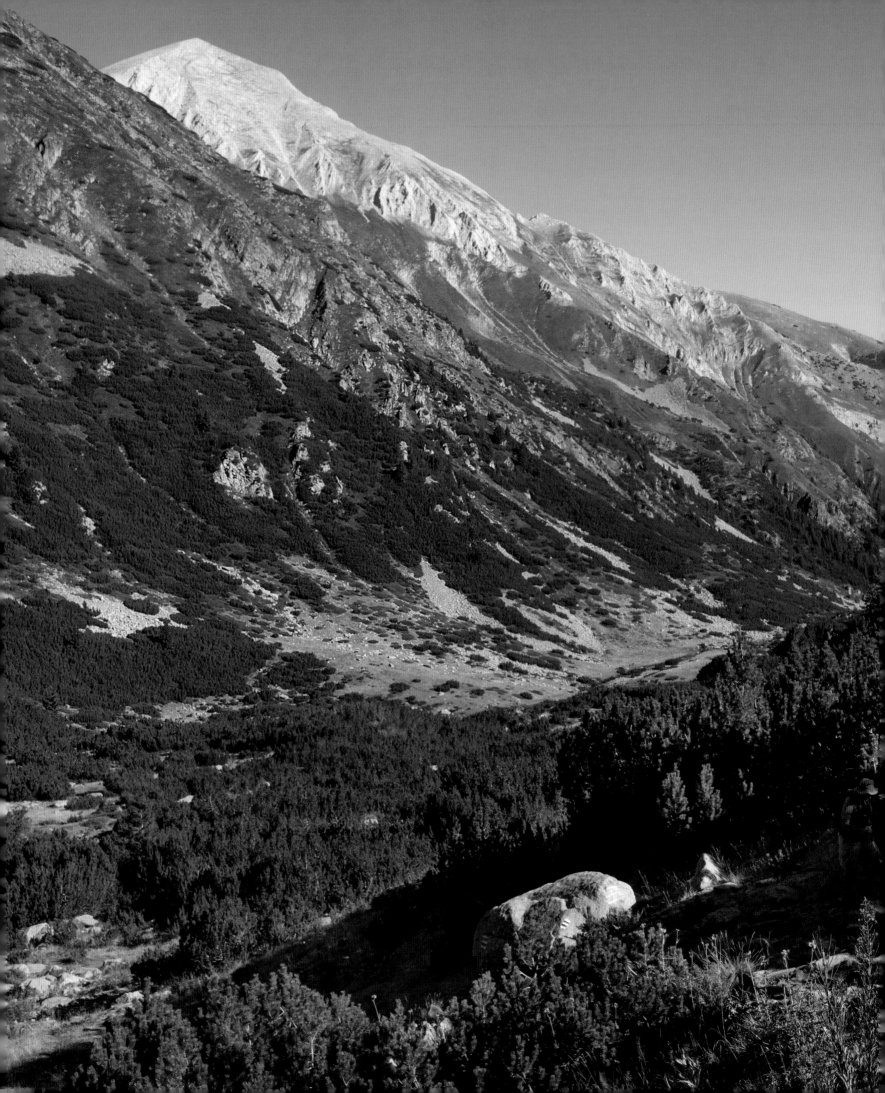

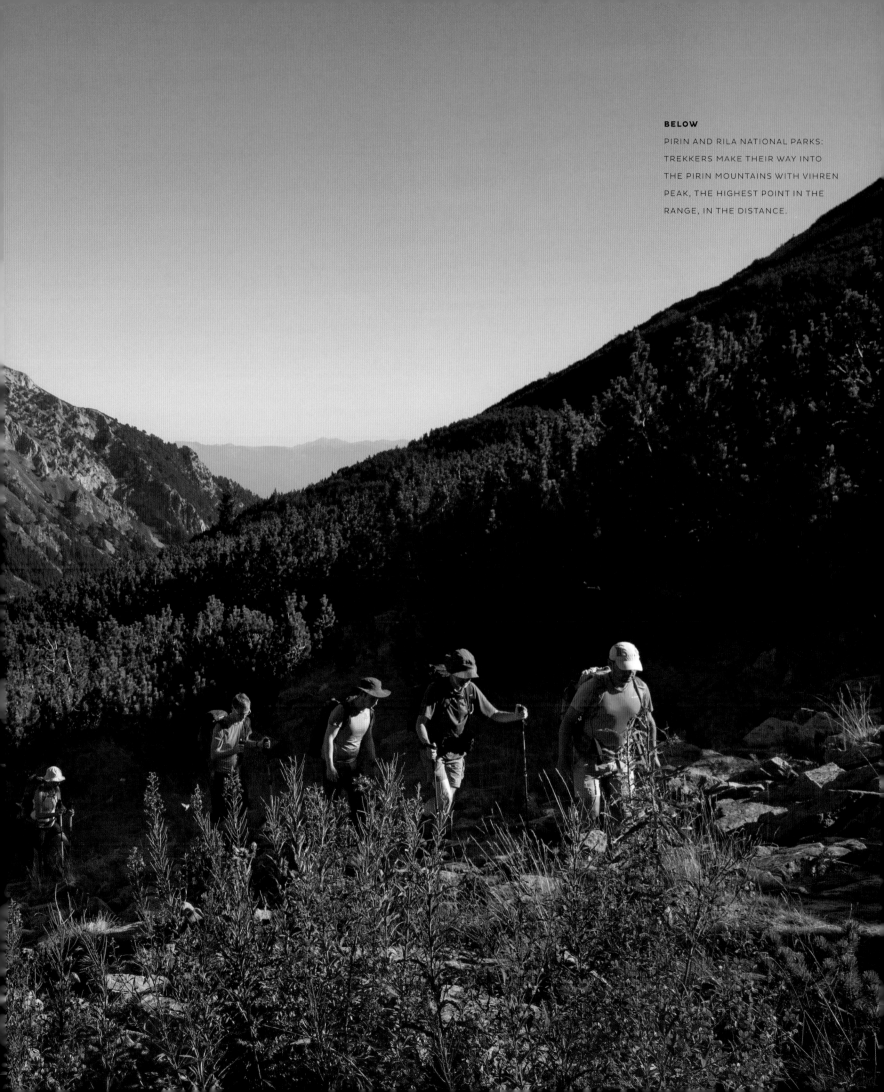

BELOW
PIRIN AND RILA NATIONAL PARKS:
TREKKERS MAKE THEIR WAY INTO
THE PIRIN MOUNTAINS WITH VIHREN
PEAK, THE HIGHEST POINT IN THE
RANGE, IN THE DISTANCE.

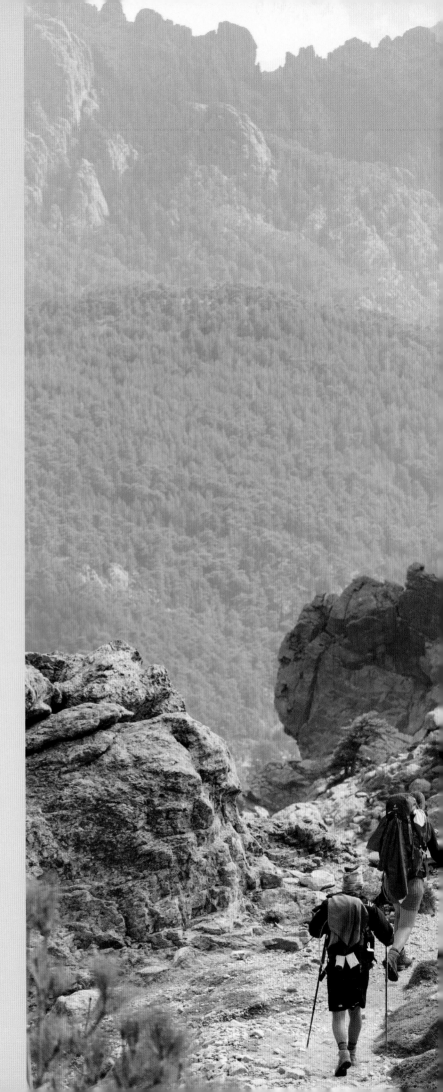

GR20
CORSICA, FRANCE

'In 13 hours of toil, we have yet to encounter a section of flat path that stretches for more than 10 metres,' wrote *We Could Be Heroes* author Tom Fordyce in Britain's *The Guardian* newspaper. 'Only rarely have we encountered a path at all.' With a reputation as Europe's toughest long-distance trail, the GR20 is a 180-kilometre (110-mile) route along Corsica's rugged north–south spine. With 13,000 metres (43,000 feet) of vertical gain, the gruelling path is split into 17 segments, it takes most hikers at least two weeks to complete the trek.

The route demands some scrabbling in challenging boulder fields, vertiginous scree slopes and precipitous rock faces, though the effort is rewarded with astounding panoramic views. In June 2016, three-time Ultra Trail du Mont Blanc winner François D'Haene set a fastest-known time (FKT) for the GR20, of 31 hours and six minutes. Anything is possible, though not always advisable.

The northern part of the GR20 – or 'Jhay Air Vang', as locals pronounce it – is considered a difficult part of this trek, because of the steep and rocky terrain. Dizzying climbs rise through dense maquis forest and larico pines, past shepherds' huts and hoofprints left by wild boar, up through the coastal clouds and the silent, enormous granite lumps. Going south, the landscape gradually softens to a succession of lush oak forests and rolling pastures, which, conversely, make the going harder, with soaring temperatures in summer. Vizzavona is considered the middle of the trek, as there is a train station – an accessible point for walkers doing a half GR20.

The Cirque de la Solitude is the most notorious section. After 800 metres (2,600 feet) of rope-free climbing, there are 300 metres (1,000 feet) of straight descent – down a sheer rockface, with little trace of a path. There is little but the occasional jutting outcrop between you and the valley floor 1,200 metres (4,000 feet) below.

Scenically set but rudimentary mountain huts (*refuges* or *gîtes*) dot the route, and camping is possible here. In winter, GR20 is impassable due to snow; in high summer, it can be sweltering, so locals recommend late June to early September for the best hiking weather.

'For all the tribulations, the rewards are remarkable,' concluded Fordyce. 'The terrain is like nothing else in Europe.' Many reward themselves with rock-pool bathing as a much welcome end-of-day activity.

RIGHT

GR20: TREKKING NEAR THE AIGUILLES DE
BAVELLA TOWARDS REFUGE D'ASINAU.

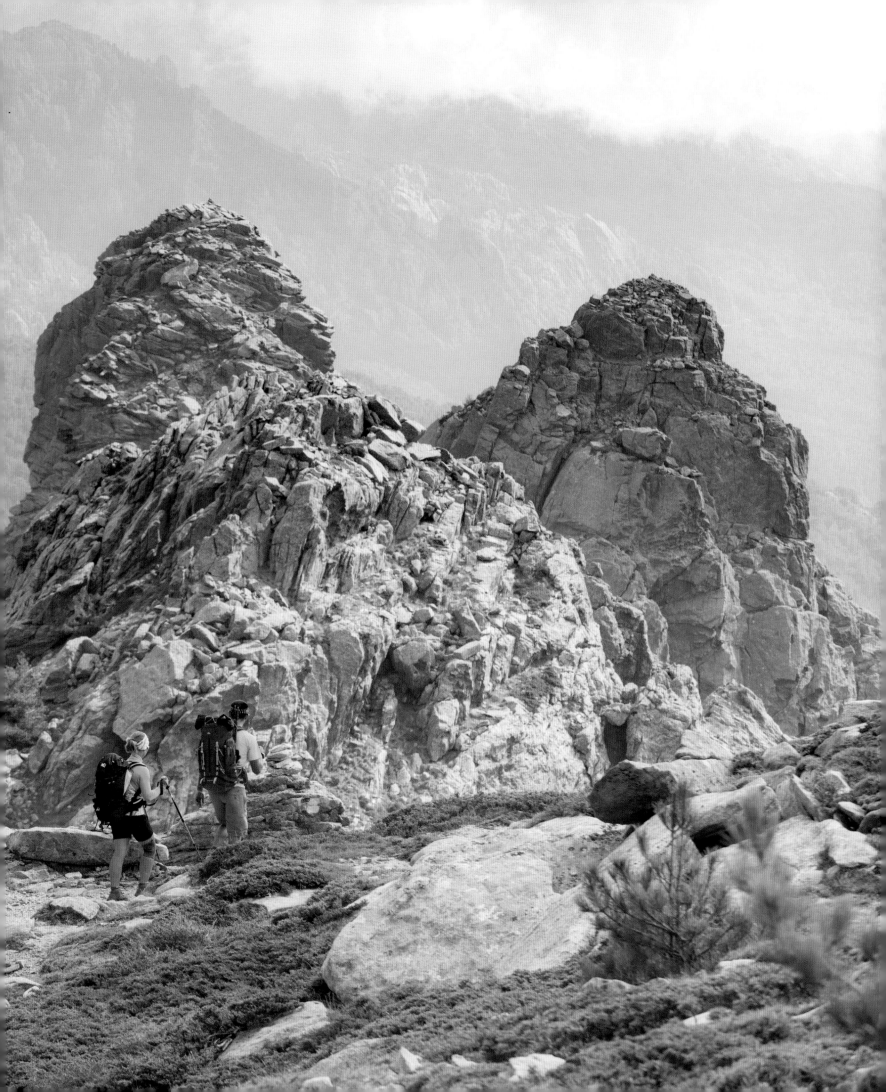

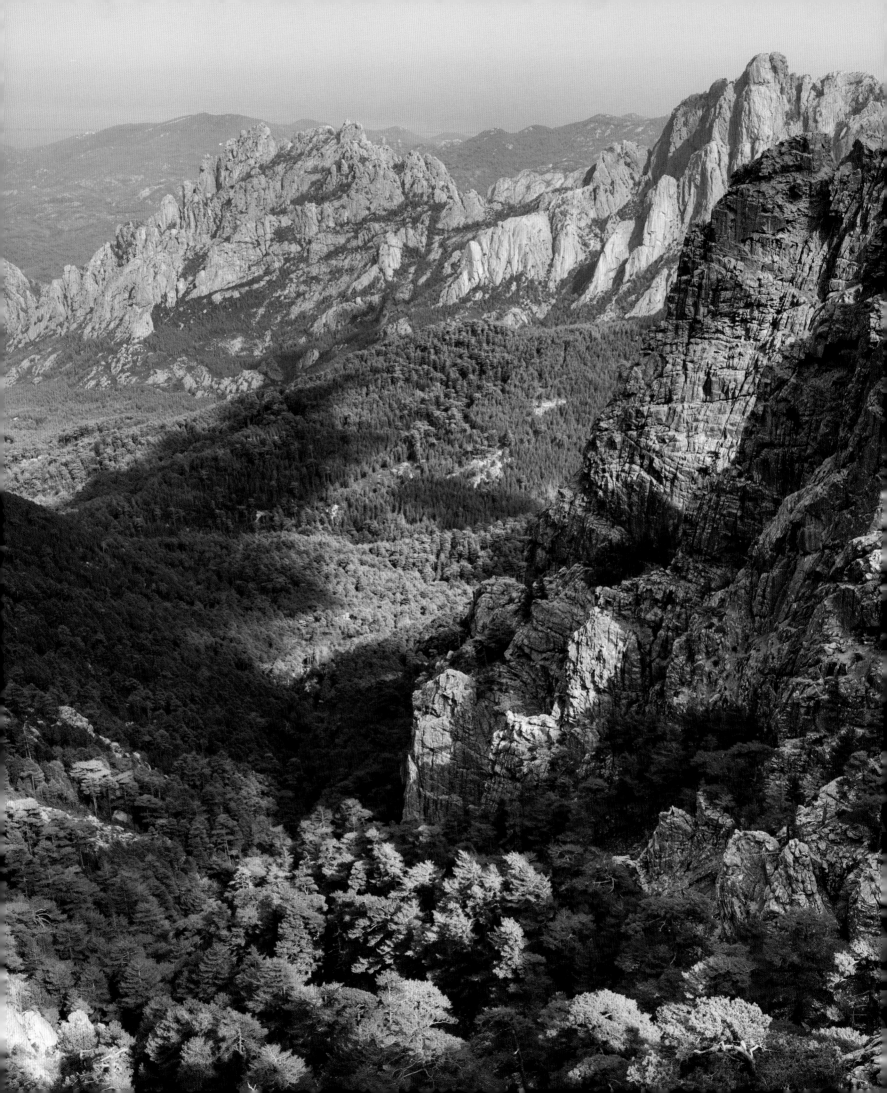

LEFT

GR20: NEAR THE AIGUILLES DE
BAVELLA.

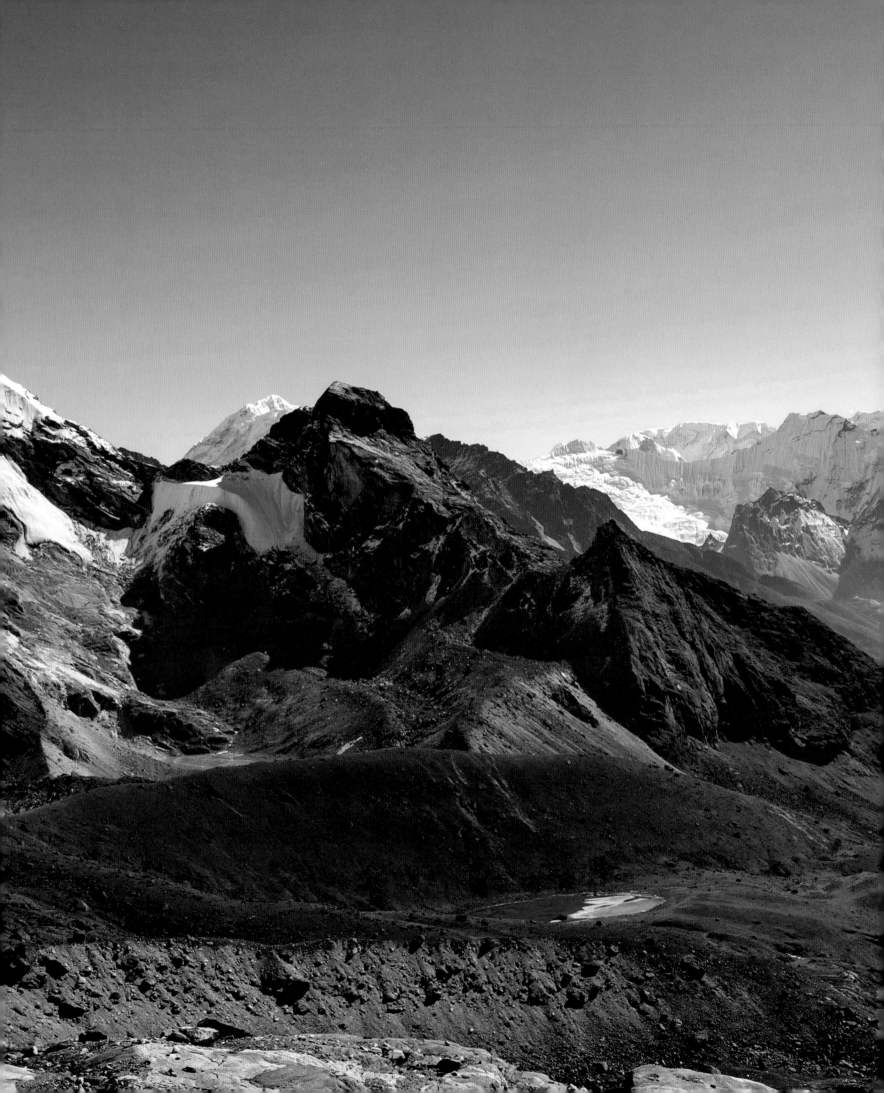

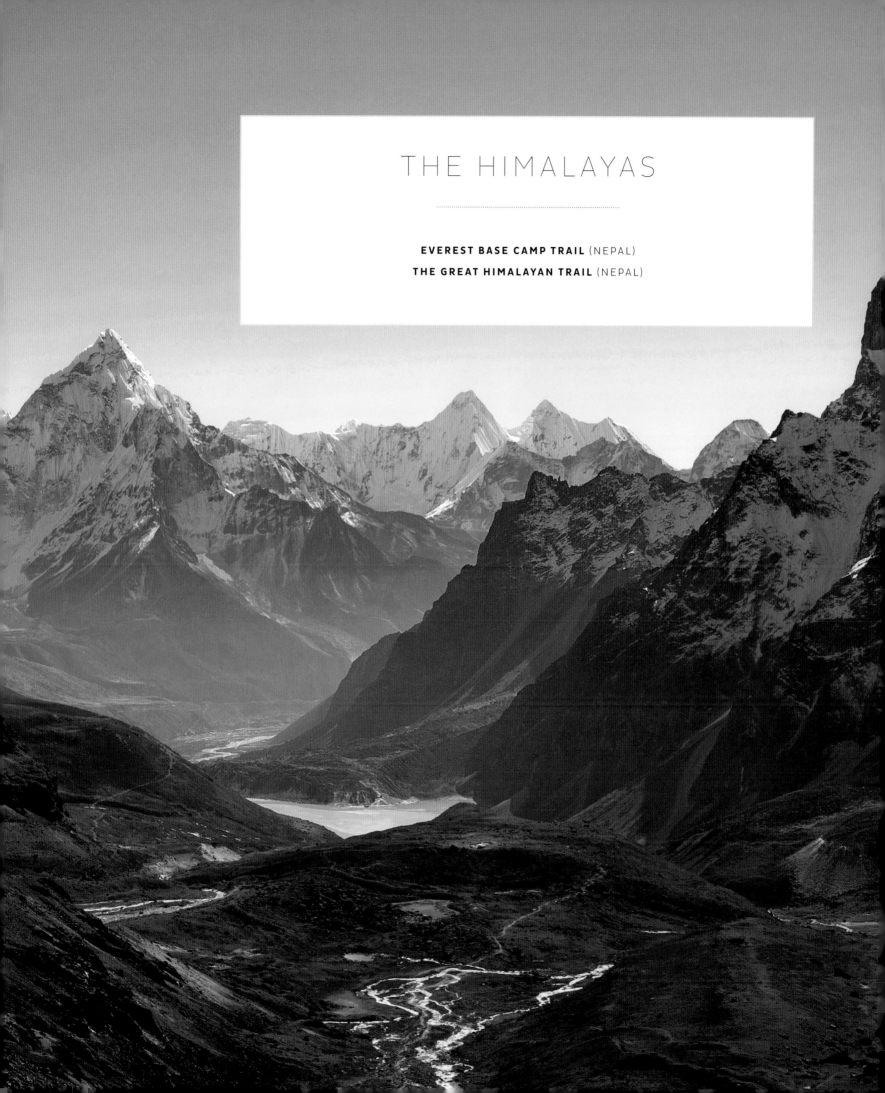

THE HIMALAYAS

EVEREST BASE CAMP TRAIL (NEPAL)

THE GREAT HIMALAYAN TRAIL (NEPAL)

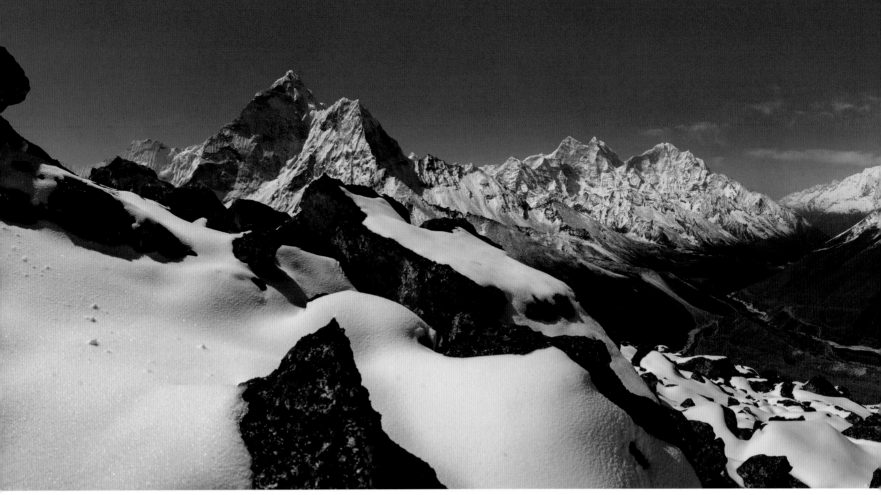

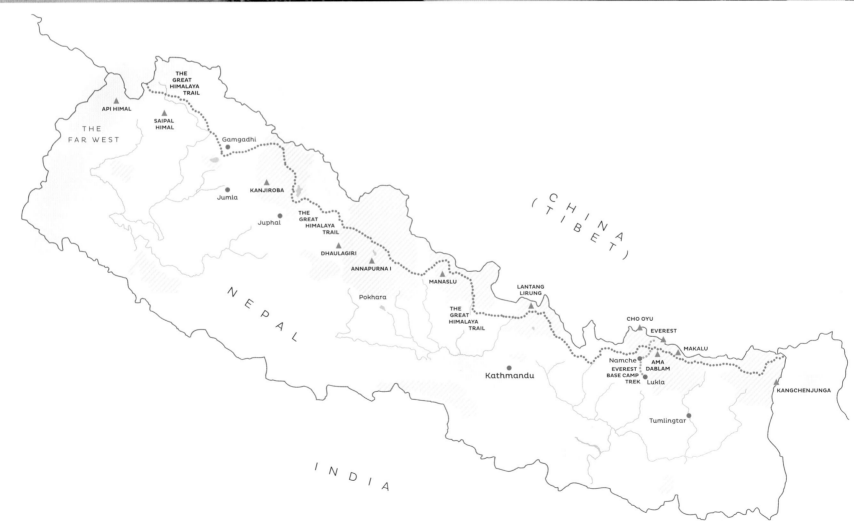

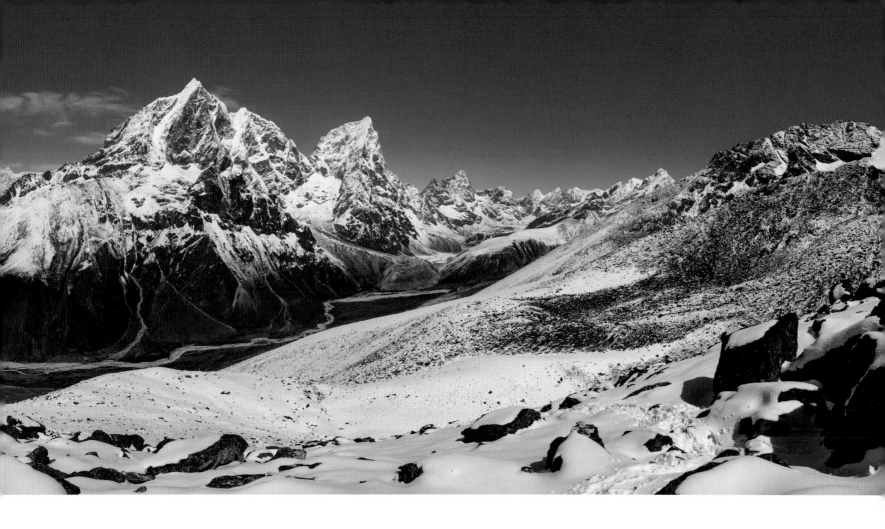

The Himalayas

Home to the tallest peaks on Earth, the sheer beauty and size of the Himalayan giants leave most trekkers breathless, and that's not only because of the oxygen-deprived air of the higher elevations. This truly epic region, home to many villages, is a highly spiritual place. Buddhist prayer wheels and flags line the trails, and their distinct colours have become as much a part of the trek as the stunningly beautiful snow-capped mountains. According to a Hindu saying, you could not do justice to the Himalayas in 'a hundred ages of the gods', which makes it hard to imagine where we mere mortals should start.

Stretching over 2,400 kilometres (1,490 miles) and passing through territory in Nepal, Pakistan, India, China and Bhutan, the Himalayas are twice as long as the Alps, and host mountains almost twice the size of Mont Blanc. At 8,848 metres (29,029 feet), the tallest peak in the world, Mount Everest, nestles on the border between Nepal and Tibet, and has been centre stage of many mythologies, legends, sightings of mystical creatures and incredible feats – as well as tragedies – since the first explorers visited its flanks as early as the 19th century.

In 1854, the adventurous geologists and cartographers, the German Schlagintweit brothers mapped the region and researched the glaciers of the Himalayas – an incredible feat given the technology of the era. Back then, Nepal's borders were still closed to outsiders, forcing the brothers to remain in India for their research. The same applied to the early reconnaissance expeditions to Mount Everest with the 1920s British expeditions all exploring Chomolungma, its Buddhist name meaning 'Mother Goddess of the Earth', from its northern flanks in Tibet.

It was not until 1951 that Nepal opened its borders and foreigners started to scrutinise the world's highest mountain from the south. After the Swiss almost got to the summit, reaching 8,580 metres (28,150 feet) in 1952, a British expedition led by Sir John Hunt put New Zealander Edmund Hillary and Tenzing Norgay on the top on 29 May 1953. This opened the gates to Everest and the surrounding region. Commercial trekking kicked off about ten years later, when British Colonel Jimmy Roberts set up the first trekking agency in Nepal in 1964. He found that the two climbing seasons, April/May before the monsoon and October/ November in the post-monsoon period, not only offered great opportunities for climbers, but also gave trekkers the chance to hike along the myriad paths that cross the mighty Himalayan mountains.

Even though the other Himalayan countries all have something unique to offer, Nepal, hosting eight of the fourteen 8,000-metre (26,247-foot) peaks is still the most popular choice. With its relatively small size of 800 by 200 kilometres (500 by 125 miles) horizontally, its vertical difference is unrivalled: going from 150 metres (490 feet) in the west up to 8,848 metres (29,029 feet) in the east. Hiking through the high elevations of this landlocked country brings splendid views and also introduces a myriad of mountain cultures. On a typical trek, you stay in simple but cosy teahouses run by Sherpa, Gurung, Tamang, Rai or any other of the dozens of ethnic groups inhabiting the mountains.

The Langtang Trail is probably one of the most imposing of Nepal's routes. The 7,000-metre (23,000-feet) peaks straddling the trail majestically dominate your view, and

the route is a fierce test on legs, feet and lungs. The lower treks, hovering at an altitude of about 2,000 metres (6,560 feet) – such as the Royal Trek, which received its name after Prince Charles completed a four-day hike in 1980 – are not quite as demanding; however, they give you a good sense of Himalayan trekking. Here you can capture traditional lifestyles and ancient traditions that have remained unchanged for thousands of years.

The main attraction – and very understandably so – remains the Everest Base Camp Trek. Even though heavily trodden, especially during the spring trekking season, when hundreds of Everest aspirants descend on its trails, the sheer immensity of some of the world's highest mountains never fails to take the breath away from new and returning trekkers. And it is not just the physicality of the rock that makes this incredible spot beautiful; it is also the huge variety of flora and fauna that spreads out in the valleys and scales the mountainsides.

Over the past two decades, other less frequented areas such as the Manaslu Circuit – circumventing the eighth highest peak in the world – or the Kangchenjunga Circuit, meandering along the foot of Earth's third-tallest mountain in the Far East, have undergone huge development efforts, making trekking these less populated routes more comfortable.

A trek in Nepal can be as short as two to three days or, if you manage to have 160 days at your disposal, you can walk the entire length of the country by following the Great Himalayan Trail. Whatever you do, the Himalayas will leave a lasting impression.

ABOVE

THE GREAT HIMALAYAN TRAIL: PRAYER FLAGS ON THE SUMMIT OF PIKEY PEAK.

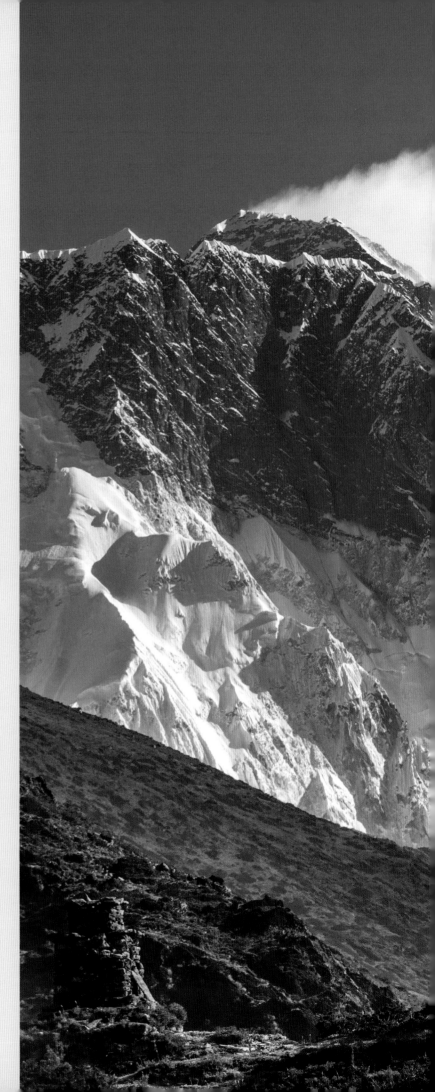

EVEREST BASE CAMP TRAIL
NEPAL

Marking the start of every Everest aspirant's climb to the top of the world, this trek is unbeatable in terms of beauty, history and cultural experience. With their epic first ascent in 1953, mountaineering legends Sir Edmund Hillary and Tenzing Norgay put this mighty mountain on the mountaineer's map, and, to this very day, thousands of people have followed their example. For those unable to financially afford or physically manage such a challenging climb, but are keen to glimpse the roof of the world, trekking to Everest Base Camp has become an achievable goal.

Despite being highly frequented with annual visitor numbers that recently surpassed the 37,000-mark, this trek is a must for those wanting to follow in the footsteps of some of the greatest mountaineers. It takes you along the gigantic flanks of Mount Everest, Lhotse and Makalu – three of the five tallest peaks in the world – and offers you magnificent views of Ama Dablam, also known as the Matterhorn of Asia.

The adventure usually begins when you land in Lukla. Perched on a steep cliff, the 527 metre- (576 yard-) short runway demands the pilot to hit the brakes hard, spin the plane around and get immediately back into take-off position.

The second day promises no less excitement, as the first suspension bridge festooned with prayer flags takes you across the raging Dudh Khosi River, before the path zigzags up to Namche Bazaar. Stop at every left-hand turn and look towards the north, as you could get your first glimpse of Mount Everest here. At 3,400 metres (11,155 feet), the hustle and bustle of the Sherpa capital is certainly a reward for having climbed the notorious Namche Hill. Whether craving a caffè latte or desperately in need of a warm jacket, new boots or an oxygen bottle, you'll find it here. As you hike towards Base Camp the air gradually thins, which is why adopting a slow pace is important, so expect to trek at least eight to nine days to reach the 5,350 metres (17,552 feet) of altitude. The way is lined with Buddhist monuments, such as prayer wheels, shrines, monasteries and, of course, the omnipresent prayer flags flapping in the wind, indicating that you have just reached a high point.

In spring, expect Base Camp to be teeming with aspirational Everest climbers, Sherpa guides and expedition leaders and staff preparing for the summit. However, with autumn no longer being a popular climbing season for the 'big hill' – due to severe weather conditions – you will probably find the camp here deserted in October and November.

RIGHT

A TREKKER ON HIS WAY TO EVEREST BASE CAMP
IN NEPAL. EVEREST IS THE DISTANT PEAK ON THE
LEFT, AND LHOTSE IS ON THE RIGHT.

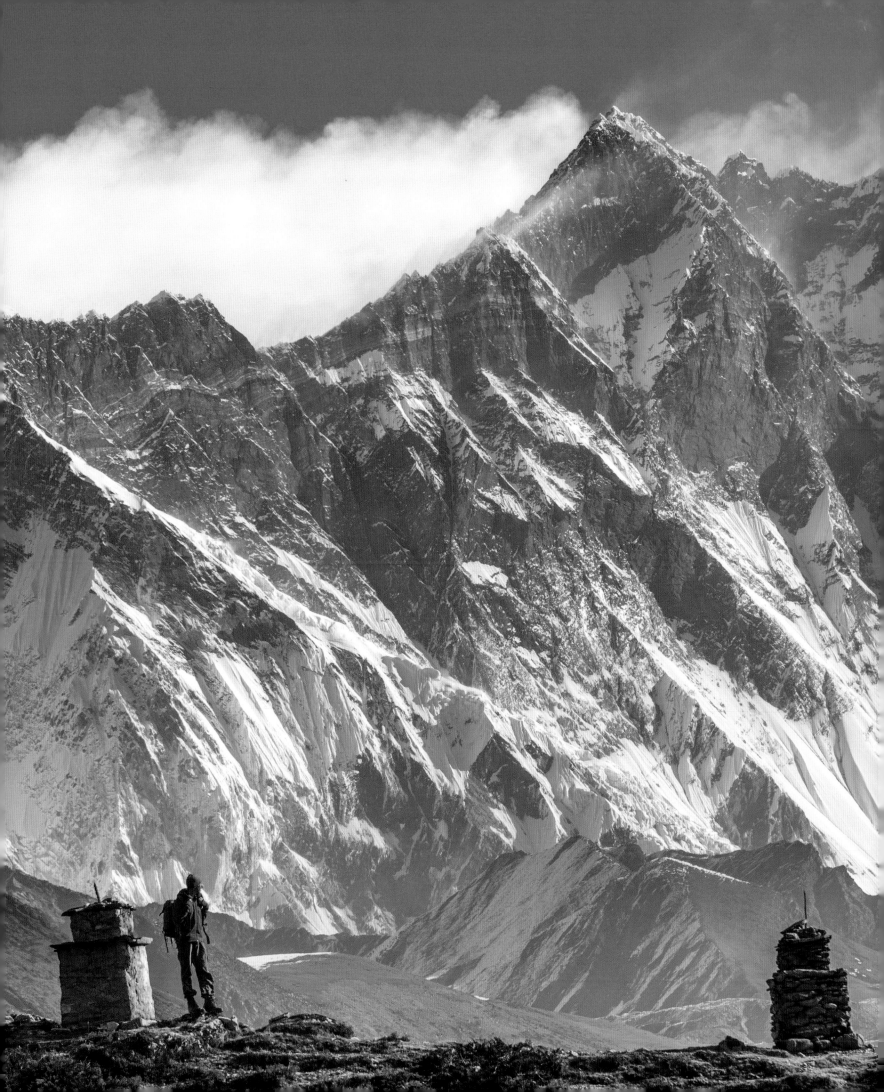

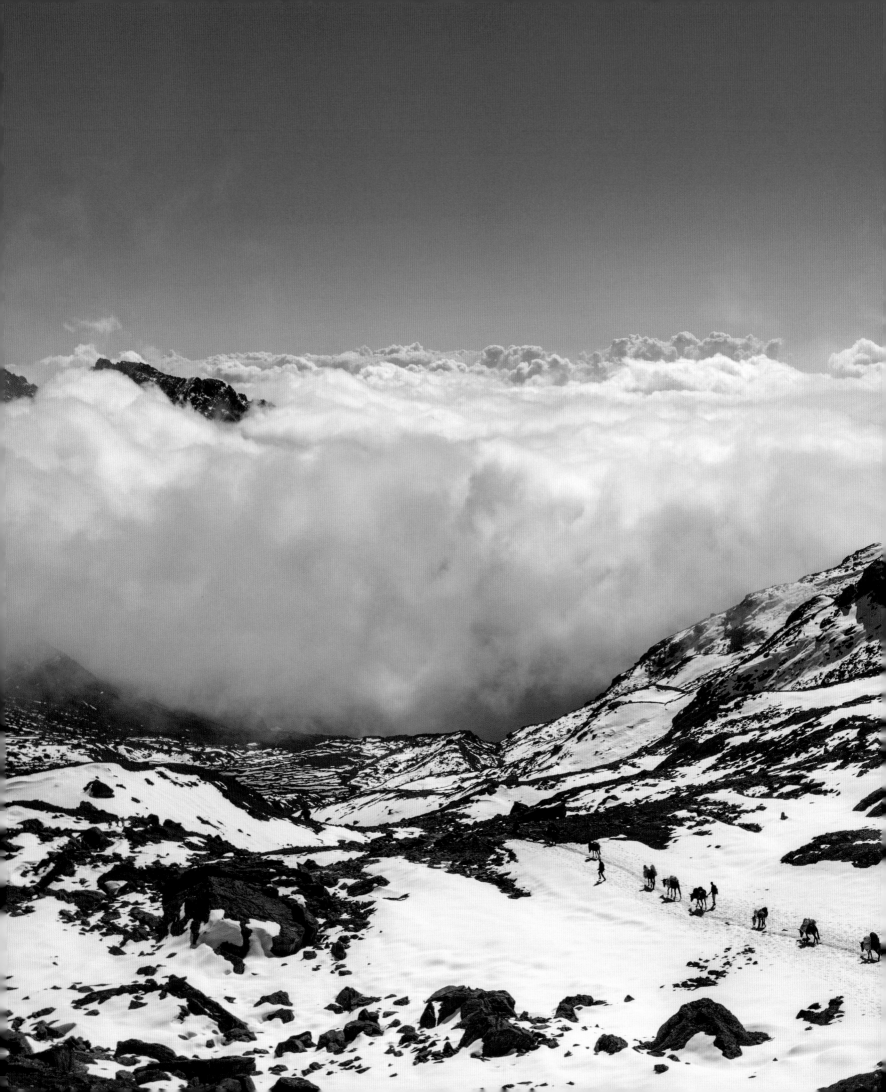

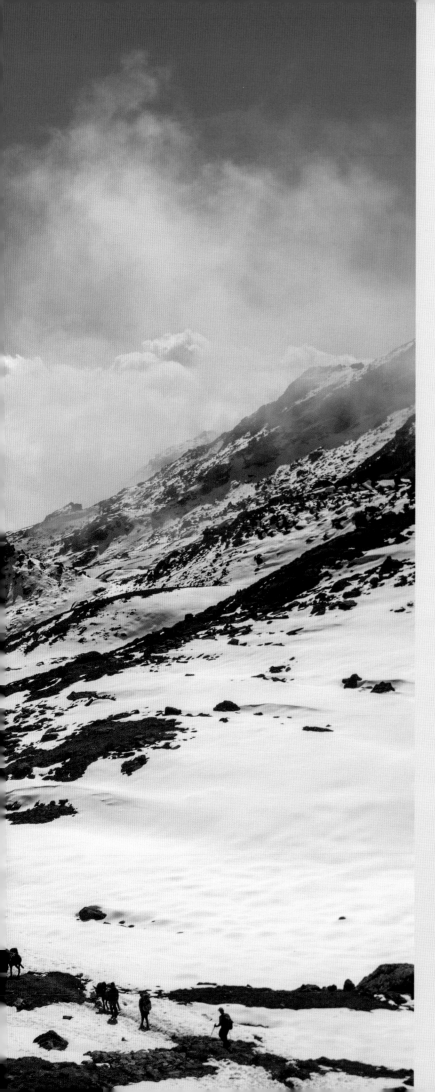

THE GREAT HIMALAYAN TRAIL
NEPAL

The Great Himalayan Trail (GHT) holds the majesty of past and tradition in its every inch. As you trek past the incredible heights of its beautiful mountains, you are guided by a trail that has seen trail herders, traders and pilgrims traverse its tracks for thousands of years.

Stretching over 1,700 kilometres (1,000 miles) across Nepal, the core section of the trek takes a mere 160 days to complete, if done in one go. You walk in the shadows of eight of the world's fourteen 8,000-metre (26,250-feet) peaks, including Mount Everest, and cross passes of over 5,000 metres (16,400 feet) high, ascending a total of 150,000 metres (492,125 feet). And this is only the Nepal section of this epic trail. The entire Himalayan range actually covers a distance of 4,500 kilometres (2,800 miles) and connects the countries of Bhutan, Tibet, Nepal, India and Pakistan. However, as some of the areas along the trail are closed or restricted, the classic GHT focuses on Nepal.

The immense variety, magnitude and sublime grandeur of the regions that the GHT takes you through are impossible to replicate. The trail is also incredibly demanding – something that draws many to its paths and their own personal challenges. The natural passes allow the route to be separated into more manageable chunks, and you can choose anything from meandering through subtropical jungles to braving the higher elevations, which demand more technical skills and glacier travel.

Regardless of which route you decide on, the experience will be unforgettable. If you decide to split the GHT, which officially came into existence in 2009, the treks can be as short as five or six days at low elevations, through to extreme journeys of months at high altitude. However, weather and time restrictions often make trekkers choose areas that bypass technical passes or navigation problem areas.

Those looking for more remote spots simply opt for regions in which tourism has yet to leave its mark – where they can still find the 'Old Nepal'. One such place is the stretch from Mugu to Dolpo in the far west. Edging towards the top of the Nyingma Gyansen Pass gives you the feeling that there is no further you can go on this Earth. A similar sensation is triggered by the Tashi Laptsa Pass in eastern Nepal, its dizzying heights giving you the opportunity to peer down at the many layers of mountains that circle beneath – a vista that seems to have infinity as its subject.

LEFT

PACK PONIES DESCEND THE LAUREBINA LA.

PREVIOUS PAGES

EVEREST BASE CAMP.

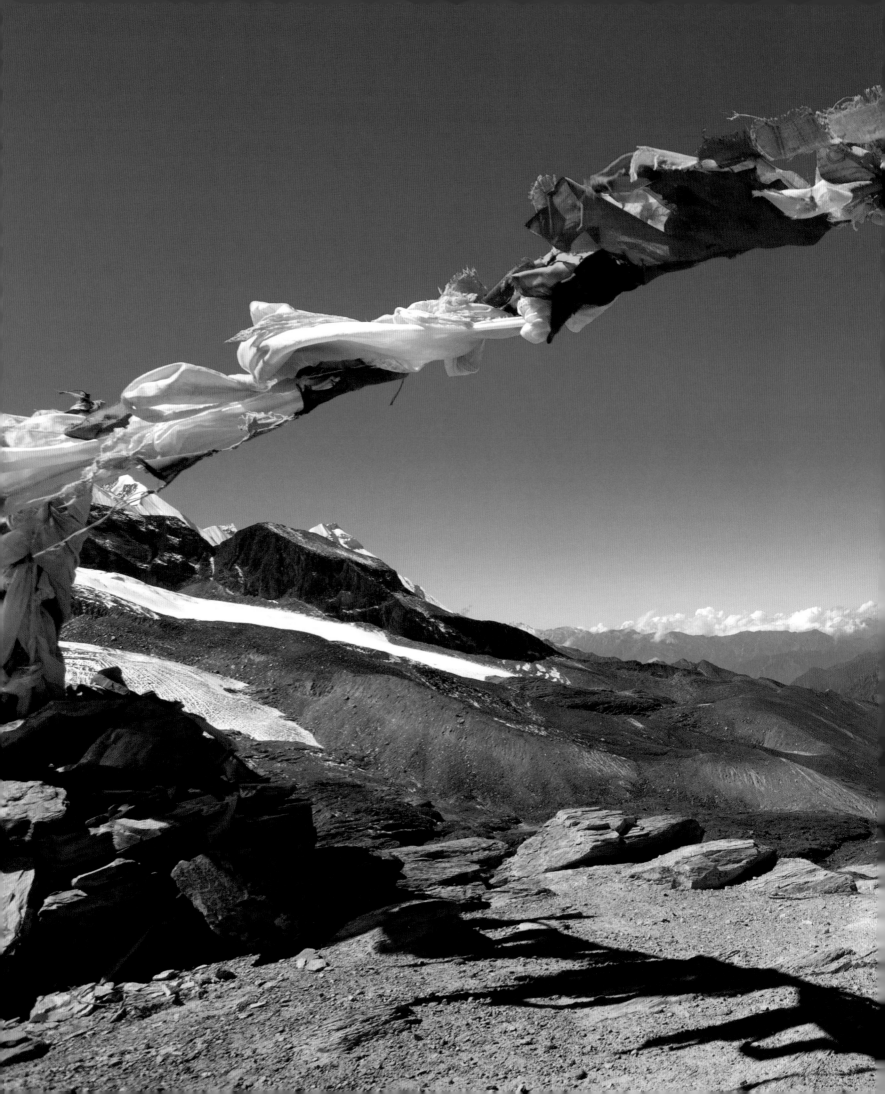

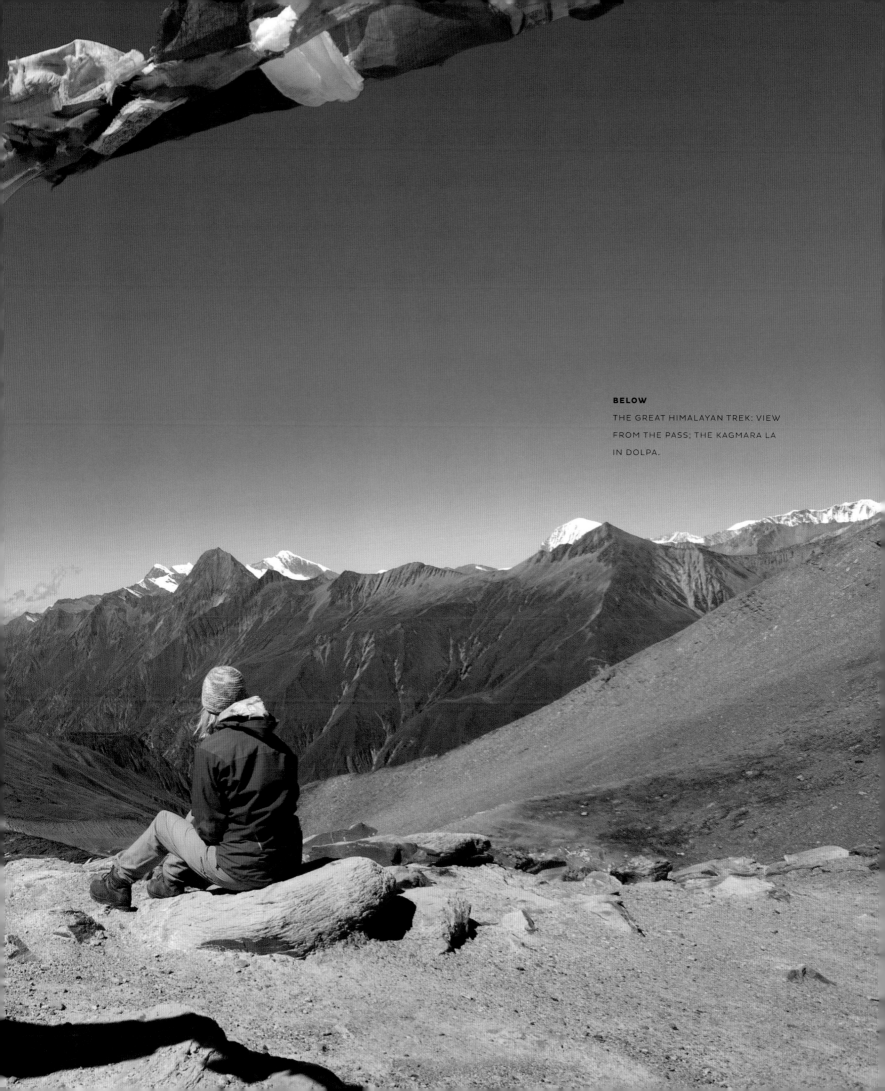

BELOW
THE GREAT HIMALAYAN TREK: VIEW
FROM THE PASS; THE KAGMARA LA
IN DOLPA.

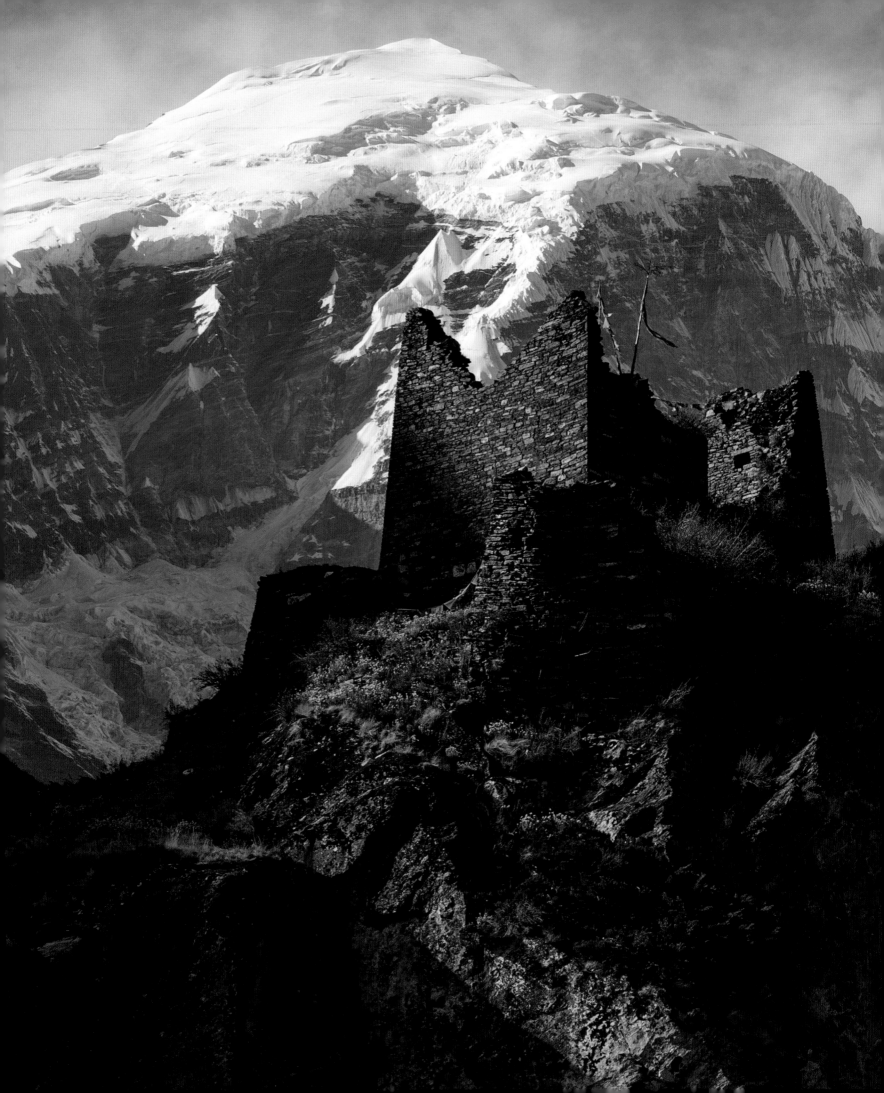

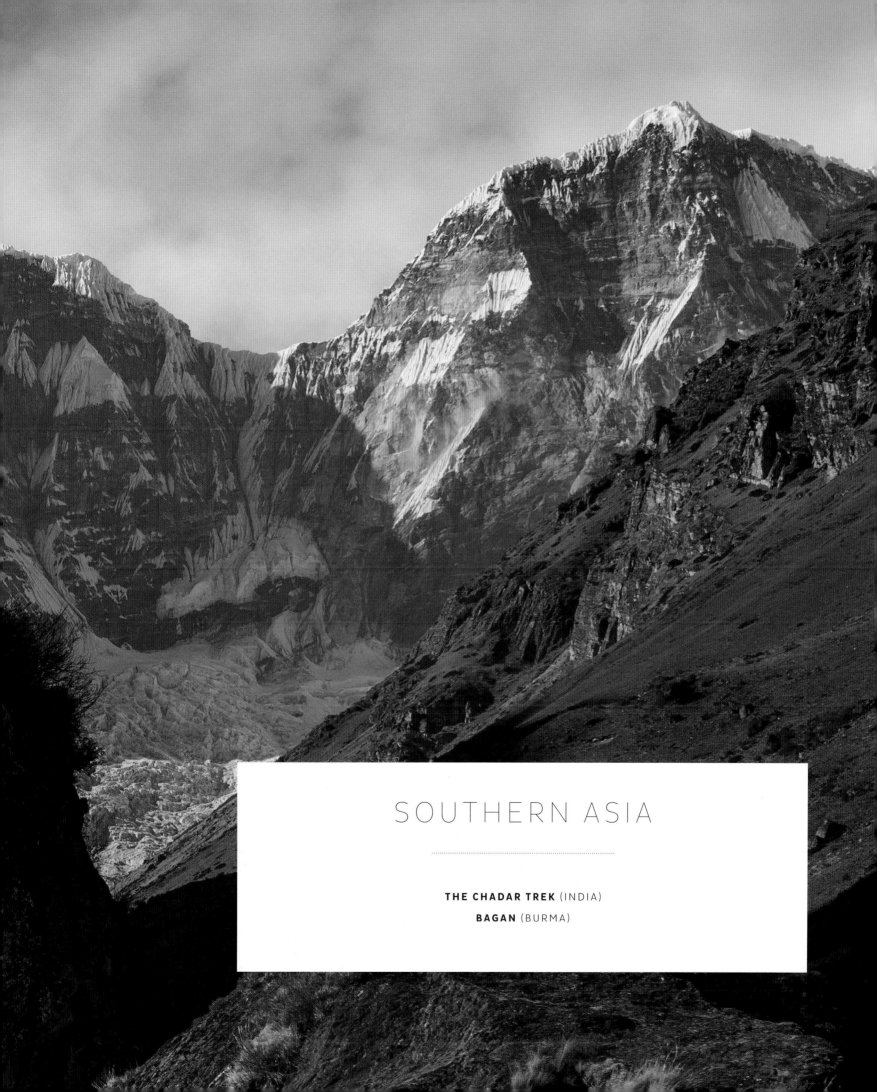

SOUTHERN ASIA

...........................

THE CHADAR TREK (INDIA)

BAGAN (BURMA)

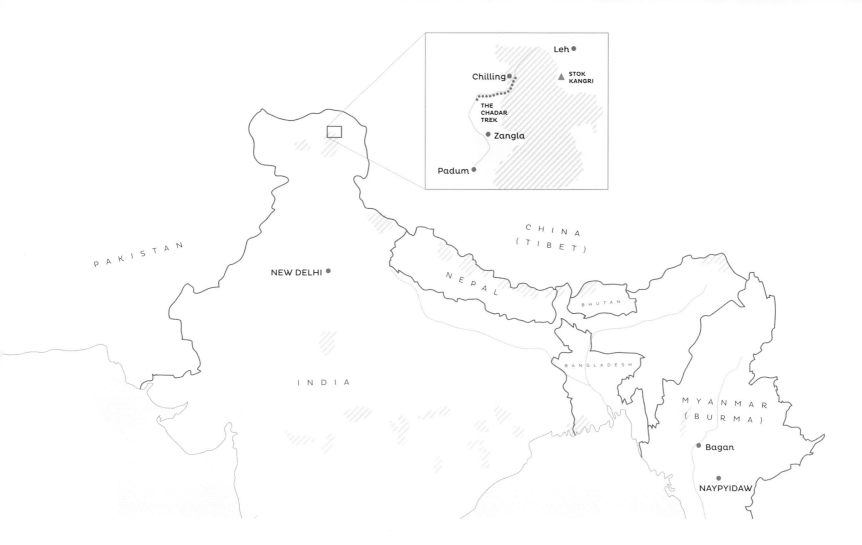

The inset map shows: Leh, Chilling, STOK KANGRI, THE CHADAR TREK, Zangla, Padum.

The main map shows: PAKISTAN, CHINA (TIBET), NEPAL, BHUTAN, INDIA, NEW DELHI, BANGLADESH, MYANMAR (BURMA), Bagan, NAYPYIDAW.

Southern Asia

The lowest latitudes of Asia are filled with head-reeling extremes: from the frozen, arid, high-altitude mountains of northern India to the hot, humid mangrove forests of Bangladesh and the wide-open central plains of Burma; down to the dense jungles of Thailand, Cambodia, Laos and Vietnam. Geography, climate, culture, economics and politics can all change quickly simply by crossing over a mountain pass, a river or a seemingly arbitrary international border. Navigating the almost incomprehensible range of variety in this diverse region is one of the most difficult challenges when trekking here, along with one of the greatest rewards.

The country of India is home to more than 1.3 billion people, yet it still manages to have some of the least crowded spaces left on the globe. In the northern provinces of the former British colony it is still possible to walk for days without seeing another soul. This is because the human population is largely concentrated in the flat, fertile lowlands near the country's major river systems, whilst much of the vast northern provinces are occupied by the Himalayas: the highest, harshest and most inaccessible mountains on Earth.

No other country can claim a greater change of elevation within its borders than India. From the sea-level city of Goa on the southwest coast to the top of Kangchenjunga, the third-tallest peak in the world, the ground in India gradually and then suddenly rises 8,586 metres (28,169 feet). For this reason, the country's trekking paths can be as varied in difficulty and surroundings as the landscape. It is a relatively simple stroll to wander among the mesmerising, green hills of Kerala and its numerous tea gardens and spice plantations, for example. Forging one's way up the frozen Zanskar River in the middle of the Himalayan winter in the northern province of Ladakh, on the other hand, is not so simple.

The extreme changes in elevation greatly affect the country's climate. It can be more than 30°C (86°F) in Goa and, at the same time, more than 30 degrees below zero in the Himalayan village of Padum, just over 2,000 kilometres (1,200 miles) away. And whilst the lowland, coastal cities of India get drenched with monsoon rains, the storm clouds rolling in off the Bay of Bengal are stopped in their tracks by the great ridgelines of the Himalayas; meaning that while the southeastern city of Kolkata receives an average of about 157 centimetres (62 inches) of rain each year – trekkers are well advised to bring a rain jacket – Padum only receives about 10 centimetres (4 inches), and requires a heavy down parka.

Further to the east – following the path of the great Ganges River that drains almost the entire south side of the Himalayas after joining with Nepal's Sun Kosi River – Bangladesh has the rather odd, yet remarkable, claim to fame of being one of the world's most waterlogged countries. And even though the entire nation is consumed by the largest river delta on the planet, there are still some trekking opportunities to be found – such as the trails that have been carved through the Chittagong Hills, the only noticeable topography in the country. The rest of the land is largely consumed by the Sunderbans, or Bengal Delta, which is formed by the massive volume of water flowing down from the Himalayas through the Ganges River, where it eventually divides and subdivides into a labyrinth of continually shifting channels that slowly seep into the ocean through a vast mangrove forest that is home to one of the largest populations of wild tigers left on Earth.

Across Bangladesh's eastern border, Myanmar (Burma), is an astoundingly beautiful country that is as yet relatively uncharted territory for foreigners on account of its political past and ongoing civil unrest. From the sandy beaches of the Andaman Sea in the south, near the border with Thailand, to the expansive rice fields and enormous golden stupas of the central plains, and the narrow, lonely footpaths that wind their way through the dense mountain forests and rocky peaks near the border with China, trekking anywhere in Burma is about as close to walking through ancient southern Asia as one can get.

Further to the south and east lies a seemingly impenetrable jungle that stretches across the entirety of Thailand, Laos, Cambodia and Vietnam; stopping finally at the edge of the South China Sea. Here in the far southeastern corner of Asia, towering limestone sea stacks rise out of the ocean along the Gulf of Thailand and enormous waterfalls cascade through the jungle down the steep hillsides of Laos. In Vietnam, trekkers can spend days walking through the world's largest cave – the Hang Son Doong – which, in places, is large enough to fit a 40-storey building.

All of this can be experienced in southern Asia simply by walking along footpaths – whether that path is on a mountainside, a wide-open plain, through a sun-dappled jungle or over a frozen river. The walking is the easy part. The real trick in this region is deciding in which direction to wander next.

RIGHT

PACK HORSES LADEN WITH TREKKING
EQUIPMENT CROSS THE KONZE LA IN THE
REMOTE REGION OF LADAKH IN INDIA.

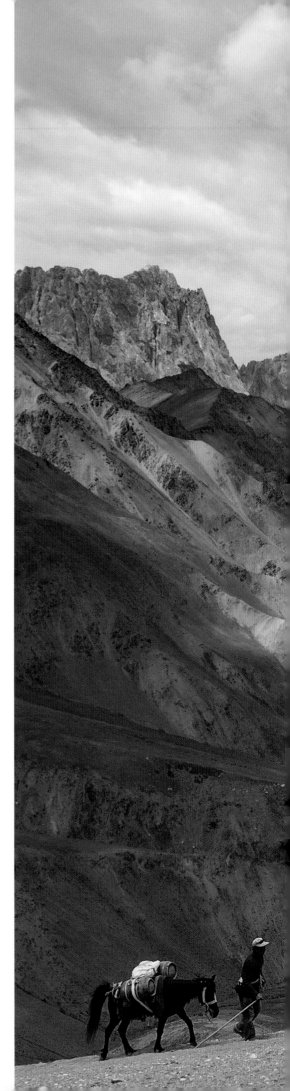

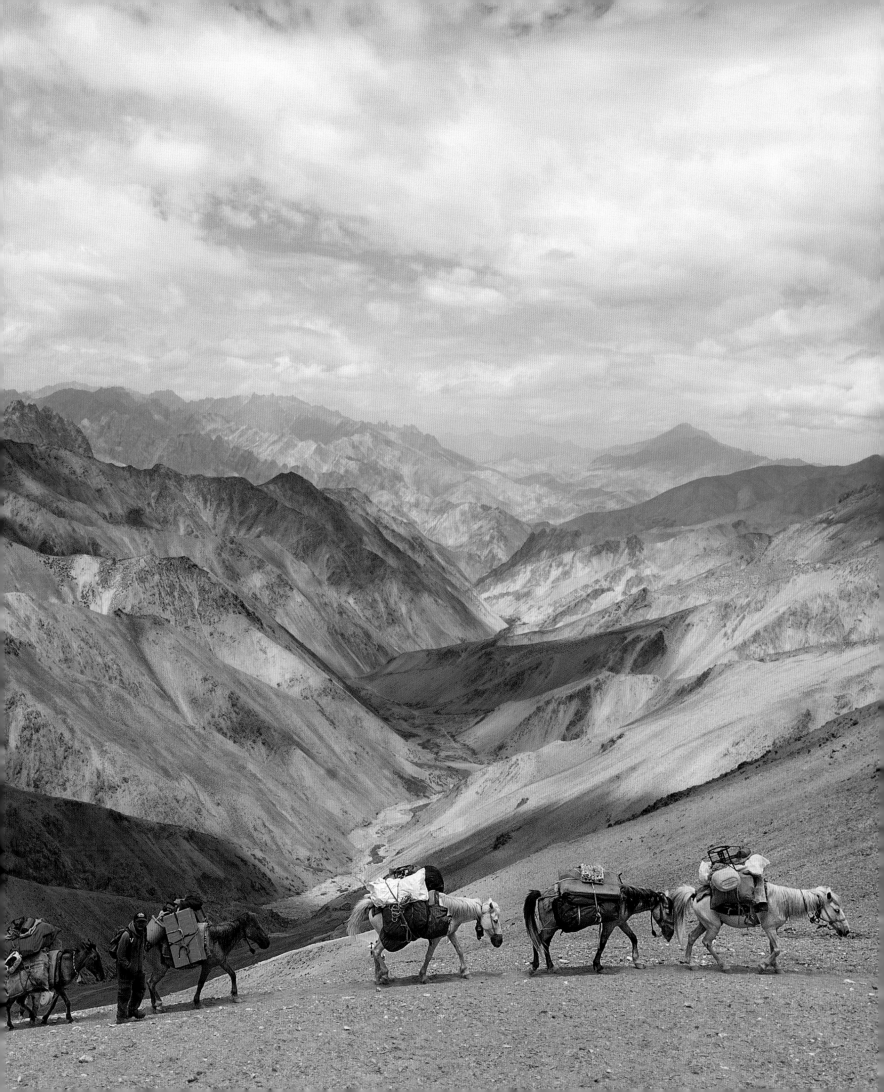

THE CHADAR TREK
INDIA

Located in the far northern Indian district of Ladakh, the Chadar Trek is one of the few well-established walks in the world that involves almost no solid ground. From January to February each year, in the middle of the Himalayan winter, this 75-kilometre (47-mile) long stretch of the partially frozen Zanskar River is the only reliable way to travel between the isolated mountain villages of the Zanskar Valley and the nearest road. It is a path of ice – and it leads straight into the heart of the Himalayas.

From Padum, the most remote village in the valley, to the aptly named community of Chilling – where temperatures can drop to more than –30°C (–22°F) – the Chadar Trek consists of about a week's worth of walking slowly on ice through a deep limestone canyon that is filled with an impressively high volume of rushing glacial meltwater. It's the sort of trail that no one would have ever probably thought to create unless they had to. And that is precisely what makes it so remarkable.

The frozen Zanskar River carves its way through the least populated area in India's scarecely inhabited district. Ladakh itself occupies more than 45,000 square kilometres (17,375 square miles), but is home to only about 270,000 people. For perspective, the population of the greater London area in the United Kingdom is more than 32 times higher and is compacted into a space nearly one-quarter of the size.

For centuries, this frigid route has been used to bring the Zanskar valley's, now famous, yak butter to trade in Leh, Ladakh's largest town and a hub on a spur trail of the old Silk Route. Whilst it is still used by local villagers to trade with the outside world, the trek has more recently developed a reputation for being a heart-pounding adventure for thrill-seekers looking to get away from just about everything, provided they are willing to dress in multiple layers of warm clothing. It is worth the effort.

Deep in the bottom of the gorge, there is nothing but the sound of the river rushing beneath the ice and the echo of the river bouncing off the cliffs. At night, stars can be seen in vivid relief against the cold, clear desert sky almost every night. And if travellers along this ancient, constantly shifting ice road manage to look up at just the right time, there is still a chance they will see snow leopards prowling high in the snowy crags above.

LEFT

SOMETIMES REFERRED TO AS THE GRAND
CANYON OF ASIA, THIS SECTION OF THE ZANSKAR
GORGE IS ONLY ACCESSIBLE BY RAFT OR BY ICE.

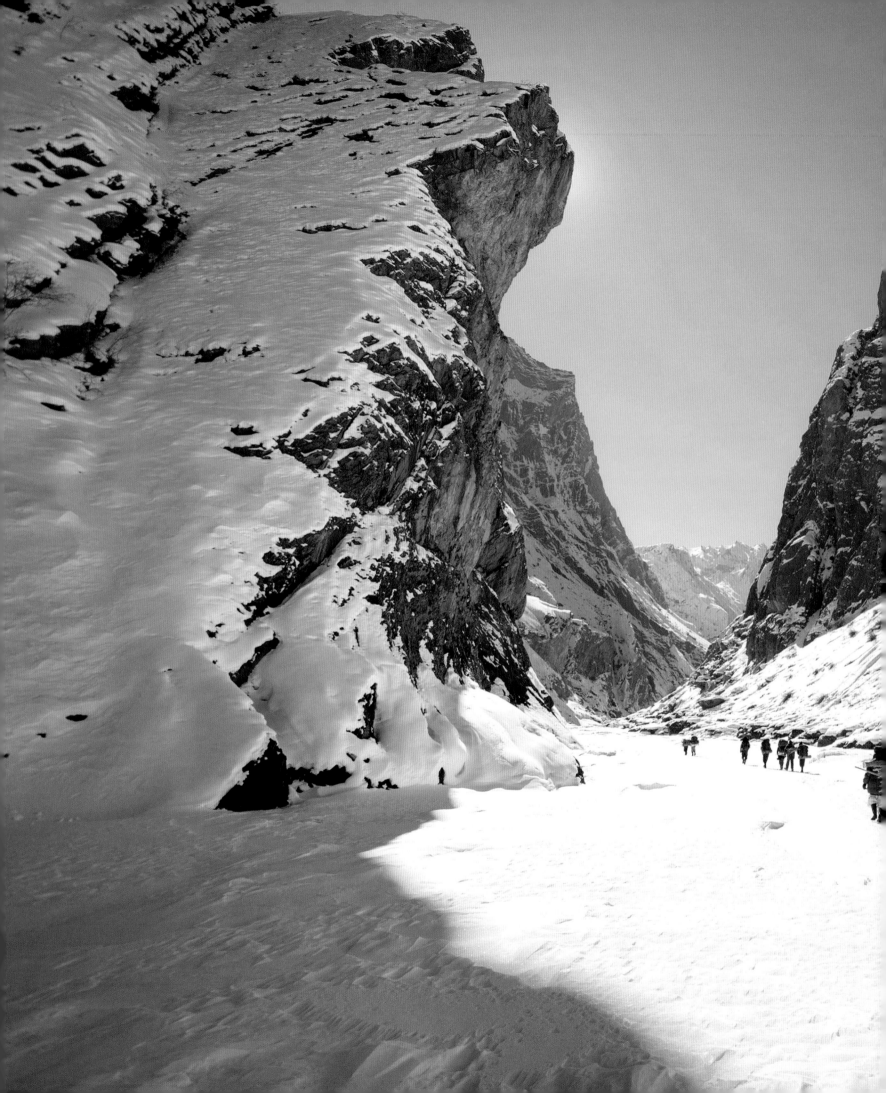

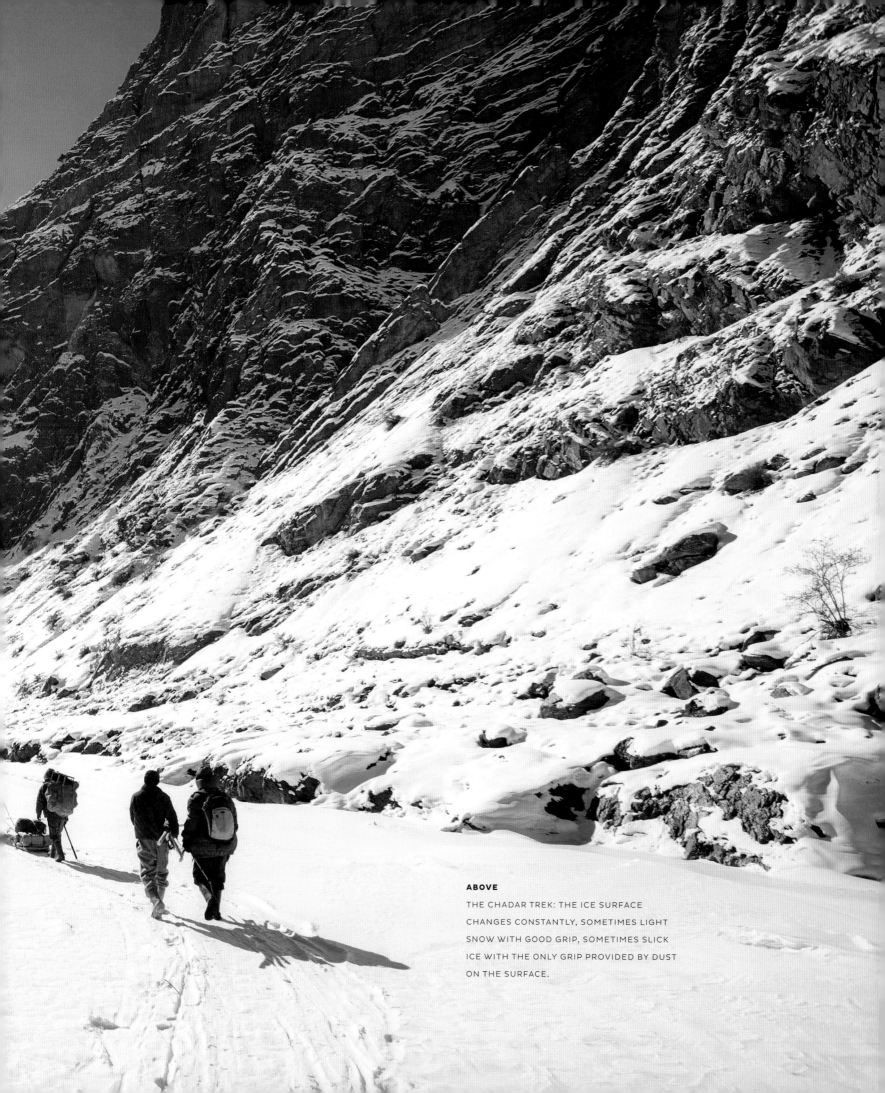

BAGAN
BURMA

More than 1,000 years ago on the hot, windswept plains of what is now central Burma, one of the most unlikely and stunningly beautiful cities to ever exist was built. Along the eastern shore of the Irrawaddy River in the ancient city of Bagan, more than 10,000 temples, pagodas and stupas were built painstakingly by hand over the course of just two centuries. Today, there is no single trail to follow through this labyrinth of historic architecture. There is just a wide-open, sun-baked plain to wander through, which is filled with temples and hot-air balloons slowly rising into the sky.

The kingdom's 42nd king, Amawrahta, had embraced Thervada Buddhism with a passion, it seems. The construction of religious monuments was supposed to be good for one's karma at the time, so he and his subjects built them with unbridled enthusiasm, creating a massive religious shrine the size of a small kingdom – and then kept it a secret.

For centuries, the city of Bagan's myriad red and gold-coloured spires rising up from the plains were hidden from the rest of the world. Rumours of its grandeur escaped the closed-off kingdom's borders from particularly daring travellers, such as Marco Polo, but few people outside of Burma ever got the chance to see the city until near the turn of the 21st century, when the ruling military regime at the time decided to allow foreigners back within the country's borders, in 1998.

Unfortunately, to make the area more appealing to tourists – who now have the freedom to wander the ancient city streets alone except for other tourists and their tour guides – the regime, forcibly relocated the local population to just outside the ancient city's gates to an area now called New Bagan. For better or worse, it is now mostly foreign tourists who fill the millennium-old streets and sacred halls of Old Bagan, dodging in and out of the shade offered by the slowly crumbling buildings in the midday heat.

The fact that any of the old buildings remain upright is miraculous to the extreme. Whatever had been made of wood is long gone here; however, the terracotta bricks that formed most of the buildings and their edifices have weathered well, providing an aged appearance not entirely unlike the great pyramids of Egypt. However, these pyramids-of-sorts are much more numerous, and shrouded in even greater mystery. And it could take weeks, if not months, to see all of them on foot.

Today, about 2,200 of the sacred temples, pagodas and stupas are still standing after surviving countless earthquakes and centuries of sand-blasting winds. Visitors are still allowed to venture into most of these ancient buildings, from where they can take in the spectacular sunsets that descend over the Bagan Plain each night.

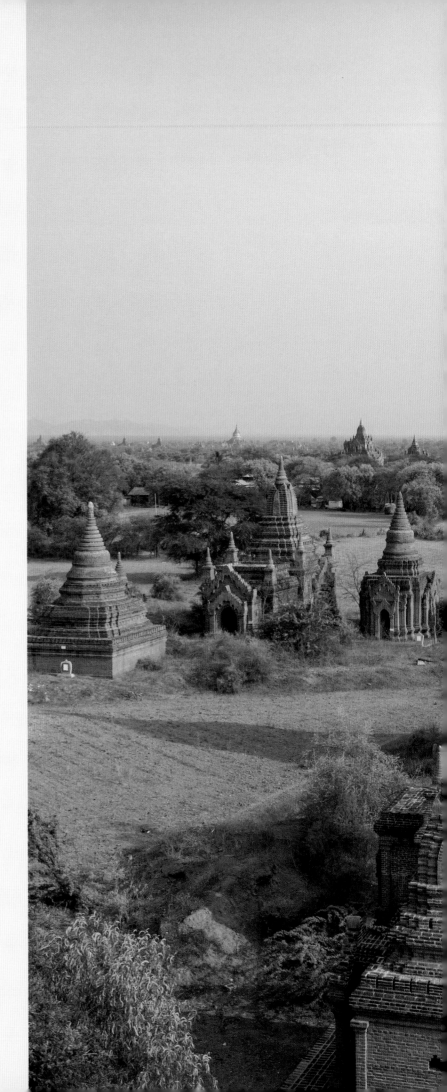

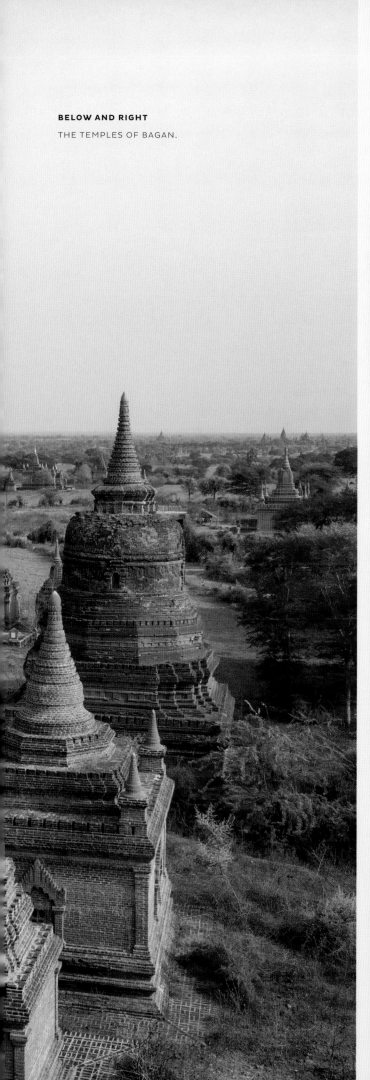

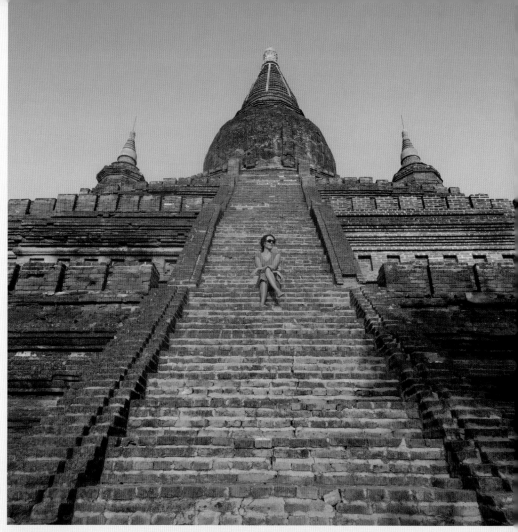

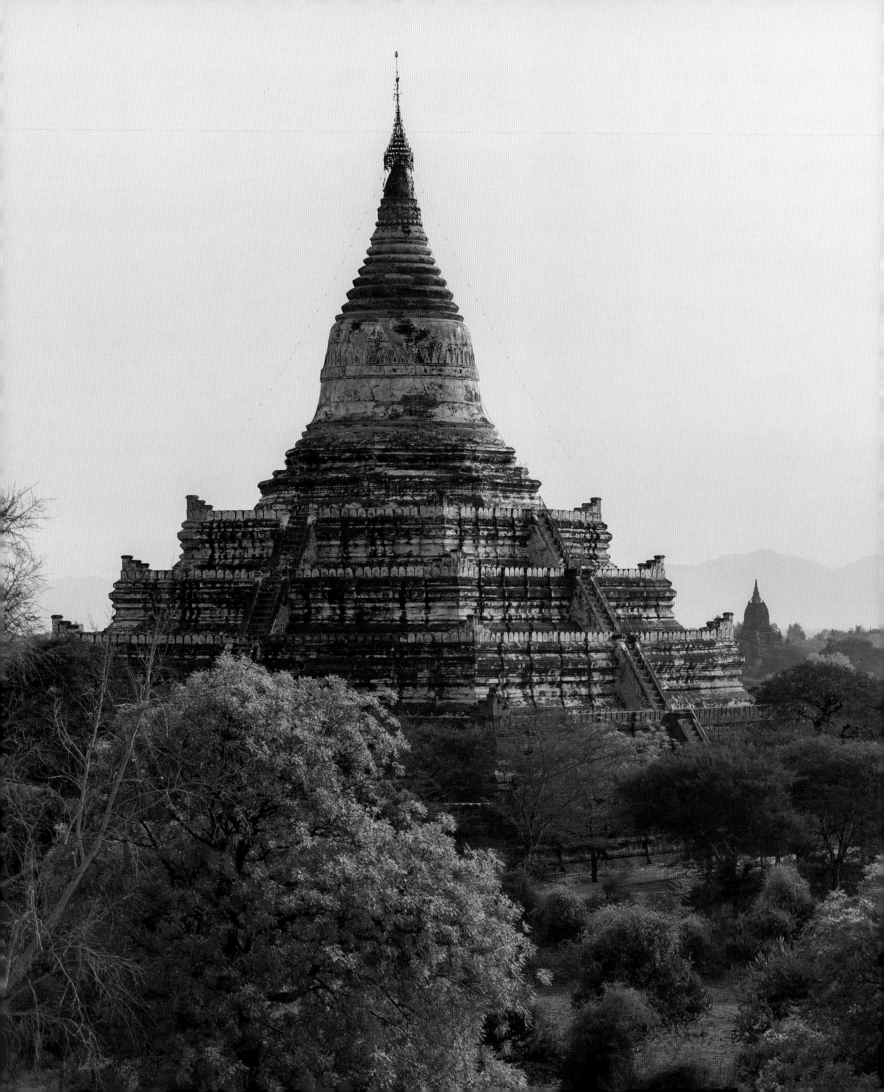

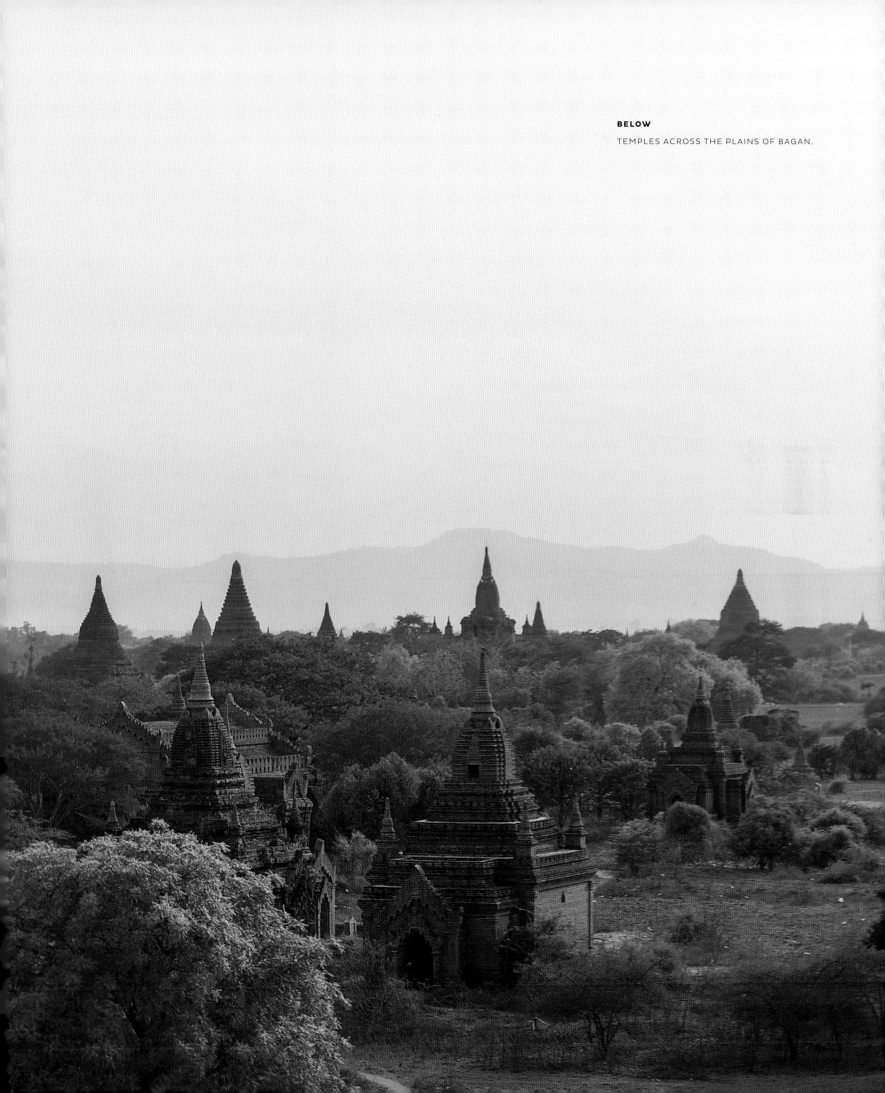

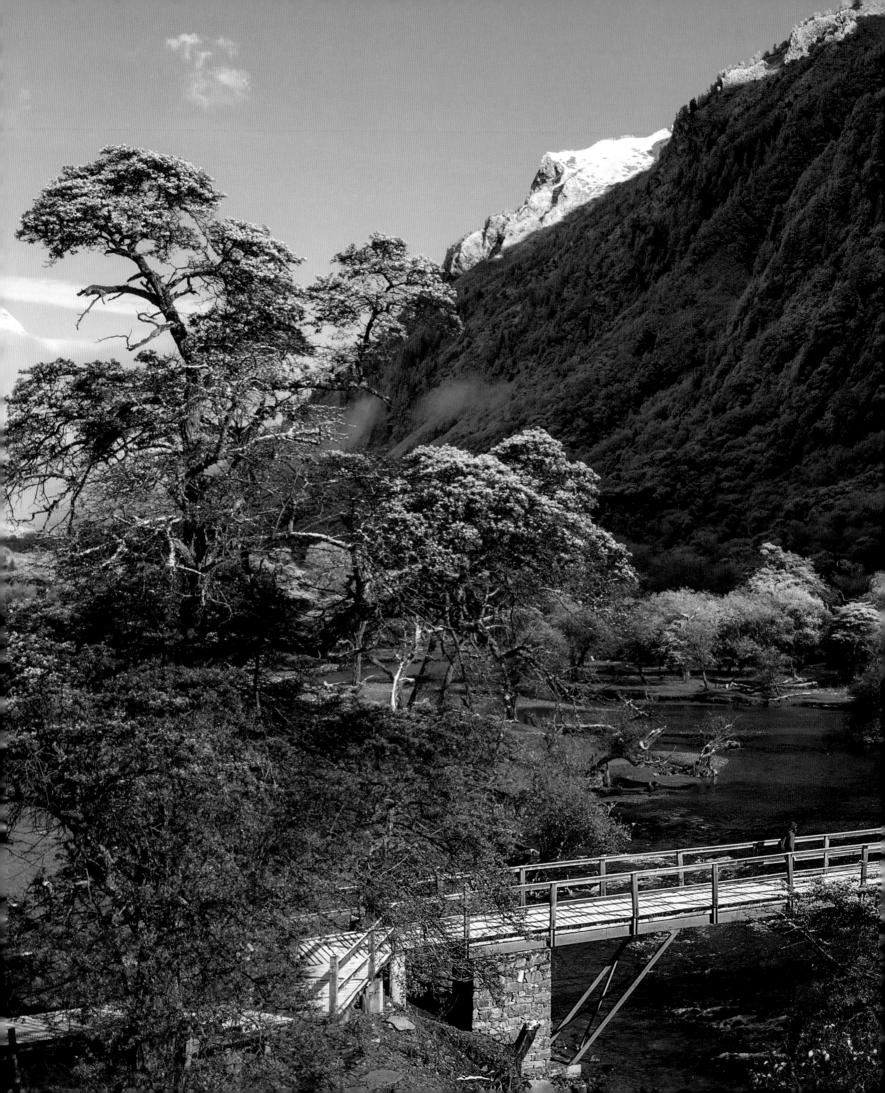

EASTERN ASIA

THE GREAT WALL OF CHINA (CHINA)
MOUNT FUJI (JAPAN)

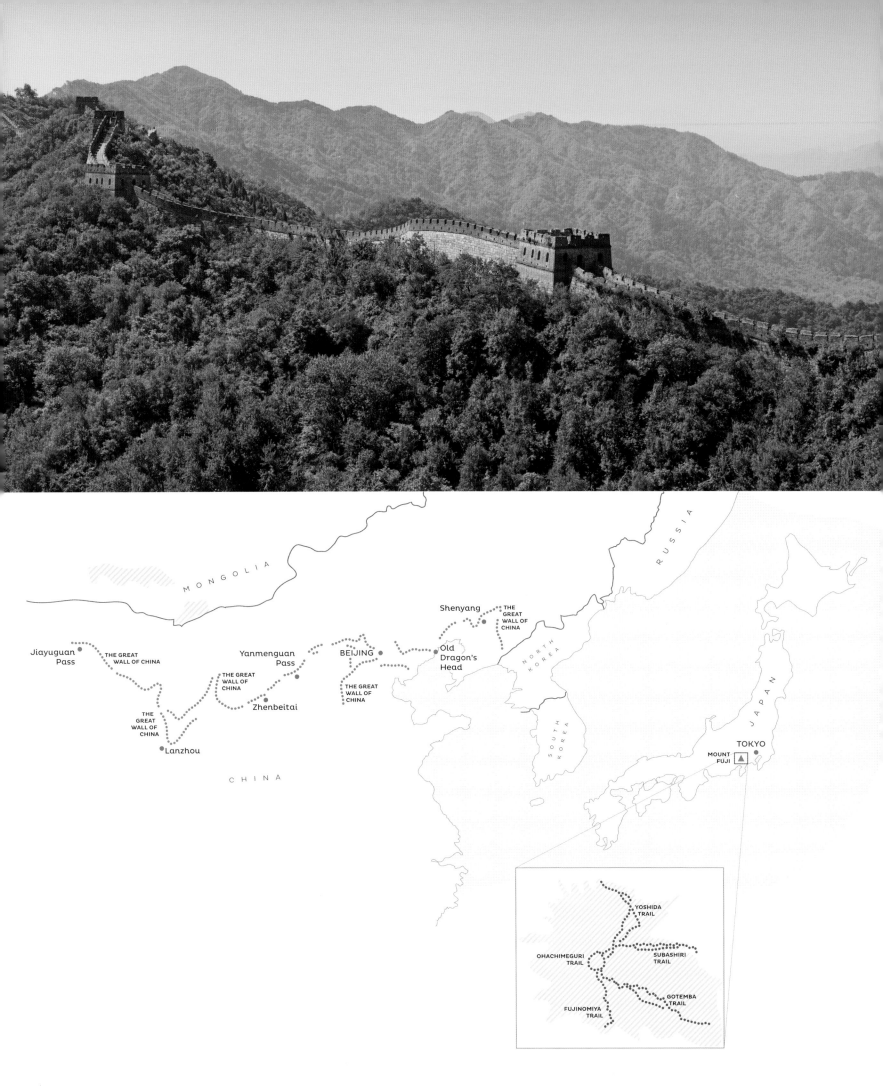

MONGOLIA

RUSSIA

Jiayuguan
Pass

THE GREAT
WALL OF CHINA

Yanmenguan
Pass

BEIJING

Shenyang

THE
GREAT
WALL OF
CHINA

Old
Dragon's
Head

NORTH
KOREA

THE GREAT
WALL OF
CHINA

THE
GREAT
WALL OF
CHINA

Zhenbeitai

THE GREAT
WALL OF
CHINA

THE
GREAT
WALL OF
CHINA

Lanzhou

CHINA

SOUTH
KOREA

JAPAN

MOUNT
FUJI

TOKYO

YOSHIDA
TRAIL

OHACHIMEGURI
TRAIL

SUBASHIRI
TRAIL

GOTEMBA
TRAIL

FUJINOMIYA
TRAIL

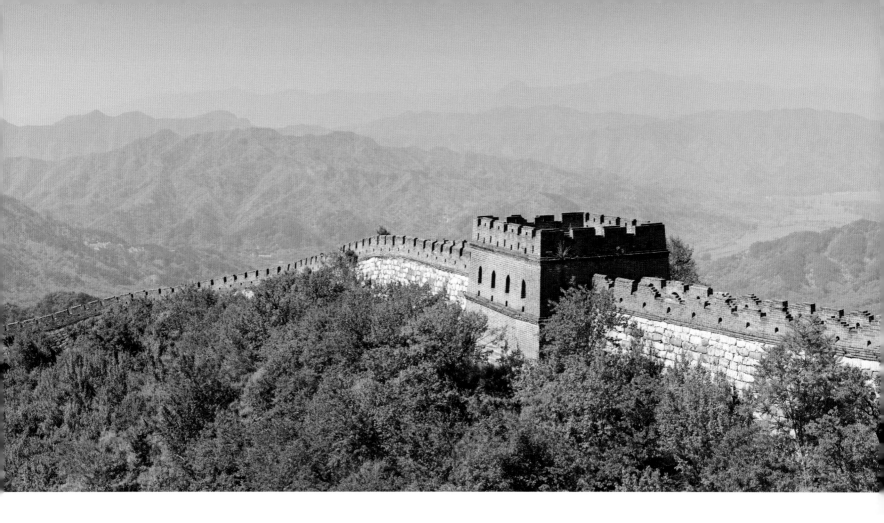

Eastern Asia

While the Himalayan mountains may naturally cause attention to sway towards the other side of Asia, the world's largest continent, the under-appreciated Far East has some sensational trekking that delves into steamy jungles, volcanic landscapes, wondrous wildlife and remote tribal cultures.

One of the best treks in all of eastern Asia is a clamber up Indonesia's second-largest volcano, Mount Rinjani at 3,726 metres (12,224 feet), in Gunung Rinjani National Park, on the small island of Lombok. It is an exhilarating two- to three-day climb through lush rainforest, with abundant wildlife – rusa deer, Indian muntjac, Sunda porcupine, surili monkeys and scaly-crowned honeyeater birds – and awe-inspiring views of the crater rim.

In Thailand, trekking visits to tribal villages are a mini-tourism industry in their own right. But as tourism develops in neighbouring, once-isolated Myanmar (Burma), its agricultural lands and Himalayan foothills offer a surprising range of trekking options. The diverse forests, accessible peaks and remote tribal groups make it a prime hiking region. Nat Ma Taung (or Mount Victoria, at 3,053 metres (10,016 feet) can be scaled and the lesser-visited Nat Ma Taung National Park explored with relish – keep an eye out for the endangered white-browed nuthatch and larger birds of prey.

Vietnam is known for its patchworks of vivid-green rice paddies, verdant peaks and colourful hill-tribe villages. The laid-back feel and spectacular views of the town of Sapa, built by the French in 1922 as a retreat from the lowland's oppressive heat, is the hill-tribe trekking capital; while Cao Bang province is home to soaring peaks, fantastical caves and more hill villages. The spectacular Ban Gioc Waterfalls are the largest in Asia. Dubbed the

ABOVE

THE GREAT WALL OF CHINA: A CAREFULLY RESTORED SECTION OF THE GREAT WALL AT MUTIANYU.

PREVIOUS PAGES

MOUNT SIGUNIANG NATIONAL PARK, AN AREA OF OUTSTANDING NATURAL BEAUTY IN THE SICHUAN PROVINCE IN CHINA, KNOWN AS THE 'ORIENTAL ALPS'.

Roof of Indochina, Vietnam's highest peak Fansipan, at 3,143 metres (10,312 feet), is a one- to three-day hike, offering different routes for tourists and more seasoned trekkers alike. At the summit you will be greeted with far-reaching views of the richly forested Lai Chau province and all its glorious greenery.

Nicknamed the Playground of the Gods, Philippines' Mount Pulag is where North Luzon tribes bury their dead. Its popularity with mountaineers and trekkers, who usually climb it in two days, has much to do with its ability to make you feel as if you are walking amongst a sea of fluffy clouds. Its rich biodiversity includes vast, mossy forests, golden grasslands, 33 bird species and threatened mammals, such as the Philippine deer, giant bushy-tailed cloud rat and the long-haired fruit bat.

Elsewhere in the country, the 2,000-year-old rice terraces of Banaue carved into the mountains of Ifugao resemble a giant amphitheatre. Trekkers can choose from easy routes to the more challenging, but spectacular, Batad Rice Terrace trail. The trail's scarily steep staircases are worth it to witness the impressive terraces, sometimes called the 'eighth wonder of the world'.

Malaysia's Cameron Highlands are famed for both tea and trekking. The cool climate here makes for excellent tea growing, while travellers are drawn to the green region for some respite from South East Asia's sweltering temperatures. The area is still satisfyingly wild, with many kilometres of trails winding through the mountains and tea plantations.

In Borneo, thousands flock to towering 4,095-metre (13,435-feet) Mount Kinabalu, the highest summit in South East Asia, where a trek up the craggy peak usually takes two days. At one point a rope is needed, but paradoxically there are abundant creature comforts: clean bathrooms and cosy beds at the lodges.

Gunung Mulu is a beast of a mountain at 2,376 metres (7,795 feet) – a three- to four-day trek involves overnight stops in wooden huts, winding routes over limestone belts and rough terrain, and a difficult but final, exhilarating ascent to the cloud-shrouded peak. The reward? Far-reaching views over one of the most richly biodiverse rainforests in the world.

South Korea's Seoraksan National Park is home to the nation's third-highest mountain, Seoraksan. Here, well-maintained and clearly signed (in Korean and English) trails lead through the thick forest, passing curious rock formations, hot springs and ancient temples.

Mongolia's Altai Tavan Bogd National Park straddles borders with China and Russia. Here, nomadic herders are known for their eagle-hunting skills and warm hospitality, and live under towering white mountains, some 34 glaciers, lush valleys, big lakes and waterfalls.

The 96-kilometre (60-mile) Kokoda Trail of Papua New Guinea cuts a straight line through the Owen Stanley Range and was the location of a World War II battle between Japanese and primarily Australian troops. Rising to 2,190 metres (7,185 feet) as it passes Mount Bellamy, the jungle trail goes through the land of the Mountain Koiari people. Hot and humid weather, along with cold nights, torrential rain and tropical diseases, make it a challenging trek. But many Australians see it as both an endurance challenge and a tribute to their soldiers. Some take 12 days, some just one (the fastest descent time is recorded as 16 hours and 34 minutes).

Eastern Asia also boasts two of the most famous and unique hikes to be had anywhere in the world: China's epic 6,000-kilometre (3,700-mile) Great Wall; and the significantly shorter (it's a day walk) but equally totemic Mount Fuji in Japan.

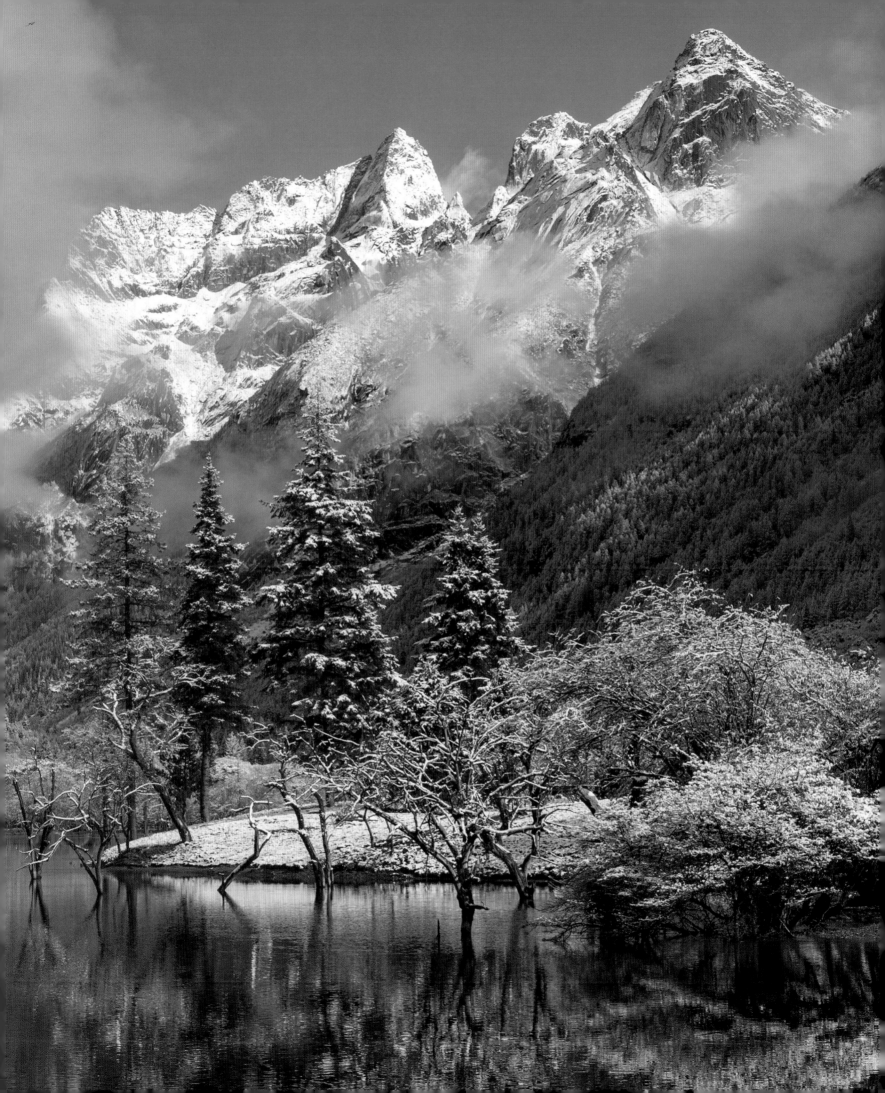

THE GREAT WALL OF CHINA
CHINA

Few, if any, trekking routes are as laden with history and atmosphere as the 6,000-kilometre (3,700-mile) Great Wall of China.

Built on an east-to-west line along China's historical northern borders, to protect against raids from Eurasian Steppe nomadic groups, the architectural masterpiece of the wall dates back to the fifth century BC. But there is plenty more to the Great Wall than some ancient brickwork. It provides a spectacular yomp, with surprisingly varied scenery and experiences. The route goes up and down mountains, through rich woodland and along remote valleys. It visits memorable tourist sites such as the Ming tombs and the classic Confucian designs of the Temple of Heaven.

From leisurely day hikes to demanding treks, there are lots of ways to experience the Great Wall on foot. Jinshanling to Simatai is an impressive 11-kilometre (7-mile) section, reachable in a day trip from Beijing. It mixes unreconstructed wall – in places you are scrambling on steep, crumbly inclines – with jutting obstacle walls and oval watchtowers. From Mutianyu (90 kilometres/56 miles from Beijing), it is a pleasant stroll along a ridge through forested hills, passing some 20 guard towers. The Huanghuacheng Wall, from Huanghua Road to the Eighth Guard Tower, offers a challenging, perhaps wilder, 12-kilometre (7-mile) walk, without crowds and with impressive views of remote mountains.

Plenty of wild scenery and a chance to camp in a guard tower accompany a hike from Hexi to Gubeikou or Panlong – a 36-kilometre (22-mile) section. A trail leads up Wohu Mountain, with magnificent views from the highest well-preserved guard towers.

The 20-kilometre (12-mile) Jiankou Great Wall, from Xizhazi village, is a challenging and intriguing section. The wall here is white (made of dolomite), with a picturesque stretch wending along thickly forested mountain ridges. Some parts are so steep they have to be climbed on all fours; stone is loose, and a local guide is recommended. It is possible here to camp on the wall itself – the chance to experience a magical sunrise over the Great Wall, all to yourself, should not be turned away lightly.

From Jiayuguan you can see the wall's final fortification and the fascinating culture of the Uighur people. All trade on the Silk Route into central Asia came through here, with Tibet's mountains to the south and desert to the north helping to create an effective funnel. Today, the large population of Muslim Uighur is a reminder that you are a long way from Beijing; the language (Turkic) and architecture are strikingly different. The magnificent fort itself (built in 1372) stands on a bleak plain, the same colour as the desert around it and backdropped by mountains.

Is the Great Wall visible from space? Sadly, that's a myth. But there is plenty here to wonder at from the ground.

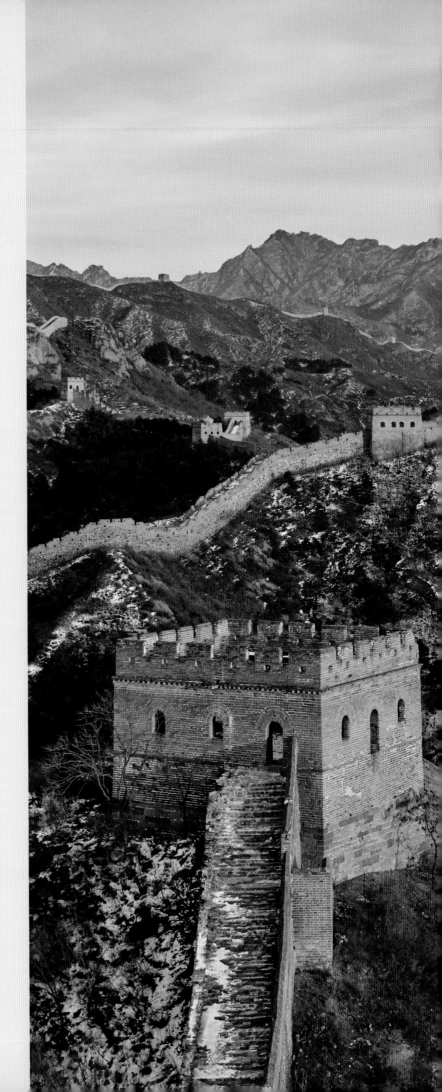

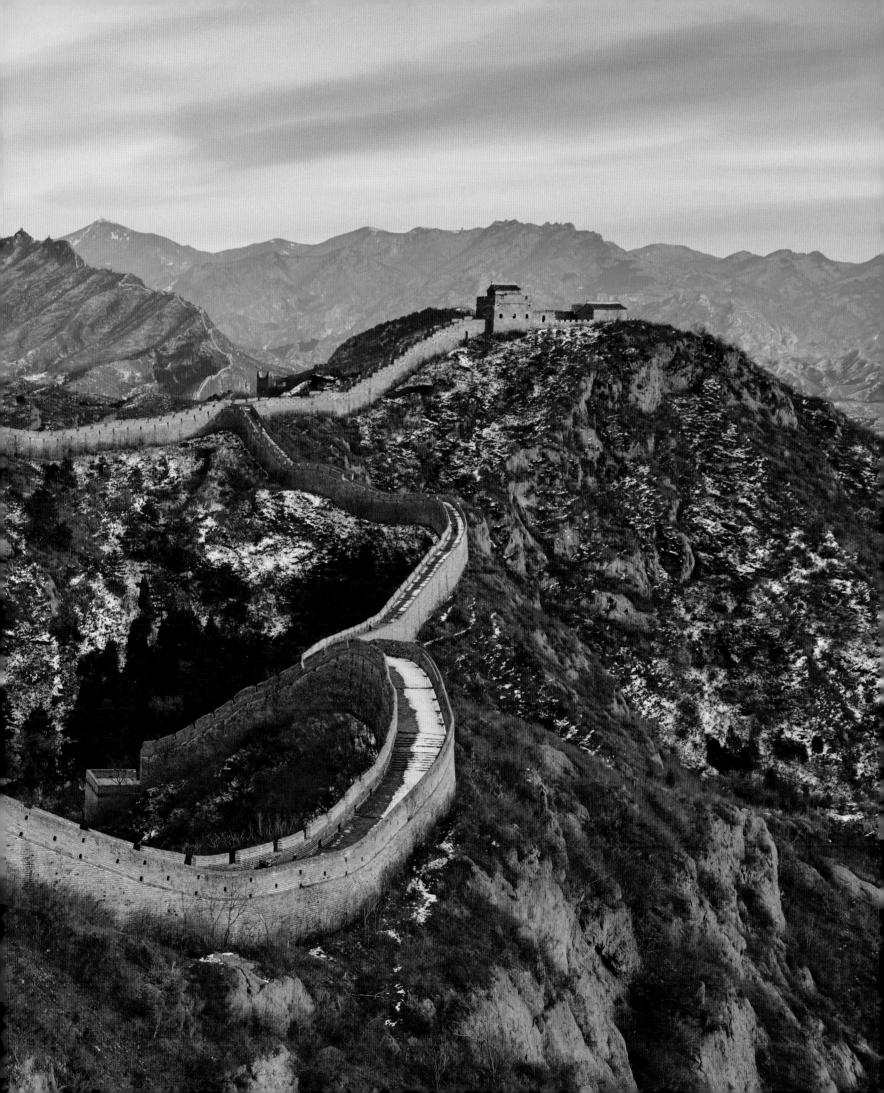

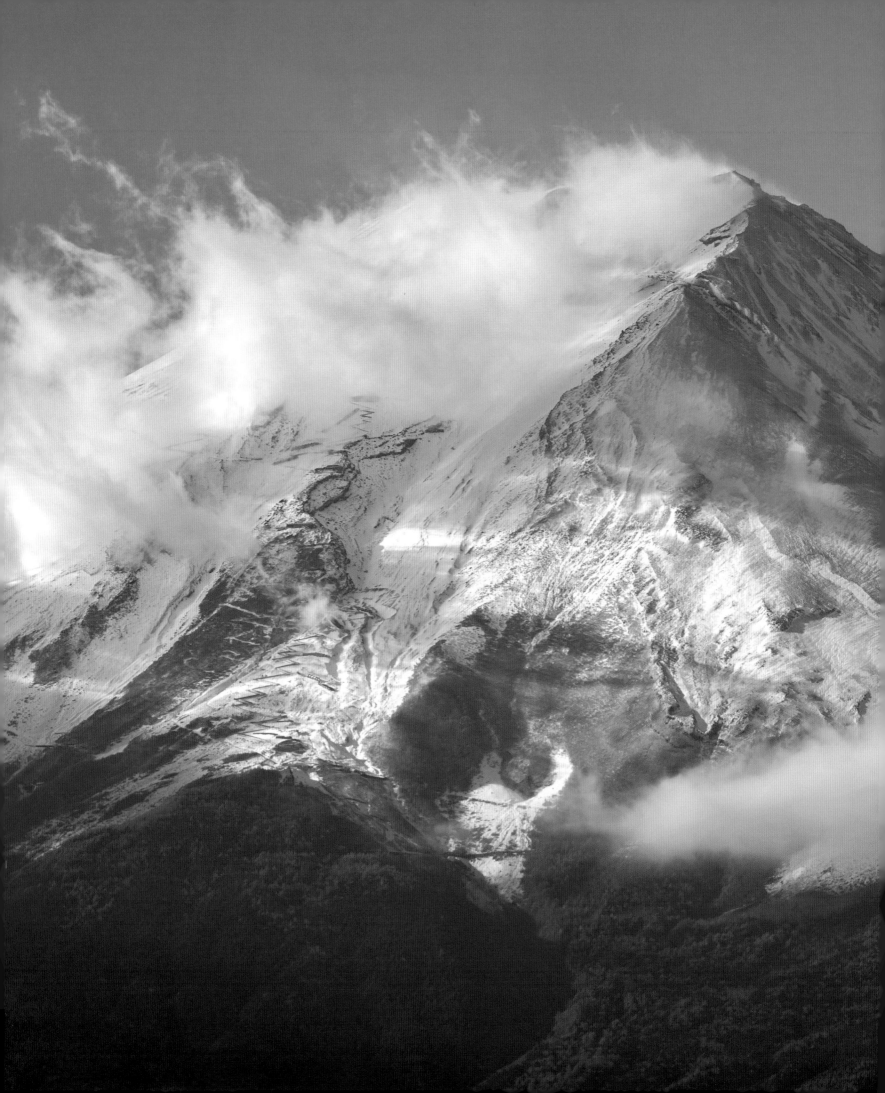

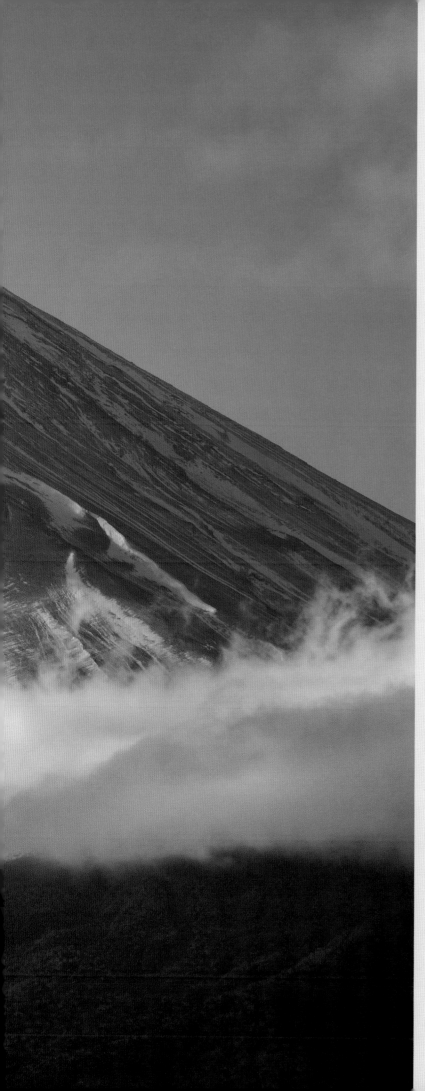

MOUNT FUJI
JAPAN

Along with Everest and Kilimanjaro, Mount Fuji is one of the most famous mountains in the world, and the distinctive conical peak has long been revered as a sacred Shinto (Japan's ethnic religion) shrine. Poets and artists have worshipped Fuji, and the mountain has also long been a site of pilgrimage, attracting the spiritually minded to its summit to witness the famous red sun emerging from the Pacific, an experience known as *goraiko*. Some start their walk at night, others climb most of the way in the afternoon, rest in a mountain hut and ascend the final stretch before dawn.

After the national flag, Mount Fuji is Japan's most treasured symbol, found on the 1,000 yen note. According to Japanese mythology, Fuji, or Fuji-san, as it is respectfully called, used to be the home of a fire goddess who would be jealous of any woman nearby. Indeed, until 1868, only men were allowed to make the climb. The goddess has displayed her irritation at times, discharging hot molten lava and clouds of ash, covering the streets of Tokyo 97 kilometres (60 miles) away during the last eruption in 1707.

Starting in lush forest vegetation, the trail thins out as spectacular views of lake-filled valleys open out below, and the terrain becomes more desolate: crumbling, ashen black cliffs and volcanic scree. The summit is a volcanic crater with a Kusushi shrine and shops. This is not a wilderness experience.

Traditionally, straw-sandalled pilgrims started their hike close to the town of Fuji-Yoshida, at Sengen-Jinja. Nowadays, most walkers begin much higher up the mountain, on one of four trails, from the fifth 'stations' between 1,440 and 2,400 metres (4,724 and 7,874 feet). The Subashiri route is one of the least crowded and, at about five hours, one of the shortest. Fuji can be hiked all year round, although the official climbing season is July and August, when the peak is snow-free and the huts providing refuge and food along the way are open.

As many as 400,000 summit Fuji each year, sometimes reducing the pace at the top to a congested shuffle. The O-Bon holidays in late August – when the spirits of the dead can return to Earth, a chance to communicate with those who have passed on – bring even bigger crowds.

Fuji gets very steep, and at 3,776 metres (12,388 feet) the mountain is high enough to cause altitude problems, and so stalls close to the walk's start sell oxygen. The price of canned drinks rises as you do, and you can send postcards from the summit post office.

The popularity of climbing Mount Fuji may have made it an unusually commercial and crowded experience, but it's an unforgettable one, nonetheless.

BELOW

SNOW CAP ON SUMMIT OF MOUNT FUJI.

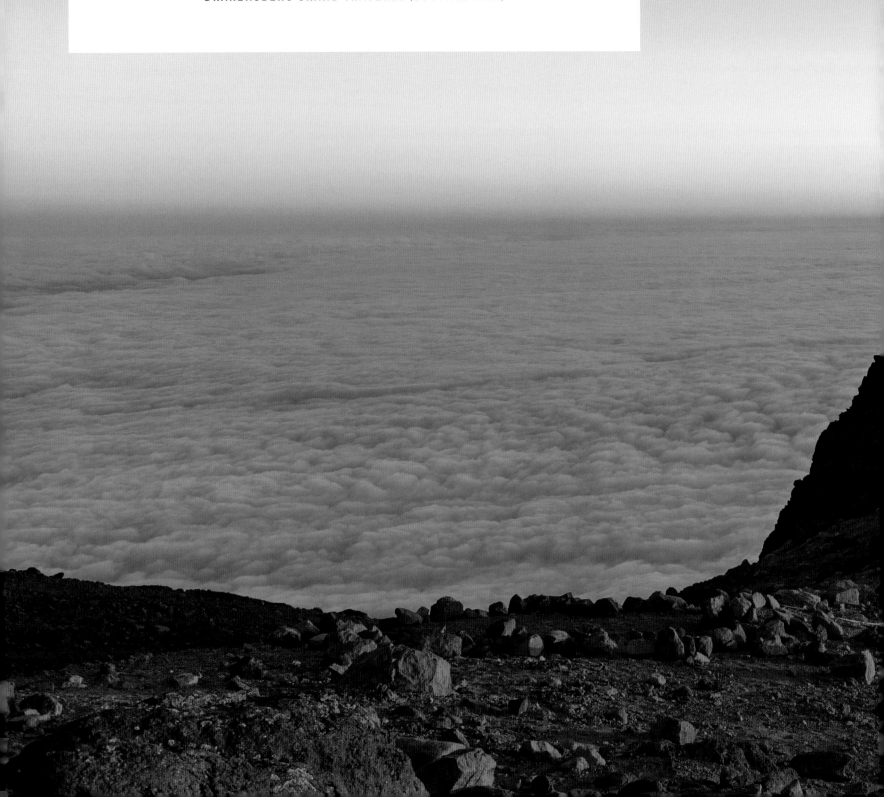

AFRICA

FISH RIVER CANYON (NAMIBIA)

KILIMANJARO (TANZANIA)

DRAKENSBERG GRAND TRAVERSE (SOUTH AFRICA)

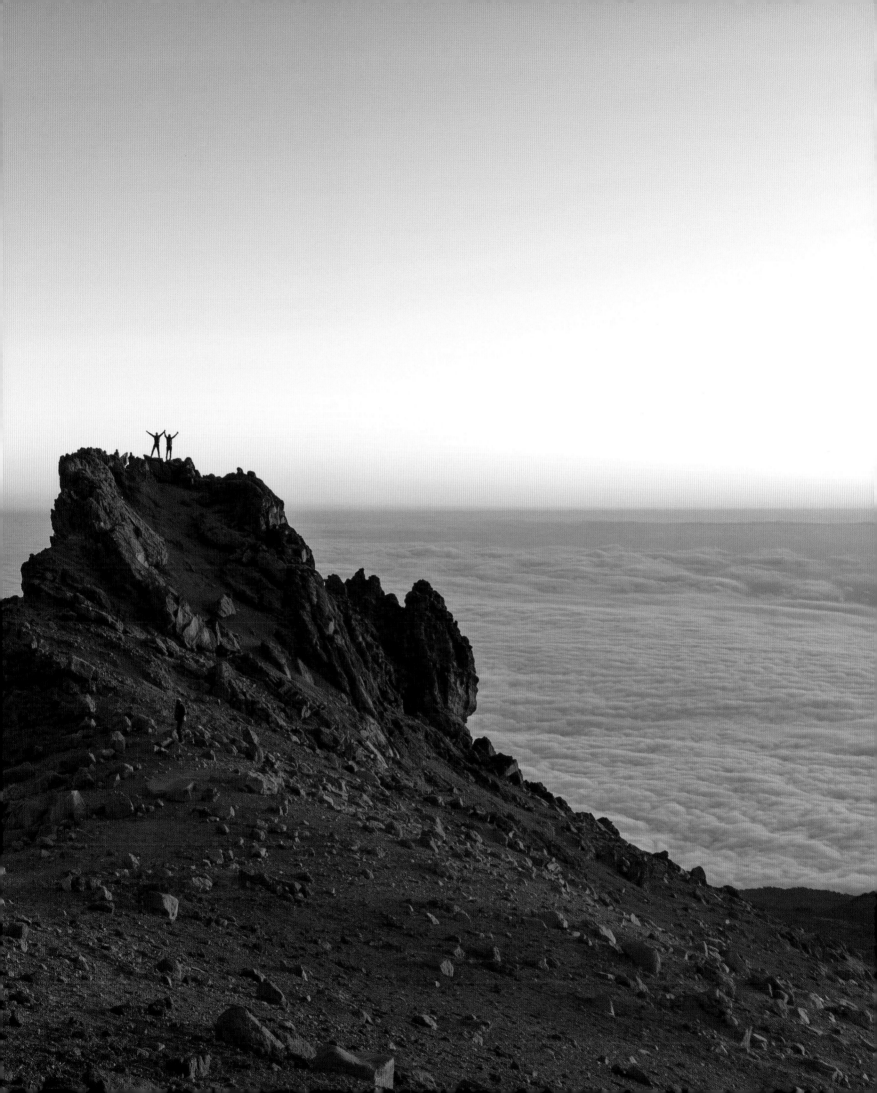

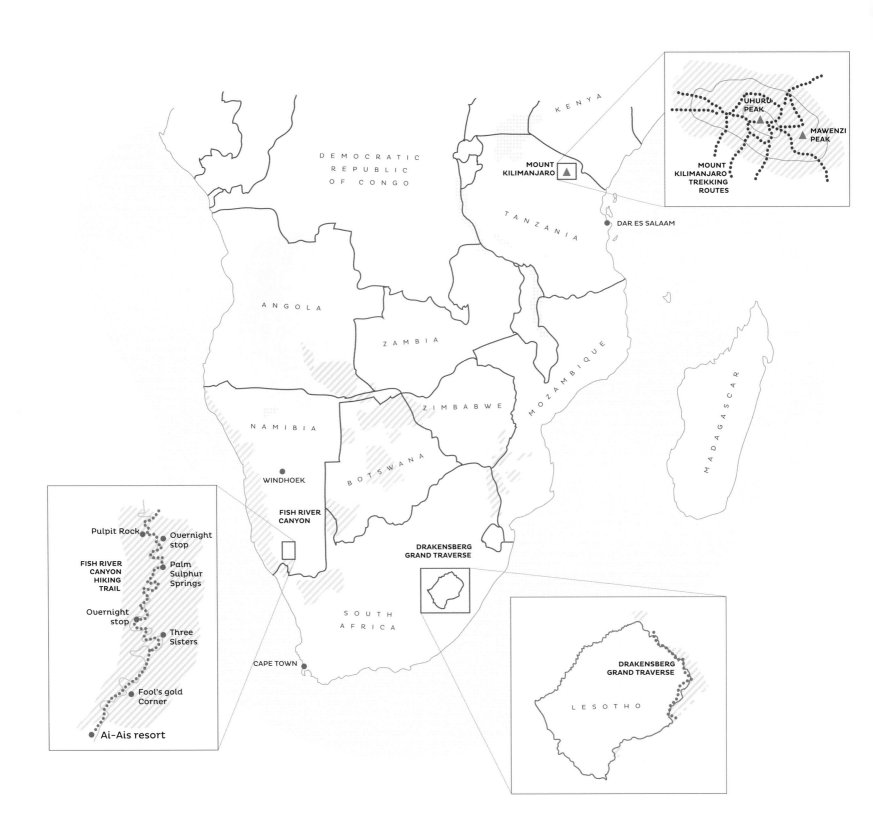

DEMOCRATIC
REPUBLIC
OF CONGO

KENYA

MOUNT
KILIMANJARO

TANZANIA

DAR ES SALAAM

UHURU
PEAK

MAWENZI
PEAK

MOUNT
KILIMANJARO
TREKKING
ROUTES

ANGOLA

ZAMBIA

ZIMBABWE

MOZAMBIQUE

MADAGASCAR

NAMIBIA

BOTSWANA

WINDHOEK

FISH RIVER
CANYON

DRAKENSBERG
GRAND TRAVERSE

SOUTH
AFRICA

CAPE TOWN

LESOTHO

DRAKENSBERG
GRAND TRAVERSE

Pulpit Rock

Overnight
stop

FISH RIVER
CANYON
HIKING
TRAIL

Palm
Sulphur
Springs

Overnight
stop

Three
Sisters

Fool's gold
Corner

Ai-Ais resort

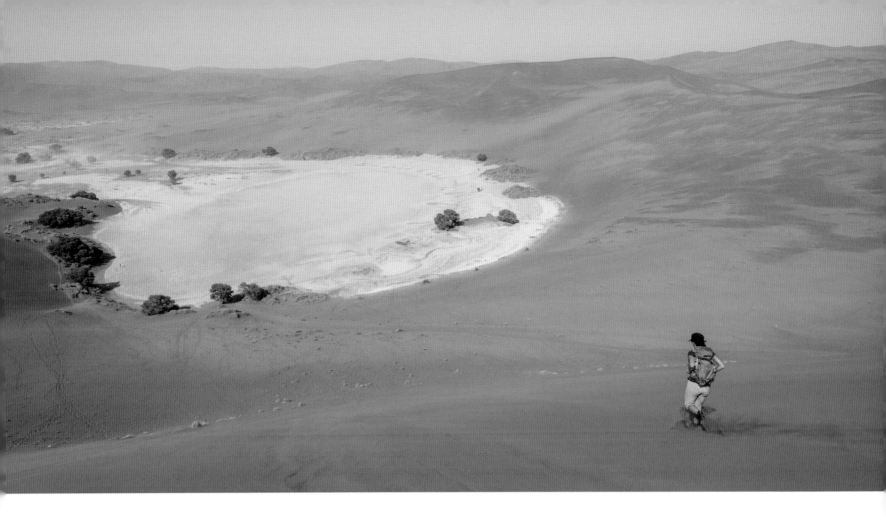

Africa

While travel in Africa is mostly associated with hopping on a jeep and going on safari, the opportunities for embarking on a different and arguably more intimate adventure are endless here. One of the best ways to truly get to know Africa is to do so by exploring the multitude of trails with your own feet. It is in doing so that you allow yourself to touch, taste, hear and smell Africa, and to open yourself to the opportunity to genuinely engage with the people and the country you are travelling through.

It is not only the diversity Africa has to offer that makes it such a unique choice for a journey on foot, but also its sheer rawness. No matter whether you go on a two-hour hike or undertake a multiday trek, walking in Africa can make hiking in Europe seem like a stroll through Disneyland. The terrain in Africa is rough, the huts are basic and do not offer the same luxury as Alpine lodges, and the trails are often ungroomed, sometimes even nonexistent. What you may forego in luxury, you certainly gain by getting off the beaten track and discovering the very essence of trekking, which is to be wholly present in the environment through which you are journeying.

Africa is so vast and diverse that it is all but impossible to address it as a single continent. According to the United Nations, Africa consists of 54 countries each with its own history, people, culture, languages, music, food, geology, geography and so much more. Within each country there is a richness of diversity seen almost nowhere else in the world. Africa doesn't simply offer something of everything, it offers a lot of everything, from rolling green foothills to undulating sand dunes, from coastal traverses to high mountains. It is this variety that makes the African continent a trekker's paradise, with the additional value of

ABOVE

A WOMAN RUNS DOWN FROM THE SUMMIT OF SOSSUSVLEI SAND DUNE IN NAMIBIA.

PREVIOUS PAGES

KILIMANJARO: NEAR ARROW GLACIER CAMP ON THE VERY STEEP WESTERN BREACH ROUTE.

offering a chance to explore remote wilderness areas, with histories so ancient that only fossils remain to tell their story.

Africa is the second largest continent in the world, which is fitting, as it is also home to the second longest mountain range in the world. There are plenty of meandering paths, interesting rock formations and hilltops to explore. The Great Escarpment range in southern Africa covers a distance of 5,000 kilometres (3,000 miles), which is almost twice the length of the highest mountain range in the world, the Himalayas. It lies predominantly in the Republic of South Africa and Lesotho, but extends into Zimbabwe, Namibia and Angola. The eastern portion of the Great Escarpment, within the borders of South Africa, is referred to as the Drakensberg, meaning Dragon Mountain. Naming a mountain range after the shape of an animal makes sense in Africa, as the fascinating wildlife is what this continent is mainly known for. However, whilst most people look at the Big Five and their peers from the comfort of their cars, the best way to explore this magnificent and rich animal world is to do so on an adventurous hike.

From the snow-capped peak of Kilimanjaro in Tanzania, through the forest-clothed slopes of Mount Kenya, to the alpine meadows of the High Atlas Mountains in Morocco or the strikingly beautiful Fish River Canyon in Namibia, Africa's magnificent rooftops offer glorious views and a wide range of trekking experiences that appeal to all kinds of active people, from hardcore mountaineers to dedicated walkers looking for an adventure.

Whilst this book can only scratch the surface of the abundance of hikes spread across the 30 million square kilometres (12 million square miles) of this vast continent, there are a multitude of treks that are worth exploring, such as hiking in the Simien Mountains in Ethiopia or scaling Mount Elgon in Uganda. But no matter where you go, Africa's landscapes, along with the people and their ancient traditions, are likely to touch your soul and stay with you forever. The beating African drums become your very heart beat, so much so that an African trekking experience is impossible to leave behind. Many say that Africa 'gets under your skin' – which could explain why so many return time and time again to be wrapped in the warmth that is the spirit of this continent.

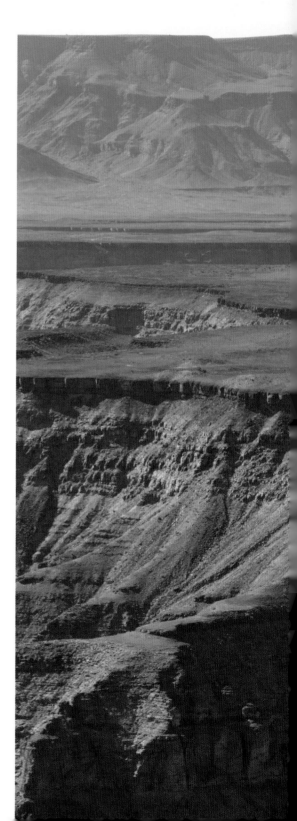

RIGHT

FISH RIVER CANYON: THE LARGEST CANYON IN AFRICA.

OVERLEAF

FISH RIVER CANYON: A VIEW OF FISH RIVER CANYON IN NAMIBIA FROM THE BEGINNING OF THE HIKING TRAIL.

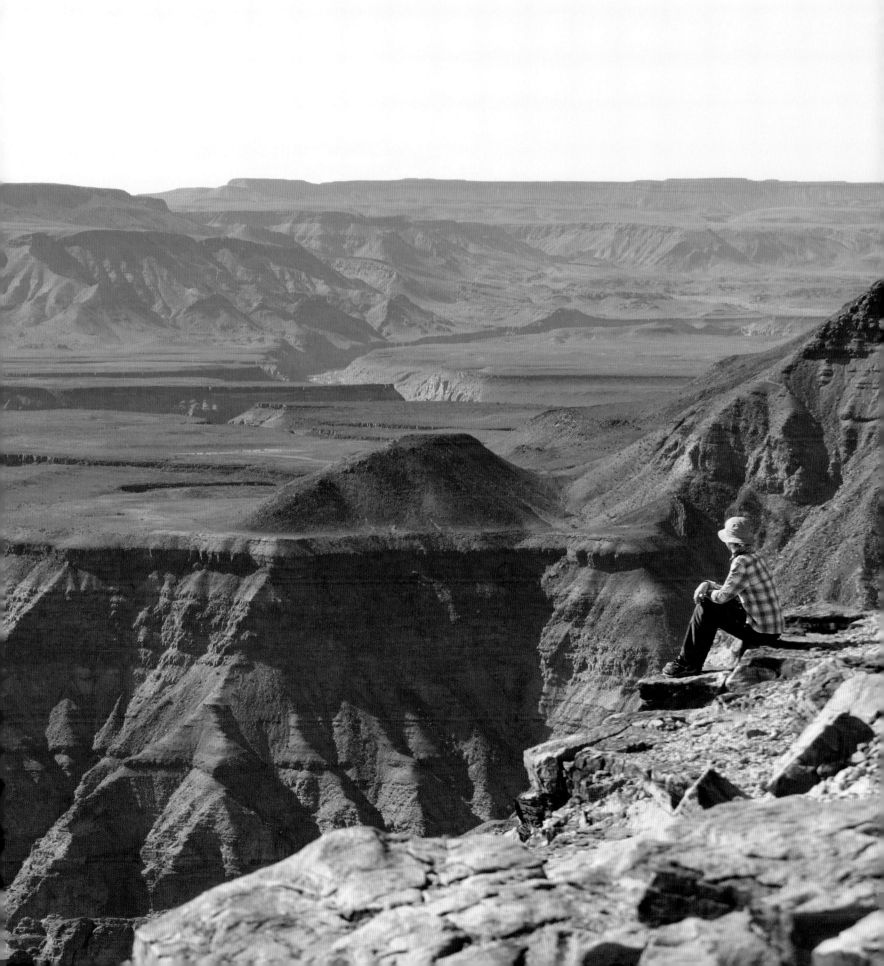

FISH RIVER CANYON
NAMIBIA

Sitting on the border between South Africa and Namibia, the Fish River Canyon trek is best described as spectacularly brutal. This 85-kilometre (53-mile) walk, covered over four to five days, offers a consistently exhilarating journey. It takes your breath away; not only by its majestic scenery, but also because of the excruciating heat.

Whilst this trek doesn't involve anything more technical than walking along a riverbed (bar the first 529-metre (1,736-foot) descent into the canyon), it is not for the faint-hearted. Arguably, this trek could be dubbed as the hottest in the world. Daytime temperatures can rocket above 40°C (104°F), with nights potentially dropping below freezing. But don't let this put you off. Being dwarfed by the dramatic setting of the world's second-largest canyon, with its gently bubbling sulphur springs and ancient rock formations standing proud against the barren sandscapes, makes it well worth the effort, not to mention encounters with wild horses and the potential sighting of a shy leopard.

The 180 kilometres (112 miles) of the Fish River Canyon stretch south from Seeheim down to the Orange River. If no shortcuts are taken across the rivers, the trek is 90 kilometres (56 miles) long, starting from Hobas and finishing at the hot-water spa resort of Ai-Ais. Many assume that walking a riverbed for almost a week would be monotonous, yet nothing could be further from the truth. Whilst there is a great deal of time spent revisiting your childhood – jumping across boulders – or attempting to be a light-footed lizard crossing shifting sands, every bend opens up a new scene for you to absorb. Unmoved for centuries, large relics of boulders that once formed the side of the canyon lie scattered across the riverbed, and great ridges entice you to explore them, as they rise high into the sky, guiding your eye upwards. Just south of Palm Springs, grab the opportunity to make a short ascent. It's well worth it, as you will be rewarded with a view of the four thick pinnacles known as the Four Finger Rock.

An extraordinary part of the trek's charm is the canyon's changing face. At dawn, it is alight with bright fires of gold, which give way to bleached whites in the heat of the day, ending with deep reds and blues as the sun goes to sleep, making way for the night sky to explode with stars. The sky here is famous for being the clearest almost anywhere in the world, allowing you to lose yourself in the darkness as you lie by the campfire being lulled to sleep by the restless movement of the canyon.

This is a fully self-supported trek. The remoteness of the canyon requires you to carry everything, except water, which is available with the use of purification. Due to high demand for permits, it is recommended to book early and ensure that you have at least two others to walk with. Once you are in the canyon there are limited escape routes, so the trek definitely needs your full commitment.

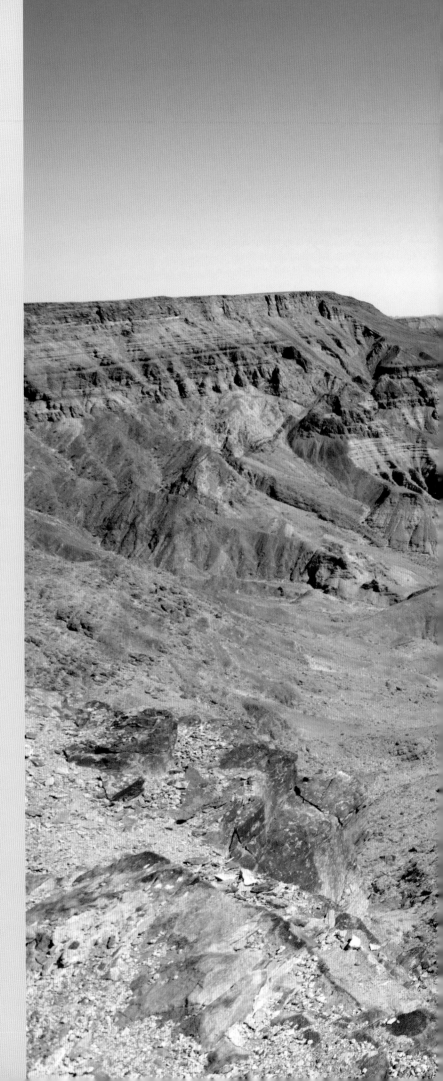

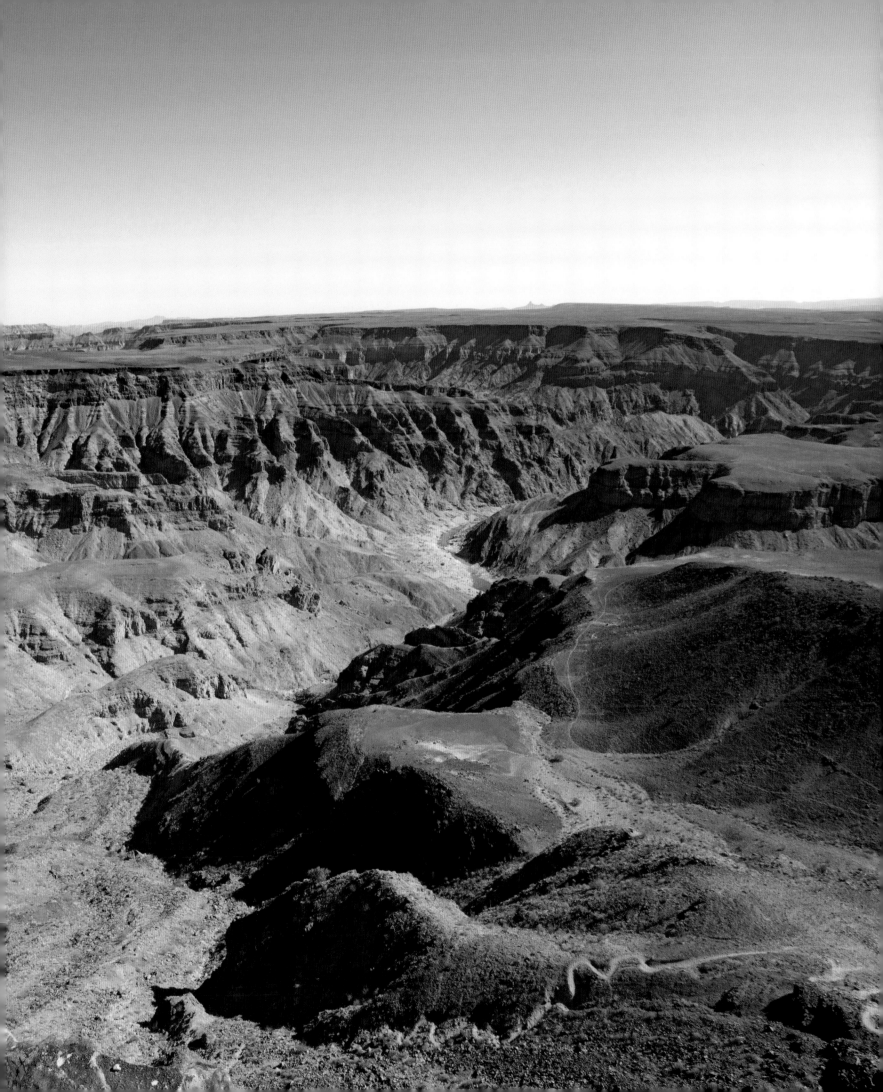

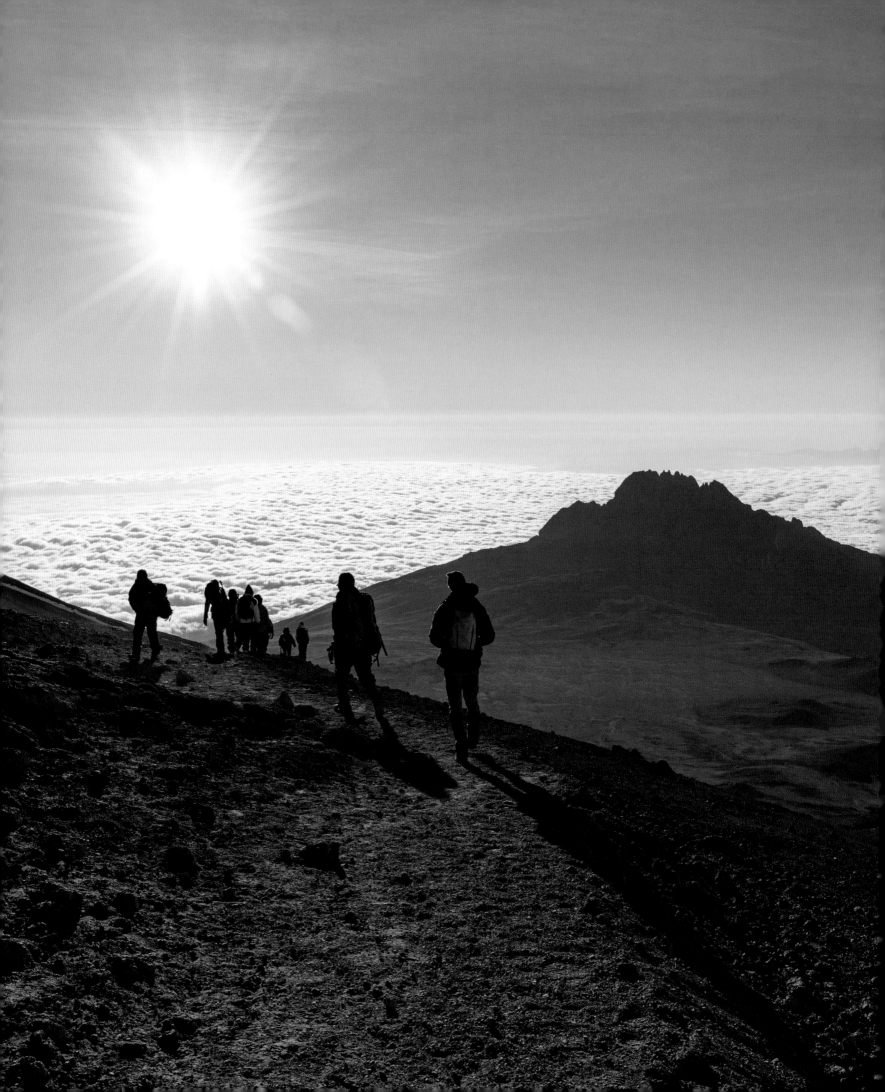

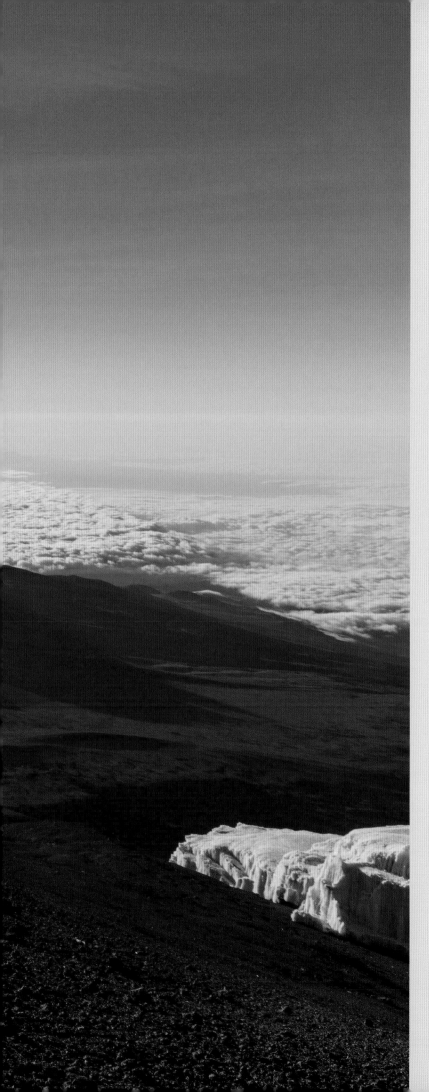

KILIMANJARO
TANZANIA

Perched between Kenya and Tanzania, the Shining Mountain's ice-capped summit rises 5,895 metres (19,340 feet) from vast equatorial plains dotted with the 'Big Five' animals. As the highest point in Africa, and the tallest free-standing mountain in the world, Kilimanjaro has become the pride of Tanzania. It is on many people's bucket list, and the reasons range from wanting to do it for the physical challenge, to simply longing to watch the sun cast its first morning light over the plains of Africa, or to lie under a freezing night sky and marvel at the snow cap being illuminated by the ever-present Milky Way.

Every year, around 40,000 people follow in the footsteps of the Austrian/German pair Ludwig Purtscheller and Hans Meyer, who were the first to set foot on the top of this dormant volcano in 1889. While it is an important accomplishment for mountaineers striving to climb the highest peaks on the seven continents, this climb requires no technical skills. Trekkers with a moderate level of fitness, adventurous spirit, good patience and a body that adapts well to altitude have a good chance of reaching the Roof of Africa.

Kilimanjaro has seven established routes and deciding which one to take depends on how much time you have, whether you want to sleep in mountain huts or a tent and your level of technical experience. Most people opt for the Marangu route, which due to its touristy character is also known as the Coca-Cola route. This is the fastest and most accessible way, and can be completed in six days – though be aware that attempting such a quick trip makes you more susceptible to altitude sickness.

The climb starts in the montane forest, with its eerie lichen dripping from the trees shrouded in low cloud, before heading into alpine moorland and heath dotted with bright flowers. The most intriguing section is probably between 4,000 and 5,000 metres (13,100 and 16,400 feet), where the landscape resembles that of *Jurassic Park*. From here, the terrain is lunar: volcanic scree and rock is dotted with yellow daisies. While Kilimanjaro's permanent but constantly retreating icecap is towering above, you will be able to watch a wide array of bird life, as well as monkeys, nocturnal cats, aardvarks, honey badgers, antelopes and, if you are lucky, maybe even a leopard.

The summit bid starts at around midnight from the Kibo hut, and trekkers usually reach the top just in time to welcome dawn. Watching the sun rise over Africa is a spectacular compensation for the steep and exhausting climb up the unforgiving scree slope.

LEFT

TREKKERS HEAD DOWN FROM KILIMANJARO'S
SUMMIT, LOOKING OVER MAWENZI, AFRICA'S
THIRD-HIGHEST PEAK.

DRAKENSBERG GRAND TRAVERSE
SOUTH AFRICA

The Drakensberg Grand Traverse (DGT) is best described as a journey rather than a trek, which carries a notoriety and respect not only for those who complete it, but also for those who start it. Covering approximately 230 kilometres (140 miles), this unmarked, self-supported, off-trail hike is like no other in the world. The DGT is certainly not a hike for amateurs. Whilst there are no technical sections, there is no such thing as an 'easy kilometre', so be advised to choose both your footwear and your trekking partner wisely.

The Drakensberg mountains are indescribably beautiful – and brutal. They demand respect from all who choose to venture into them, but those who do, rapidly learn that this respect is well rewarded. With the literal translation of Dragon Mountains, it is no surprise that the DGT route is formed of approximately 34 ridge lines and valleys that need to be navigated, each with their own spectacular waterfalls and rock formations. The gagged edge of the escarpment gives way to rolling hills that connect South Africa with Lesotho, and that are often scattered with herds of goats, donkeys and horses of the Basotho people, who have roamed these lands for years.

With a constantly changing weather pattern, it is easy to encounter four seasons in one day and, more often than not, you feel as if you are walking in the sky, with the cloud base forming below you. Thunderstorms and heavy rain showers are commonplace in the summer months, whereas the winters generally see the mountains covered in snow. You can undertake the DGT at any time of year, though most opt for May, as the weather tends to be more stable then.

You should expect to be in the mountains for approximately 12 to 15 days, though there are exit points along the way, leading down to well-stocked camps run by the South African National Parks (SANParks). There are caves in which you can sleep; however, as some are hard to find and you may not always reach them, it is probably best to plan to camp. A tent is better than just a bivouac bag, and travelling in groups of three or more is sensible for security reasons. As you will cross between South Africa and Lesotho without realising it, always have your passport handy, in case you bump into the border control.

The Drakensberg escarpment is certainly not for the faint-hearted. If you want to complete the DGT, you need to summit the six highest peaks in the region, all of which sit above 3,000 metres (9,800 feet). This means that the total elevation gain of the trek is more than 9,000 metres (29,528 feet) – higher than climbing Mount Everest all the way from sea level. Once you're up there, there is little chance of turning back or pulling out – you are committed. So, never head up there unprepared, always carry more food than you hope to need and never skimp on safety gear.

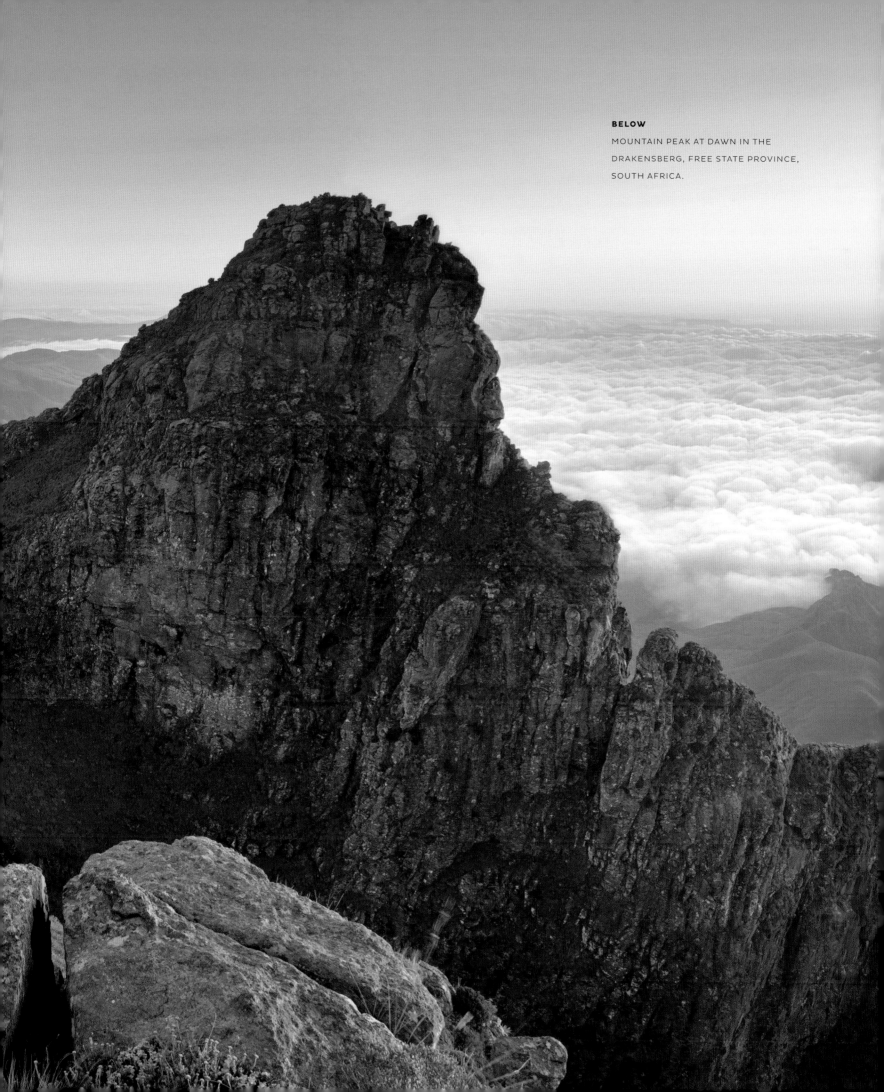

AUSTRALIA & NEW ZEALAND

..

OVERLAND TRACK (AUSTRALIA)

LARAPINTA TRAIL (AUSTRALIA)

TONGARIRO ALPINE CROSSING (NEW ZEALAND)

MILFORD TRACK (NEW ZEALAND)

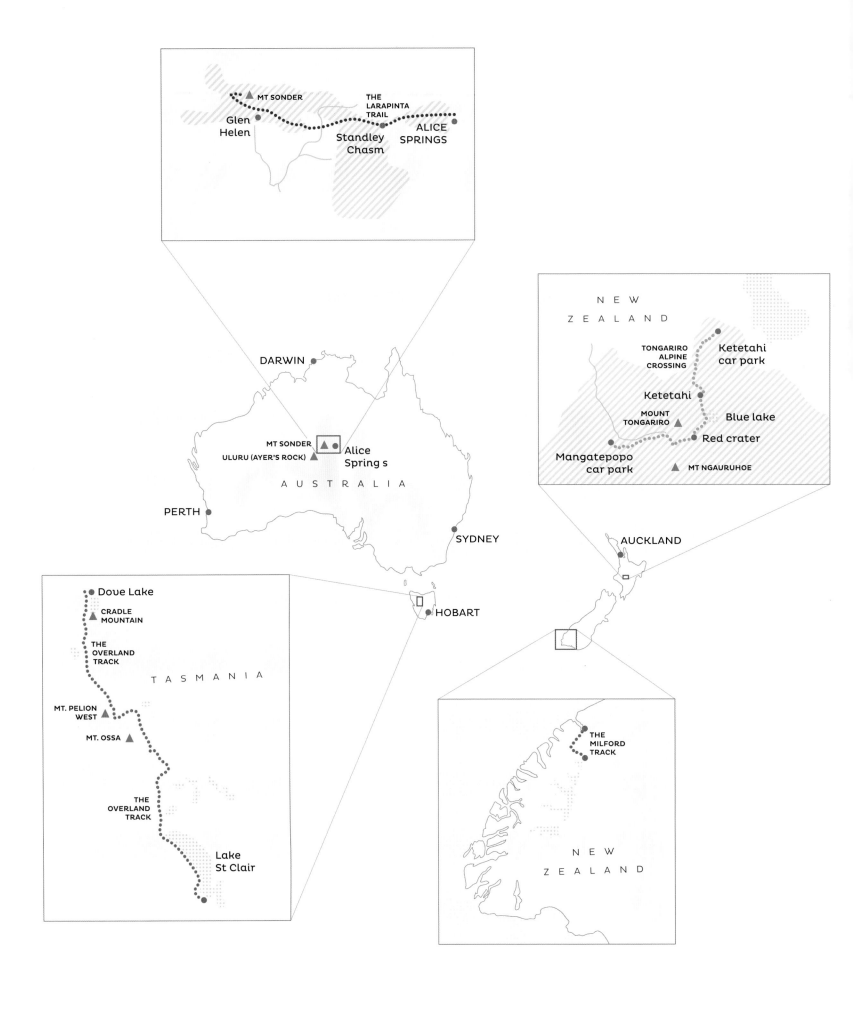

Australia — Larapinta Trail region (inset)

MT SONDER
THE LARAPINTA TRAIL
Glen Helen
Standley Chasm
ALICE SPRINGS

Australia

DARWIN
MT SONDER
ULURU (AYER'S ROCK)
Alice Springs
AUSTRALIA
PERTH
SYDNEY
HOBART

New Zealand — Tongariro (inset)

NEW ZEALAND
TONGARIRO ALPINE CROSSING
Ketetahi car park
Ketetahi
MOUNT TONGARIRO
Blue lake
Red crater
Mangatepopo car park
MT NGAURUHOE
AUCKLAND

Tasmania (inset)

Dove Lake
CRADLE MOUNTAIN
THE OVERLAND TRACK
TASMANIA
MT. PELION WEST
MT. OSSA
THE OVERLAND TRACK
Lake St Clair

New Zealand — Milford Track (inset)

THE MILFORD TRACK
NEW ZEALAND

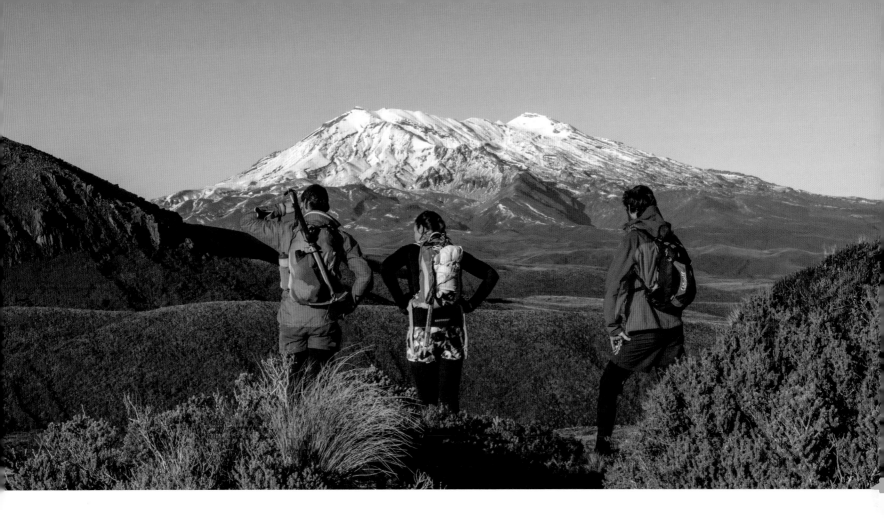

Australia & New Zealand

Saying that a landscape is reminiscent of *The Lord of The Rings* films has become one of the biggest clichés around. Say it in New Zealand, however, and you are often simply stating a fact. The Oscar-hoarding, Orc-slaying trilogy was filmed in the Land of the Long White Cloud (the translation of 'Aotearoa', the Maori name for the country), chosen partly because director Peter Jackson is a New Zealander; but, more pointedly, simply because the scenery has a majesty and drama of fantasy proportions.

Few places match New Zealand for its combination of safe, well-maintained trails, excellent hiking facilities and fantasy-level scenery. Unlike across the Tasman Sea, there are no creatures (other than an exceedingly rare spider) that pose real risk to the walker. And while there are some serious mountains, the main trails are excellently managed. Nine Great Walks – technically, one of which is a kayak trip – are, like England's National Trails (see page 10): government funded, well maintained and waymarked. But here, the trails are also dotted with huts that include toilets, cooking facilities, drinking water and sleeping areas – you still need to take a sleeping mat and bag (to rest your weary head and smelly socks in, respectively); and which provide a sociable place for playing cards and drinking wine with like-minded souls.

The Nine Great Walks (also, coincidentally, a totemic number in Tolkien mythology) are popular trails, and include what some say is the most spectacular trail in the world: the Milford Track. Locals may tell you that the nearby Routeburn Track is just as good, while the Kepler Track is another dramatic alternative – all three are in Fiordland National Park, part of the Te Wāhipounamu region.

ABOVE

TONGARIRO ALPINE CROSSING: LOOKING ACROSS THE TONGARIRO CROSSING TOWARDS MOUNT RUAPEHU.

PREVIOUS PAGES

LARAPINTA TRAIL: ANCIENT ROCKS OF THE HEAVITREE RANGE IN THE FOREGROUND WITH THE ALICE VALLEY SEPARATING MOUNT GILES IN THE DISTANCE.

Indeed, South Island has marginally superior scenery, because of the dashing, snow-topped Southern Alps, glaciers and the deep, soggy greenery of Fiordland National Park. Towards the top of the island is Abel Tasman National Park, offering curved beaches and palm-tree-festooned trails. The Rakiura Track, on the lesser visited Stewart Island, offers a remoter experience. North Island's star attraction is Tongariro National Park, a volcanic landscape that evokes Mars and was the backdrop for Mordor in Peter Jackon's films. Elsewhere, native forests, huge lakes, fierce rivers, spurting geysers, snow-topped mountains, deep gorges and clandestine valleys await.

Almost everywhere you go in New Zealand, there is great tramping to be had. Walking here is, largely, very safe, spectacular and very much a part of the Kiwi psyche – outdoor leisure is central to the culture. New Zealand really is a trekker's Valhalla.

BELOW

THE 82-KILOMETRE OVERLAND TRACK, CRADLE MOUNTAIN-LAKE ST CLAIR NATIONAL PARK, TASMANIA.

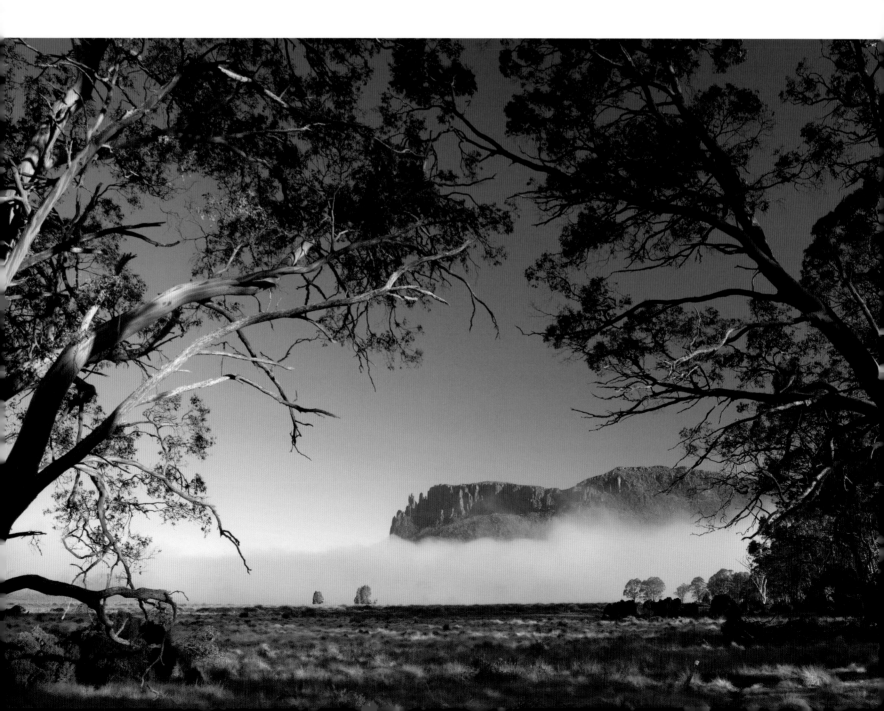

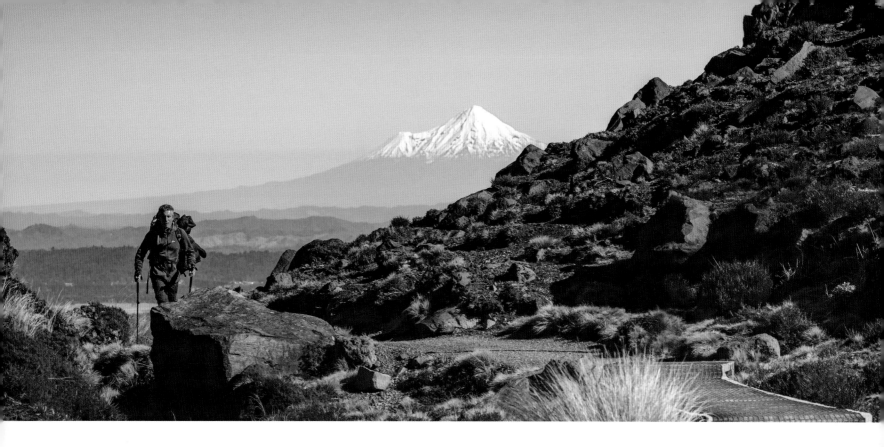

ABOVE

TONGARIRO ALPINE CROSSING: NEAR
THE START OF THE TREK, LOOKING BACK
TOWARDS MOUNT EGMONT (TARANAKI).

Across the Tasman Sea from New Zealand's shores, few country names are as evocative of dreamy landscapes and weird and wonderful animal life as the simple, powerful word 'Australia'. The quintessential Aussie image would likely include kangaroos bouncing across an orange, dusty, warm landscape to the soundtrack of a didgeridoo – and that can certainly be experienced. But Australia's trekking options are surprisingly diverse.

Of course, there are alluring desert regions, with huge rock formations and plunging canyons, all smothered in ancient, rusty redness. This is, after all, thought to be Earth's oldest landmass, and the Larapinta Trail is one of the most satisfying ways to get a taste of this rich, historic rock. In the northeast, tropical regions invite the walker to explore jungles, incredibly picturesque beaches and unique ecosystems, not least on Fraser Island National Park, and the comparable Hinchinbrook Island's Thorsborne Trail. The south, meanwhile, offers huge, forested mountainous and wilderness regions – with approximately 21 million inhabitants on an island the size of the United States, but most of them living in coastal cities. Wilderness regions are something Australia does exceptionally well. The biggest wonder about the Blue Mountains is not that they are blue, but more that they are not really mountains, rather epic canyons, stretching on forever. There is some spectacular coastal walking to be had, too, in both New South Wales and Victoria.

The number-one trekking destination in Australia, however, is that apple-shaped island at the bottom, Tasmania. With a climate more similar to New Zealand or the United Kingdom, it is uber-green, with a deeply ancient feel, and has different landscapes and fauna to the mainland. Tasmania is also home to what is probably the country's premier trail, the Overland Trek.

The wildlife is extraordinary – and often unique – right across Australia, and, though scare stories about crocodiles and sharks make occasional headlines, there is far more to marvel at in the cheeky kookaburras, kangaroo rats, wobbling iguanas, stout wombats and – if you're really, really lucky – duck-billed platypuses.

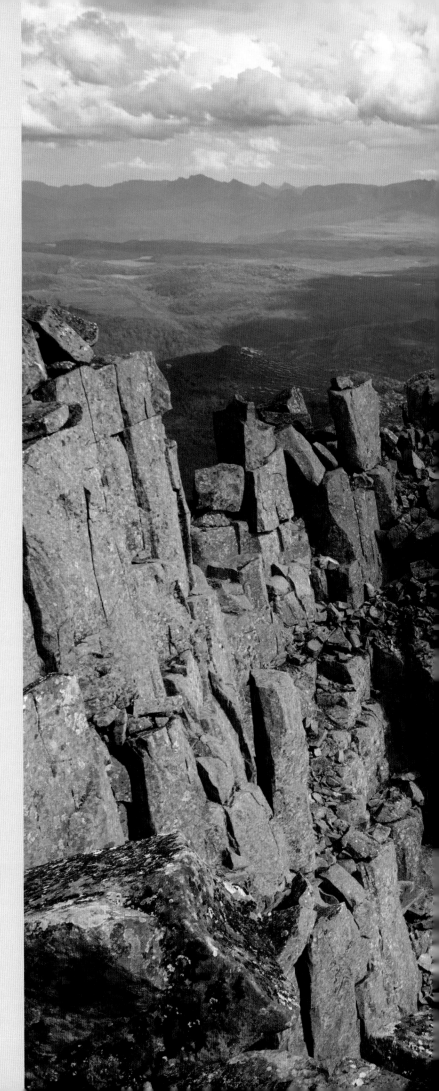

OVERLAND TRACK
AUSTRALIA

Tasmania's 82-kilometre (51-mile) Overland Track regularly tops the lists of best world treks, and rightly so. There are tougher treks (such as the South Coast Track) and significantly quieter, more remote ones (Mount Anne Circuit, for example), but there are probably none more spectacular.

Cradle Mountain-Lake St Clair National Park is an ancient landscape of alluring lakes and valleys, carved by glaciers over two million years. The region is one of the last expanses of temperate rainforests in the world, home to towering trees, threatened plants and ancient conifers, such as the wonderfully named Huon pine and King Billy pine.

Lunar-like high meadows, buttongrass-clad moorlands and towering trees distinguish the region as a vital refuge for fauna species already extinct in mainland Australia, such as pademelons, the Tasmanian devil, the orange-bellied parrot and the eastern quoll. Some of the wildlife here is plentiful and surprisingly tame – it is one of the best places to see the elusive, shy platypus in all of Australia.

Going south, the Overland Track starts with a dramatic view as you approach Cradle Mountain and Lake Lilla, nestled at the ankles of the totemic, double-headed gothic peak. From there, you traverse alpine plateaus, with steep, green valleys on either side of the trail, and lakes and snow-capped mountains stretching into the distance, all alluringly anachronistic. The route passes Mount Ossa – at 1,617 metres (5,305 feet), Tasmania's highest peak is often snow-encased, and is most remarkable for its two devilish horns – and one of several tempting detours from the main trail.

Finally reaching St Clair, the deepest lake in Australia, it can appear serene, shimmering and imperious. Well worth the multiday pilgrimage, this is the perfect place to watch the sun bleed across the horizon. From here, a ferry can transport you back to civilisation, though the temptation not to rush back may be stronger, and the final 17-kilometre (11-mile) lakeside stretch can be hiked, through enchanting moss and fern-dominated woods.

The mystery of the Tasmania tiger pervades the area (officially extinct, but claimed sightings occur, especially around here, and conspiracy theories abound). The fact that the weather could do almost anything at any time of year adds to the sense of adventure.

The Overland Track can be experienced in several different ways: in the company of others during the popular summer season; in a less-crowded shoulder season; during winter (take snow shoes); guided, independent; camping, or in the comparative luxury of a hut-to-hut experience.

RIGHT

BARN BLUFF FROM CRADLE MOUNTAIN-LAKE,

ST CLAIR NATIONAL PARK.

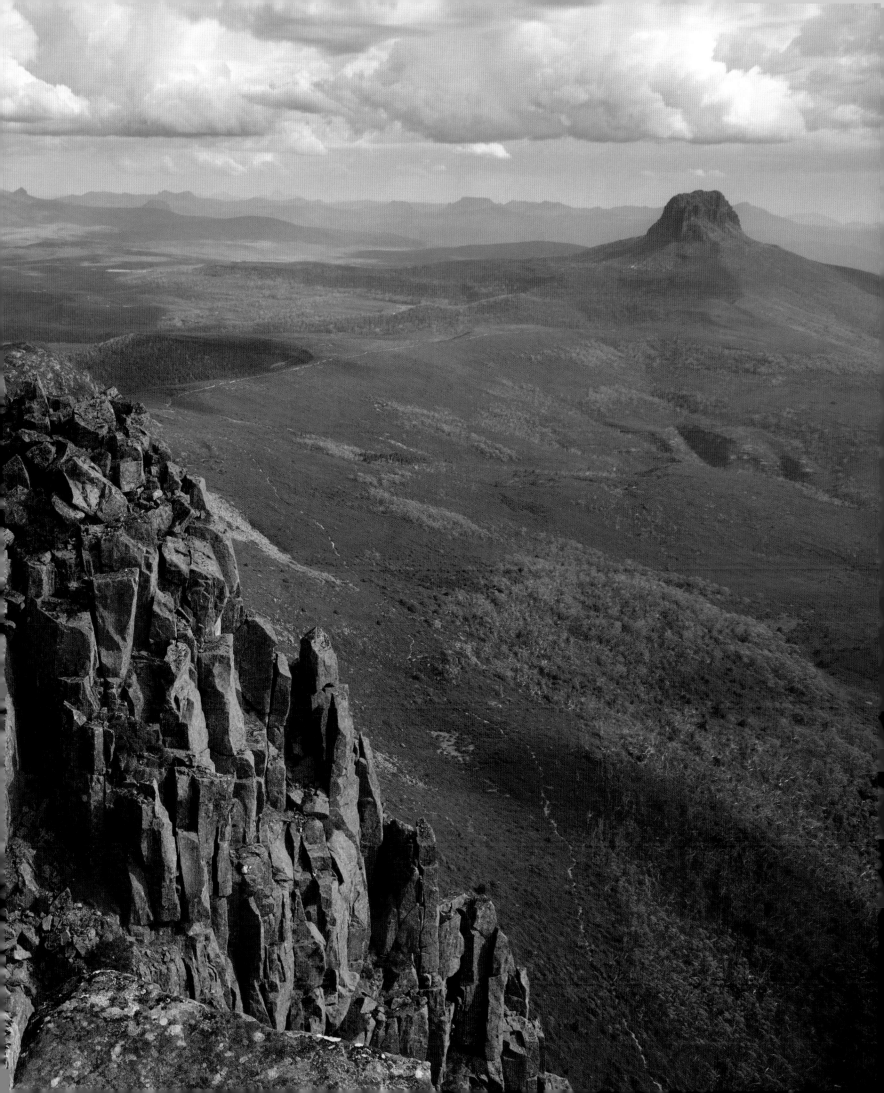

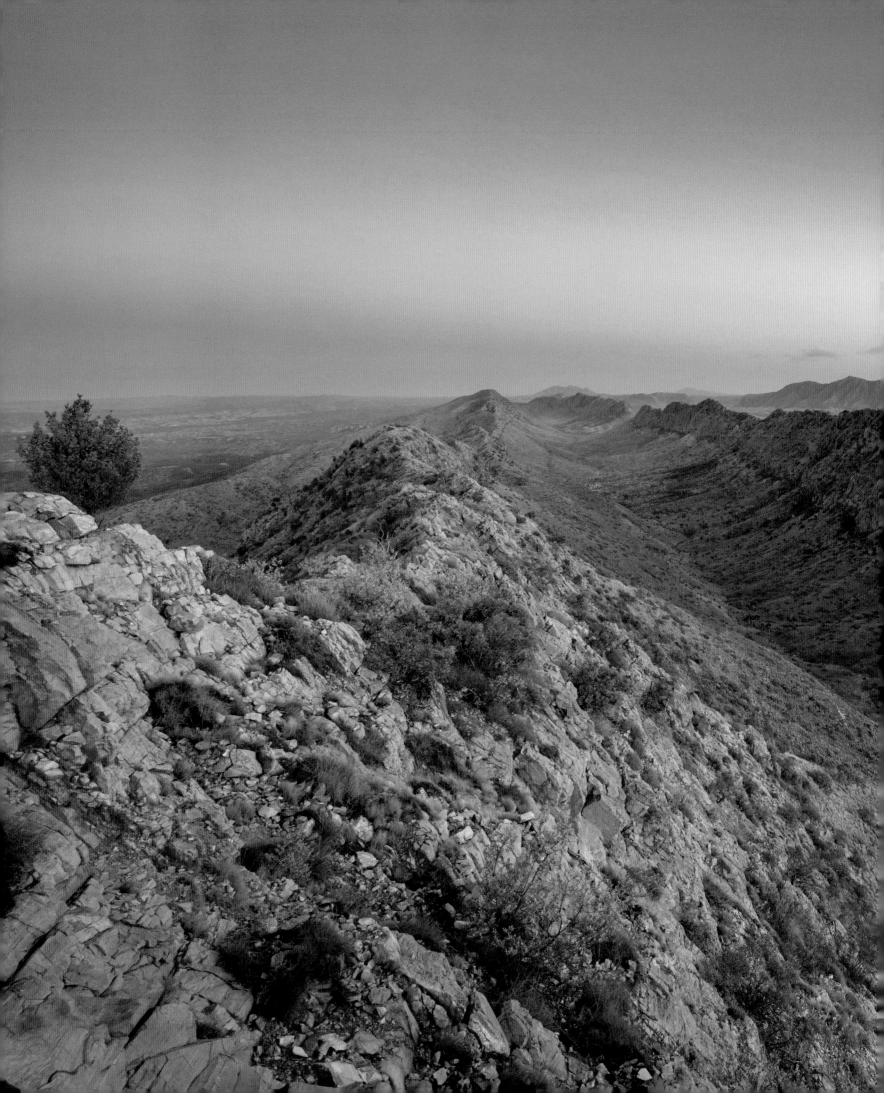

LARAPINTA TRAIL
AUSTRALIA

The hefty Larapinta scorches a 223-kilometre (139-mile) trail through the Red Centre, Australia's remote, idiosyncratic, much-mythologised Outback. It's a seemingly inhospitable – but you'll be surprised how much life there is – and hyper-rugged land of rust-red rocks and sand, deep gorges, ghost gum trees and cooling waterholes.

The Larapinta Trail is part of Australia's Big Three, along with the Overland Track (see page 160) and Western Australia's Bibbulmun Track.

The trail can be walked in either direction between Alice Springs' historic Telegraph Station and Mount Sonder 1,380 metres (4,528 feet) to the west, one of the territory's highest mountains. The route traces the West MacDonnell Ranges, in the West MacDonnell National Park, sometimes along ridges, sometimes in the plains below. The MacDonnell Ranges were once as large as the Himalayas, but are a great deal smaller today, although still irresistibly alluring.

The trail includes numerous sites sacred to the Arrernte Aboriginal people, including The Ochre Pits, layers of multicoloured rock traditionally mixed with emu fat to create body paint for ceremonies and also traded with neighbouring clans. Other highlights include: the swimming hole at Ormiston Gorge; enigmatic Ormiston Pound – a ring of mountains; the Finke River, which could be a string of puddles, or a raging torrent, depending on the time of year; and Serpentine Gorge – actually two gorges, created by a creek cutting through two ridges of Heavitree quartzite. Simpsons Gap is a literal gap in the ranges with a picturesque waterhole, again, sacred to the Arrernte. One almost constant highlight are the numerous views across the rugged West MacDonnell Ranges ridges.

During summer months, temperatures can exceed 45°C (113°F), and the dangers of heatstroke and dehydration mean that most people walk the trail during the winter. The trail is remoter than most, and food-drops will be needed by most trekkers. Designated campsites have water tanks approximately a day's walk apart. The walk needs some planning, although it isn't a complete wilderness experience – places such as Simpsons Gap are popular tourist spots.

Independent trekkers take an average of 10 to 14 days to hike the trail, while some guided options are available with three- or seven-day itineraries – a sort of greatest hits, ending each day kicking back in your swag bag by a campfire at nightfall, admiring the famously star-filled Outback night skies.

LEFT

LONG RIDGES AND VALLEYS RUNNING IN AN
EAST–WEST DIRECTION OF THE CHEWINGS
RANGE, SEEN AT DAWN FROM COUNTS POINT.

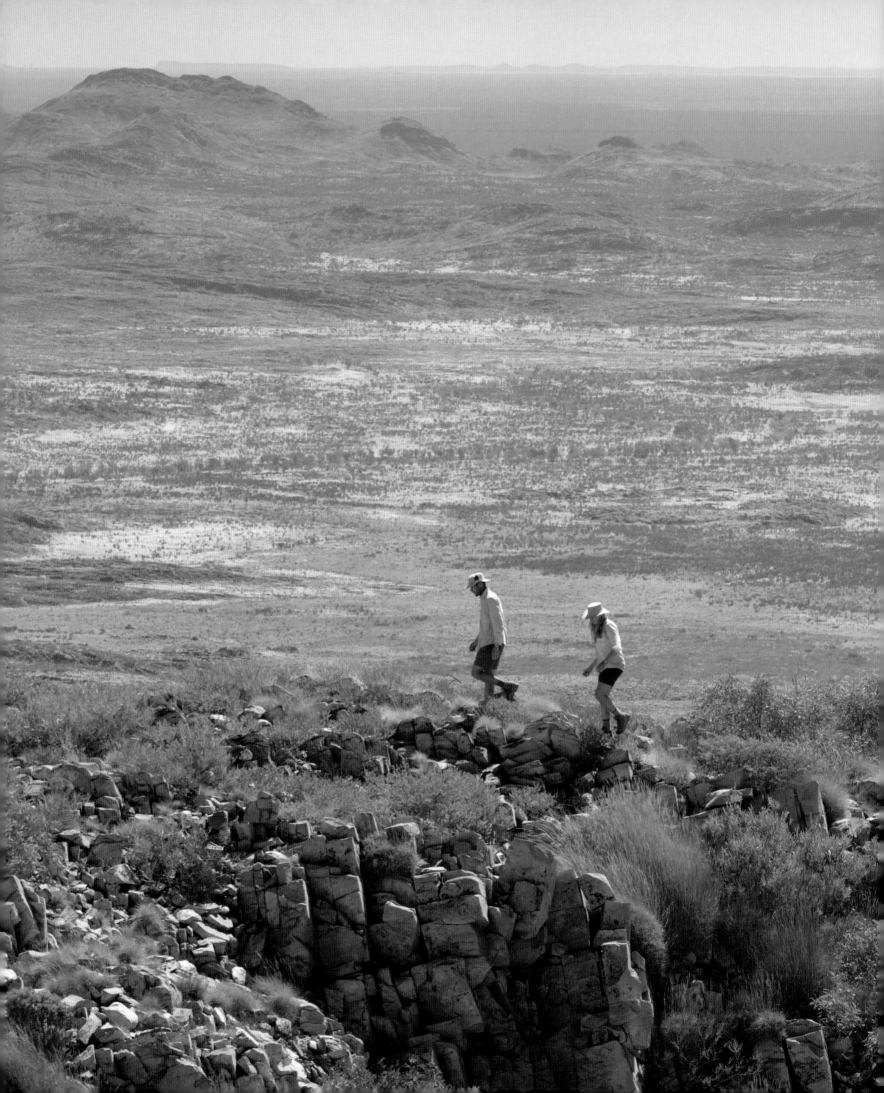

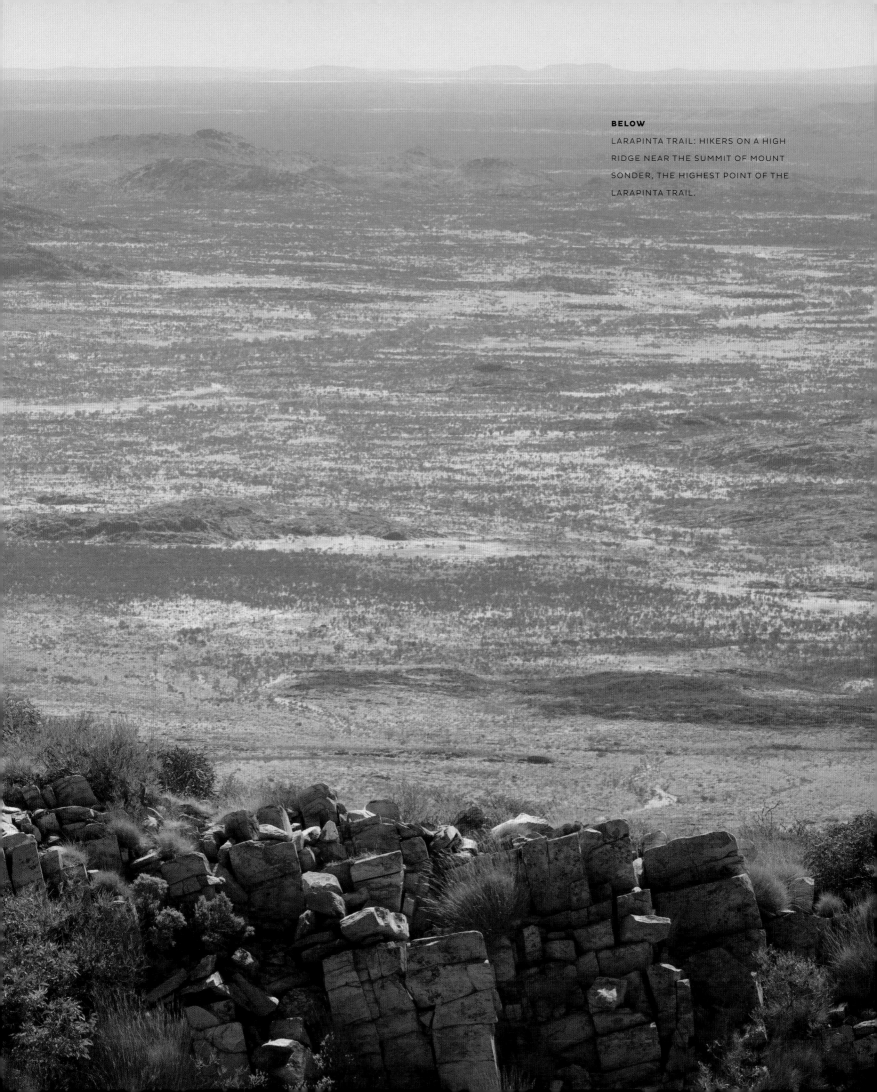

TONGARIRO ALPINE CROSSING
NEW ZEALAND

By all reputable accounts, the Tongariro Alpine Crossing in Tongariro National Park on North Island, New Zealand, is one of the greatest day hikes in the world – or, at least, one of the most unique. Over the course of just 19.4 kilometres (12 miles) and, generally, about eight hours of moderately strenuous walking, it is possible to see three active volcanoes, two dormant volcanoes, multiple emerald-green volcanic lakes, hot springs and horizon-to-horizon views of a landscape that is more similar to Mars than one would expect from any place on Earth.

There is a reason that *The Lord of the Rings* and *The Hobbit* trilogies were filmed, in part, here. Tongariro National Park is the closest thing to the mythical evil kingdom of Mordor that exists. The perfect volcanic cone shape of 2,287-metre (7,503-feet) Mount Ngauruhoe – which the Tongariro Alpine Crossing traverses directly beneath – was used to film Mount Doom.

From the expansive, multicoloured desert brush of the surrounding plains to the red, volcanic dust and rock of the high alpine areas of Tongariro National Park, and up to the eight permanent glaciers of 2,797-metre (9,177-feet) Mount Ruapehu, the Tongariro Alpine Crossing brings travellers through an area that is, in every sense of the phrase, another world entirely.

Part of a 2,500-kilometre (1,553-mile)-long string of active volcanoes, Tongariro National Park does not stay the same for long – not even the weather, which can shift from sunny skies to whiteout blizzard in a matter of minutes. That is part of what makes the Tongariro Alpine Crossing so interesting, and why it's worth returning again and again. It is rarely the same experience, even after just a few days.

The Te Maari craters on the northern slopes of Mount Tongariro erupted in August 2012, and then again in November that same year. Mount Ngauruhoe historically erupted about every nine years; although, as of this book's publication, its last eruption was in 1975, so another could happen at any time. As recently as 2007, Mount Ruapehu erupted violently, not long after two previous eruptions in 1995 and 1996.

It is hard to see at any given moment, but if you look closely, and wait long enough, the barren landscape of Tongariro National Park appears as transitory and impermanent as the molten lava that created it.

RIGHT

FROM THE SUMMIT OF MOUNT TONGARIRO TO
MOUNTS NGAURUHOE AND RUAPEHU AT SUNRISE.

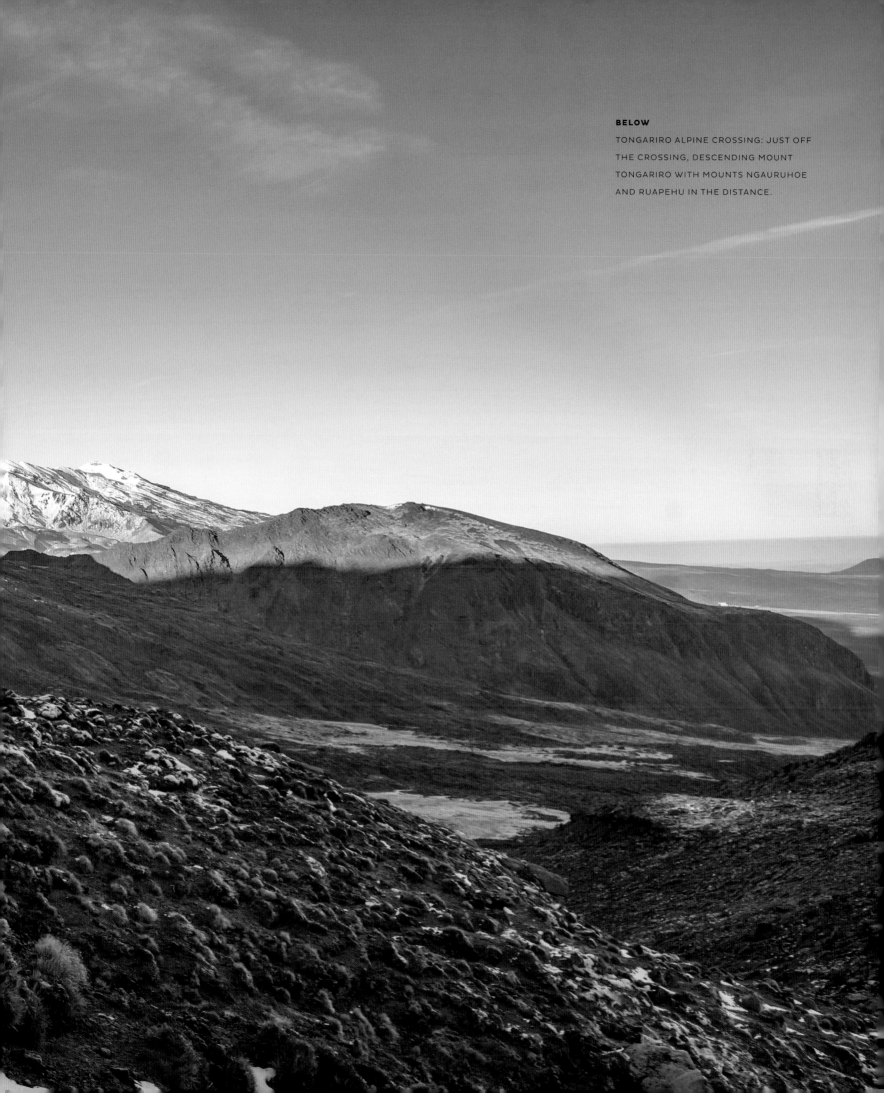

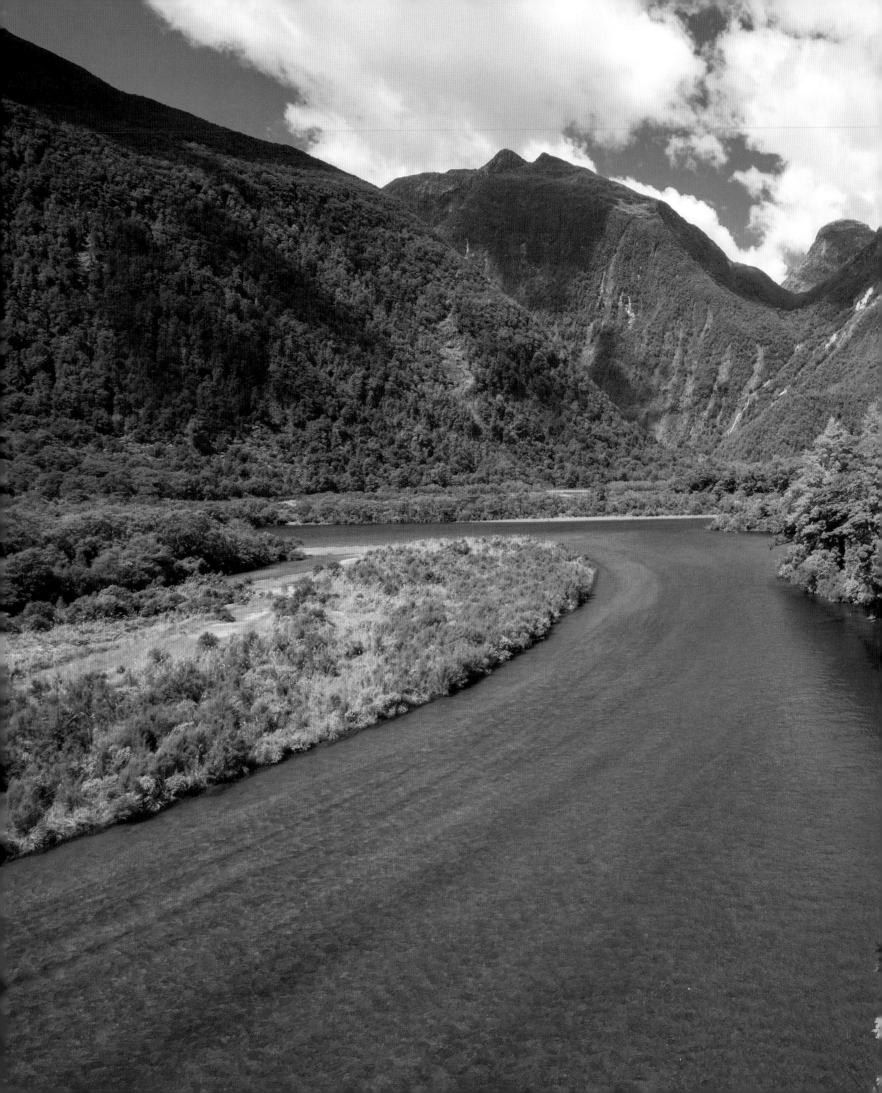

MILFORD TRACK
NEW ZEALAND

Steep-sided, mountain-lined fiords, dense rainforest and 53 kilometres (33 miles) of immaculately kept foot trail make up the four-day long Milford Track. For those who want to experience some of the remotest corners of New Zealand, but don't have significant trekking experience, the Milford Track is a great place to start.

Running through the heart of the 12,500-square kilometre (4,800-square mile) Fiordland National Park on New Zealand's South Island – the country's largest and most aptly-named national park – this over 100-year-old trail is arguably the greatest of the nine official Great Walks in the entire country; and, quite possibly, one of the best man-made treks in the world. It is also one of the easiest, most accessible multiday alpine routes anywhere.

Rainforest-covered mountains butting up against deep, ice-cold ocean isn't typically the most conducive terrain for strolling. Yet, that is precisely the environment through which the Milford Track cuts its way with aplomb.

The well-manicured and, sometimes even, gravelled footpath is almost wide enough for two people to walk side by side along its entire length. Trampers, as hikers are called in New Zealand, don't even require a tent, since there are high-capacity huts conveniently situated about a six-hour walk apart from one another. Provided a tramper doesn't sleep in until noon, there is no reason why they shouldn't make it to the next shelter before nightfall, at least during the summer months.

Most trampers begin the trek by taking the regularly scheduled ferry across Lake Te Anau and spending their first day meandering for a pleasant hour through magnificent, old-growth beech forest to the first mandatory night's stay at the Neale Burn Hut. Only 40 walkers are permitted to start the track each day, so each night's stopping point is set in stone for each tramper, ensuring there is enough space for everyone on the trail at each hut, every day.

Following along the shore of the eerily emerald-green-looking Clinton River, the trail then climbs up out of the forest into grassy prairie lands rimmed by ice-clad mountaintops and dotted by cold, alpine lakes. On day three, a series of switchbacks leads higher into the mountains over Mackinnon Pass, which affords some of New Zealand's best mountain views on clear days and a sense of being on top of the world. From the pass, the track descends rapidly back into the forest, eventually crossing the Arthur River over an impressive swinging bridge to end at a white-sand beach and another boat ride back to civilisation.

LEFT

THE ARTHUR RIVER FLOWING PAST THE
STEEP-SIDED MOUNTAINS TYPICAL OF
FIORDLAND NATIONAL PARK.

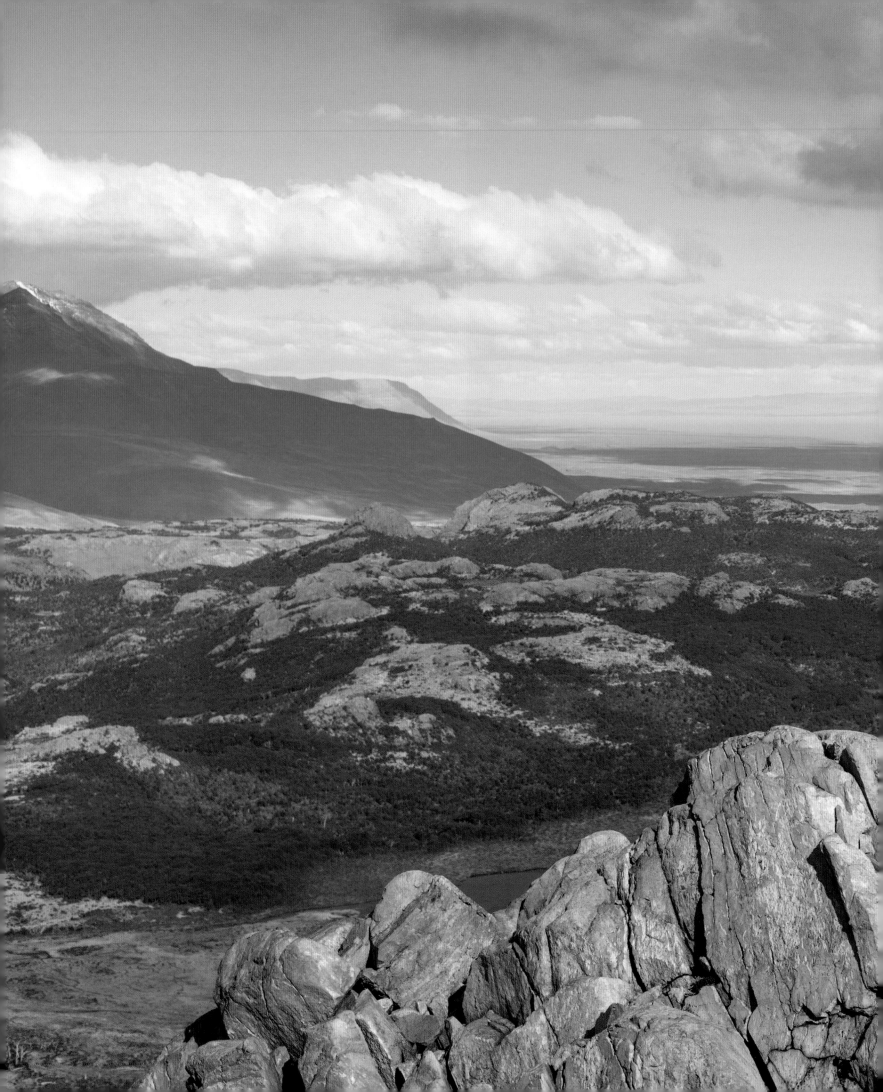

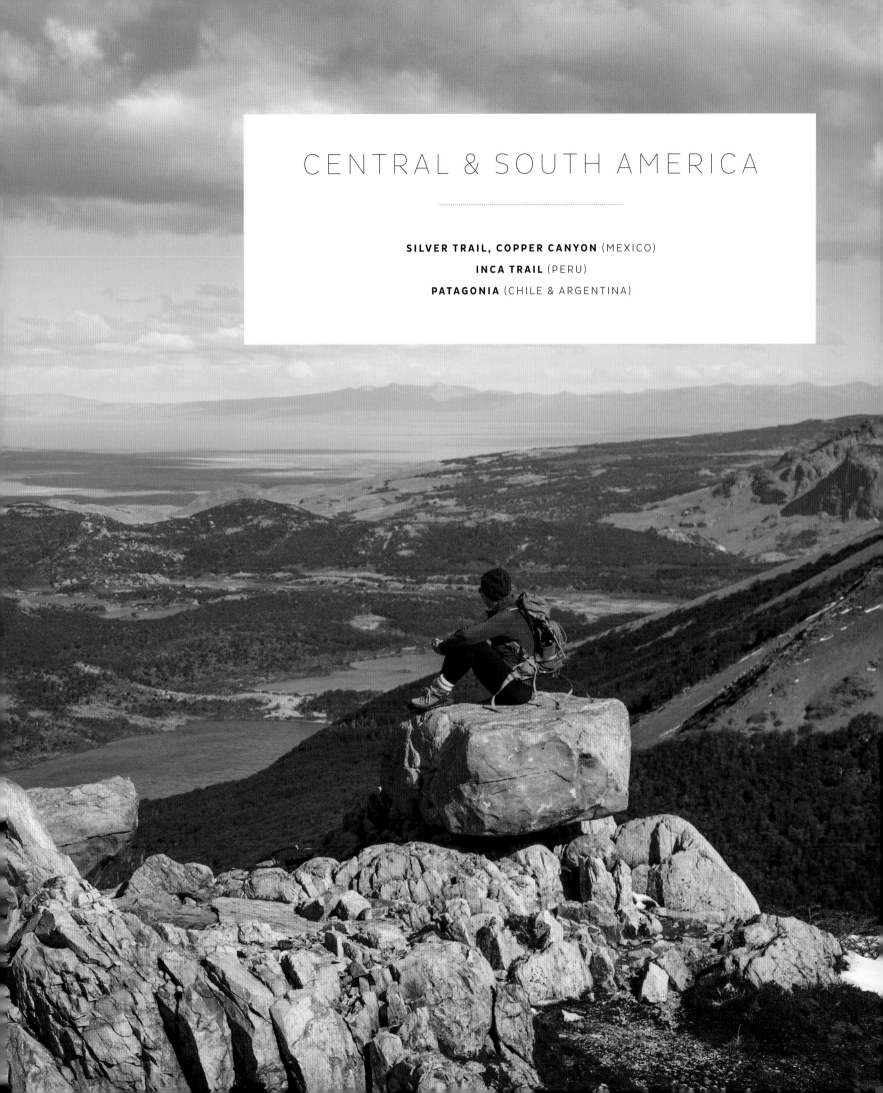

CENTRAL & SOUTH AMERICA

..

SILVER TRAIL, COPPER CANYON (MEXICO)

INCA TRAIL (PERU)

PATAGONIA (CHILE & ARGENTINA)

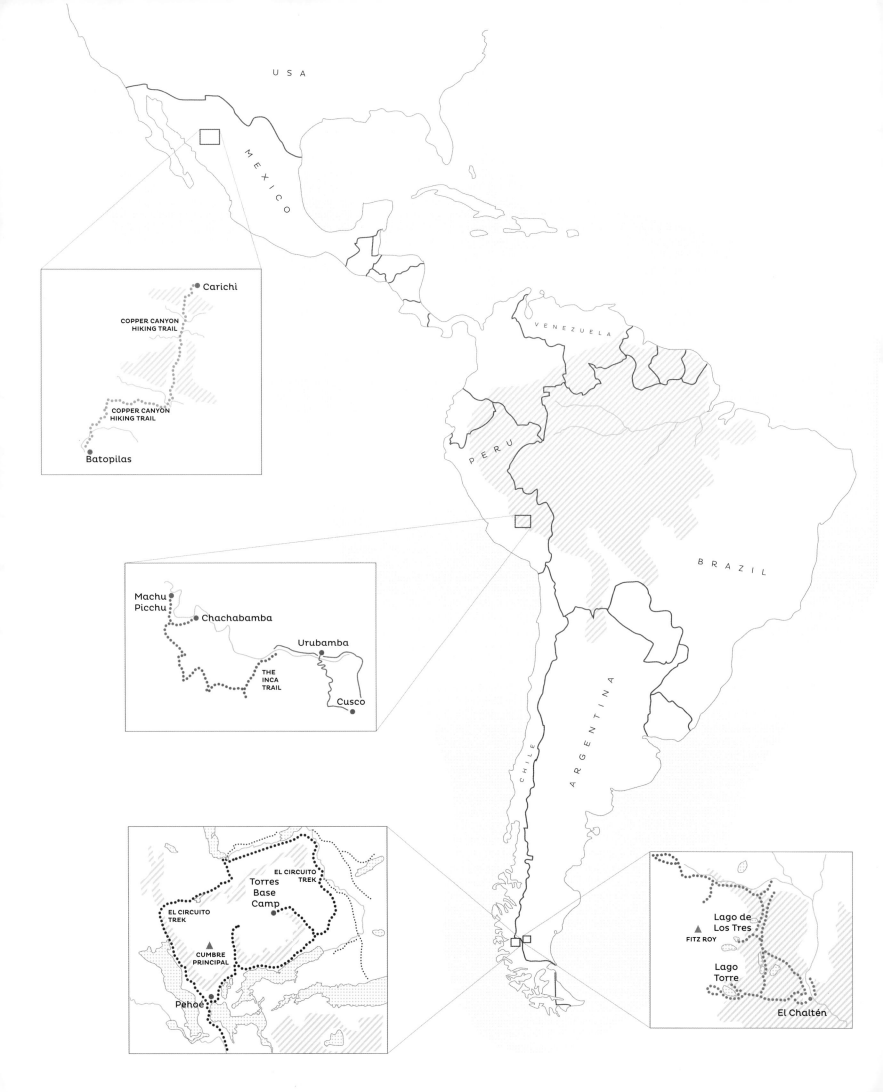

USA

MEXICO

● Carichì

COPPER CANYON
HIKING TRAIL

COPPER CANYON
HIKING TRAIL

● Batopilas

VENEZUELA

PERU

BRAZIL

Machu
Picchu ●

● Chachabamba

Urubamba ●

THE
INCA
TRAIL

Cusco ●

CHILE

ARGENTINA

EL CIRCUITO
TREK

Torres
Base
Camp

EL CIRCUITO
TREK

EL CIRCUITO
TREK

▲
CUMBRE
PRINCIPAL

Pehoé ●

Lago de
Los Tres

▲
FITZ ROY

Lago
Torre

El Chaltén

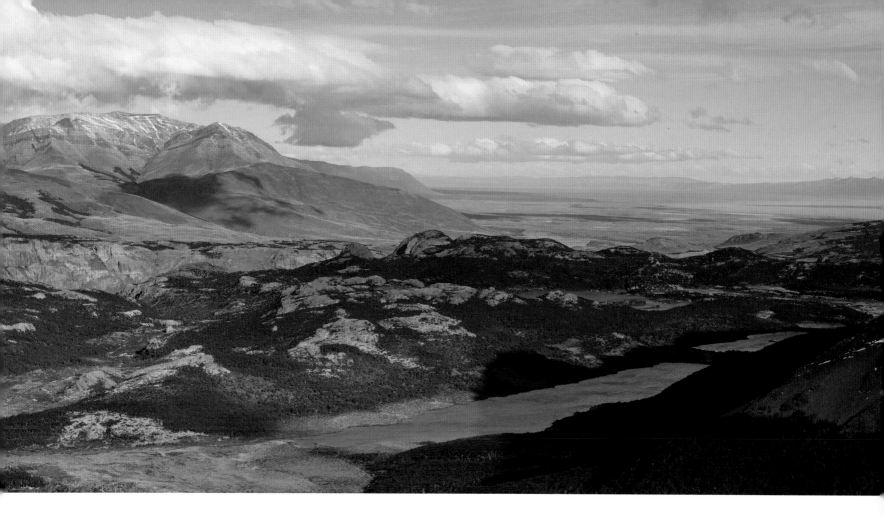

Central & South America

With giant glaciers, shimmering salt flats, hidden ruins of ancient civilisations, soaring snow-topped peaks, steaming jungles, searing deserts and over-excitable volcanoes, Central and South America are not short of dramatic landscapes. Or, for that matter, dramatic long-distance walks.

As well as being the second-highest, after the Himalayas, the Andes form the longest continuous mountain chain on Earth – an epic, white, dragon's back that stretches nearly 8,000 kilometres (5,000 miles) from Venezuela to southern Patagonia. The legendary range is peppered with volcanoes, too, which make for some testing shorter challenges, key spots being the Chilean Lake District, Nicaragua's Lake Ometepe and Ecuador's Big Two – the multiheaded Chimborazo at 6,263 metres (20,548 feet) and Cotopaxi at 5,897 metres (19,347 feet), when the latter is safe for summit attempts.

In the deep south, Patagonia is a real-life ice kingdom, home to Chile's extraordinary Torres del Paine National Park and a popular network of trails and *refugios* (well-furnished wooden huts for hikers). But on the opposite side of the Andes, the crowds are fewer and things are no less spectacular in Los Glaciares National Park and its Fitz Roy range. Further north, the highest mountain on the American landmass – in fact, outside Asia – Argentina's Mount Aconcagua, at 6,961 metres (22,828 feet), can be scaled by trekkers with the patience to build-up their altitude acclimatisation slowly and safely.

Further north again, Peru's Huaraz is the mountaineering and trekking capital of the Andes, with both Cordillera Blanca and Cordillera Huayhuash nearby, including 5947-metre (19,511-foot) Nevado Alpamayo, once termed 'the most beautiful mountain in the world' by

ABOVE

EL CHALTÉN: TREKKING IN LOS GLACIARES
NATIONAL PARK.

PREVIOUS PAGES

EL CHALTÉN: THE VASTNESS OF PATAGONIA
AS SEEN FROM THE TRAIL. VIEDMA LAKE IS
VISIBLE IN THE DISTANCE.

the Austrian Alpine Club. Peru's highest peak is Nevado Huascarán at 6,768 metres (22,205 feet), but perhaps more famous is Artesonraju – at 5,999 metres (19,682 feet) or 6,025 metres (19,767 feet), depending on who you believe – which millions have unwittingly seen at the cinema: it doubles as the logo for Hollywood's Paramount Pictures. Some of these, and many, many others can be experienced on the superlative Santa Cruz Trek, starting near Huaraz.

The Incas had the largest empire in the world in the 16th century, and mainly in Peru, but also in Bolivia, Chile, Ecuador and Colombia, their ruins can be explored, often in the mountains. Machu Picchu is the most famous trail, but the Incas had vast networks of trails and mountainside fortresses, which often still showcase both their impressive engineering skills and worship of the natural elements.

The Inca Trail is justifiably world famous, but there are many more treks like it: several days of hard-breathing, high-altitude mountain passes, to reach a dramatic, atmospheric ruin. As well as the Incas, the Mayans, Aztecs and other tribes and civilisations have left much to be enjoyed and puzzled over – the Lost City (or Ciudad Perdida) trek, deep in the Colombian jungle, being another excellent case in point. Lake Titicaca, too, on a border shared by Peru and Bolivia, has some good trekking options. Then, of course, there is the Amazon basin, deserts in Chile and Peru, and some 200 national parks in all.

Ostensibly, the isthmus of Central America doesn't have the famous multiday trails of South America, but with its abundance of sprightly volcanoes and noisy cloud forests, especially, there is still plenty that appeals to the walking-boot favourer.

The best hiking in Panama – such as clambering to the top of seven-cratered Volcán Barú – can be found in the mist-covered, coffee-scented hills of the fertile Chiriquí highlands and Barú Volcano National Park.

From jungle treks to volcano climbs, Costa Rica's natural wonders are begging to be explored on foot. Cloud forests, for example, cover a mere 0.25 per cent of Earth's land, yet can be easily experienced here. Rustling with wildlife, exploding with mossy vines, ferns and rushing streams, and swathed in mist, it is as exciting as the imagination of the famous *Jungle Book*.

On Nicaragua's Isla de Ometepe, all-day ascents of the active, conical Volcán Concepción at 1,610 metres (5,282 feet) and the more jungly and wildlife-rich (though the sound of the howler monkey is an acquired taste) Volcán Maderas at 1,394 metres (4,574 feet) are essential experiences (guides are now mandatory for both climbs). Views from the summit of Concepción are stunning on a clear day, while at the top of Maderas you'll find an eerie crater and lake.

Guatemala's El Altiplano, or the Highlands, offers a playground of volcanoes, mountains, lakes and ruin-rich jungles. From Antigua, guided hikes up Volcán Pacaya bring you to flowing lava, where you can toast marshmallows, and enjoy wondrous sunset views. The ultimate hike, however, is the 60-kilometre (37-mile) trail into Petén jungle to the spectacular ruins of El Mirador, a fascinating, largely unexcavated, pre-Columbian Mayan city.

In Mexico, you can walk in the footsteps of the Aztec and Mayan civilisations, through volcanic or jungle landscapes or huge canyons. There is so much to enjoy for historians and anthropologists, especially, here.

Unlike in Europe or the United States, trekking is not a big pastime in South America. For many, walking is merely a form of transportation. Despite this, there is good infrastructure around the more famous trails and mountaineering regions, where good guides, porters, cooks and other ancillaries can be hired – which may seem an extreme measure, but some treks are more remote than hikers may be accustomed to.

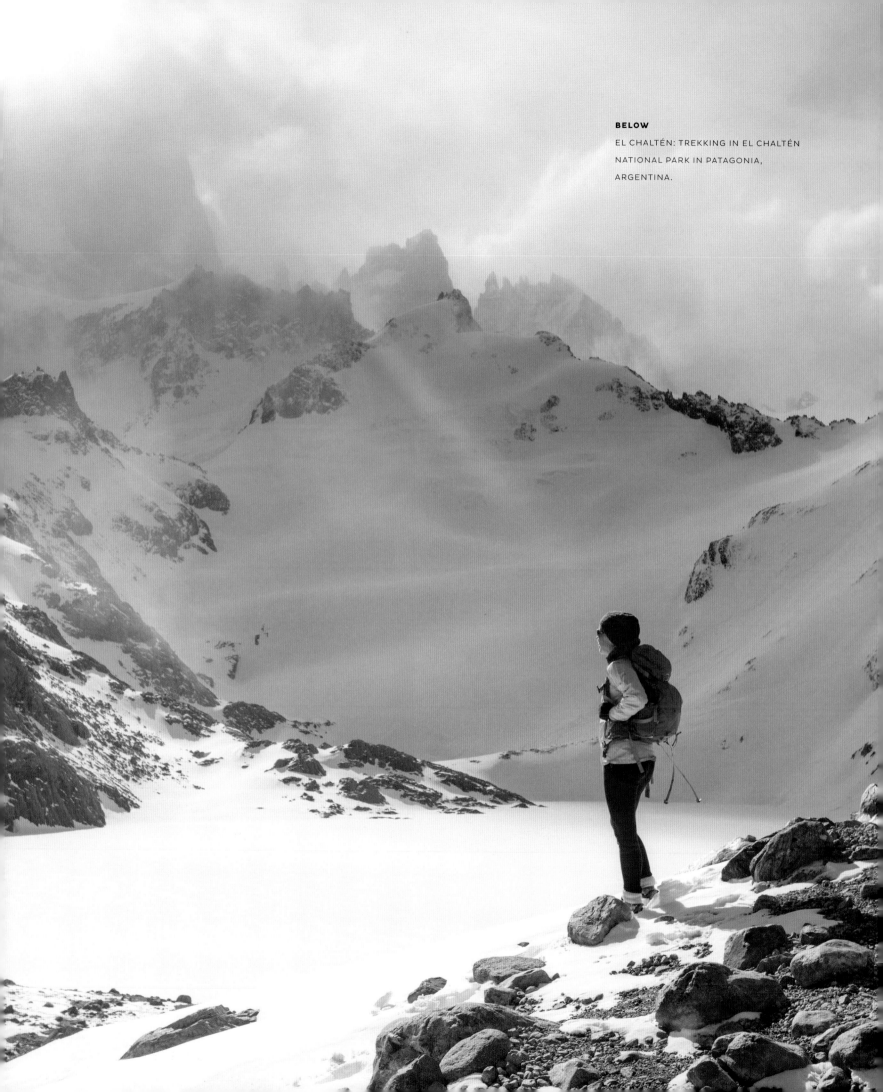

BELOW

EL CHALTÉN: TREKKING IN EL CHALTÉN
NATIONAL PARK IN PATAGONIA,
ARGENTINA.

SILVER TRAIL, COPPER CANYON
MEXICO

In southwestern Chihuahua, a state in northwestern Mexico,
stand the Sierra Madre Occidental Mountains. Within them lie six
labyrinthine canyons, formed by six rivers draining from the Sierra
Tarahumara. The walls of the canyons are a striking copper-green
colour and collectively, they are the legendary Barranca del Cobre, or
Copper Canyon. You can get a train ride into the labyrinthine canyons,
go mountain-biking, horse-riding or sign up for the Copper Canyon
Ultra Marathon. But the best way to experience it is on a trek.

The Copper Canyon – larger than the Grand Canyon and
half the size of Switzerland – is perhaps most famous today for
the Tarahumara Indians and their amazing endurance running,
brought to public attention by Christopher McDougall's book,
the bestselling *Born to Run*. Film fans may also know of it, thanks
to Tommy Lee Jones's 2005 neo-western, *The Three Burials of
Melquiades Estrada*.

The Silver Trail is based on a historical route used by the silver-
mining trade. Once a month in the 1880s and 1890s, between
50 and 100 mules would make the treacherous journey through
soaring mesas (tablelands) and gorges, from Botapilas to Carichí.
Armed guards escorted them and their cargo of $120,000-worth of
silver up steep climbs, hairpin bends and hair-raising drop-offs.

The 160-kilometre (100-mile) route can be retraced today.
Trekkers pass through spectacular and wild canyon backcountry of
the mysterious but friendly farmer-runners of Tarahumara, who
call themselves Rarámuri ('those who run'). This is wild and remote
frontier country, and a guide is recommended.

The Silver Trail crosses the Continental Divide, countless sub-
canyons, three major river drainages, some 6,000 metres (20,000
feet) of ascent, soaring ridge tops and apocalyptic chasms. Rich
tapestries of plants and trees cling to cliffs that boast rainbow
colours of exposed bands of rock, and there are plenty of silvery
waterfalls, the ruins of old stage stations (used by the mining
industry's mule trains), natural hot springs and ancient caves.

One of the highlights is the Arroyo de Las Iglesias (the Church
of Gorges) – a valley of towering stones, cut through by the rushing
Corghi River.

Copper Canyon is home to several species of trogons: parrot-
like birds with emerald backs and mango-coloured bellies; along
with hooded orioles, acorn woodpeckers, yellow-eyed juncos,
rufous-crowned sparrows and berylline hummingbirds; not
forgetting the pumas and mountain lions.

RIGHT

SUNRISE ON THE EDGE OF THE COPPER
CANYON.

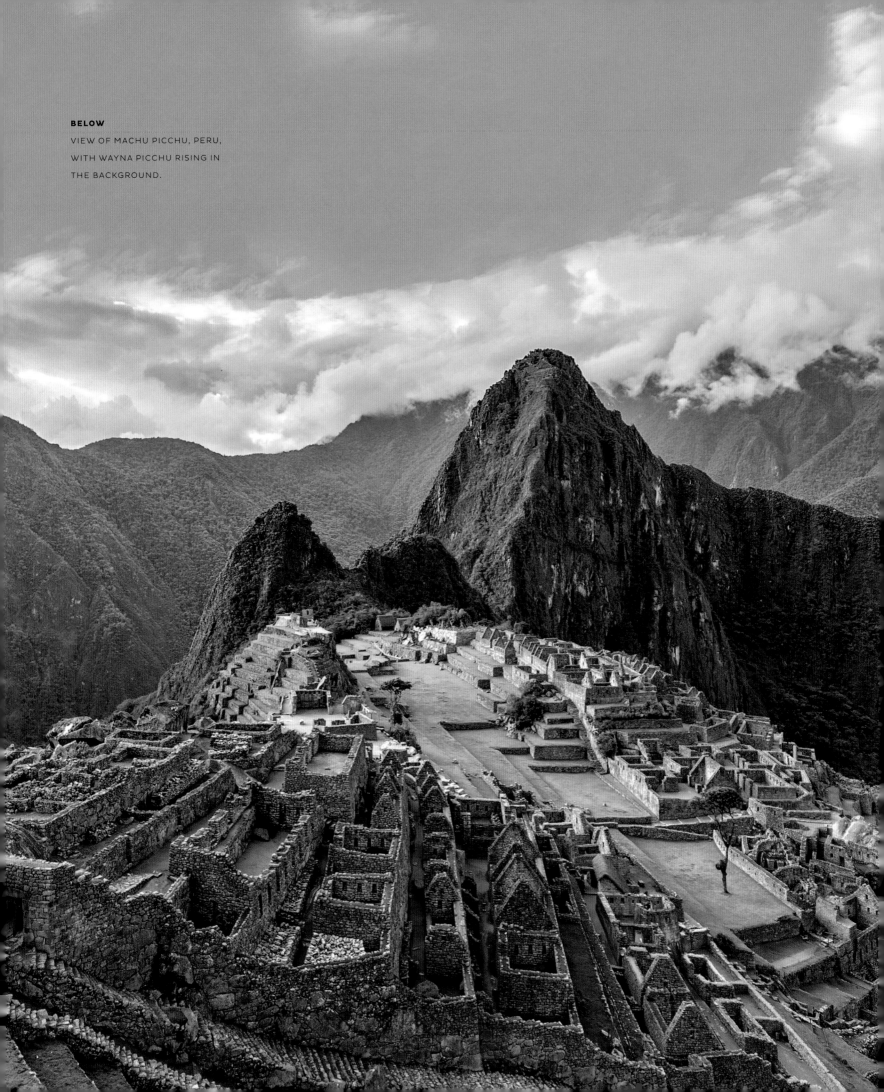

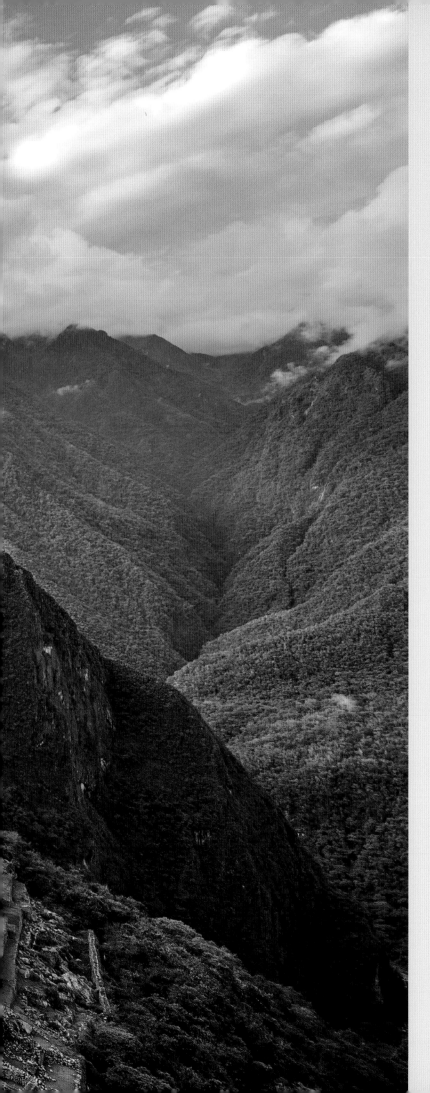

INCA TRAIL
PERU

Before the brutal Spanish conquistadors tore into South America in the 16th century, the Inca Trail was part of an astonishing road network stretching from Santiago, halfway up Chile, to southern Colombia. Today, a part-reconstructed section of the highway leads to the mountain kingdom of Machu Picchu (Old Mountain) – a kingdom mysteriously abandoned, only 100 years after completion, in around 1560. Climb through villages and hummingbird-populated cloud forests, pass atmospheric Inca ruins and up into the giant Andes and breath-stealing, high-mountain passes.

You can catch a train up to Machu Picchu, or take the 43-kilometre (27-mile) ancient trail, slaloming through snow-tipped Andean peaks. Both are very popular options, with the latter needing a licensed guiding company, and numbers are limited to a maximum of 500 people (including guides and porters) starting the walk each day.

Beginning near Cusco – the administrative and religious centre of the Inca empire, built in the shape of a panther – pleasant ambling ascents lead through villages where drinks are sold from homes often painted with political slogans.

The route is littered with Inca ruins, sometimes perched intriguingly above a canyon. The route gets steeper, rising through cloud forests where hummingbirds hover like little helicopters. On day three, the trail improves further still, clinging precariously to mountainsides, leading past mysterious dark-green lakes, high above verdant valleys, close to proud Andean peaks and a dramatic clifftop fortress, as condors swirl above. Most will feel the altitude at the trail's highest point of 4,198 metres (13,773 feet) – the unsettlingly named Dead Woman's Pass.

Day four means descending past yet more ruins into the misty jungle and the legendary Inca castle, Machu Picchu. The dramatic ruins comprise 216 buildings, including temples, palaces, houses and a hospital with an orthopaedic bed carved into stone. The Incas were engineers, architects and agriculturists way ahead of their time. As well as mountain roads and stable crops grown on improbably steep slopes, they built earthquake-proof walls. In places, the walls' shapes mimic the mountains that surround them, in tribute to them. It is the surroundings, however, that really give the place of high priests and sun gods its great drama – drifting mists, steep valleys either side and that fang of a peak (Huayna Picchu, which means Young Mountain) rearing up behind Machu Picchu.

If the Inca Trail sounds too much like a tourist carousel, there are some good alternatives, such as the five- to seven-day Salkantay to Machu Picchu Trek (which is still subject to Inca Trail regulations) or the 'Alternative Inca Trail', which runs from Mollepata to Machu Picchu.

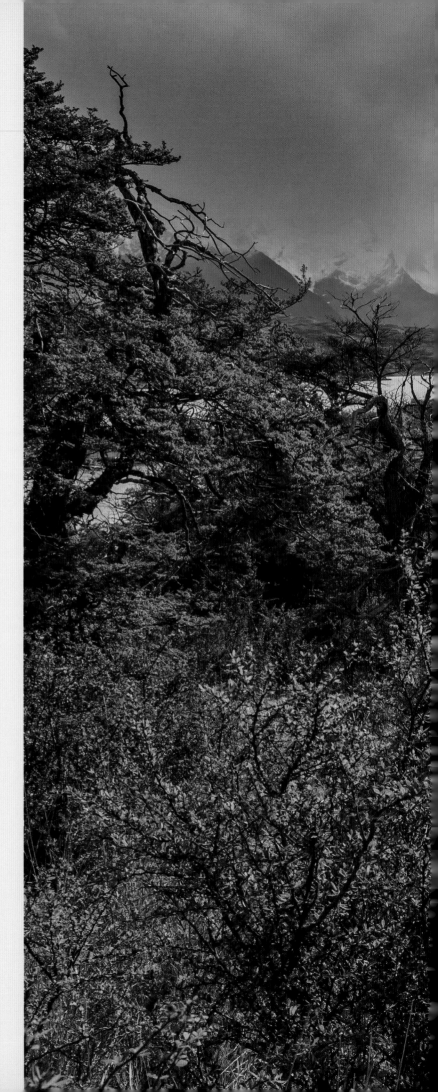

PATAGONIA
CHILE & ARGENTINA

Patagonia is a glorious medley of glowing ice, crashing waterfalls, rocketing granite, glacial lakes, circling condors and puma footprints in the snow. On the Chilean side, is the popular Torres del Paine National Park; just over the border in Argentina is a more rugged, less polished and less peopled (though the secret is out) landscape – of which El Chaltén has become known as the trekking capital – with equally high drama and reward for the more adventurous hiker.

The Chilean Torres del Paine (which translates as Towers of Paine – someone's name, rather than pain per se, although it is a hearty stomp up to see them) attracts thousands of hikers. Those walking the circuit enjoy turquoise lakes, huge glaciers and those titular 2000-metre (6,500-feet) granite spires, all on sign-posted trails and staying in a network of homely *refugios*. An escape from the hordes, El Chaltén, overshadowed by the dashing mountains of the Fitz Roy range, the village-cum-mini-city borders the magnificent Los Glaciares National Park, which hosts a network of trails to suit most abilities and ambitions.

Fitz Roy is highly prized by the world's finest mountaineers, who are often held hostage here by the capricious weather. Frozen lakes and snow-covered mountains are testament to the chilly temperatures, harsh winds and storms that pester the inhabitants. Visitors should always allow a few extra days in their itinerary to avoid disappointment – missing out here would be regrettable.

El Chaltén can be used as a base for excellent shorter walks, such as to the Fitz Roy and Cerro Torre base camps. Laguna Torre is the most popular day walk, with views of the icy towers of Cerro Torre, standing at 3,128 metres (10,262 feet). The trail follows Rio Fitz Roy up to the glacial lake of Laguna Torre and a small campground. Continue for another hour to reach Mirador Maestri (named after the Italian climber who controversially used a compressor to create a bolt ladder up Cerro Torre's southeast face).

Alternatively, the Laguna de los Tres and Piedra del Fraile Trek takes from two to five days and rewards with the best views of Fitz Roy and surrounding glaciers, plus the beautiful Rio Electrico Valley. From the campsite at Poincenot, the best views of Monte Fitz Roy are witnessed just after dawn, and so may require an early climb up to Laguna de los Tres, a beautiful lake towered over by Fitz Roy, plus other peaks and glaciers.

RIGHT

AUTUMN COLOURS IN TORRES DEL PAINE
NATIONAL PARK.

OVERLEAF

TREKKING IN EL CHALTÉN NATIONAL PARK
WITH VIEWS OF MOUNT FITZROY.

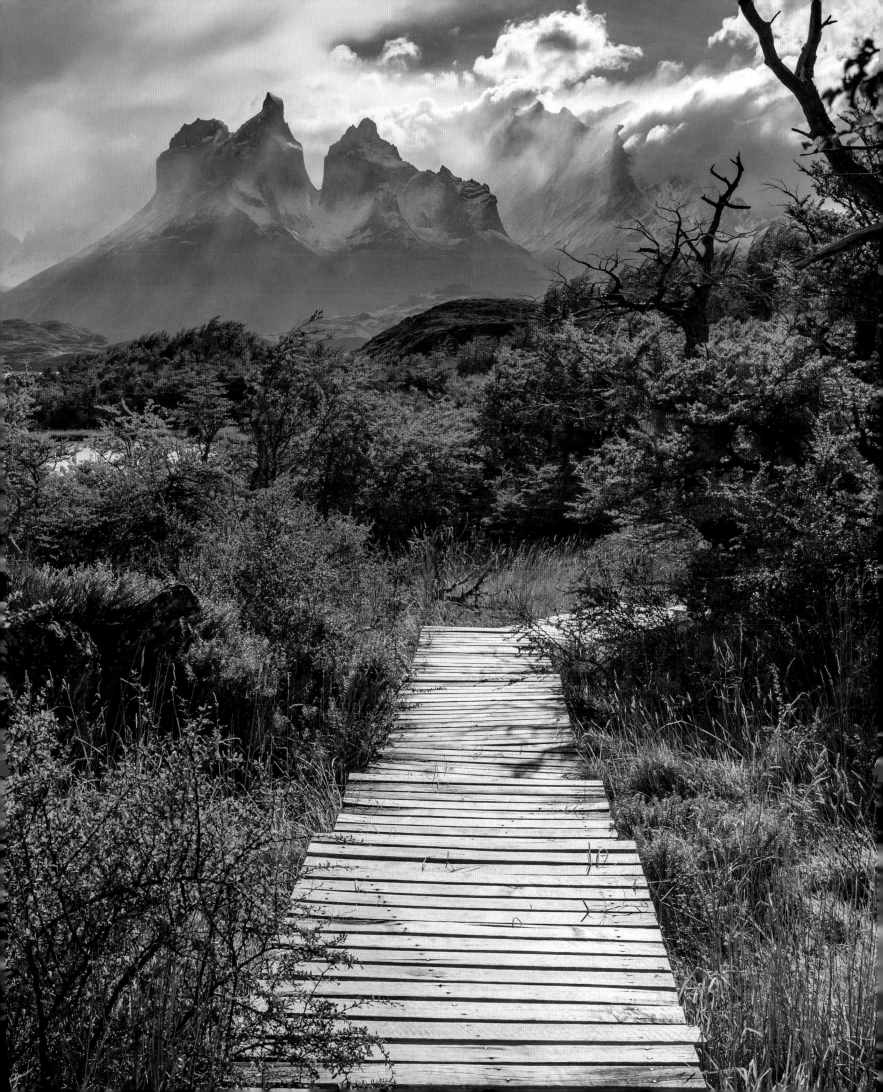

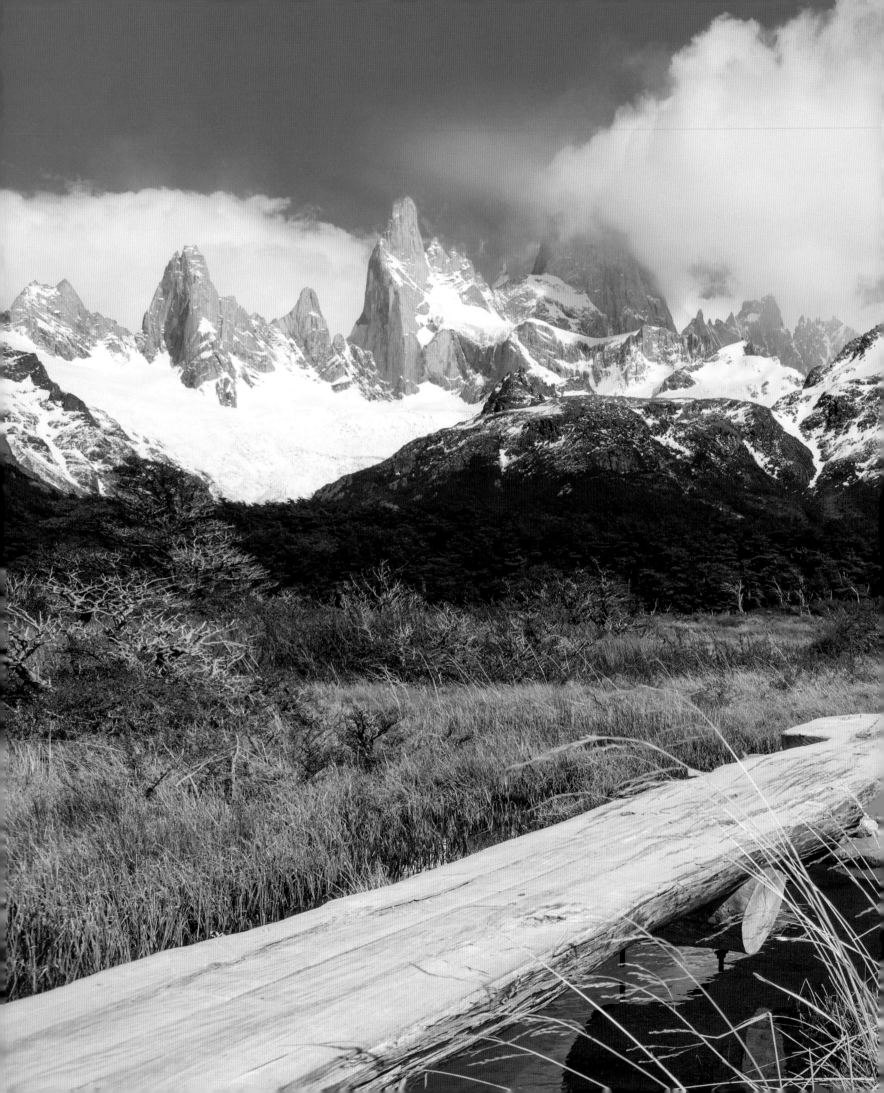

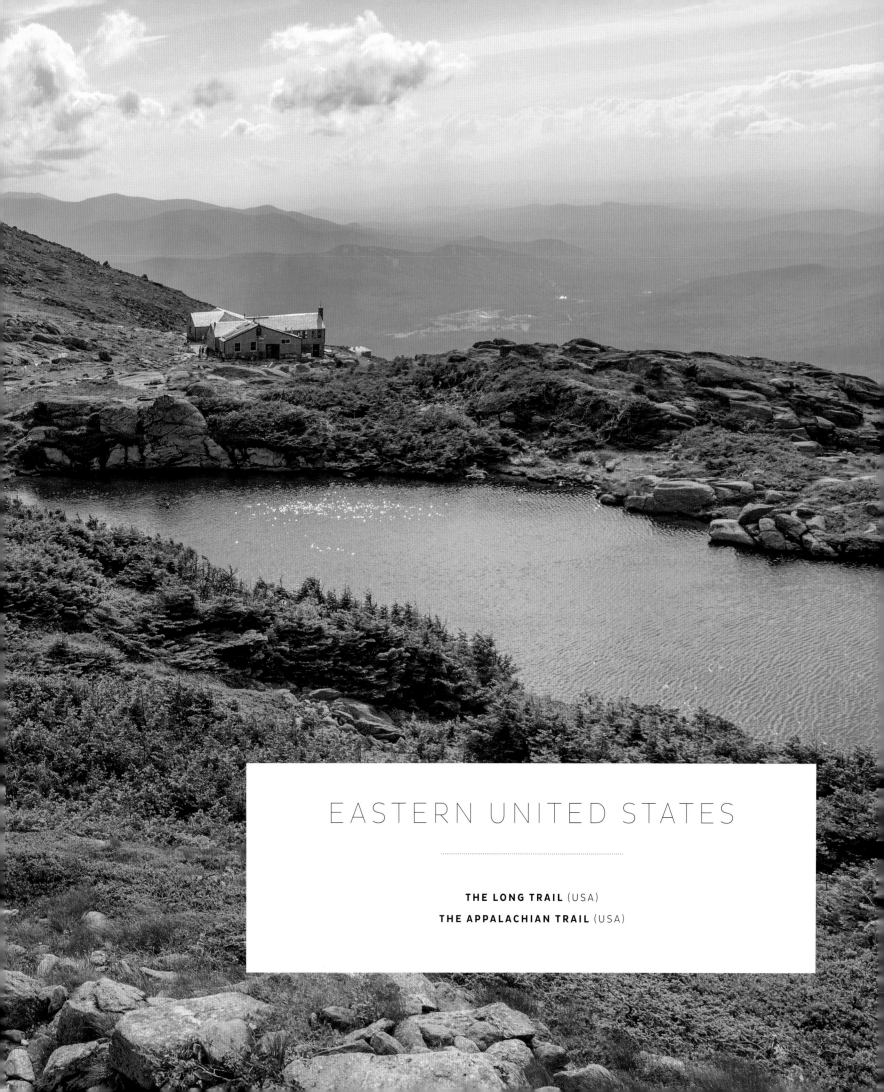

EASTERN UNITED STATES

..

THE LONG TRAIL (USA)

THE APPALACHIAN TRAIL (USA)

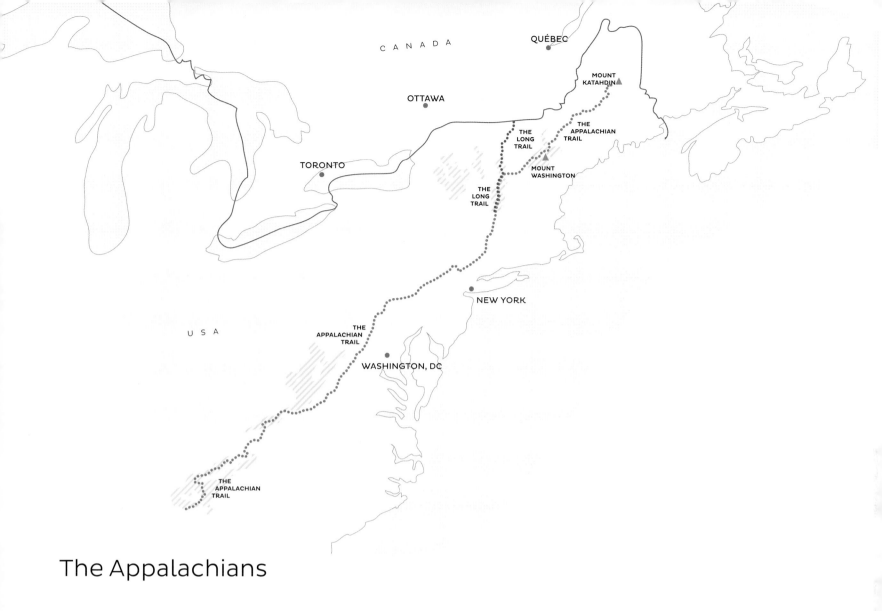

The Appalachians

Millions of years ago, the eastern edge of North America was dominated by one of the tallest, longest and most continuous mountain ranges ever to exist on Earth. Stretching from modern-day Newfoundland in Canada to what is now Central Alabama in the United States, the tallest peaks of the Appalachian Mountains used to rival those of the Alps in Europe. Today, however, the range is mostly dominated by forest, and the single long, winding footpath that runs its length has become the definitive North American ultra-long-distance hike – the 3,500-kilometre (2,200-mile) Appalachian Trail.

Rain, snow, wind and time have taken their toll on the Appalachians. The ancient, permanently snow-covered peaks have slowly eroded over the millennia to less than half their original size. Now, the tallest amongst them, Mount Mitchell in the state of North Carolina, is low enough to be completely covered by trees, to the top of its 2,037-metre (6,683-feet) summit. Nearly all of the Appalachians are blanketed by a layer of dense foliage. In the north and at higher elevations, a dark, evergreen forest of fir and spruce covers the mountains. In the winter months, the entire region is covered in a thick layer of white snow, making snowshoeing the only practical way to get around on the trails almost six months of the year. In the south and at lower altitudes, a mix of broad-leafed deciduous trees such as birch, oak and beech dominate the landscape. Only a handful of rocky summits scattered throughout the range offer completely unobstructed vistas – such as those found in the western United States – but those that exist are more than worth the effort to reach.

The nature of the landscape and the climate here means that established hiking trails in the Appalachian Mountains are almost a necessity. The forest and underbrush here is so

OPPOSITE

THE APPALACHIAN TRAIL: NEW HAMPSHIRE.

PREVIOUS PAGES

THE APPALACHIAN TRAIL: HIKERS ON THE CRAWFORD PATH SECTION.

thick in most places, it is nearly impossible to travel anywhere without the aid of a clear, arm's-length-wide trail, or a chainsaw to make a new one. It is also why a compass, a map and the knowledge of how to use them are essential when travelling along the shadowy and sun-dappled paths in Appalachia. It is easy to get lost in the beauty here by stepping off the trail.

Regardless of their comparatively diminutive stature, the Appalachians are the only significant topographic feature in the entirety of the eastern United States. If not for this expansive string of old, rolling, tree-covered mountains, the majority of the country would otherwise be a pancake-flat plain.

To early European settlers' disappointment, there is also no convenient east-to-west river valley, mountain pass or any other semblance of an even remotely easy-to-navigate, passable corridor cutting through these mountains. The only way through for the early settlers was up and over, through more than 1,000 kilometres (600 miles) of nearly impenetrable underbrush, or going even further around to the south, almost all the way to Florida.

The grandeur of the Appalachians is substantial. The vertical gain trekkers must climb on the standard route up New Hampshire's 1,760-metre (5,774-foot) tall Mount Adams in the Appalachians, for example, is more than that required to scale Colorado's 4,401-metre (14,439-foot) Mount Elbert, the highest peak in the Rocky Mountains. This is because the trail up Mount Adams starts just a few dozen metres above sea level, whereas the carpark at the trailhead of Mount Elbert is already set high on the central plateau of North America, at more than 3,000 metres (9,843 feet).

While hundreds, if not thousands, of trails dissect, ascend and descend small portions of the Appalachian Mountains, the ones that afford the best scenery and all-round experience tend to be concentrated within the three national parks located within the range. The state of Virginia's Shenandoah National Park occupies more than 800 square kilometres (300 square miles) and has more than 800 kilometres (500 miles) of well-maintained trails within its borders. Great Smoky Mountains National Park, which spills over the border of the states of North Carolina and Tennessee, covers more than 2,100 square kilometres (810 square miles) and boasts about 1,370 kilometres (850 miles) of awe-inspiring trails. Acadia National Park in the state of Maine, at the far northern end of the Appalachian Mountain range, also happens to sit on the edge of the Atlantic Ocean. This offers trekkers on its short and notorious Precipice Trail – which follows a precipitous ridge up Champlain Mountain for nearly 5 kilometres (3 miles) – views of the deep-blue coast.

Travelling along the now well-worn path of the Appalachian Trail, it takes most trekkers months to experience these mountains in their entirety. Even then, those months are filled with continuous glimpses of a far greater, expansive wilderness. . . and something much harder to define.

RIGHT

THE APPALACHIAN TRAIL: MOUNT KATAHDIN,
ONE OF THE MOST CHALLENGING ASCENTS
ON THE TRAIL.

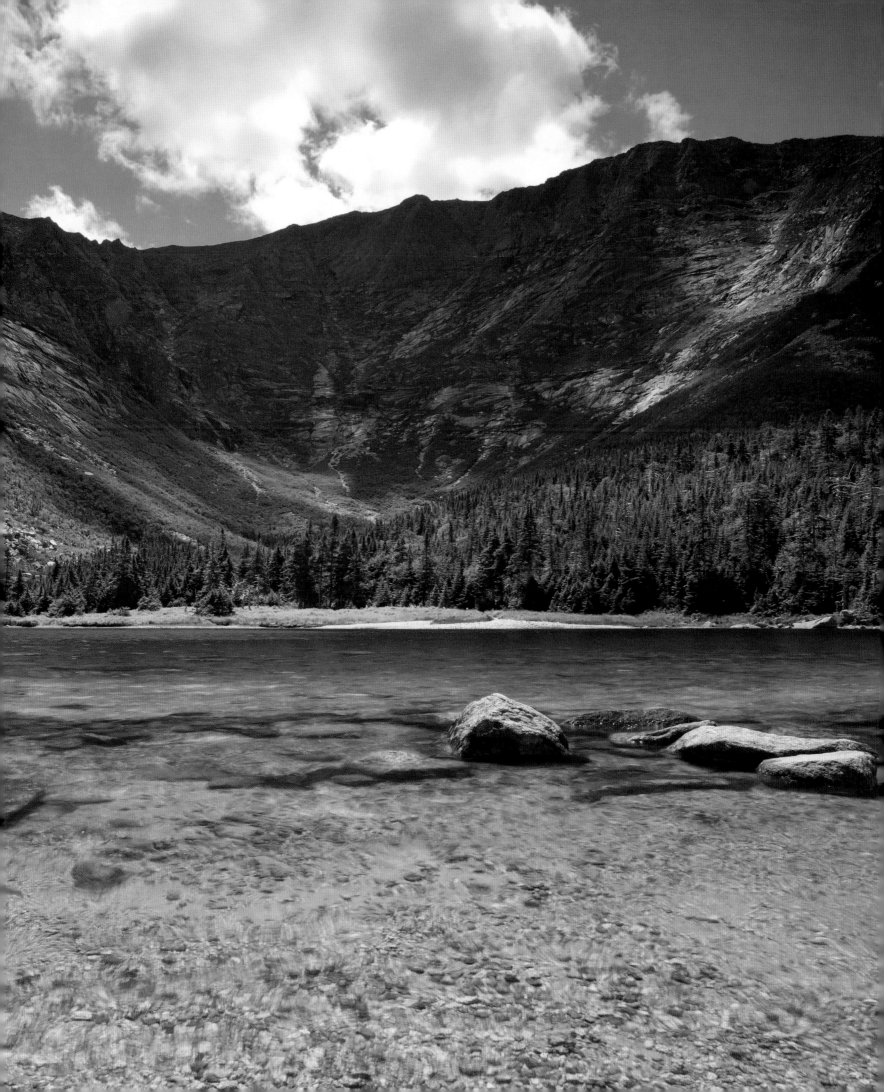

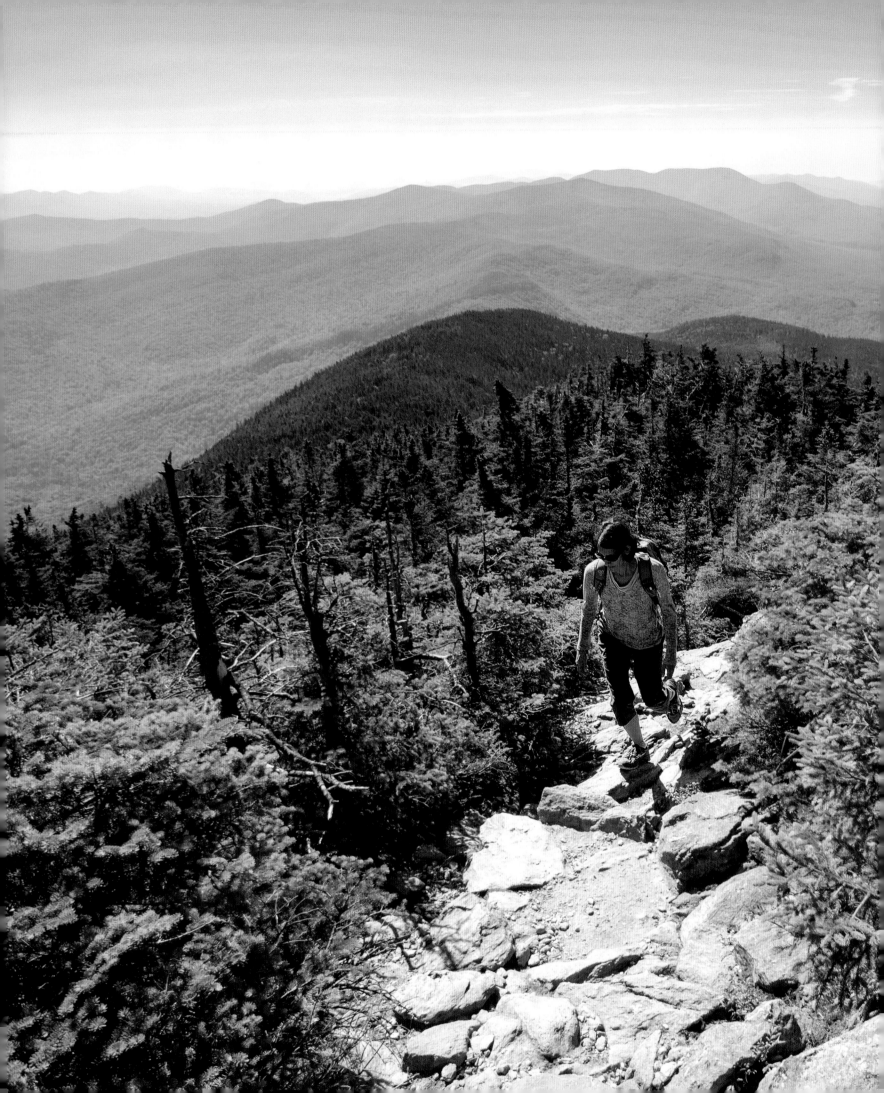

THE LONG TRAIL
USA

Perhaps one of the most aptly named footpaths anywhere, the Long Trail in Vermont follows the spine of the Green Mountains – a section of the larger Appalachian Mountain range in the eastern United States – for more than 400 kilometres (250 miles) through some of the most rugged, muddy and steep terrain in the country.

The only way The Long Trail could have been named more accurately and descriptively would have been to call it The Long, Hard Trail. Traversing all eight of the Green Mountains' major peaks, it requires a mind-boggling 19,202 metres (63,000 feet) of elevation gain from start to finish. That's an average of climbing almost 50 metres (165 feet) every single kilometre. Step for step, it is one of the most difficult, maintained, long-distance hiking trails. It is also one of the oldest – at least, it's the oldest in the United States.

Whilst the storied ultra-long-distance Appalachian Trail (AT) is significantly longer, more widely known and generally more celebrated, the Long Trail, which shares 100 kilometres (60 miles) of its route with the AT near its southern end, came first. Built by hundreds of volunteers between the years of 1910 and 1930, the Long Trail was, in fact, the AT's inspiration. The trail builders at the time just decided to make the AT substantially longer and less difficult – for reasons that are obvious to anyone who's completed the Long Trail.

Extending from the Massachusetts state line to the Canadian border, the Long Trail is accommodated with nearly 60 overnight shelters; although, it is always advisable to bring a tent, since the combination of inclement weather and even more inhospitable terrain has a tendency to delay trekkers' anticipated progress. Rain, hail, thunderstorms, blizzards and blue skies are all possibilities almost all year-round. When the trail isn't climbing or descending a steep mountain, it's crossing through a root-filled, rocky forest of maple, birch, beech, pine, hemlock, spruce and a host of other tall, green, towering trees.

Some 20 per cent of hikers attempting the route head north-to-south, starting with the steepest sections located near the international border with Canada. Those choosing to trek the Long Trail straight through in one hard month-long push, start on the slightly less steep southern end near the Vermont–Massachusetts border.

Few finish the Long Trail, understandably, but those who do are often lured back repeatedly – for the challenge, and all the rewards that come with overcoming it.

LEFT

HIKING THE LONG TRAIL ON MOUNT ABRAHAM IN
THE GREEN MOUNTAINS OF VERMONT.

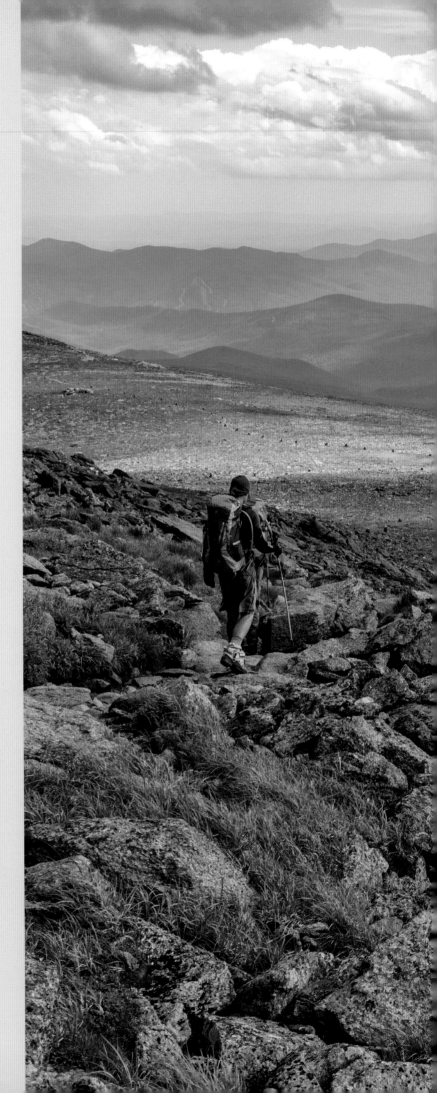

THE APPALACHIAN TRAIL
USA

At 3,500 kilometres (2,000 miles) long, the Appalachian Trail, or AT, is the longest foot-travel-only path in the world. It requires, on average, approximately five million steps and nearly five months to travel from the traditional southern trailhead at Springer Mountain in the state of Georgia to the 1,605-metre (5,266-foot)-tall summit of Mount Katahdin in the state of Maine. It is a popular, yet insanely long-distance, trek.

The setting for the central plot line of multiple bestselling novels and major motion pictures, the AT sees more than 1,000 people attempting the hike from start to finish annually; significantly less than half succeed. Only about one quarter of those who start out from Springer Mountain each spring make it to the end of the trail in Maine before winter arrives.

The reason for this is understandable when the scope and difficulty of the AT is taken in context. Considering that someone travelling the entire distance of the trail would need to ascend 141,569 metres (464,465 feet) – the equivalent of climbing Mount Everest 16 times, consecutively – it is more surprising that as many people who complete the trail in its entirety actually do so. Most hikers on the AT lose an average of 13.5 kilograms (30 pounds) during the trip, even after gorging themselves on the traditional half-gallon of ice cream at the midway point. They also burn through four to five pairs of boots, generally.

Regardless of the difficulties, there is a good reason why so many people continue to spend months of their lives plodding through these dense woods. In the spring, dustings of snow hang on the trees, mixing with fresh wildflowers. As the skies turn a deeper shade of blue in the summer, the surrounding woods seem almost to be breathing with life. By autumn, the maple, birch and poplar trees that stretch to the horizon in every direction simultaneously burst into flaming hues of red, yellow and orange. Along the entire length of the trail, gurgling mountain streams cascade down from high, inaccessible valleys, as each new summit provides a different once-in-a-lifetime, awe-inspiring view.

The best way to experience and appreciate the sheer scope of the Appalachians and the vast forests that cover it is to walk even just a short section of the AT. A few kilometres and the knowledge of the trail ahead is enough to command an almost reverent respect for it, and for those who have travelled its entire length.

RIGHT

DESCENDING FROM THE SUMMIT OF MOUNT WASHINGTON, HEADING SOUTH ALONG THE CRAWFORD PATH SECTION OF THE TRAIL IN NEW HAMPSHIRE.

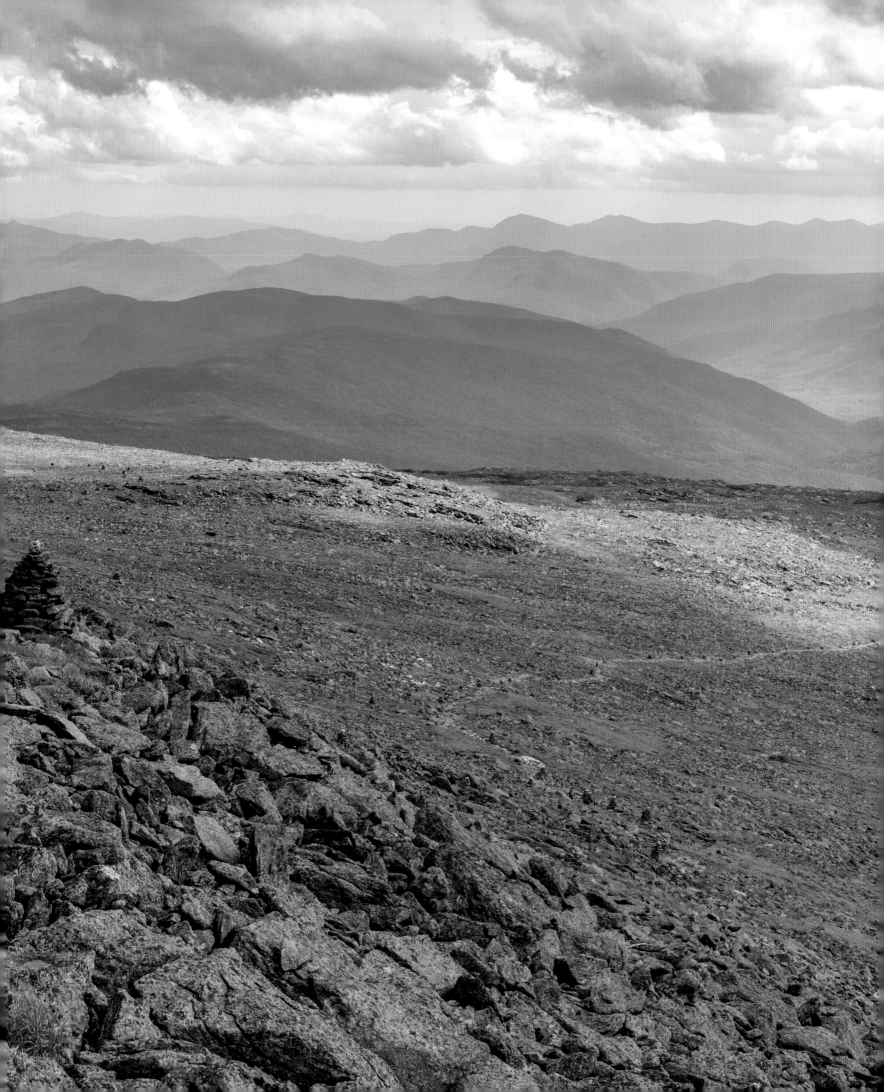

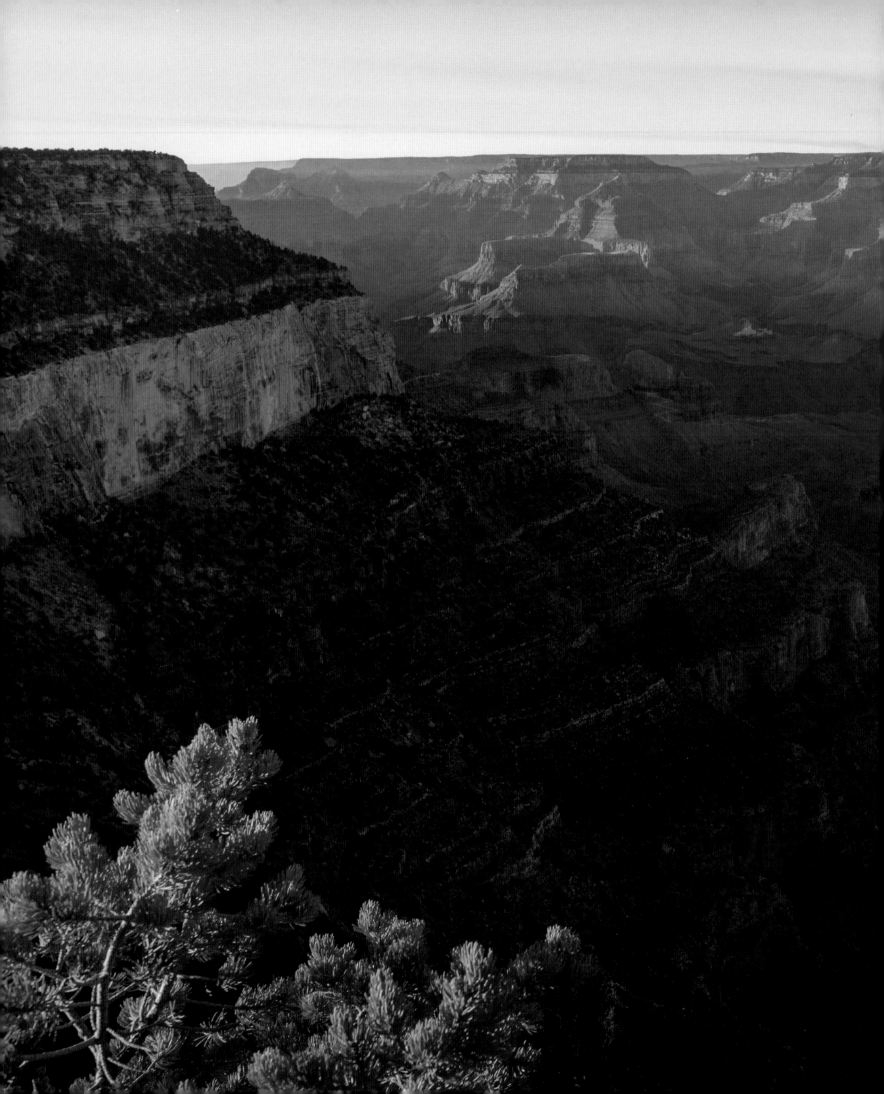

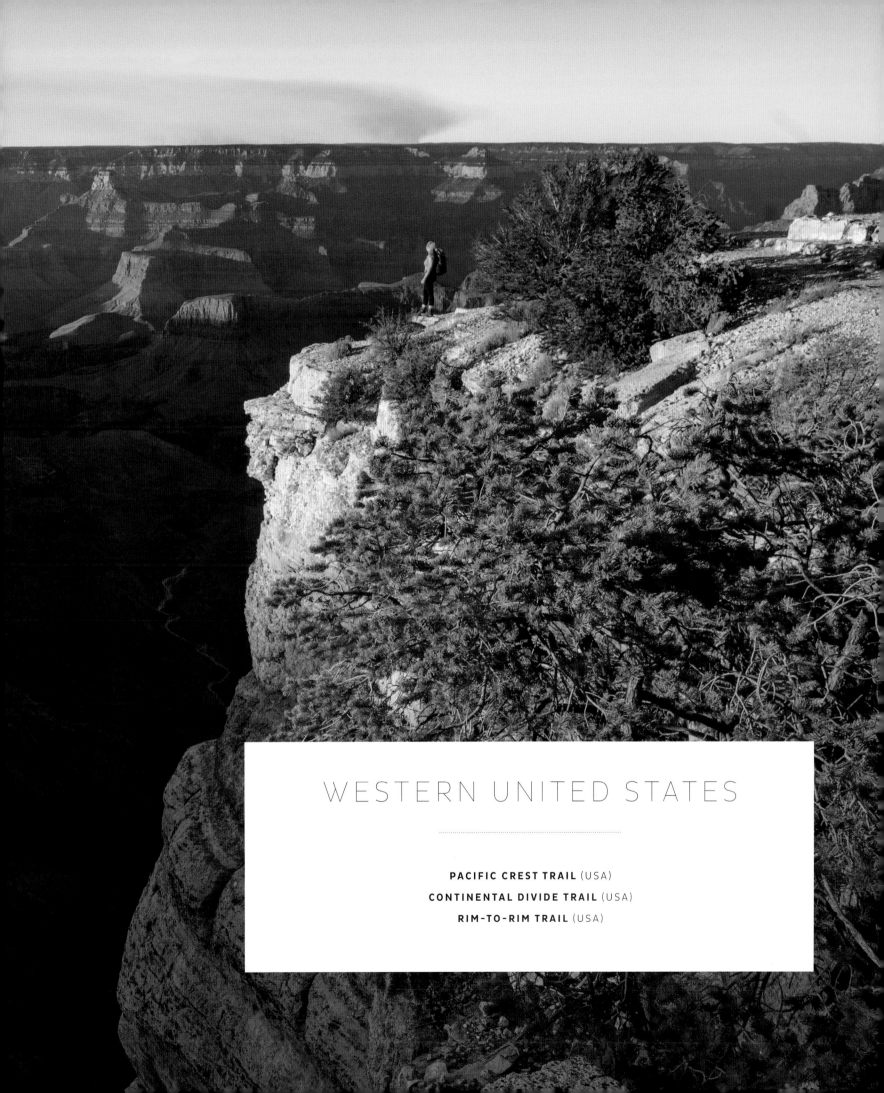

WESTERN UNITED STATES

PACIFIC CREST TRAIL (USA)
CONTINENTAL DIVIDE TRAIL (USA)
RIM-TO-RIM TRAIL (USA)

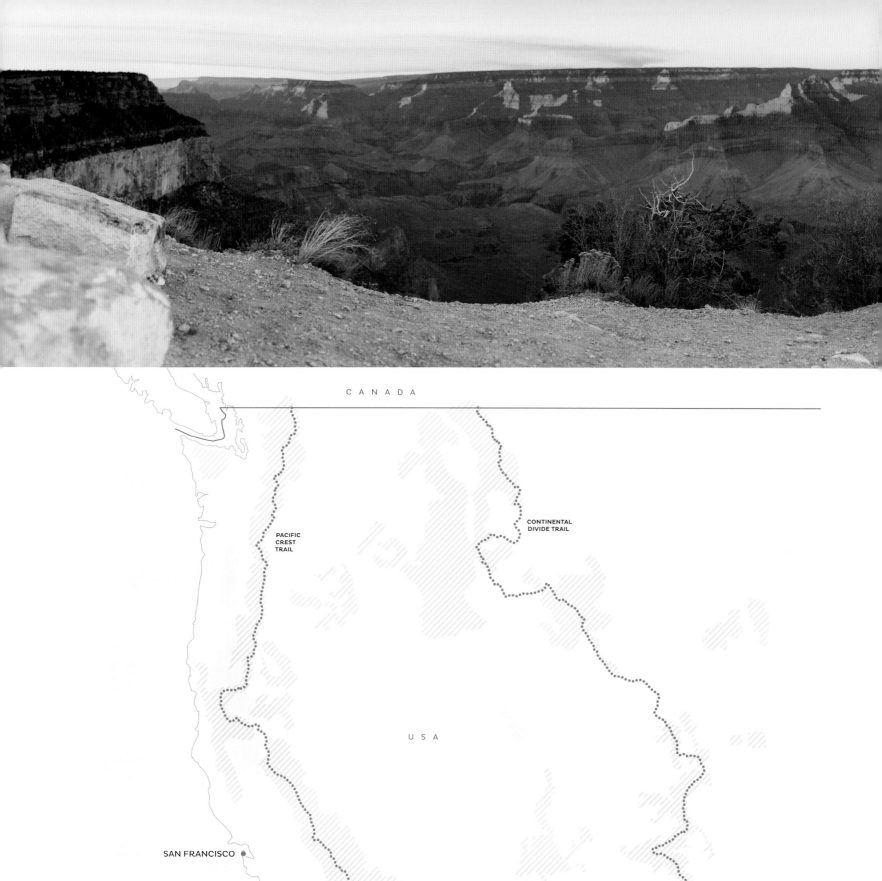

CANADA

PACIFIC
CREST
TRAIL

CONTINENTAL
DIVIDE TRAIL

USA

SAN FRANCISCO

▲ MT WHITNEY

LAS VEGAS

North Rim

GRAND CANYON
KAIBAB TRAIL

South Rim

LOS ANGELES

PACIFIC
CREST
TRAIL

CONTINENTAL
DIVIDE TRAIL

SAN DIEGO

Campo

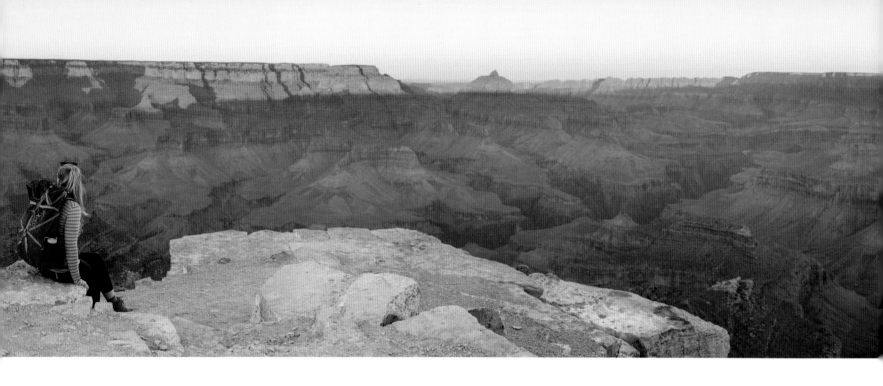

Western United States

The simplest way to describe the American West, or just 'the West', as it is called in the United States, is BIG. Almost everything about the region is best described with superlatives: the tallest, longest and largest of just about everything is found here.

The western United States are home to the Rocky Mountains, which at nearly 5,000 kilometres (3,000 miles) in length and more than 4,000 metres (13,000 feet) tall in many places, are the longest and tallest string of mountains on the continent. Some of the Northern Hemisphere's biggest rivers flow through the heart of the western United States, too, such as the 2,000-kilometre (12,000-mile) long Columbia, which at its mouth on the border between the states of Washington and Oregon drains enough water to fill more than three Olympic-sized swimming pools every second. The region also has some of the planet's deepest canyons, largest sea caves and tallest, most ancient trees – some of which are thought to be more than 5,000 years old. That's not to mention the world's two longest, continuous wilderness footpaths that happen to run through the middle of it all: The Pacific Crest and Continental Divide trails.

Occupying more than half of the United States' total land area of 9,161,923 square kilometres (5,692,955 square miles), it is not easy to make sweeping generalisations about the West. Both climate and geography, for example, are impossible to pin down unless looked at in subregions. In the Pacific Northwest, in the states of Washington and Oregon, stands some of the world's last-remaining temperate rainforest. Washington state's 28-kilometre (17.5-mile)-long Hoh River Valley Trail on the Olympic Peninsula, receives an average annual rainfall of more than 3.5 metres (138 inches). Everything in the valley is perpetually covered in thick, green moss, and rain gear is essential almost 365 days a year. Mount Baker, one of the state's largest active volcanoes, at 3,286-metres (10,781 feet), holds the world record for the most snowfall in a single winter: 29 metres (95 feet). Experienced mountaineers can tag the summit in a long day trip, but most choose to take at least two full days to make the climb.

In Southern California, a few thousand kilometres down the coast, in a subregion known as the Southwest, the weather couldn't be more different. Whilst raincoats can generally be left behind, the volume of water needed to travel safely for any length of time

ABOVE

RIM-TO-RIM TRAIL: A SECLUDED VIEWPOINT A SHORT WALK ALONG THE SOUTH RIM FROM THE START OF THE KAIBAB TRAIL.

PREVIOUS PAGES

RIM-TO-RIM TRAIL: SUNSET FROM THE SOUTH RIM OF THE GRAND CANYON AT SHOSHONE POINT.

in this region can become burdensome. The so-called 'Sunshine State's' infamous Death Valley is the hottest, driest and lowest-elevation spot in North America. Temperatures as high as nearly 57°C (135°F) have been recorded there. That's hot enough to cook a steak on the sidewalk. When it does rain in Death Valley, however, super blooms of wildflowers such as poppies, brittlebrush, primrose and desert sunflower cover the landscape in a veritable carpet of red, blue and yellow.

Further inland, the Southwest contains all of the North American continent's driest places, including the Mojave, Sonoran, Great Basin and Chihuahua deserts; each with well-established, multiday trail systems. Yet, even here, in the some of the driest, hottest parts of North America, mighty rivers such as the Colorado and Green manage to gouge their way through deep, fiery red sandstone canyons all the way to the ocean, offering hikers and paddlers a welcome reprieve from the heat.

Inland, in the Rocky Mountain subregion that occupies most of the states of Colorado, Wyoming, Idaho and Montana, the terrain is dominated by towering, often snow-covered peaks – 62 of which are over 4,000 metres (13,000 feet) tall – hanging glacial lakes, raging whitewater rivers and wide, green valleys. Most trekkers here choose to climb individual mountains, such as 3,436-metre (11,273-feet) Long's Peak in Rocky Mountain National Park in Colorado, or wander in and out of a single valley like the mountain-lined Maroon Bells area. However, some devout long-distance through-hikers choose to cut straight through the heart of the mountains along the 5,000-kilometre (3,000-mile) Continental Divide Trail, too – a feat few manage to accomplish.

Go off-trail and it's easy to get lost. In the state of Idaho, the aptly named Frank Church–River of No Return Wilderness forms the largest roadless area in the entire lower 48 states, excluding Alaska and Hawaii. Hardly any established footpaths even dent the 9,578 square-kilometre (3,698 square-mile) wilderness area. The only practical way to travel through it is either by bush plane or raft, floating down the 167-kilometre (104-mile) long Middle Fork of the Salmon River and its hundreds of Class II–IV rapids.

Through-hiking anywhere in the West quickly becomes serious, time-consuming business. From the bottom of the Grand Canyon in the state of Arizona, to the top of 4,392-metre (14,409-feet) tall, glacier-clad Mount Rainer in Washington to the mirror-like lakes and swift mountain streams of Montana, the astounding variety and the undeniably impressive scale of just about everything in the West makes it a rewarding place to hike, and beckons travellers to journey continually deeper into its wilderness – whether setting out on a short trek or an exceedingly long one.

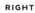

RIGHT

PACIFIC CREST TRAIL: STARRY SKIES FROM
YOSEMITE NATIONAL PARK.

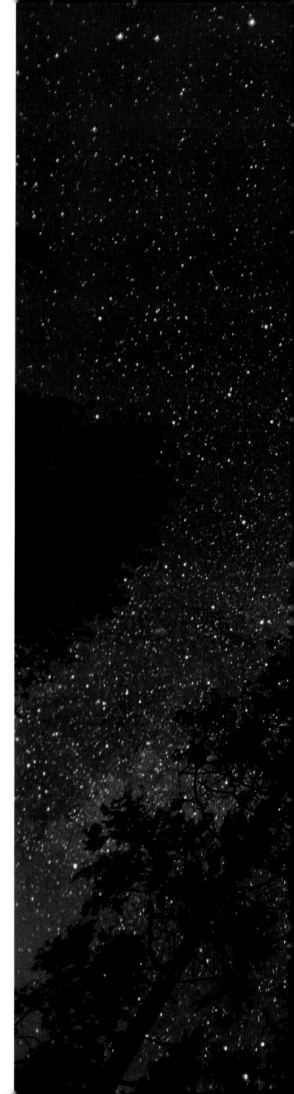

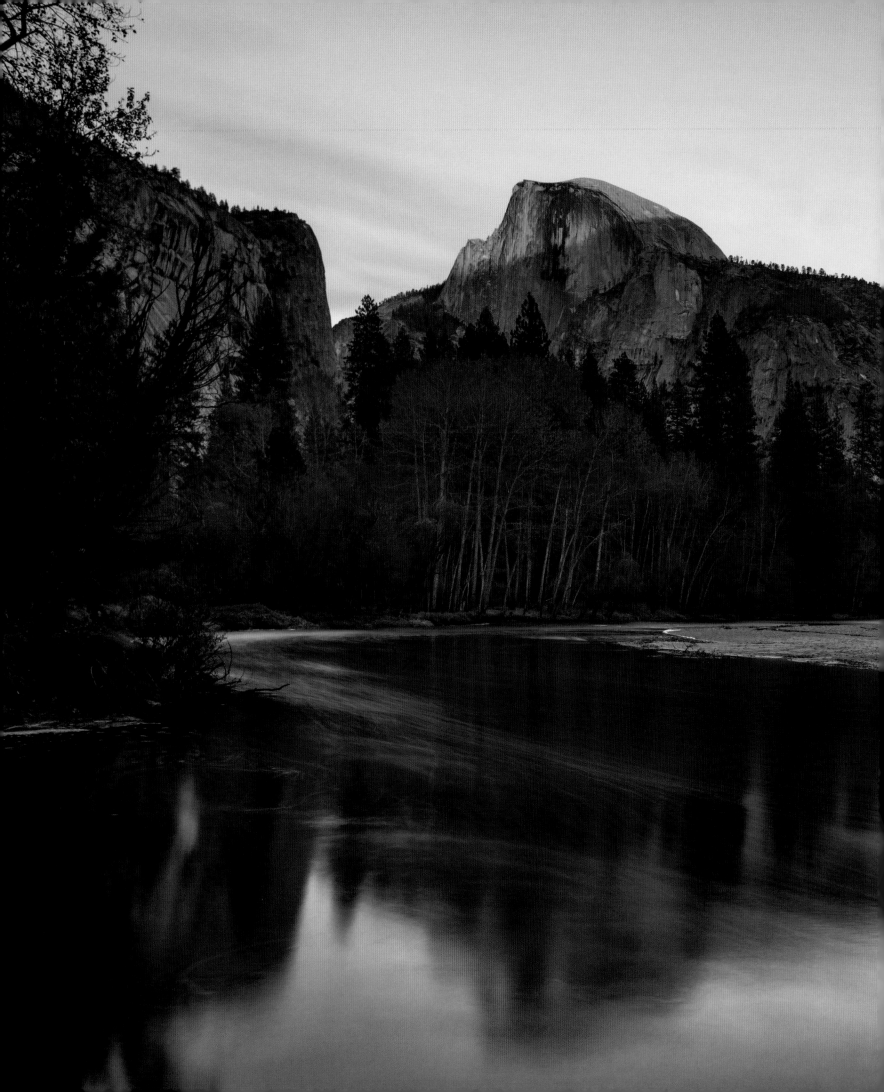

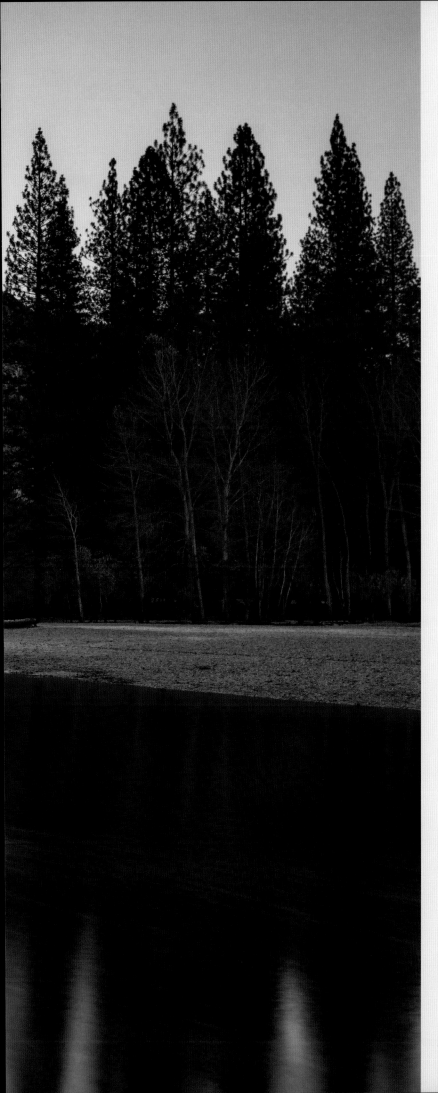

PACIFIC CREST TRAIL
USA

It is fairly remarkable that anyone thought to establish a path where the Pacific Crest Trail (PCT) currently lies. Winding its way along the crest of the coastal mountain ranges of the Sierra Nevada and Cascades for 4,285 kilometres (2,663 miles) – from the United States–Mexico border to Canada – the PCT is the second-longest hiking trail on Earth.

Walking its length is like crossing a continent, cutting through the heart of seven of the United States' 58 national parks and 25 of its national forests, managing to traverse some of North America's harshest wildernesses.

Only the more recently developed Continental Divide Trail that runs through the Rocky Mountains further to the east covers more terrain. Because of this, it takes most hikers half a year to complete the trail, if they manage it at all. Most trekkers end up spending less than a week wandering on the PCT, cherry-picking highlights from its most scenic sections, such as summiting 4,421-metre (14,505-feet) Mount Whitney in California, the tallest mountain in the Lower 48 states. And for good reason. Planning to walk anywhere for five to six months straight is a commitment, to say the least, let alone whilst intentionally crossing some of the harshest, most unforgiving terrain on the continent.

Where most people choose to start the trail, in Southern California, in spring, the route begins with more than 1,000 kilometres (620 miles) of desert. By the time summer rolls around, timely trekkers have reached central California's Sierra Nevada mountains, and the noticeable views and elevation gains associated with them. In Northern California, where successful through-hikers usually find themselves by midsummer, the weather begins to turn cool and the rain begins to pick up in frequency, marking one of the most isolated portions of the entire trail. Oregon offers largely a flat walk through moss-covered, old-growth forest, before trekkers find themselves trudging uphill through the high, rugged mountain passes of the North Cascades, near the Canadian border, just before full-on winter sets in.

Perhaps even more remarkable than PCT's scale and difficulty is the fact that it has become one of the most popular long-distance through-hikes anywhere in spite of it; perhaps more so, even, than the storied and much older Appalachian Trail in the eastern United States. More than 5,000 people attempt the PCT from start to finish every year; not nearly that many make it to the other end, understandably.

LEFT

HALF DOME CATCHES THE LAST GLOW OF
SUNSET IN YOSEMITE NATIONAL PARK.

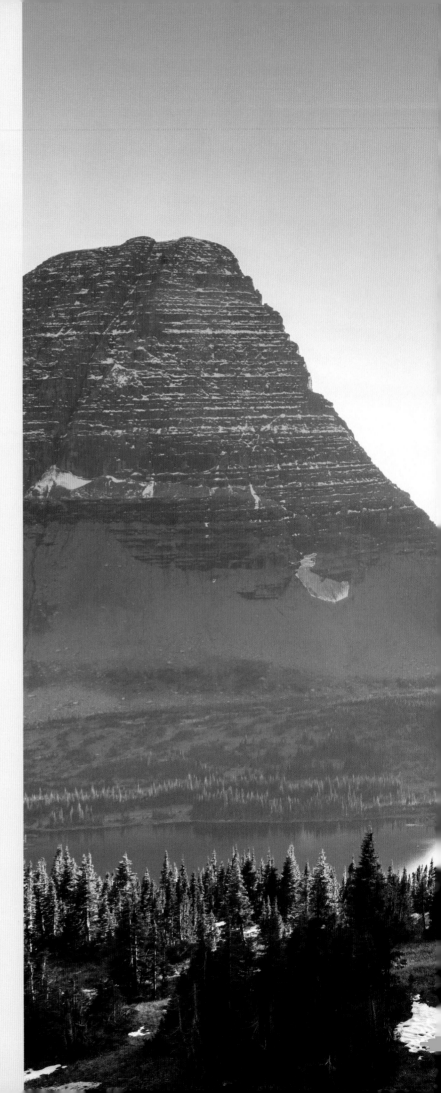

CONTINENTAL DIVIDE TRAIL
USA

This is the longest long trail of them all. Following the length of the Continental Divide in the United States, where water falling on one side of the Rocky Mountain range drains east towards the Gulf of Mexico and the Atlantic Ocean, and the water falling on the other side goes west towards the Pacific Ocean, the Continental Divide Trail (CDT) is just shy of 5,000-kilometres (3,000 miles). Almost everything about it is bigger and more extreme than other, even remotely, comparable long-distance treks.

Cutting through hundreds of kilometres of high-altitude deserts, and requiring trekkers to climb 127,901 metres (419,623 feet) over the course of its entire length, it usually takes seasoned, well-conditioned trekkers the better part of a year to complete the CDT from end to end. As with its slightly older sister long-distance trail that follows the Pacific Crest through the coastal mountains of North America, most people choose to bite off smaller sections of the CDT before trying to give it a go from start to finish.

Starting at the US–Mexican border and ending at the US–Canadian border clear on the other side of the country, the CDT passes through five states – Montana, Idaho, Wyoming, Colorado and New Mexico – 25 national forests, 21 wilderness areas, three national parks and one national monument. This means that the majority of those 5,000 kilometres (3,000 miles) are incredibly remote. Take, for example, the half-million-acre Weminuche Wilderness in Colorado: it is quite possible to walk for a week through the mountains here without seeing another soul.

This is why so few people attempt to hike the entire length of the CDT. After it was first built in 1972, only one person was known to have completed it over the course of five years. In 1977, only one other person apparently managed it. As of 2017, fewer than 200 people were known to have completed the CDT in its entirety. The trail itself is still only about 85 per cent complete, as of this book's publication, requiring serious through-hikers to either bushwhack or navigate around the hundreds of kilometres of trail-free stretches found along the route.

Still, the CDT offers the most direct line through the centre of the Rocky Mountains – or the heart of America, for that matter – than any trail ever built, or ever likely to be built. As far as remote, rugged, long-distance trails go, there is none superior or more challenging, and it will always call to those who love the mountains because of it.

OVERLEAF

HIKERS DESCEND FROM THE
SOUTH RIM OF THE GRAND
CANYON ALONG THE SOUTH
KAIBAB TRAIL.

RIGHT

LOGAN PASS AT GLACIER NATIONAL
PARK IN MONTANA, USA.

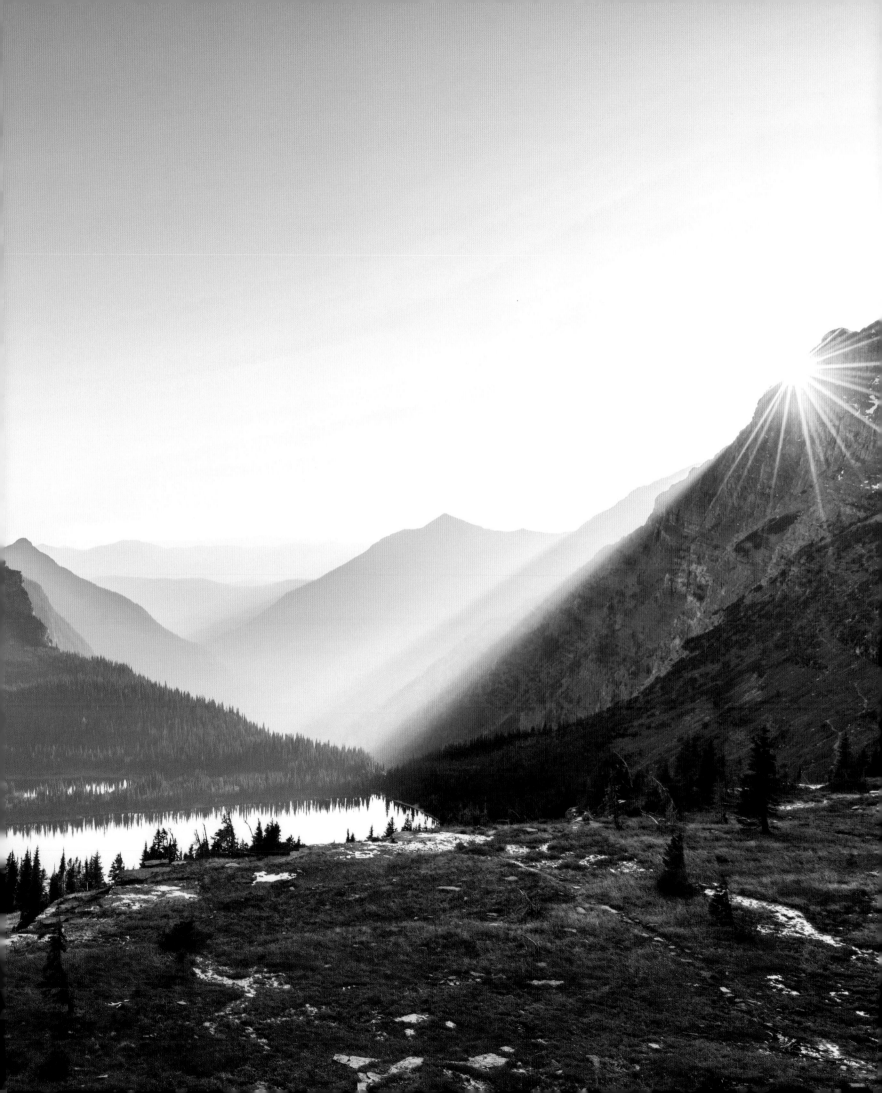

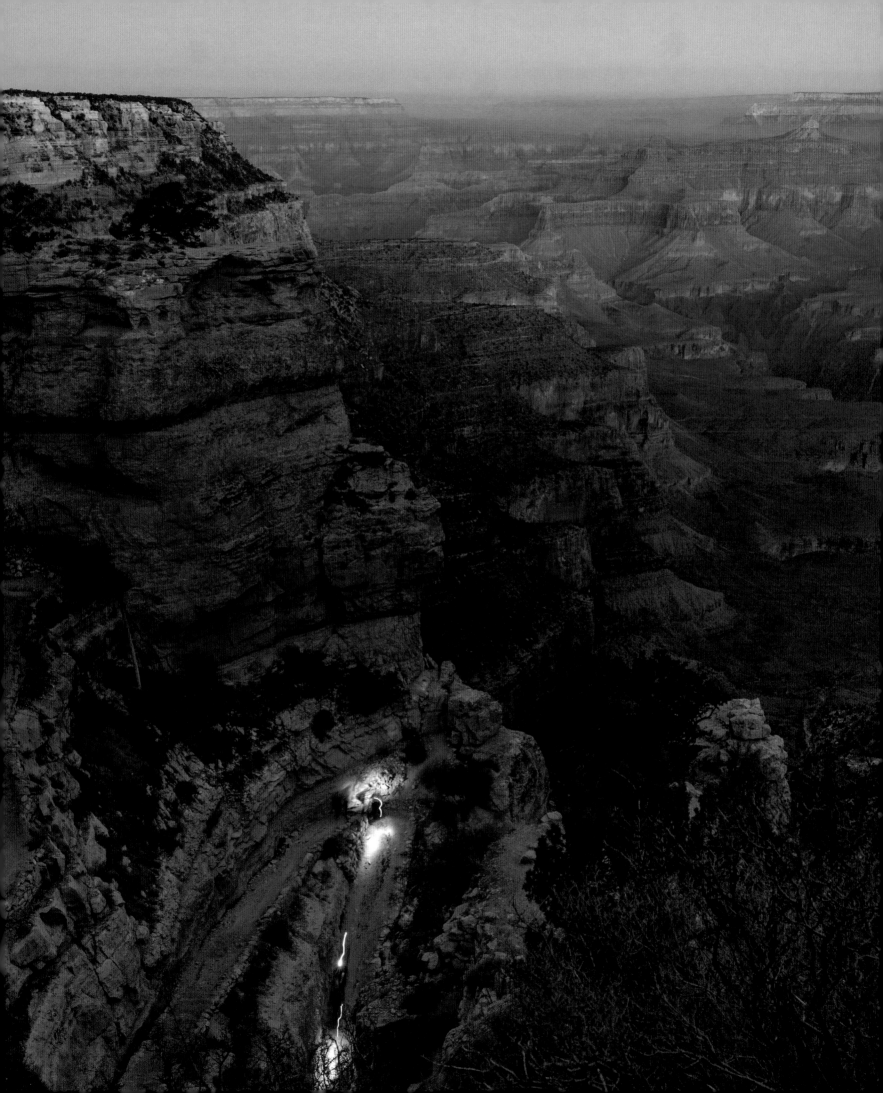

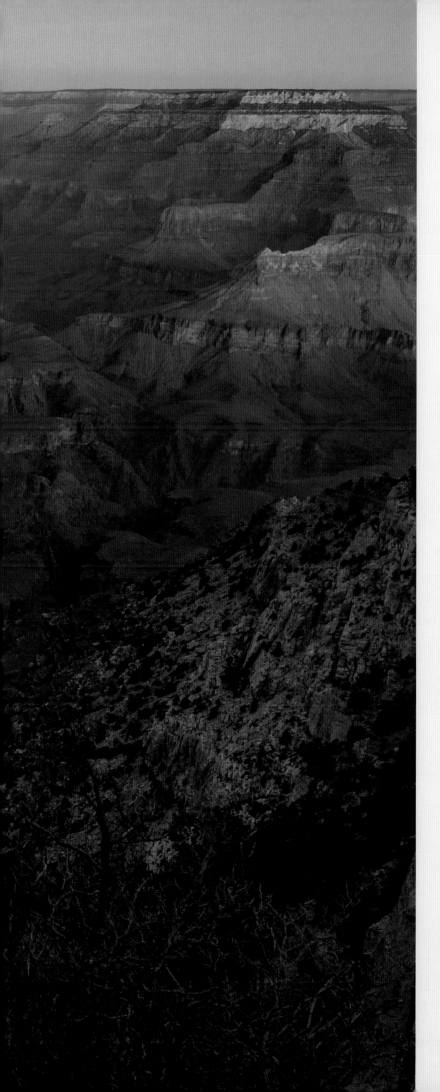

RIM-TO-RIM TRAIL
USA

The biggest up-and-down, one-way day hike on Earth – and one of the most unique –the Rim-to-Rim Trail is the only place where you can look up and see more than a kilometre of near-vertical cliffs above you, on all sides. It is also miraculously accessible, considering its otherwise severe topography. For all these reasons, it is generally considered to be one of the best day hikes anywhere.

Exactly what it sounds like, the Rim-to-Rim Trail in the Southwest region of the United States, in Grand Canyon National Park, starts on one side of the world's largest canyon and ends on the other, 38 kilometres (24 miles) and more than 3,140 metres (10,300 feet) of elevation change later.

Whilst doing the Rim-to-Rim Trail sounds at first like climbing into a big ditch only to scramble back out again, it is much, much more than that. In fact, it is arguably one of the most unique and scenic treks available, and something that is understandably on most people's bucket list. It is also the best way to see the Grand Canyon from the bottom of it, without needing to go through the intensive lottery permitting process that can sometimes take years, assuming it is done in a day, thereby removing the need for any back-country permits. For those who want to stay a night in the canyon, only a few hundred permits are awarded annually, in order to preserve the sense of isolation and limit human impact in the canyon. Plan in advance, and be prepared to be put on the waiting list. It's worth it.

The canyon itself is about 446 kilometres (277 miles) long, up to 29 kilometres (18 miles) wide and over 1.5 kilometres (1.25 miles) deep in places. Carved out of the solid sandstone plateau by the raging rapids of the Colorado River, it is considered one of the seven natural wonders of the world. And, unlike either the Pacific Crest or Continental Divide trails, with appropriate planning, physical conditioning and motivation, the Rim-to-Rim can be completed in one long day.

The notable size of the Grand Canyon makes the Rim-to-Rim Trail akin to an inverted mountain climb. Starting on the North Rim of the canyon, trekkers descend the North Kaibab Trail, dropping 1,780 metres (5,840 feet) over the course of dozens of tight switchbacks carved into the steep canyon walls. At the base of the canyon – an inverted summit-of-sorts – a lone swinging suspension bridge crosses the river, which is still actively shaping the surrounding canyon. It is worth pausing here, at the bottom of the canyon for a few minutes, to appreciate the surroundings: a sight that less than one per cent of the annual five million visitors to Grand Canyon National Park get to see for themselves. From there, it's a 1,360-metre (4,462-feet) ascent up the Bright Angel Trail, with minimal shade, before reaching the South Rim of the Canyon and, hopefully, a pre-planned shuttle back to the other side.

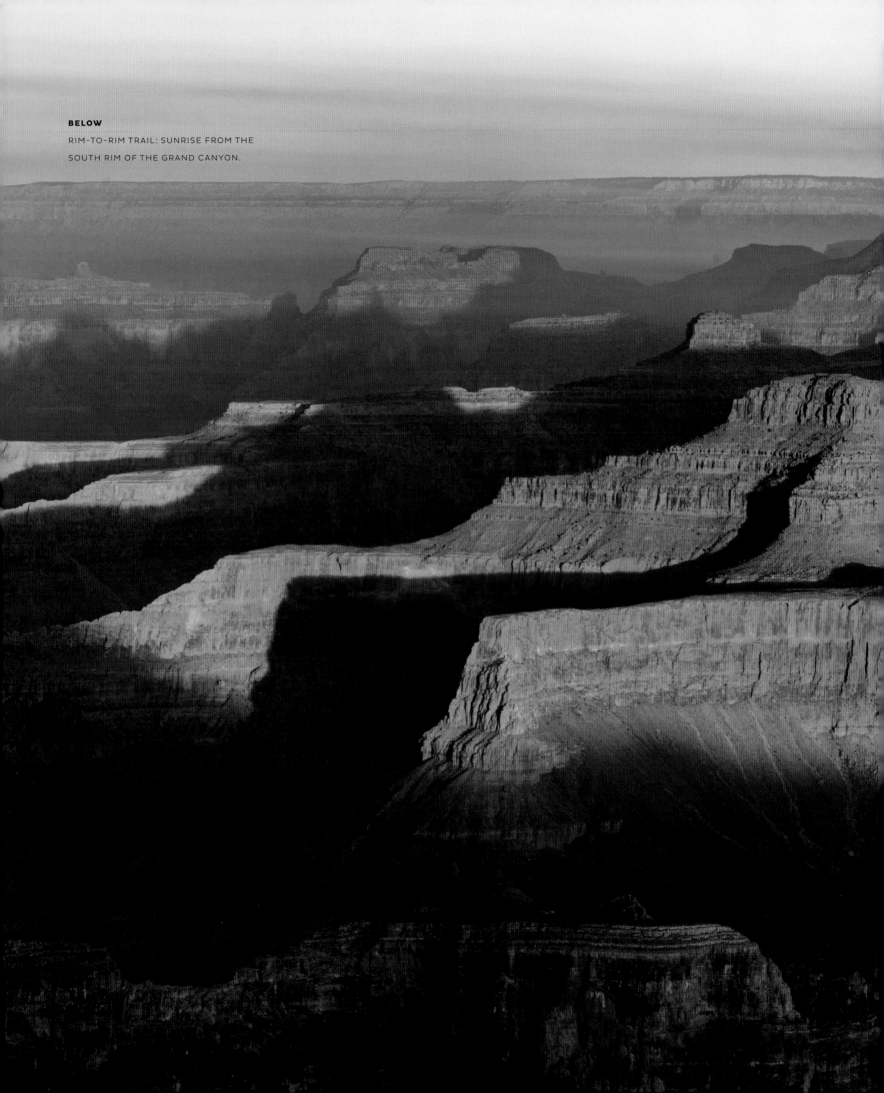

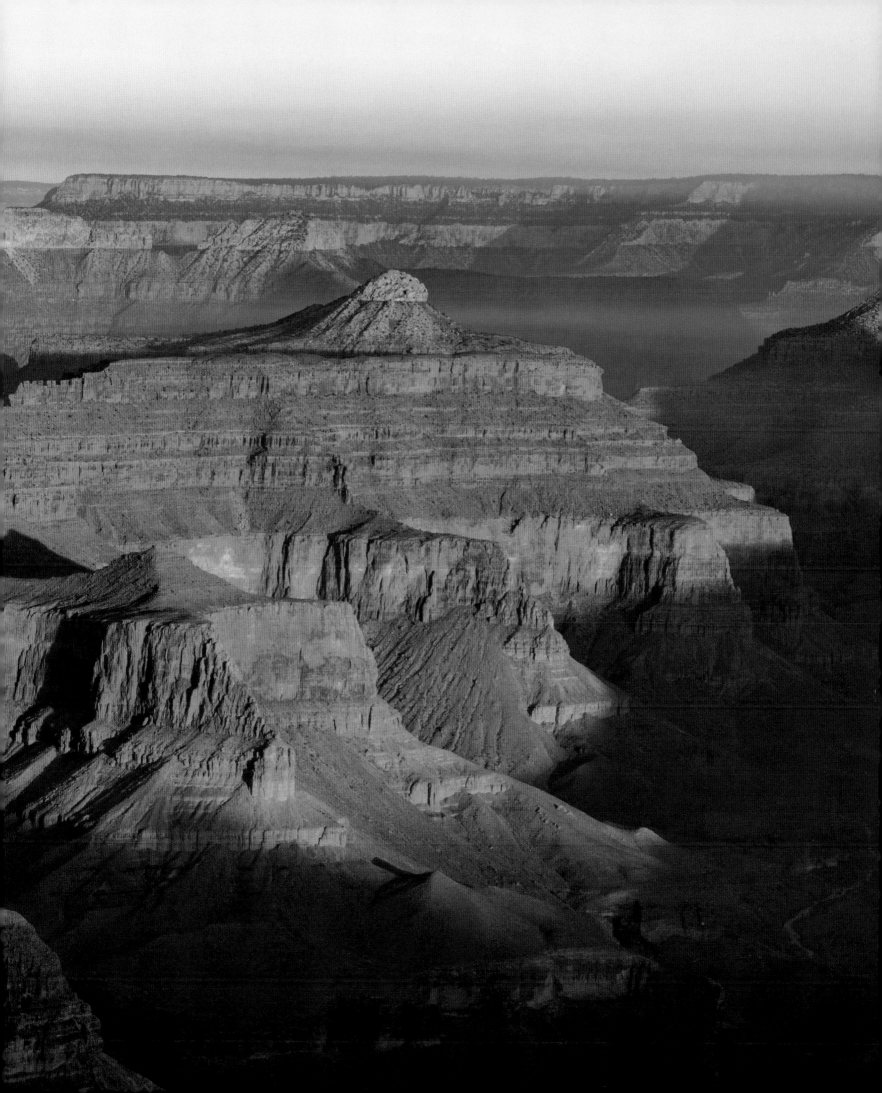

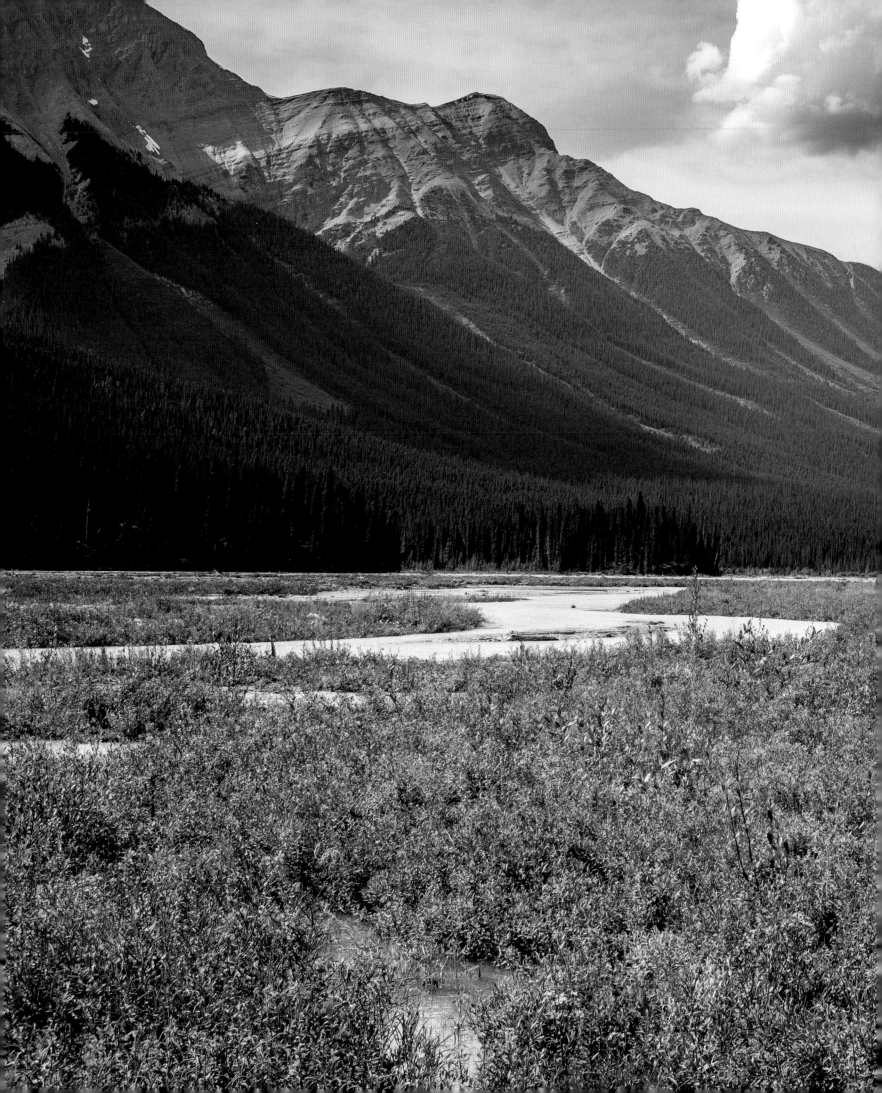

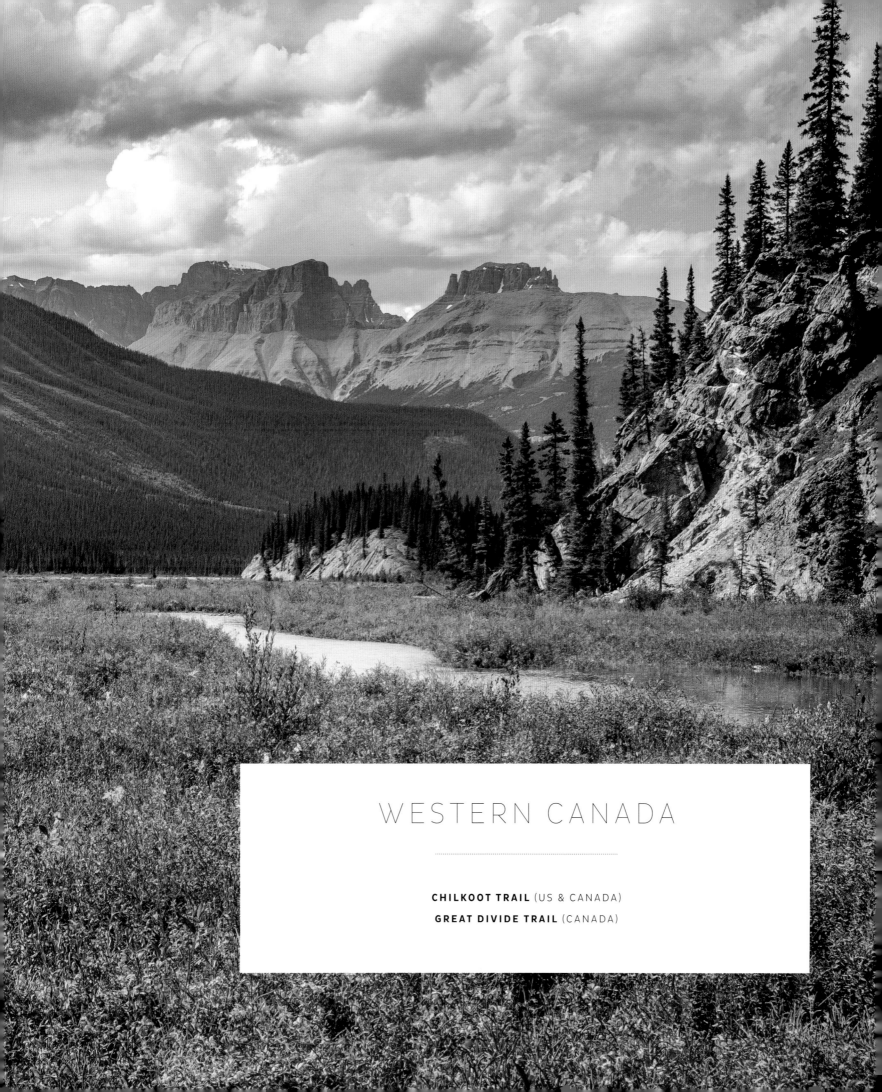

WESTERN CANADA

..

CHILKOOT TRAIL (US & CANADA)
GREAT DIVIDE TRAIL (CANADA)

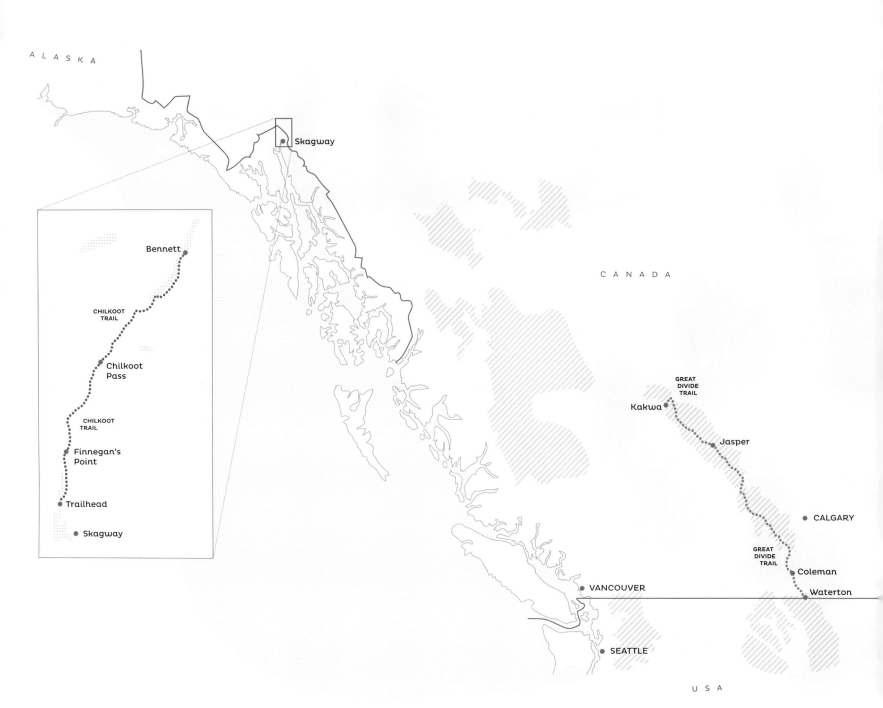

ALASKA

Skagway

Bennett

CHILKOOT
TRAIL

Chilkoot
Pass

CHILKOOT TRAIL

Finnegan's
Point

Trailhead

Skagway

CANADA

GREAT
DIVIDE
TRAIL

Kakwa

Jasper

CALGARY

GREAT
DIVIDE
TRAIL

Coleman

Waterton

VANCOUVER

SEATTLE

USA

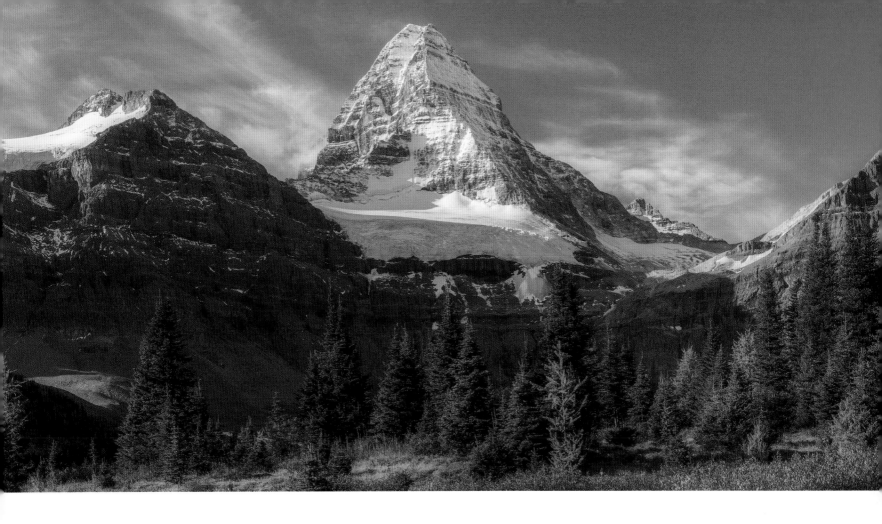

Western Canada

Trekking anywhere in the remote corners of western Canada is, beyond a doubt, one of the wildest, most solitary experiences left on Earth. The entire region is defined by wide-open spaces. It occupies such a vast area of the globe, it's impossible to generalise what western Canada is like as a whole; other than mostly empty and insanely beautiful.

British Columbia, on the West Coast by the Pacific Ocean, has an area of over 945,000 square kilometres (365,000 square miles) alone. That's about two and a half times the size of Germany. The neighbouring provinces of Yukon and Alberta, and the western provinces of Manitoba and Saskatchewan, are each about the same size. Together, they take up more space than all of continental Europe, yet have only about one per cent of the population.

There is a lot of room to roam in western Canada, to say the least, and the trekking throughout the region reflects the boundless nature of the surrounding landscape. There are more trails here than one could reasonably – or even unreasonably – do in a single lifetime. Certainly, there are more single-track trails than paved roads. And whilst one path can traverse for weeks through the harsh, alpine tundra zones that make up any of the four mountain ranges that occupy nearly one-third of British Columbia, another trail in Alberta can cross a plain that is hundreds of kilometres wide; or pass through the seemingly endless boreal forests and muskegs of Manitoba before ending on the edge of the Atlantic Ocean, a continent away on the shores of Hudson Bay. If one's willing to bushwhack off trail, the back-country opportunities are endless.

While the potential for shockingly long-distance treks is substantial, as evidenced by the 1,125-kilometre (700-mile) Great Divide Trail that follows the Canadian Rockies from

ABOVE

GREAT DIVIDE TRAIL: MOUNT ASSINIBOINE, ON THE BRITISH COLUMBIA–ALBERTA BORDER.

PREVIOUS PAGES

GREAT DIVIDE TRAIL: IN EARLY AUGUST, WILDFLOWERS ERUPT ALONG THE BOTTOMLANDS OF THE HOWES RIVER.

the US border with Alberta through British Columbia, there is no shortage of mere-mortal day hikes to be found, either. Just a 20-minute drive from downtown Vancouver in British Columbia, for example, there is a reasonable two-hour hike that leads to the summit of 1,054-metre (3,458-feet) Dog Mountain, offering unparalleled views of the city, the Coast Mountains and the island-speckled Salish Sea that stretches for thousands of kilometres north, to the Gulf of Alaska. It's not bad for a walk that downtown Vancouver office workers can do on a weekday after work. In British Columbia's Banff National Park, there are over 1,600 kilometres (995 miles) of well-maintained trails. Some range from a few hours long to several days.

Travelling north along the coast, float planes and boats become the preferred mode of transportation, especially in winter. A plane is definitely the best way to access the Turner Lake Chain in Tweedsmuir South Provincial Park, a series of seven lakes that suddenly and rather dramatically drops off the edge of a sheer 260-metre (853-foot) cliff in the middle of the Coast Mountains. It is otherwise completely inaccessible by road, other than driving to the end of a long, poorly maintained logging road and hiking uphill for 10 kilometres (6 miles) just to get to the base of the falls. Closer to the centre of British Columbia, in an area surrounded by a similarly expansive wilderness but intersected by the Alaska–Canadian Highway, a 1.5-kilometre (1-mile) long boardwalk through a boreal forest deposits visitors at Liard River Hot Springs, possibly one of the best-maintained natural hot springs in North America.

Even further to the north, Yukon is cut off at the top by the edge of the Arctic Circle, and has the largest grizzly bear population in North America along with the most massive mountain in Canada: 5,956-metre (19,540-feet) Mount Logan. It is also home to another four of the eight tallest mountains in the country, all of which lie in Yukon's isolated and perpetually snow-covered Saint Elias Mountains. Trekking here is not for the faint-hearted, or those without extra food and warm clothes.

The territory also boasts the most expansive, non-polar permanent ice fields on the planet: the Kluane Icefield in Kluane National Park, which is more than 22,000 square kilometres (850 square miles) on its own; making the park itself larger than many small countries. On the northern coast of the territory, along the Beaufort Sea, the ground is permanently frozen.

Within the 475,000 square kilometres (185,000 square miles) of land in Yukon, there are only about 36,000 people who live there permanently. The country of Luxembourg, by comparison, has more than 16 times as many people living in an area that is less than 0.05 per cent the size of Yukon. For those who wander into the mountains here, or float the wild, winding rivers, it is perfectly normal not to see another soul for days, if not weeks.

RIGHT

THE GREAT DIVIDE TRAIL.

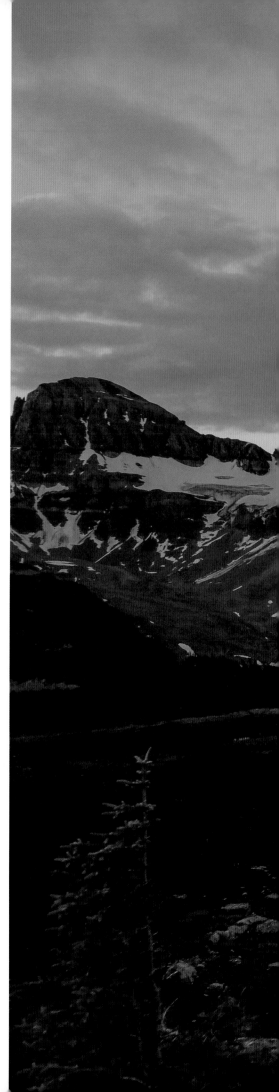

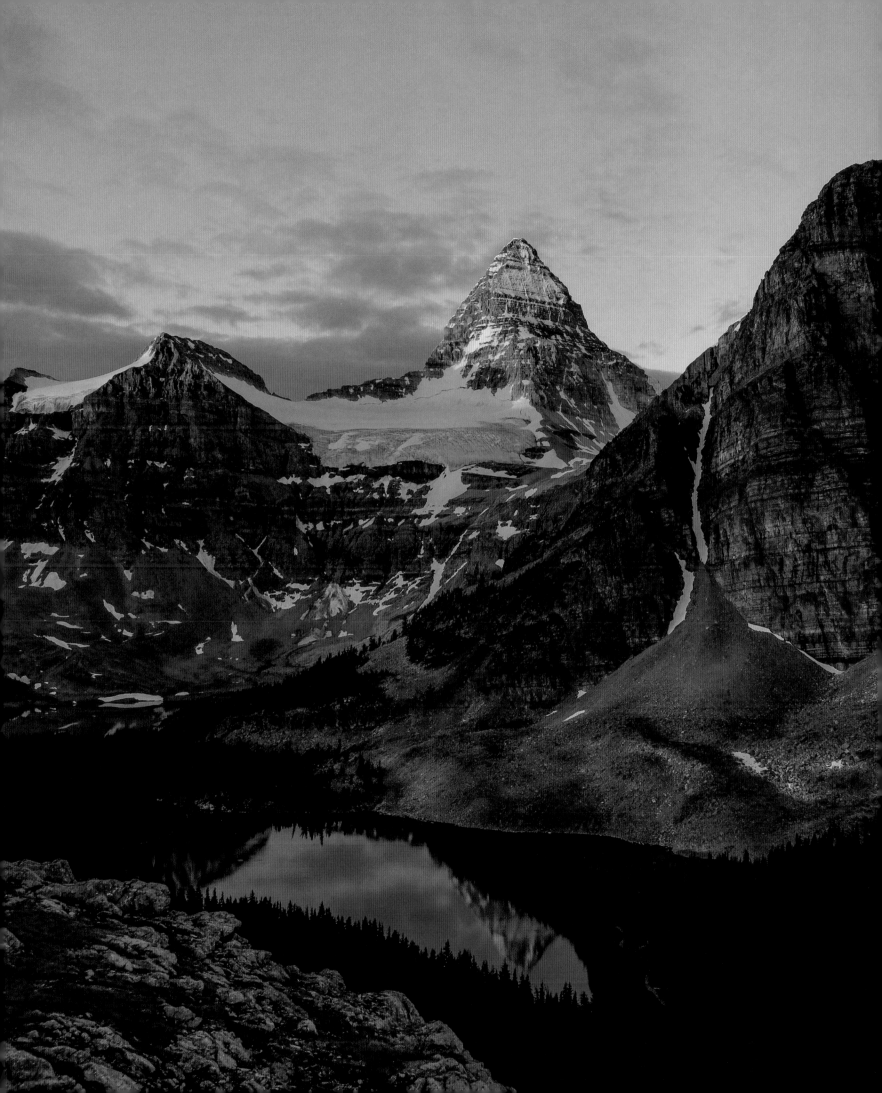

CHILKOOT TRAIL
USA & CANADA

Starting in the rugged and isolated port of Dyea in Alaska and ending in Lake Bennett in Yukon Territory, the 53 kilometres (33 miles) that make up the now infamous Chilkoot Trail are undoubtedly better than any natural history museum in North America: nowhere else can someone climb a rugged mountain pass and look at so many historical artefacts simultaneously. It is also one of the only ways to see the Coast Mountains up close on an established, relatively safe and well-patrolled trail, at least in the summer months between June and September. The rest of the year, trekkers are on their own, since the trail isn't staffed by either the US or Canadian national parks systems in the winter.

In August 1896, local miners in the Klondike region of Yukon Territory in Canada found a noticeable amount of gold. Word of their good fortune spread – fast. Over the course of the next three years, more than 100,000 people travelled to the then US territory of Alaska to climb – often alone, shuttling a metric ton of gear, which was required by the Canadian government at the time – over 1,000 vertical metres (3,200 feet), across one of two mountain passes that cross the Coast Mountains to Lake Bennett.

Once at the lake, the prospectors would then fashion crude rafts from the local stands of pine, and sail down the icy Yukon River for hundreds of kilometres to find their fortunes. It was the Klondike Gold Rush, and while some of the prospectors struck it rich, most wound up wandering the wilds for years, digging more holes than they could count, only to return home empty-handed. Most left something behind. Old buildings, shovels, packs, coffee cans and other gold-rush memorabilia can still be found, slowly decaying beside the path, offering an intimate and personal glimpse into North America's pioneering history.

Today, the trail offers a slightly more manageable, typically four-day-long trekking holiday; although it is still not for the inexperienced, or those just getting up off the sofa. Starting at near-sea level, the trail begins benignly enough, meandering through several kilometres of coastal rainforest for the first two days. Then, quite abruptly, it climbs nearly 1,000 metres (3,200 feet) on day three over Chilkoot Pass, through dramatic snow and ice, before descending into the slightly higher-elevation boreal forests of Yukon and a series of glistening alpine lakes.

There's no gold at the end of the trail, but the view from the top of the pass is priceless.

RIGHT

CHILKOOT RIVER FLOWING FROM CHILKOOT
LAKE, TONGASS NATIONAL FOREST, CHILKAT
BALD EAGLE PRESERVE NEAR HAINES,
SOUTHEAST ALASKA.

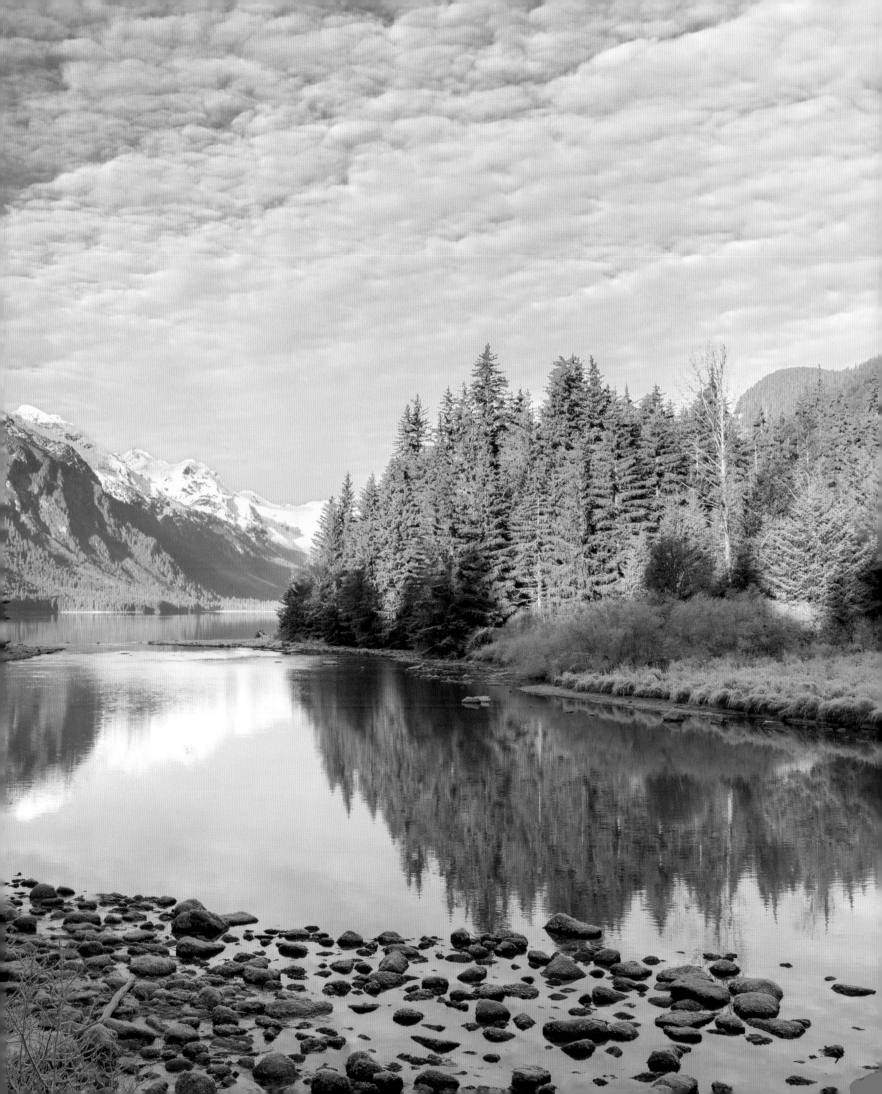

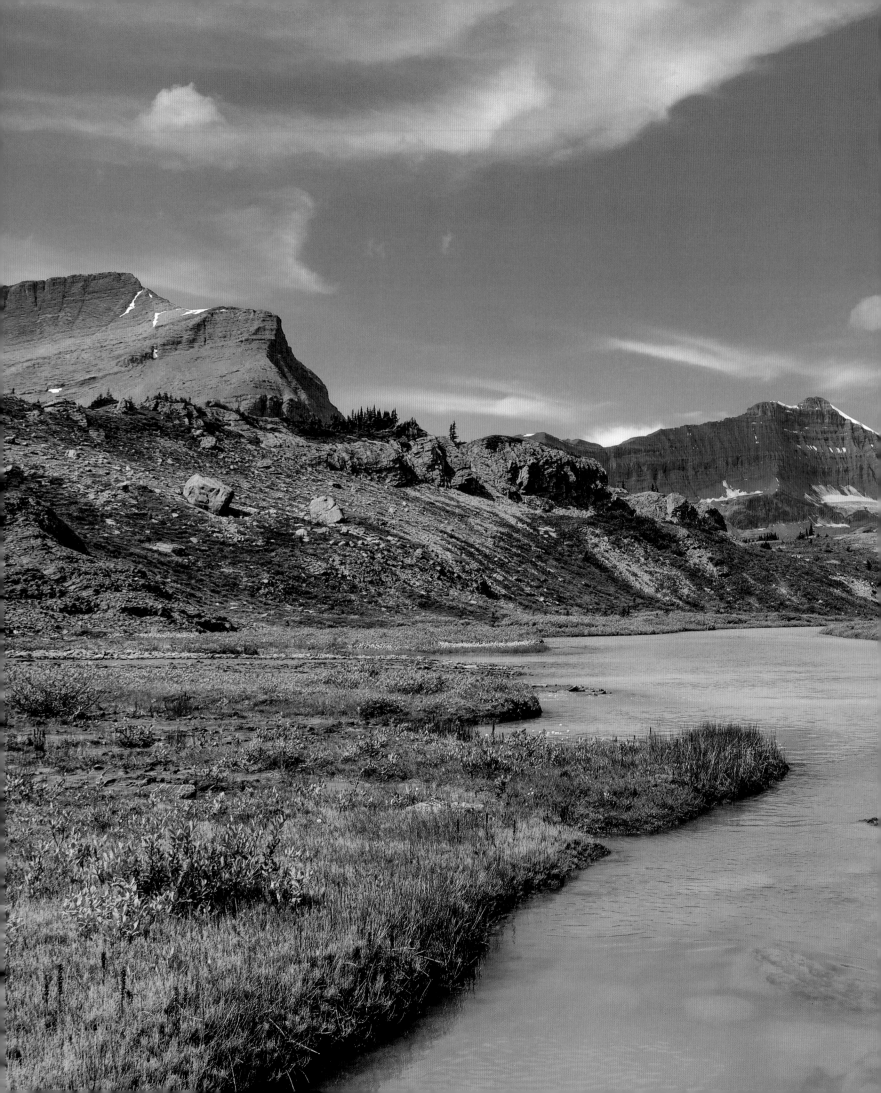

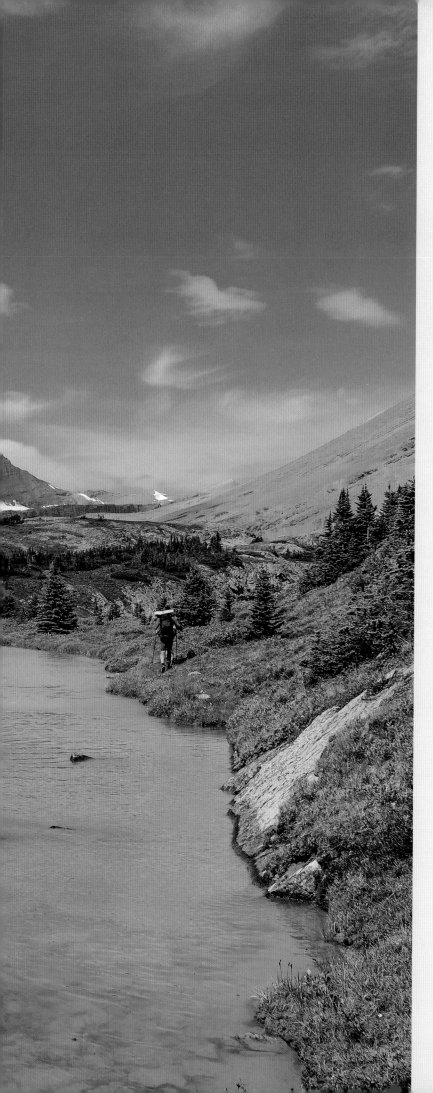

GREAT DIVIDE TRAIL
CANADA

For those looking to disappear from urbanity, Canada's Great Divide Trail (GDT) is a great option. Over the course of 1,200 kilometres (750 miles), it follows the spine of the Canadian Rockies through some of the most remote wilderness left outside of the Arctic Circle.

The remoteness of this trail is too complete for many: to say that hikers on the GDT are a rarity is a gross understatement. For perspective, nearly 5,000 through-hikers obtained permits for the Pacific Crest Trail in the United States in 2017; fewer than 100 attempted to complete the entire GDT over the same time period.

The GDT more or less follows the border of Canada's provinces of Alberta and British Columbia, crossing the Continental Divide more than 30 times. Unlike other long-distance hikes, however, almost half of the GDT is not a maintained trail. It is largely wide-open, untrampled country that trekkers enter with the understanding that they need to reach some point on the other side. Many of the best long-distance hikers in the world haven't even attempted it.

The start of the trail (which still isn't formally recognised by the Canadian government) begins where the United States' famous Continental Divide Trail ends on the Canadian border. It then dives into five national parks and seven provincial parks before finally ending – usually months later – at Kakwa Lake in Kakwa Provincial Park.

From beginning to end, there are almost 42 kilometres (26 miles) of elevation gain along the GDT. That's like climbing from sea level to the summit of Mount Everest five times. Only 44 per cent of it is maintained, by a small group of devoted volunteers. The rest is distinctly unmaintained, or requires complete off-trail navigation. Much of the route isn't even marked, and it isn't supposed to be. That's the idea.

Three distinct climates converge along the GDT's length: alpine, temperate rainforest and, at the northern end of the Canadian Rockies, arctic. Weather changes quickly along the entire trail. It is possible to be baking in a T-shirt in the afternoon and be donning a puffy, insulated down jacket the same evening, making it quite difficult to prepare for.

That's not to mention the estimated 1,000 or more grizzly bears that roam the area the GDT passes through, along with countless moose, elk, wolves, wolverines, mountain lions and other big, wild animals that like spending time where humans rarely go.

The GDT, in short, is a great place to get lost – or find oneself, depending how you look at it.

LEFT

WHEN THE PATH PETERS OUT, HIKERS FIND
THEIR OWN WAY ALONG THE HEADWATERS OF
THE BRAZEAU RIVER.

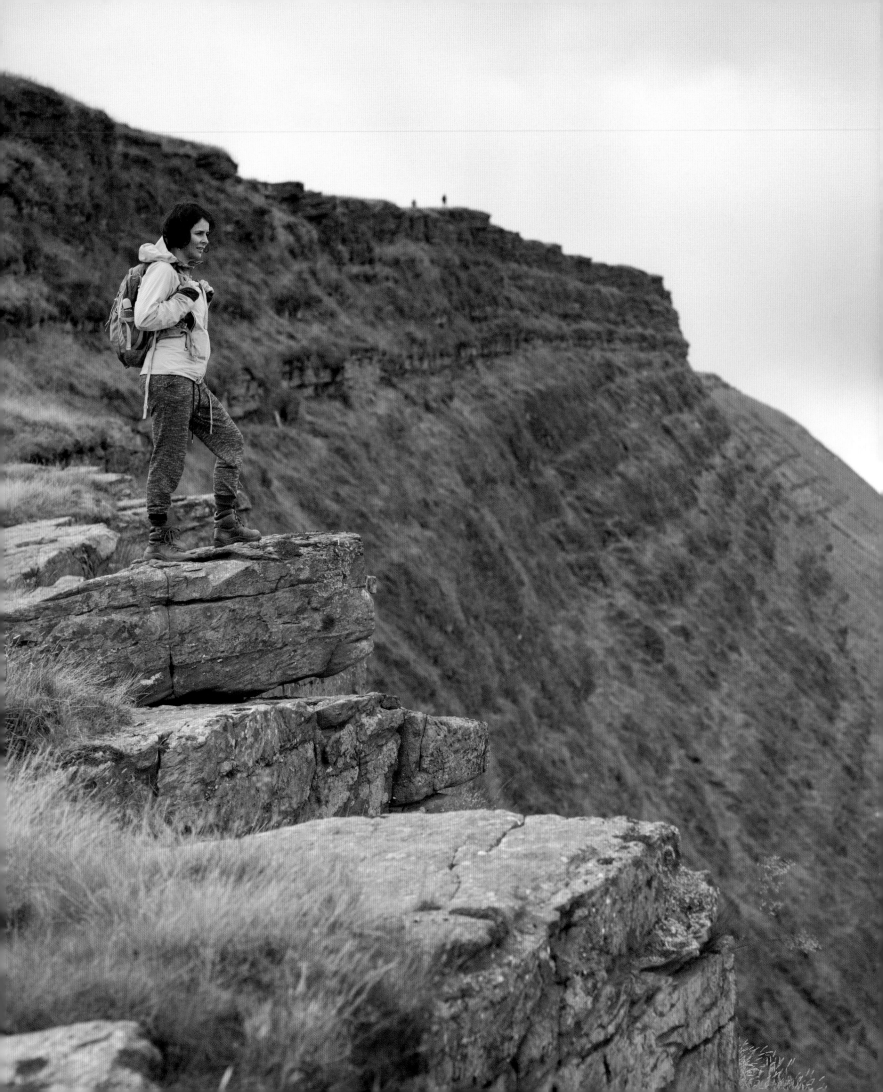

ALEX TREADWAY has worked around the world as a travel photographer for fifteen years, four of which he lived and worked in Kathmandu. As well as working for environmental and humanitarian NGO's in Nepal, his work has been published multiple times in *National Geographic* and *Geo Special*, along with many other publications.

BILLI BIERLING is a renowned mountaineer with special experience in high-altitude climbing. Based in Germany, Switzerland and the Himalayas, Billi has led treks in Europe, Nepal, northern India and Tanzania. She writes regularly for German and English-speaking publications, such as *The Nepali Times*, *Alpin* and *Münchner Merkur*.

DAVE COSTELLO is an award-winning writer, editor, photographer and filmmaker. He is the author of *Flying off Everest*, a former senior editor at *Alaska* magazine, and has also been published in *Outside, National Geographic, Backpacker, Rock & Ice, Climbing* and more.

DAMIAN HALL is an outdoor journalist and ultramarathon-runner who has completed many of the world's famous and not-so-famous long-distance walks, including the Everest Base Camp trek for his honeymoon. His most memorable trek, however, was when a possum stole his walking boot on the Six Foot Track in Australia's Blue Mountains.

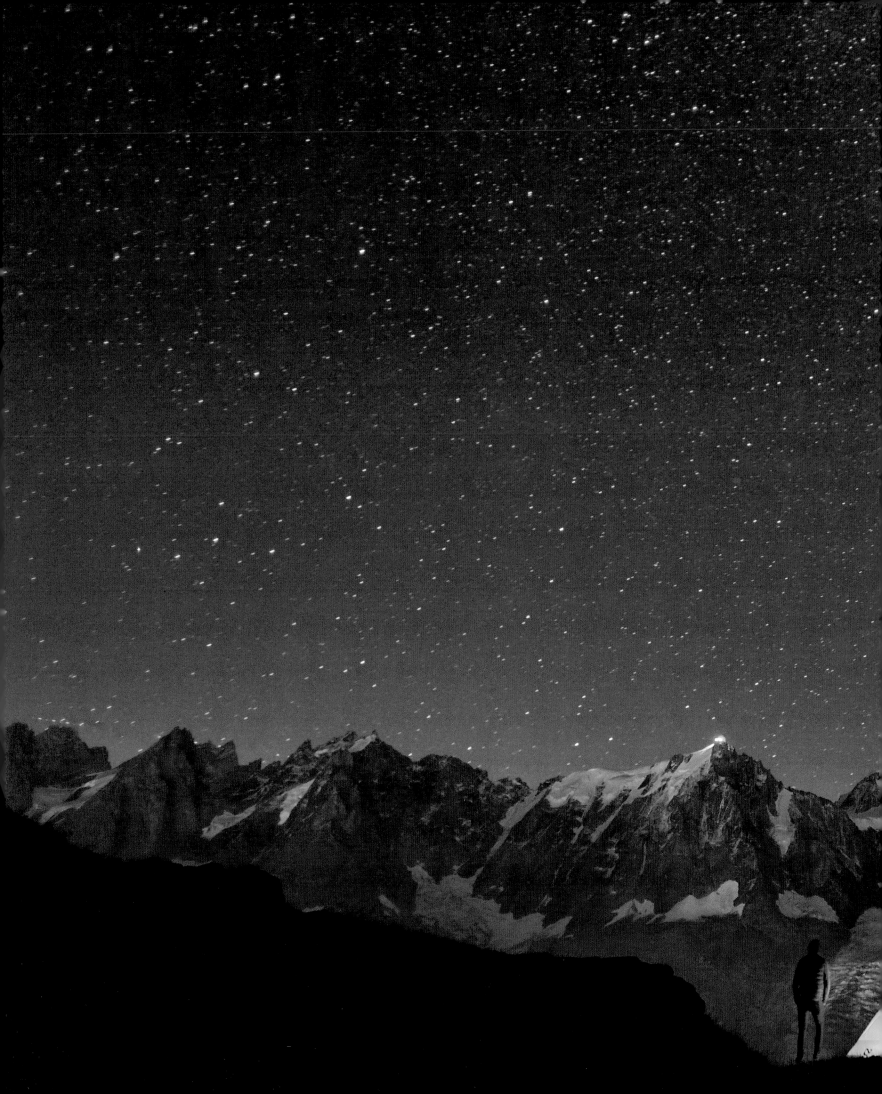

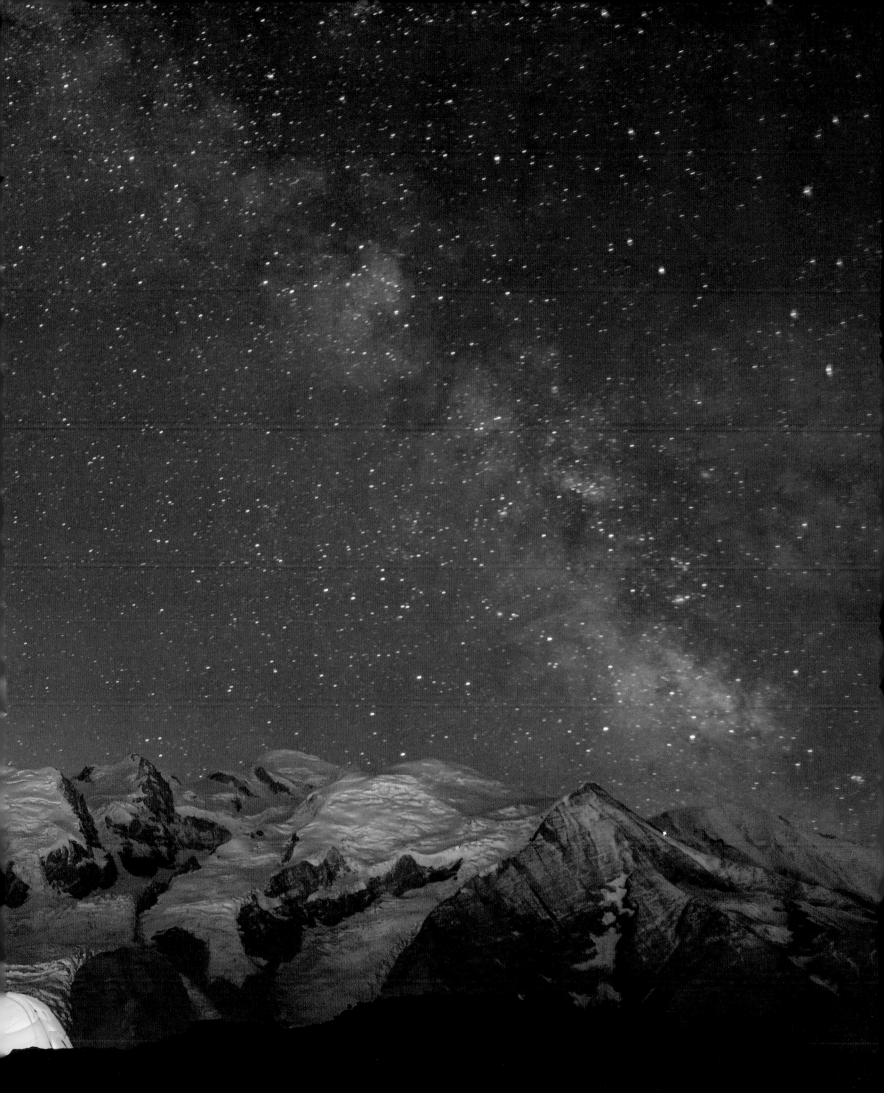

Brimming with creative inspiration, how-to projects and useful information to enrich your everyday life, Quarto Knows is a favourite destination for those pursuing their interests and passions. Visit our site and dig deeper with our books into your area of interest: Quarto Creates, Quarto Cooks, Quarto Homes, Quarto Lives, Quarto Drives, Quarto Explores, Quarto Gifts, or Quarto Kids.

First published in 2018 by White Lion Publishing,
an imprint of The Quarto Group.
The Old Brewery, 6 Blundell Street,
London, N7 9BH, United Kingdom
T (0)20 7700 6700 F (0)20 7700 8066
www.QuartoKnows.com

All images supplied by Alex Treadway, with the following exceptions: 26-27, 31, 37 Ville Palmu; 29, 32, 34-35 Frederik Ludvigsson; 124, 126-127, 142, 150 Jamie McGuiness; 134-135 fotoVoyager (Getty); 139 Tuul & Bruno Morandi (Getty); 140 Pratan Ounpitipong (Getty); 153 Emil von Maltitz (Getty); 154, 158, 161, 162, 164, 170 Ben Blanche; 157, 159, 167 Kurt Matthews; 179 Alison Wright; 180 Jesse Kraft/EyeEm (Getty); 183 Anton Petrus; 186, 188, 195 Joe Klementovich; 191 Justin Lewis (Getty); 192 Caleb Kenna; 205 Boogich (Getty); 210, 215, 218 Jon Meyers; 213 TerenceLeezy (Getty); 217 Ray Bulson (Getty)

A catalogue record for this book is available from the British Library.

ISBN 978 1 78131 696 2
Ebook ISBN 978 1 78131 855 3

10 9 8 7 6 5 4 3 2
2022 2021 2020 2019

Design by Bobby Birchall, Bobby&Co.

Printed in Singapore